The Calligrapher's Handbook

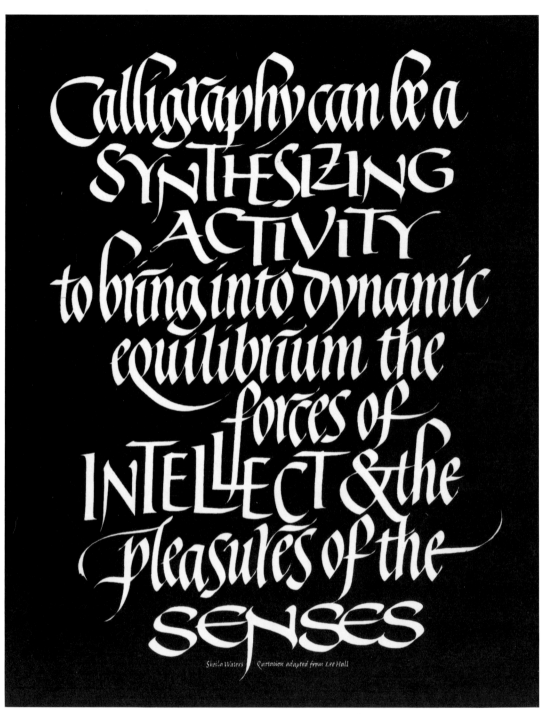

Sheila Waters: Quotation adapted from Lee Hall. Written out in black on white; reversed and printed by photolithography in black on Mohawk Superfine paper. Size of print $14\frac{1}{4} \times 11\frac{1}{4}$ in. 1977.

The Calligrapher's Handbook

Edited by Heather Child
on behalf of
The Society of Scribes and Illuminators

A&C Black · London

First published 1985
Reprinted 1986, 1991
A & C Black (Publishers) Ltd
35 Bedford Row, London WC1R 4JH

ISBN 0-7136-2695-X

© 1985 The Society of Scribes and Illuminators

Information about
The Society of Scribes and Illuminators
and application for membership
may be obtained from:
The Honorary Secretary, SSI
54 Boileau Road, London SW13 9BL

British Library Cataloguing in Publication Data

The Calligrapher's handbook.
 1. Calligraphy
 I. Child, Heather II. Society of Scribes and
Illuminators.
745.6′1 Z43

 ISBN 0-7136-2695-X

Typeset in Monotype Sabon by August Filmsetting,
St Helens
Printed in Great Britain
by BAS Printers Limited, Over Wallop, Hampshire

CONTENTS

PHOTOGRAPHS

vi

ACKNOWLEDGEMENTS

Grateful acknowledgements are due to all who have allowed their manuscripts to be illustrated; to the Trustees of the British Library; the Victoria & Albert Museum; the Bodleian Library for permission to reproduce manuscripts from their collections; and to Dr Ragab, Papyrus Institute, Cairo, for information about making papyrus.

Finally thanks are due to our publishers A & C Black and in particular to Anne Watts for her patience and interest and the meticulous care she has taken in preparing this book for the press.

Heather Child
April 1985

SUPPLIERS

Nibs, penholders, inks, brushes and pigments are generally available from Art Shops, including the following

Winsor & Newton
51 Rathbone Place, London W1
tel: 01–636 4231

Rowney
12 Percy Street, London W1
tel: 01–636 8241

Reeves
178 Kensington High Street, London W8
tel: 01–937 5370

Home-made pens (see page 12): nylon tubing may be obtained from Plastics manufacturers, particularly those specialising in extrusions; felt may be obtained from the British Felt Company, 73 Canning Road, Wealdstone, Middlesex

Parchment and vellum

William Cowley
Parchment Works, Newport Pagnell, Bucks.
tel: 0908–610038

Paper

Falkiner Fine Papers
117 Long Acre, Covent Garden,
London Wc2E 9PA
tel: 01–240 2339

J. Barcham Green Ltd
Hayle Mill, Maidstone, Kent
tel: 0622–674343

Paperchase Products Ltd
216 Tottenham Court Road, London W1
tel: 01–580 8496
and 167 Fulham Road, London SW3
tel: 01–589 7839

Papyrus

Dr. Ragab
Papyrus Museum, 3 Nile Avenue,
Giza
P.O. Box 45, Orman, Cairo, Egypt.

Gold and silver leaf

George M. Whiley Ltd (imported leaf)
Firth Road, Houston Industrial Estate,
Livingston, West Lothian EH54 5DJ
tel: 0589–38611

Habberley Meadows (English leaf supplied)
5 Saxon Way, Chelmsley Wood,
Birmingham B37 5AY
tel: 021–770 0103

C. F. Stonehouse & Sons (English leaf made and supplied)
Unit 1, Grove Avenue, Lymm, Cheshire
tel: 0925–754368

Gilding materials, burnishers, mullers, pounces, gums, knives, inks, nibs, quills, pigments, brushes, etc.

Falkiner Fine Papers (see above)

Cornelissen
22 Great Queen Street, London WC2
tel: 01–405 3304

Philip Poole & Co.
182 Drury Lane, London WC2
tel: 01–405 7097

Preface

HEATHER CHILD

The Calligrapher's Handbook is unique in being a collection of articles written by distinguished craftsmen with the aim of making their own methods, experience and workshop practice available to students of calligraphy.

The authors are all people concerned with the interests of the Society of Scribes and Illuminators and they write on many aspects of the craft: ranging from its tools and materials; the theory and design of formal scripts; stretching and mounting vellum; and methods of gilding; to the binding of manuscript books. The text is fully illustrated by instructive line drawings and there are reproductions of modern manuscripts by well-known calligraphers and illuminators.

At the beginning of this century Edward Johnston pioneered the rediscovery of the use of the edged pen through his scholarly study of historical manuscripts. A direct result of his teaching was the founding in 1921, by some of his early students, of the Society of Scribes and Illuminators with the aim of advancing the crafts of formal writing and illuminating.

The first *Calligrapher's Handbook*, published in 1956, and edited by the Rev. C M Lamb, originated in a suggestion by Alfred Fairbank and it constituted a memorial to two craftsmen: firstly, Edward Johnston, whose eminence as a teacher and calligrapher of genius is widely acknowledged; secondly, Colonel J C H Crosland who was a gifted carver, engraver and penman, with a great interest in the methods, models, tools and materials used by calligraphers. A generous gift from his widow to the SSI made it possible to commission the essays which were written for the book by invited craft members of the Society. The success of *The Calligrapher's Handbook* spread knowledge of the craft world wide and it became a classic publication.

Since 1956, however, many changes have taken place, especially in the past ten years, as new methods and materials have become available to the calligrapher.

In 1982 the SSI committee, under the chairmanship of Stan Knight, decided to embark on an up-to-date *Calligrapher's Handbook* fully illustrated and with an entirely new format. A number of people professionally engaged in calligraphy and related crafts were invited to write on tools, materials and methods of work in which they had informed practical experience and skill. The scope of the earlier book has been widened to include articles on: *Preparation of Quills and Reeds; Papyrus; Painting Letters on Fabric; Calligraphy as a Basis for Letter Design; The State of Handwriting* and *Printmaking, Printing and the*

Calligrapher. Four valuable articles in the earlier Handbook have been reprinted in this volume: *Pigments and Media* and *Illumination and Decoration* by Dorothy Hutton; *Ink* by Thérèse Fisher; *Cursive Handwriting* by Alfred Fairbank.

This book could not have been produced without considerable co-operative effort. Grateful acknowledgements are made to the authors of the articles in the earlier and in this new *Calligrapher's Handbook*. The editor owes special thanks to the craft members of the Society who were appointed advisers: Ann Camp, Stan Knight, Alison Urwick and John Woodcock. They gave generously of their time in planning the book and reading and commenting on the articles. Many of their suggestions have improved the book as a whole. I would especially like to thank Ann Camp for her constructive advice and help and for suggesting the advantages of a larger page format. In addition to writing two important articles, John Woodcock was concerned from the start with the preparation and design of the new book. Alison Urwick made the many line drawings throughout the text, with the exception of those in *The Binding of Manuscripts* which were drawn by Joan Rix Tebbutt; John Woodcock and Tom Perkins did the alphabets for their respective articles on *Formal Scripts* and *Calligraphy as a Basis for Letter Design*.

The widespread interest in calligraphy today has led to the production of numerous new books dealing with practical aspects of the subject, and new art history books give the results of the latest historical research. Brenda Berman, SSI Librarian (with valued assistance and extensive recommendations from Ann Camp) was responsible for compiling a *Selected List of Books*. This is given on page 249.

It is appreciated that readers may want to know where they can buy tools and materials. The addresses of suppliers have not been given in the text because they may go out of date. However, a short list of current suppliers and their addresses is given on page viii.

While *The Calligrapher's Handbook* is intended to be of practical use to serious students of calligraphy, lettering artists, designers and teachers, amateurs and all enthusiasts for fine writing and lettering should derive both information and pleasure from its contents.

It is not easy to acquire practical techniques from the written word alone. The beginner is advised to read an article through and then to follow the directions closely in conjunction with the line drawings. There is no substitute for actually cutting a quill, stretching and mounting vellum, laying gold leaf, or sharpening a metal nib. It is only by *practising* the techniques described that confidence and experience can be gained. The authors are not laying down hard and fast rules, they aim to take the reader through stages and methods of working that from long experience have proved satisfactory to them.

Since the Johnston revival scribes in Britain have been in the forefront of traditional calligraphy for the production of formal addresses, manuscript books (many of them memorial books and Rolls of Honour) and other ceremonial and illuminated documents on vellum which often include heraldry.

Until the 1960s most scribes were primarily concerned with fine craftsmanship in the making of 'things'[1]

[1] E.J. wrote about and recommended the making of 'things': *W & I & L* p.xxii. *Formal Penmanship* p.144

where legibility and fitness for purpose are essential.

A tradition of fine craftsmanship still actively exists but gradually over the years, growing out of it and combining with it, new forms of self-expression have increasingly been in evidence on both sides of the Atlantic. The motivation for work has moved away from the functional making of manuscripts into the more innovative sphere of individual expression and experiment where mood, colour, texture and dynamic use of space often take precedence over legibility. It should be emphasised however that innovation and invention are also, but less obviously, essential qualities in traditional calligraphy and future possibilities of development in both directions seem limitless.

Heather Child
April 1985

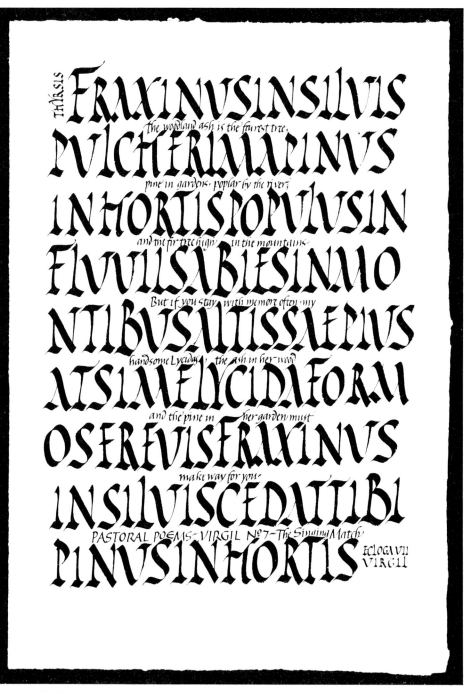

Peter Halliday: Quotation from Virgil, *Eclogue VII*, written in Rustic script. English translation by the scribe in semi-formal italic. Sumi ink on Bodleian handmade paper. 20 × 14 in. 1983. By courtesy of Professor and Mrs. David Taylor.

Pens in Perspective

HEATHER CHILD

Calligraphy is a craft requiring singularly few tools – the writing instrument, the ink and the writing surface are the only essentials. The *art* of calligraphy depends on the scribe having an understanding of the proper use of all three, on his knowledge of letterforms and on his skill and freedom in their use.

The chisel, the pen, the brush and other tools have all been used: to declare, to inform, to decorate, to worship, to show off dexterity and skill. Chinese calligraphy – the art of the brush – translates manual skill into pure poetry.

Writing is concerned with communication. It is a substitute for the voice; sounds are replaced by marks and these endure when men die. From earliest time, men scratched symbols for things, they carved and painted them on wood and stone and metal. Historically a style of writing has always been influenced by the nature of the writing instrument and the writing surface.

Around 3000 BC the Sumerians developed the principles of picture writing and subsequently cuneiform writing which spread to other countries of the Near East. The Ancient Egyptians, too, developed a pictorial writing that involved many carefully-drawn symbols and these hieroglyphs were used as a monumental script for some 3500 years.

The development of papyrus as a writing surface encouraged the use of two later scripts, both descended from the cumbersome hieroglyphs, which over the centuries became firstly the hieratic or priestly script, and later the demotic or people's script which lasted some thousand years. Both scripts were written nimbly with ink on papyrus by scribes using pens made from a thin-stemmed rush plant.

These rush pens were solid, varied in thickness and were used variously as a 'brush-pen' when frayed at the tip; as a drawing pen with ink or colour when sharpened to a point; or as a writing pen when cut at an angle. The fibres of the plant were able to absorb and give off ink by capillary attraction.

It is thought that the reed pen was introduced by the Greeks in the third century BC, as the earliest incidence of its use comes from the period when Egypt was occupied by the Greeks. This pen was made from a hollow-stemmed reed which was slit to allow the ink to flow more freely and trimmed in the manner of a modern square-cut reed or quill. Examples of writing from that period show gradations from thick to thin strokes in the formation of letters. Such a technique gives a particular character and grace to the calligraphy of any period – including our own.

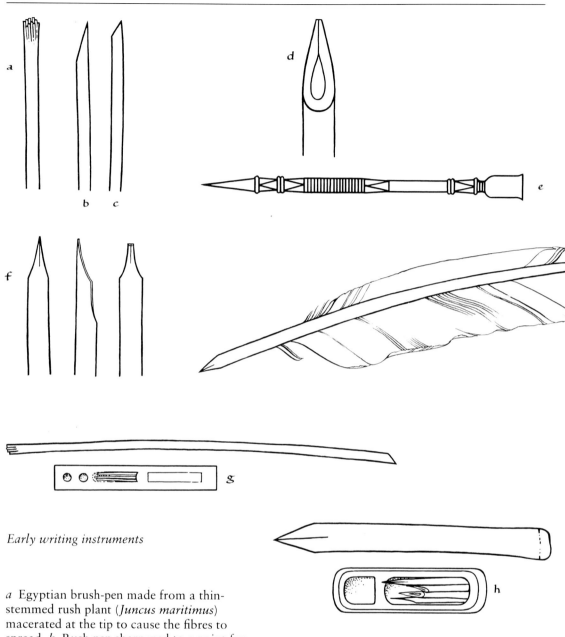

Early writing instruments

a Egyptian brush-pen made from a thin-stemmed rush plant (*Juncus maritimus*) macerated at the tip to cause the fibres to spread. *b* Rush pen sharpened to a point for drawing. *c* Rush pen cut at an angle for writing. These Egyptian pens made from the rush plant were solid and varied in thickness according to the size of the plant and of the writing required. (From drawings made in the British Museum.)

d Pen made from the hollow-stemmed reed (*Phragmites communis*), slit and square cut. *e* Roman stylus. *f* Quill: pointed, side view, square-cut. *g* and *h* Early Egyptian pen boxes, with hollows for pigments.

In classical times the most common alternative to the reed pen was the stylus, of wood or metal, often pointed at one end and flattened at the other. This was used for writing on tablets of wood that were hollowed out and coated with wax. The pointed end scratched angular letters on the wax, the other erased by smoothing the surface for further use – a forerunner of the more recent slate and slate pencil.

The development of parchment (skin) as an alternative to papyrus and the introduction of the quill pen brought about a revolution in writing – both were in use in Rome by the sixth century AD. Parchment is more durable and has a smoother surface than papyrus; the quill, made from the strong pinion or flight feathers of a goose or other large bird, is a more pliant and refined instrument than the reed. As the hollow barrel of a quill is similar in principle to the hollow stem of a reed, there was a sympathetic transition to the quill as the perfect instrument for writing on skin.

The mediaeval monastic scribes were fine exponents of the art of formal writing on vellum, as their splendid surviving manuscripts testify; these were equalled by the beauty and elegance of the Renaissance scripts. It was from the latter period that professional scribes – scriveners – were also employed by courts, merchants, men of property and the law.

Paper-making came originally from China; increasingly available from the twelfth century onwards in the West, paper began to replace parchment by the fourteenth century. With the increase of literacy and the use of paper, writing became a skill expected of every educated man. Advice on choosing, cutting and cleaning quills, on preparing paper and on the comely shaping of letters was given in the copybooks of the Writing Masters.

Many attempts were made over the years to improve the durability of the quill but until the invention of metal nibs no satisfactory substitute had been found. Quills continued in use into the nineteenth century when they became inconvenient for the then fashionable copperplate style of writing, as their finely sharpened points required frequent recutting or mending.

However, by the 1830s the quill was being replaced as a popular writing instrument by the steel pens now being mass-produced by industrial methods. To manufacture steel nibs sheet metal was punched into shape by machinery, moulded, polished and provided with a slit. Nibs of many different shapes and thicknesses became available. Such pens required frequent dipping into inkwells and spillage of ink was a hazard not only in the schoolroom.

So the stage was set for the invention of fountain pens which carried their own ink supply and were capable of continuing refinement and convenience. By the 1880s, the fountain pen was a popular writing instrument, though the dipping pen continued in use well into the twentieth century.

Another revolutionary development occurred with the coming of ballpoint pens. On the market by 1940, it took another ten years for the technology of a precision-ground ball rotating in a housing to be refined and in particular for the difficult problem of suitable quick-drying ink to be solved.

Ballpoint pens changed the inky character of education but have been held responsible for a general deterioration in the standard of handwriting. The pen slides so easily on the writing paper that it is difficult to control and it makes a line of even thickness which, unless used by a skilled penman, lacks the character and

vitality of writing with the edged pen.

The past twenty years have seen the development of writing instruments with tips of felt, man-made fibre and plastic, now available in many colours and widths. The finer-pointed pens are a popular alternative to the ballpoint for everyday handwriting and have the advantage that they are easier to control. However, the softness of felt-tips and the tendency for the ink to fade and bleed into the writing surface means that they fall short of the standard required for formal calligraphy.

The coming of word-processors and micro-computers into the educational field in the 1980s, earlier in some schools especially in the USA, is yet another challenge to the handwriting of today and in the future.

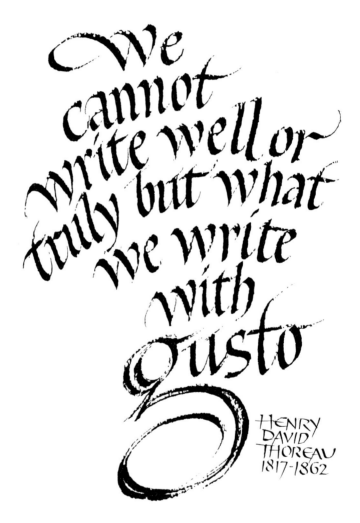

John Shyvers: Quotation from Thoreau. Panel in black stick ink on white Canson paper. 29 × 20 cm. 1980.

Modern Writing Instruments

JOHN SHYVERS

Writing instruments used by calligraphers today fall broadly into three categories:
- formal calligraphy;
- semi-formal calligraphy, italic and cursive handwriting;
- display work, posters, notices, teaching and demonstration purposes.

PENS

Pens may also be grouped into those that make thick, thin and gradated strokes by change in direction rather than pressure; pens that are pointed and require pressure to make the thicks and thins; pens that write without variation in the thickness.

The square-cut, broad, or chisel-edged pen, as it is variously described, is one that has a writing edge instead of a point. The pen may differ in the width of the edge and the angle of the edge to the slit. Without the scribe using pressure the edged pen, whether it is a reed, quill, or metal nib, will give gradations of thicks and thins (called shading) to the strokes as it forms each letter.

Illus. 1: Square- and oblique-cut pens differ in the width of writing edge and in the angle of pen's edge to the slit.

In writing with the square-cut pen the angle of pen hold, which is usually kept constant, determines where the characteristic thick and thin strokes fall. Any change in the angle of pen hold will result in change in the distribution of wide and hairline strokes; this in turn will alter the appearance and character of the writing. These qualities relate equally to square-cut brushes, pencils, felt and fibre-tip markers, crayons, chalks and the like.

The pointed pen is more flexible but it will only make strokes of gradated thickness if pressure is applied and released.

Semi-formal writing, whilst it may retain the characteristic thick to thin strokes of formal writing, has fewer pen-lifts in making the letters and more joins between letters. It is important for the scribe to *feel* the difference in writing with a pen suited to more rapid handwriting (as opposed to formal calligraphy) –and notice the degree of agreeable contact or friction between the nib and the writing surface.

QUILLS AND REEDS

Although the metal square-edged nib is commonly used by scribes today for formal writing, experienced calligraphers may prefer the traditional pens made from the strong wing feathers of larger birds and the hollow stems of reeds. Quills are good for small and medium-sized writing, reed

pens for larger writing. The preparation and cutting of reeds and quills is an art and one that requires a good deal of practice and patience to acquire (the process is described on pages 15–36).

The quill is the most sensitive and pliant of tools, it can be trimmed and slit and the writing-edge cut to the width and angle required. The combination of a well-cut quill, ink freshly made from a Chinese stick and the nap on the surface of well-prepared vellum, gives the calligrapher great satisfaction and control over the pen stroke. The beginner will make progress more quickly, however, by writing with a metal pen and using bottled ink.

METAL NIBS

Nibs are made in a variety of metals and writing varies perceptibly according to the kind of metal and its thickness: low-carbon steel, stainless steel, gold, etc. Nibs made of precious metal are usually tipped with osmium or iridium; gold nibs will wear out if not hardened with a more durable metal. This strengthening takes the form of a blob of hard metal on the underside of the nib which if left unshaped may fail to produce the clearly-defined thick and thin strokes characteristic of the edged pen. Some manufacturers of italic fountain pens will shape the tip of gold nibs to the scribe's own requirements.

A new nib should be cleaned of the factory-applied lacquer (an anti-corrosive) before the ink will flow evenly. Manufacturers recommend immersing the nib in boiling water. An alternative is to hold the nib briefly in the flame of a lighted match, and immediately afterwards to plunge it into cold water which re-tempers the metal. The underside of a nib should be scrutinized before starting to

write to make sure that the ink is lying evenly on the surface. A small watercolour brush may be used to feed ink into the pen reservoir.

It takes a clean sharp nib to produce clean sharp strokes. Nibs must be kept clean during use or the ink will not flow freely. They should be wiped with a soft rag and afterwards washed and dried to prevent corrosion. If thin lines still appear to thicken, the nib may need resharpening. Nib-resharpening is a valuable skill which may be acquired with practice (see Illus. 5).

For formal scripts *Round Hand* metal nibs are generally available with a square edge in a range of ten widths from 0.6 mm to 3.3 mm. A similar range of sizes in left-oblique nibs is available for left-handed scribes. Left-oblique nibs are also used by right-handed scribes in Arabic and Hebrew calligraphy. Pen sizes from different manufacturers vary considerably, a size 1 in one make may be wider or narrower than size 1 in another.

These nibs are made to fit into a pen holder and it is important for a scribe to choose one with a round barrel into which the nib will fit and that is comfortable to hold in the hand. Some pen holders incorporate a brass reservoir. The object is to allow a small quantity of ink to be retained on the underside of the nib which gradually feeds the tip and thus obviates too frequent filling of the pen. If the nib is used in an ordinary pen holder, slip-on reservoirs can be used. Reservoirs are not essential but if used the tip of the reservoir should lie about 2 or 3 mm from the writing edge, resting but not pressing against the underside of the nib as this will force it apart at the slit. If the reservoir is too near the writing edge the ink will flow too freely, if too far away the nib will become starved of ink.

For semi-formal writing a nib cut from

Illus. 2: Round Hand pens. *a* Square-cut.
b Left-oblique. *c* Pen holder with built-in
reservoir. *d* Underside of Round Hand nib
showing position of slip-on reservoir.

a b d

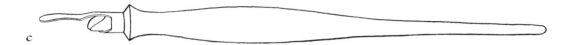

c

the thinner and softer metals is preferred as, being more pliant and with a smoother finish to the tip, it will move more readily to meet the need for increased speed and fluency. Nibs for *Italic Pens*, made with a brass finish, are available in Britain in five sizes each in straight-cut and left-oblique forms.

Copperplate is an elegant seventeenth-century style of writing little practised by scribes today. Whereas the breadth of the square-cut pen determines the form of letters without pressure, copperplate writing requires a narrow-pointed pen with a deep slit, made to respond to pressure from the writer's hand in order to produce the swelling lines and curves characteristic of this style. The pronounced right-hand slope the copperplate hand requires can be helped by the 'elbow-oblique' pen which is held at one angle while the nib points in another. Not all writers of copperplate find it suitable and some prefer to use flexible drawing pens.

a b

Illus. 3: Italic Pens. *a* Straight-cut. *b* Left-oblique.

a b

Illus. 4: Copperplate pens. *a* Drawing pen. *b* 'Elbow-oblique' pen.

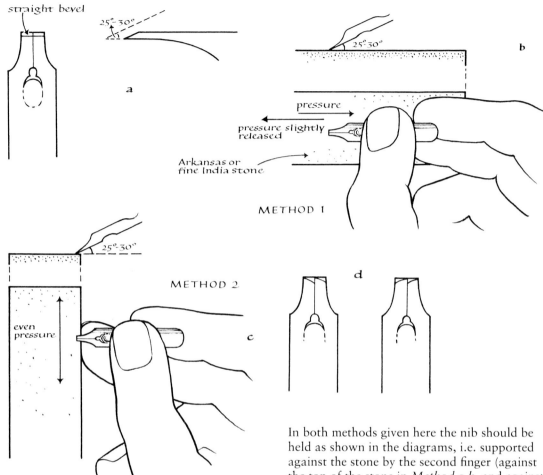

straight bevel

25°-30°

a

b

25°-30°

pressure

pressure slightly released

Arkansas or fine India stone

METHOD 1

25°-30°

METHOD 2

d

even pressure

c

Illus. 5: The aim in grinding the nib on an oil stone (Arkansas or fine India stone) is to give it a thin but not over-sharp writing edge. A thin writing edge, with good corners is necessary in order to achieve letters with well-defined contours and fine finishing strokes.

Making a straight bevel on the top of the writing edge will reduce its thickness, and give it more sensitive control over the writing. A nib with a bevel of about 25°–30° *a* will normally produce a better result than an unground nib.

In both methods given here the nib should be held as shown in the diagrams, i.e. supported against the stone by the second finger (against the top of the stone in *Method 1 b*, and against the side of the stone in *Method 2 c*). The nib should be held at a constant angle, and with very light pressure rubbed up and down parallel to the edge of the stone *b* and *c*. It must be kept straight and not twisted. In *Method 1* the pressure may be slightly released in the direction away from the hand.

In *Method 2* it is essential to maintain an even pressure in both directions or something like *d* will occur. After an initial tentative rub, the nib should be inspected for a straight bevel before proceeding further. If the nib becomes over sharp it will cut the paper, but this may be corrected by holding it as for writing and making a few figure-of-eight movements on the stone, with a light touch.

Sharpening and Shaping metal nibs

The writing edge of a metal nib may be improved by careful honing on a fine India or Arkansas stone (water should be used as a lubricant). It is also possible to grind a nib to any reasonable angle by patient rubbing on the stone. This can be helpful to the left-handed scribe if the oblique-reverse nib involves an uncomfortable pen hold or awkward tilting of the paper. It is also useful for making right-oblique nibs which are no longer manufactured in UK ranges.

In grinding and shaping metal nibs care must be taken to avoid getting them burred or over-sharp or they will actually cut through paper. The nib should be ground back and forth slowly and steadily on the stone and with a light touch. The writing edge can be smoothed by finishing with a fine polishing cloth or 'Crocus' paper.

FOUNTAIN PENS

Fountain pens are primarily designed for everyday handwriting. However, at least three manufacturers have currently on the market in Britain Lettering Sets for calligraphy which contain a fountain pen with interchangeable screw-in nib units, square-cut and left-oblique in assorted sizes with ink cartridges and an instruction booklet.

The advantage of these lettering tools is that they eliminate the need for bottled ink. The nib units are of rigid construction and have little flexibility. They are unsuitable for writing with black carbon-based ink or opaque colour as these quickly clog the nib. It is unlikely that calligraphers would use these pens for commissioned work. There is nevertheless a lively market for calligraphy fountain pen sets and they have become a help to

beginners by simplifying the important first steps in the craft.

BRUSHES

We tend to look on brushes for lettering as more in the province of the graphic designer, the signwriter or poster artist than the calligrapher and in the West this is substantially true.

The brush is best used as a letter-making tool in its own right and not just to fill in with colour the pencilled outlines of letters. Writing brushes have round or flat ferrules with round or flat bunches of hair and both have square or pointed tips. The longer the hair the more flexible the brush and the more ink or colour it can hold. The long-pointed brush is a letter-making tool which gives strokes of varying thickness according to the pressure applied.

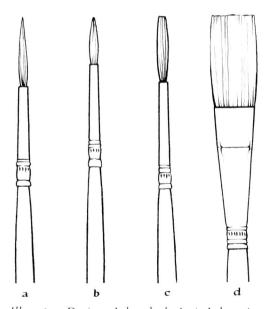

Illus. 6: a Designer's brush. *b* Artist's lettering brush. *c* Ticket-writing brush. *d* One-stroke lettering brush.

In China and Japan calligraphy is 'written' with a soft, pointed brush held vertically and high up the handle and manoeuvred with masterly control and skill. The brush held in this way is capable of far greater movement and freer manipulation than writing with the edged pen as the hand can move in any direction. A one-stroke lettering brush made of red sable hair, if held at a slant in the same way as a square-ended pen will perform in a similar manner to a pen producing thick and thin strokes.

However, lettering brushes are less rigid than pens and considerable dexterity is required in their handling. Arm and wrist movements control the brush in the writing of large letters; the brush may also be swivelled between the fingers especially for making serifs on the thin strokes of the letters E, L, C, G, and S, for example. The brush can also be finger controlled for making small letters.

A brush for lettering, as for other graphic work, needs to possess a lively springy character even when loaded with colour, so that immediately pressure is released the hairs spring back to their former position. Best sable hair has this quality but good substitutes of nylon are available.

PENCILS

The writing instrument called a 'lead' pencil is misnamed for it contains no lead whatsoever. A small disc of lead was used by ancient Egyptians, Greeks and Romans for marking guide lines for lettering on papyrus. Lead (plummet) was also used by mediaeval scribes. Later the lead was made into thin rods and housed in a wooden holder.

Today's pencil contains a finely ground mixture of graphite and clay fired in a kiln. The proportion of clay to graphite determines the hardness of the pencil which is graded from 8B, the softest, to 9H, the hardest. A fairly hard pencil, say 2H, is suitable for marking guide lines and margins on paper. A harder pencil, 4H to 8H, is required for vellum since the abrasive effect of the pumice used in preparing the surface of the skin results in a thickening and blackening of pencil lines. It is also necessary to use a hard pencil for drawing or writing on tracing paper otherwise the line will be blurred and not sharp and precise.

The single pencil is a marker. Two pencils bound together with string, rubber bands or masking tape act as a tool for writing letters in outline. If the pencils are separated by a wooden block before being strapped together larger skeleton letters can be written. Double pencils are useful in teaching and learning, to demonstrate and explore angles of pen hold and methods of letter construction.

A carpenter's pencil makes a useful lettering tool in the preparation of 'roughs'. It can be shaped to form a straight or oblique writing edge and if the edge is slightly hollowed it will write with double lines.

WRITING INSTRUMENTS FOR DISPLAY WORK

Special instruments may be needed for posters, notices, teaching and demonstration purposes where speed, time and cost are important factors.

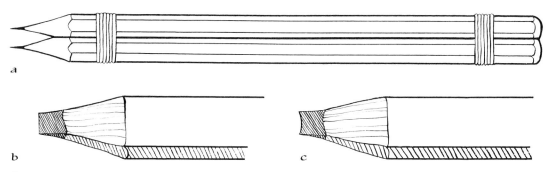

Illus. 7: a Two pencils strapped together.
b Carpenter's pencil cut to a straight writing
edge. *c* Writing edge hollowed to write double
lines.

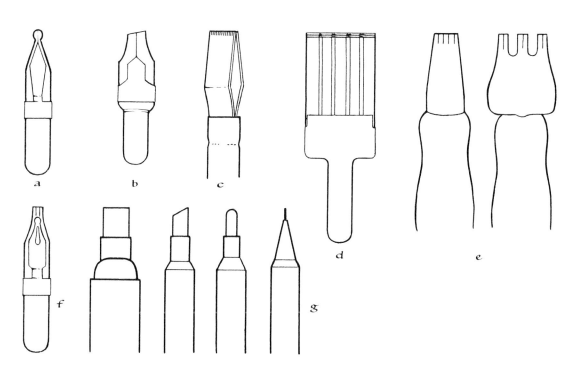

Illus. 8: a Script pen. *b* Poster pen.
c Automatic or 'Boxall' pen. *d* Steel brush
(USA), strips of flexible steel made to fit an
ordinary pen holder. *e* Coit pens (USA).
f Decro pen. *g* Selection of felt- and fibre-
tipped pens.

SCRIPT PENS

The script pen is designed for writing plain sans-serif letters, and is useful as a teaching aid and to demonstrate basic letter shapes. This monoline pen is made in a range of ten sizes from 0.5 mm to 5 mm. The nib incorporates a top-fitting reservoir and the round point is upturned.

POSTER PENS AND AUTOMATIC PENS

As the name indicates poster pens are made for writing large letters for posters and display work. They have a slightly left-oblique edge, also an upturned edge which makes for smoother writing. They are sold in several sizes. Top and bottom reservoirs are incorporated in some makes to give greater ink capacity.

The Automatic pen, formerly known as the 'Boxall' pen, is used for writing large letters. It comprises two non-ferrous metal strips, one of which is toothed, contained in a holder. When in use the pen is held with the toothed side uppermost. Care should be taken not to alter the angle at which the two blades meet. There is a range of widths available. The pen is best filled – but not overfilled – with a brush.

The choice of poster pens is limited in Britain today, compared with twenty years ago. At the time of writing poster pens are no longer made in Germany, but there are more and improved models available in the USA, including a steel 'brush-pen', also a range of single line and multiple-line pens made of non-rusting polished brass, complete with holder and suited to either right- or left-hand use.

For scribes who enjoy experimenting: Scroll Pens are twin-pointed; Five-line pens are for drawing music staves; these and Decro Pens are among the fancy pens available for display work, borders, or just writing for fun.

SOFT-TIP WRITING INSTRUMENTS

Felt-tip, fibre-tip and plastic pens are available today in numerous colours and widths. They may be broadly divided into those supplied with spirit-ink and those with water-based ink. The former will write on almost any surface. The finer-pointed pens of this kind have become a popular alternative to the ballpoint for handwriting, their advantage being that they do not slide over the paper surface so readily and are therefore easier to control.

The softness of felt-tip pens and the tendency of those with spirit-based ink to bleed into the writing surface, makes them fall short of the standard required for formal calligraphy, and some of the inks are of insufficient permanence for important work. However, interesting and unusual calligraphic effects have been created by scribes with these soft-tipped pens. They are useful for short-term display work, colourful notices and showcards and in preparing 'roughs' for commissioned work.

HOME-MADE LETTERING TOOLS FOR POSTERS, DISPLAY WORK AND TEACHING DEMONSTRATIONS

Nylon Pen

Nylon tubing (Nylon 66), obtainable from makers of industrial extrusions, is tough, flexible and hardwearing. It can be cut into a pen with a sharp pen knife, in the same way as a reed or quill, and used as an alternative. It will write clean, crisp letters and keep sharp for a long time without further attention. Instead of a single slit it is better to make two or three slits at the tip, depending on the nib width, to assist the flow of ink.

As with the reed pen the curvature of the tube must be removed by the knife to

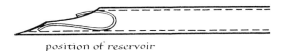

position of reservoir

Illus. 9: Nylon hand-made pen.

make a perfectly flat end to the nib. The end should be finished smooth with an abrasive silicon paper (commonly known as 'wet and dry'). This abrasive is also used to dull the polished surface inside the tube for about 20 mm ($\frac{3}{4}$ in.) from the tip, which helps it to hold the ink or colour. The reservoir inserted is made from shim (strip of thin sheet metal).

Felt Pen

In an extensive range of manufactured marker pens, few have tips over 1 cm ($\frac{3}{8}$in.) in width and many hold spirit-based inks. They dry out fairly quickly and consequently become an expensive item of equipment. Compressed felt is an ideal substance with which to make one's own pens for writing large letters because of its softness and resilience.

The felt used for a home-made marker can be purchased in pieces of about 30 cm square (a square foot) in various thicknesses. As it is made of wool containing animal oil, which prevents absorption of water-based colour, it should be washed in detergent before use.

The simplest tool of all can be made by placing a strip of half-inch (10–15 mm) felt between two strips of thin flexible metal or plastic and binding them together with waterproof adhesive tape. Better still, house the felt in a wooden holder, any width up to 7.5 cm (3 in.) is possible. Note

that in both examples the felt tip is supported by a metal brace to prevent the felt from curling up – otherwise it would fail to give a sharp contrast between thick and thin strokes.

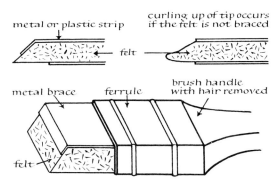

metal or plastic strip — felt — curling up of tip occurs if the felt is not braced

metal brace — ferrule — brush handle with hair removed — felt

Illus. 10: Felt Marker pen.

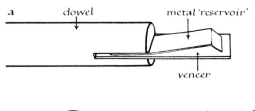

a dowel metal 'reservoir' veneer

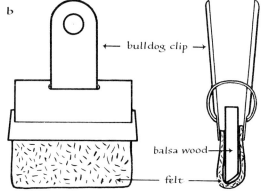

b ← bulldog clip → balsa wood felt

Illus. 11: a Wood veneer pen. *b* Balsa wood covered with felt and held in a 'bulldog' clip.

Two other useful tools for display work are shown in Illus. 11. The first has a small strip of wood veneer braced by a strip of metal which is inserted into the end of a piece of wooden dowel rod. For the second, cut a small piece of 3 mm ($\frac{1}{8}$ in.) balsa wood to measure 20 mm ($\frac{3}{4}$ in.) by whatever width you want the 'nib' to be. Bevel one side of what will be the nib edge to give extra sharpness – although this is not absolutely necessary. Wrap round with felt and fit into a 'bulldog' clip.

These home-made felt markers are pleasant to use and have the feel of a tool halfway between a steel pen and a brush. They are especially useful for children. They are easy and firm to handle and somehow give a very immediate impression of how the manipulation of the tool alters the form of the stroke.

They can be dipped in either spirit- or water-based colour and used on paper for demonstration purposes. Or they can be dipped in clean water for writing on a blackboard where the letters will show up black on a seemingly grey background.

The writing instruments, both traditional and new, which are most likely to interest modern scribes have been briefly described in this article. However, the design and manufacture of pens is developing all the time; new products are coming onto the market every year. Practitioners should be alert to the imaginative possibilities of improved and different forms of writing tools as they become available.

Preparation of Quills and Reeds

DONALD JACKSON

When Edward Johnston wrote *Writing and Illuminating, and Lettering* in 1906, he gave directions for *re-making* a 'Turkey's quill . . . as supplied by the stationers' and assumed that 'The nib already has a split, usually about $\frac{1}{4}''$ long.' Professionally cured and cut pens were still available in London from Henry Hill and Sons as recently as 1956, when the first *Calligrapher's Handbook* was published. We may assume that in the cities of Europe pen-making was, for hundreds of years, a separate, if humble, trade; thus, even the most vociferous of writing masters over the previous centuries seem to have confined their advice on pens to the finer points of re-cutting, nibbing, and trimming them, with hints here and there on how to keep them in good condition. Nineteenth-century literature on the subject emphasizes techniques related to mass production for a huge market. Millions of feathers were imported each year into England alone to be forged into pens by skilled craftsmen. There was little incentive for generations of students or teachers to research methods of preparing and tempering quills. We, however, must now make them for ourselves.

FEATHERS

The quality of the raw material is important, and wherever possible, try to obtain moulted feathers from mature birds. The Hudson Bay goose quill was highly favoured in nineteenth-century Britain. This was probably from the moulted feathers of the wild Canada geese, which were retrieved from the summer breeding grounds in the far north, and imported by the Hudson Bay Company. The flight feathers of the wild geese are of excellent strength and resilience and are often clear and hard even before tempering. The barbs of these feathers are usually dark grey in colour. However, for most of us, choice is limited to such domestic goose and turkey feathers as are available from local sources, or from a feather merchant, who may also be able to supply swan feathers.

The different species can be told from each other only after examining a number of each type. All three are often similar in colour (white) but, in general terms, the goose and swan differ from each other only in size (the swan being larger), whereas a turkey has a more stocky shape, with a pointed 'nose' and a shorter barrel. The turkey quill also has a thicker barrel wall than most goose or swan feathers, can be had in large sizes and is usually available from a farmer or butcher. Its disadvantages are that because of its strength it can be too rigid for small writing unless specially modified in cutting, and stiffness can hamper the free flow of ink, especially opaque colour or gesso. This can limit the potential for those subtleties which occasional variations in

pressure can impart to the letterforms.

The goose quill's barrel and shaft are more slender than the pen holder most people are accustomed to handling, but the proportionate thickness of the barrel wall to its circumference, provides an ideal balance of flexibility and strength for small to medium-sized writing. So it is worth persevering even though at first the grip is unfamiliar. Swan is of larger diameter than goose, but the barrel wall is not so thick as turkey, thus enabling you to make a wide pen which is naturally flexible. A pen, however, can be made from almost any primary feather of reasonable size and strength.

The three main parts of a feather can be described as: the *barbs* which are each side of the solid *shaft* leading down to the hollow *barrel* from which we cut the shape of the pen (Illus. 1). The quill barrel is a form of albumen similar to our fingernails; the aim of tempering it with heat is to fuse and harden this albumen so that a pen cut from it will be hard-wearing and less likely to soften and distort through prolonged exposure to wet (ink). A quill may harden somewhat with age, but it will not clarify (take on a transparent hardness) any more than a piece of steel will temper itself over the years.

The first five strong flight feathers from each wing are most suitable for pen making. They can be identified by their having a much narrower barb on one side of the shaft than on the other. This is the side of the feather which would have cut into the wind in flight. Swan, turkey and goose, because of their size and availability, are the ones most likely to be useful for general work.

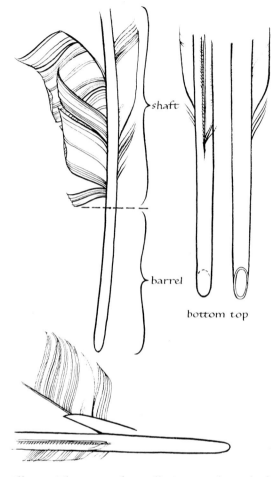

Illus. 1: The parts of a quill. Cutting the end of the stripped barb before it can tear into the barrel wall.

CURING QUILLS

The following directions for preparing and tempering can be applied with whatever variations you wish. The simple method of tempering with hot sand was developed as a result of work with several classes of students.

16

If a dry, raw quill is placed in hot sand, it tends to become opaque and milky in appearance. The requisite concentration of matter (fusing) does not seem to occur and a slit made in such a pen is often ragged and unworkable. It appears that the minute cells must first be expanded by moisture before they can be shrunk, like cotton cloth.

There are ten stages:	Seconds
1 Cut off the end of the quill barrel.	1
2 Soak in water.	(see below)
3 Remove surplus water.	2
4 Remove internal membrane.	8
5 Prime with hot sand.	6
6 Insert in heated sand.	4
7 Inspect result.	1
8 Re-insert if necessary.	4
9 Empty sand, scrape off the membrane and mould the barrel if necessary.	8
10 Test for consistency when cooled.	4
Approximate timing when reasonably skilled	38 seconds total.

1–2 To prepare the pens for soaking, first cut off the sealed end of the barrel at a slant (Illus. 1), to allow the water to penetrate to where the shaft begins. You may soak as many as you wish, but take out only as many quills as you intend to temper immediately, or they will dry out and need re-soaking.

The raw quill barrels should therefore be soaked in water for around 12 hours, though 1 hour makes a considerable difference to the pliability of the quill, and can produce a distinctly clearer result even at this early stage.

3–4 Shake the surplus water from inside the barrel and hook out the membrane which you will see inside it. A crochet hook can be adapted to this purpose, or a straight length of metal coat-hanger or bicycle spoke; try to avoid scratching the inside of the barrel because this may damage the ultimate writing edge.

The barrel should now be soft, pliable, free from excess moisture, and have no obstruction within it, caused by the remnants of the membrane, and it is ready for tempering.

Fine silica sand should be used, such as potters use to line a kiln, sometimes called silver sand. The finer the sand, the more efficient the transfer of heat to the quill since there is less space for air in between the separate granules. The sand may be heated by a variety of means, camping stove or gas cooker, for instance, or even a thermostatically controlled electric frying-pan. Any heavy frying-pan filled to a depth of around 50 mm (2 in.) works well as a container.

5 Using a large spoon, prime the upturned quill barrel with hot sand till it overflows (Illus. 2). This will help conduct heat evenly to all parts of the barrel.

6 Thrust the primed feather into the hot sand at a shallow angle, completely covering the barrel up to the beginning of the shaft (Illus. 3). Try not to spill the sand you have already poured into the barrel.

7 After a second or so, remove the quill and examine the result. If the quill is covered in blisters and is distorted, either the sand is too hot or you should have thrust it in and out of the sand more quickly. If the quill remains

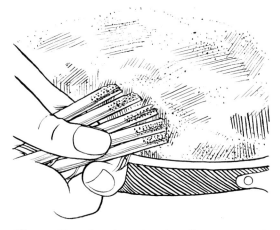

Illus. 3: Plunging the primed quills into pan of hot sand.

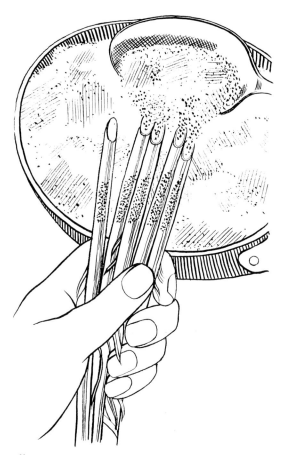

Illus. 2: Priming soaked quill with hot sand.

If the quill is left too long in sand which is too hot, the albumen melts and the grain of the quill along which a crack would otherwise naturally follow, loses its 'identity'. The pen will be brittle, and the slit will run unpredictably.

In practical operation such as this, learning is not simply a question of memorising quantities, measurements, temperatures or time. Such directions can be misinterpreted and appear to deny the need for individual experiment. It is best to try the process first, test the quill, set the experience against the principles outlined here and then adjust the temperature of the sand and the timing of operations to achieve the required aim.

George Yanagita has been successful with an electric frying-pan set at 350°F. – 60 seconds for turkey quill, or 50 seconds for goose quill. I prefer to have the sand hotter and to temper the pen more quickly – there is no 'only way'. Just as in photography where elements of time and light have to be juggled to achieve a particular result, different grades of feather require different 'exposures' at different temperatures for a particular result.

rubbery after cooling, even though it may look clear, either the sand is not hot enough, or you may need to leave it in the sand longer.

No specific degree of temperature has been mentioned so far. The test is whether the pen will clear and then harden when cooled, crack clean and straight when a slit is introduced and, in a good-quality goose quill, have a slight 'nicotine' coloured cast to the cut edge of the barrel wall (as glass looks green on its edge).

9 After withdrawing the quill from the hot sand, shake the barrel clear of sand and while it is still soft from the heat, use the *back* edge of the knife blade (which is not sharp) to scrape away the membrane which is on the outside of the barrel. This membrane should peel off easily when warm and soft, leaving a soft, shiny quill barrel underneath.

10 To hasten cooling and thus hardening, the pen can be dipped in cold water and then rubbed dry. Only when the knife is tested on the hardened quill will you know for certain that you are using the right combination of heat and time.

Detailed comments on each stage:

1 Completely remove the domed end of the quill so that the inner membrane can be removed easily and the sand afterwards allowed to fill up the barrel without obstruction.

2 If the quills are left too long in the water, especially in warm weather, they can become putrid unless a little preservative is added to the liquid. The barbs of the quills are subject to moth damage and should be stored accordingly.

3 If water is left within the barrel and allowed to mix with the sand, it can prevent the sand from penetrating to the base of the shaft, thus trapping air. When the barrel is plunged into very hot sand, the water evaporates, creating steam, and sometimes the quill explodes!

4 Remnants of the inner membrane can likewise obstruct the sand, causing uneven tempering along the length of the barrel.

5 The feathers should be held sloped over the frying-pan or other container otherwise the surplus hot sand can cascade onto your supporting hand and burn it. I temper five quills at once.

6 Once the temperature of the sand is gauged, it is possible to work quite quickly, plunging the quill barrel at a shallow angle into the sand, and with a spoon, scooping and piling up more sand onto it, generously overlapping the base of the shaft. The aim is to temper the quill to an even hardness and clarity along the whole length of the barrel.

7 If the quill goes too deep into the sand and therefore too close to the heat source, the tip can shrivel, distort, become too brittle and spoil, but the rest of the barrel may still be in good condition; after cooling, simply cut off the spoiled end. Turkey quills sometimes blister alarmingly when first placed into the heat but this is usually the thick outer membrane which will have to be scraped off anyway.

9 Whilst the pen is still soft and warm it can be moulded and flattened with a 'Dutching hook' (to make a wider pen than the natural diameter of the quill barrel would allow), using the method described below.

Norman Brown has adapted an alternative technique for clarifying and tempering pens which is a modification of the method historically called 'Dutching', in which the dampened quills were exposed to heated coals and then scraped and moulded into shape on a hot metal plate under pressure.

Mr Brown mounts a household electric smoothing iron, hot plate upwards, on a bench, soaks the quills in boiling water for 20–30 minutes, presses a soaked quill

against the hot iron with a home-made brass or copper Dutching hook (Illus. 4) which has been heating on the iron, 'twirling the quill slowly till it clarifies and softens'.

Illus. 4: A Dutching hook can mould a warm soft quill.

After testing the reaction of the quill to a high setting of the iron, he gradually reduces the temperature till undue blistering stops. When this 'proper setting' is arrived at, pens can be tempered, moulded and flattened to a desired width at the tip. This process is then repeated on a cold brass or copper plate which rapidly diffuses heat until the barrel sets in the desired shape. He prefers to cut the scoops quickly before hardening is complete, since it is easier to cut a soft warm pen. The slit is inserted later as described in the section 'Cutting Quills' (below).

This method concentrates the tempering on the tip of the barrel, but there seems to be no reason why it should not be extended to include the whole of the barrel as professional pen makers undoubtedly did when they applied a similar principle to mass production in the pen trade.

CUTTING QUILLS

Most people start the practice of calligraphy by using a steel pen; at first it seems to answer all needs but after practice and careful study the sense of touch and an awareness of subtle form develop and there is more readiness to appreciate the value of tools which helped to create the forms of the Roman alphabet still used and adapted in the designs of today. The quill pen is capable of forming a particular but many-shaded repertoire of marks, and through the medium of ink, enables us to transmit fluently and sensitively onto a page images in the mind's eye.

The first thing you are likely to sense when you begin writing with a quill is its lightness, and a new generation of brain-hand reflexes begins to grow. A quill does not need so much pressure to activate ink as a steel pen and, as a lighter touch in response to this develops, hand movements, and therefore letters, can become more free.

A normal quill pen is shaped by making four scooping cuts, three short straight cuts and a slit; a pen knife should be specially adapted to make them.

THE PEN KNIFE

The blade needs to be strong but narrow in width and preferably rounded on one face to prevent the cutting edge from snagging as it makes the tight curving scoops which shape the pen (Illus. 5) and flat on the other face to make the straight cuts.

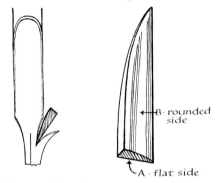

B - rounded side

A - flat side

Illus. 5: The knife blade must be shaped for scooping cuts.

The knife handle ought to be substantial enough to be gripped comfortably between the fingers and palm of the hand (Illus. 8) leaving the thumb free to support the quill and help control the blade's movements. Wooden-handled 'Bench' or 'Chipping' knives such as are at present supplied by Karl Stamm K.G. of Solingen in West Germany or R Murphy of Ayer, Massachusetts, USA, have a reasonably-shaped handle and blade from which to shape a knife for quill cutting.

However, since knives are not specifically made for our purposes, we must first reshape the blade to make it curved on one side and flat on the other and then re-sharpen it to give a new cutting edge.

The initial re-shaping is done more quickly on a coarse bench-type India or Carborundum sharpening stone, starting with a coarse and then medium grade (they are commonly available stuck back to back), and moving on to a finer 600 grit silicon carbide ('wet and dry') abrasive paper wrapped round the stone. Lastly, a much finer emery polishing paper (4/0 grade) will provide a fine-grained finish to the cutting edge.

To prevent the ground-off steel dust from clogging the stone's abrasive surface use a lubricant such as slightly dilute washing-up liquid. Oil can be used for sharpening tools but is harder to clean off afterwards than the water-soluble soap, and is easily transferred invisibly to the pen and to absorbent writing surfaces.

Examine the knife carefully with a magnifying glass before you begin and, especially if you are unfamiliar with sharpening tools, check again with the glass at each of the stages outlined below.

It may be necessary first to remove any factory-applied grinding which can still be seen on the cutting edge (Illus. 6a). The

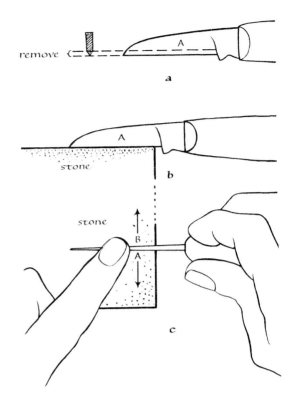

Illus. 6: Removing the factory-made knife edge.

unwanted facets should be ground off, the knife held at 90° to the coarser stone (Illus. 6b, c). Once all traces of these facets have been removed, you are free to shape the right-hand side of the blade into a curve (Illus. 7), rocking the blade whilst grinding it against the stone and steadying it with the fingers of the left hand so that you can sense the amount of movement that is taking place. The rocking motion should be continuous from the blunt edge of the knife blade right down to its cutting edge (Illus. 7a). Apply pressure as you push the blade away from you, and release pressure on its return but do not remove the knife from the stone as the continuity of the stroke must be maintained. The result should then be a gradual curve from blunt

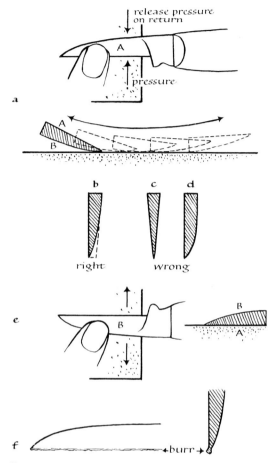

Illus. 7: Reshaping and sharpening the blade.

When this fine thread of steel has been stropped away, the edge should have achieved its ultimate sharpness with enough tooth to bite into the quill but not be so coarse as to leave a scratchy surface on the cut.

A knife made from reasonably good steel should not need to be drastically re-shaped or re-sharpened after you have made it. If it is used as it ought to be, exclusively for quills, a light sharpening on a hard Arkansas stone or the fine 4/0 emery will keep it in trim.

PRELIMINARY PRACTICE WITH THE PEN KNIFE

Before trying to produce a finished pen make yourself comfortable by establishing control over the knife and practise some of the hand movements and cutting techniques which are needed at each stage. Most of these will involve paring movements with the blade drawn towards the body. Every time you make a cut or a slit, carefully examine what you have done through a magnifying glass. By identifying each result with the feel of a particular action, you will begin to learn to see by 'looking with your fingertips'.

First, practise cutting and scooping by holding the quill and knife as in Illus. 8 between fingers and palms, steadying the wrists comfortably on the stomach. The thumbs will be free to control the rather pliable quill by supporting it against the pressure of the knife blade. Practise paring movements by taking thin shavings off the tough barrel of the quill (Illus. 9); concentrate entirely on establishing control over each slicing movement, sense the blade's edge as it bites into the quill as you would when cutting into a soft tomato. You will find that some parts of the knife are keener than others. Learn to feel for

to cutting edge (Illus. 7b), not too tapering (Illus. 7c) or the edge could be easily broken when cutting tough quills, nor too obtuse (Illus. 7d) or it would need to be sharpened too frequently. The other side of the knife blade should be checked and ground absolutely flat on the stone (Illus. 7e); both processes can then be repeated on a finer grade of stone such as an Arkansas or fine India stone. A fine burr should develop along the cutting edge (Illus. 7f) which can be removed by stropping the blade against a thick piece of leather.

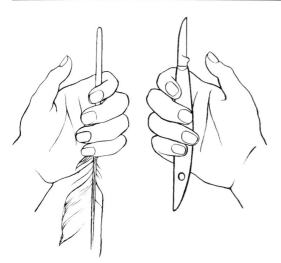

Illus. 8: Quill and knife should be gripped by the fingers to allow the thumbs to support and guide.

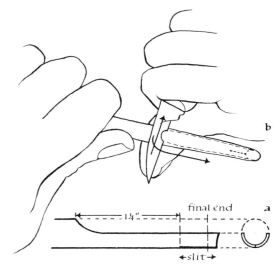

final end **a**

Illus. 10: Quill, supported by the thumbs, is *sliced*, using the full length of the knife blade.

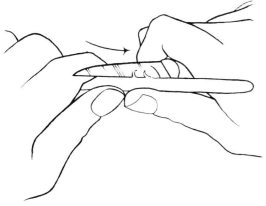

Illus. 9: Practise taking off fine slivers before starting to make a pen.

and recognize this. The general direction of the knife cut is along the length of the barrel, but at the same time, use the full length of the blade and draw the knife, in a sawing movement, at right-angles across the barrel (Illus. 10b). It is essential to acquire this slicing action especially when starting a cut in a tough quill. This enables the knife blade to cut into the material a little at a time – it is not an axe; remember the tomato!

You can now begin to practise making a complete longitudinal scoop on the underside of the barrel as in Illus. 10a. It is not necessary to make it all in one stroke. Before long, both left and right hand will unconsciously begin to work together to guide the knife and to help the blade bite into the pen. Do not forsake practising until you feel reasonably confident to take the next step. You may have found that the knife is not sufficiently sharp; if its edge is too coarse, the surface of the cut will look chalky or dry – the blade will need further stropping. If there is no bite to the blade, it may need to be returned to the stone. Whenever the knife cuts into the quill, the facet it leaves should have the sheen which a carver's sharp chisel leaves on hard wood.

Making a clean controlled slit in the quill which will allow the pen to flex enough to feed ink to the nib's edge, also requires practice. Most pens, with a nib up to 3 mm ($\frac{1}{8}$ in.) wide will work well with a

23

slit 1½ times the width of the nib, though a tough turkey quill may need a longer slit to increase its flexibility. If the slit is made too long before trimming, a lot of the quill will be wasted because the side scoops have to be positioned in relation to where the slit eventually comes to a stop.

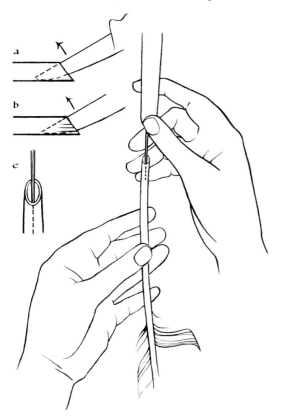

Illus. 11: A method of starting the slit by leverage.

Begin your practice in pen slitting by an exercise. Hold another quill and the knife as in Illus. 11. Note that your fingers will not need to be very close to the knife's edge at this stage. Insert the knife point, cutting edge uppermost, into the quill barrel (Illus. 11a). Gradually force the blade upwards, levering it from the

opposing inner wall until the quill cracks. The moment it does, release the upward pressure. If the quill is rightly cured, it should be like a crack in glass and run true – parallel with the barrel. Rotate the quill a fraction and repeat the process around its circumference (Illus. 11b). As you do, you will learn to gauge the amount of pressure needed to create the slit. The end will fray as you use up the available space, and its edge will become too pliable to present enough resistance to the knife to start a clean crack. As you feel this change in the tension of the quill, remember that you are still learning to experience and control your reflexes – 'to see with your fingers'.

A ragged, torn slit suggests that the quill is not sufficiently tempered, or that all the outer membrane has not been removed. A clean crack which does not run true but veers right or left, or in a zig-zag, indicates that the tempering was too heavy-handed and the characteristic grain of the quill has been destroyed. If the pen feels rubbery, as a plastic straw can, and refuses to crack, then it is not tempered enough (Illus. 12). Sometimes a pen will have a false slit, it *appears* to have a clean crack, but it has penetrated only partly beneath the surface; test for this by flexing the quill before proceeding. The slit can be lengthened further by twitching sharply upwards with a narrower quill or a pointed stick or paintbrush handle, using the same movement of the knife as in Illus. 11.

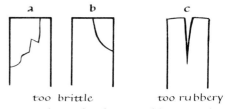

Illus. 12: Faults in the slit caused by imperfect tempering.

When you feel confident with these techniques begin to work through the processes of making a complete pen.

To transform a tempered and prepared quill into a pen: Seconds

1 Trim the barb to a comfortable length, leaving say 9 in of shaft. ·5
2 Strip off the wide barb where it interferes with the writing hand. 5
3 Form a slit. 3
4 Slice out an under-scoop. 6
5 Slice out two matching side-scoops, 22
6 Flatten the underside of the point. 4
7 Thin the nib point on the top side. ·5
8 Trim the writing edge off square or oblique. 1
9 Fine-trim the writing edge. 2
10 Fit and adjust the reservoir. 13

Approximate timing. 57 seconds
– when skilled. total

1 Trim the barb (see above).
2 The barbs can interfere with the hold of the pen and any surplus should be stripped away (Illus. 1), using a knife cut when necessary to avoid tearing into the barrel.

The feather ideally suited to the right-handed scribe comes from the left wing of the bird, because if it curves at all, it fits snugly around the knuckle of the index finger and only the wide barb needs to be stripped off. Unless they are very severely curved, as from some mature turkey wings, the first five flight feathers from either

wing may be used with reasonable comfort.

3 A narrow cleft running between the barbs marks the exact centre of the *underside* of the quill (Illus. 1a). Make a clean slit in the top of the barrel directly opposite this (Illus. 11c). If the slit is ragged, or does not run in a straight line, you can cut off the tip above the crack, and repeat the action until you are satisfied.
4 Next, turn the quill until it is bottom uppermost and make a longitudinal under-scoop starting about 30 mm (1¼ in.) from the termination of the slit. Pare it down until you have cut about halfway through the barrel (Illus. 10a) leaving the slit in the centre of this under-scoop (Illus. 10b).
5 When the pen is finally trimmed, the slit will need to be about 1½ times the nib width, so draw an imaginary line across the slit of the pen where the writing edge is to be (Illus. 13a), and gradually pare out a side-scoop alongside the slit to form half of the pen point (Illus. 13b). Copy the shape

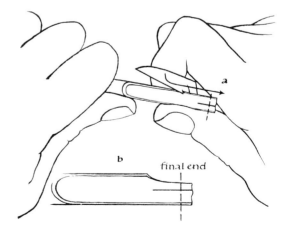

Illus. 13: Starting a side scoop allowing for wastage at the tip.

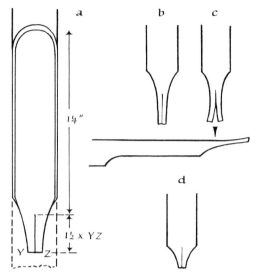

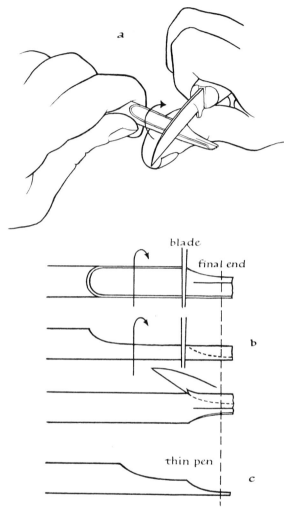

Illus. 14: a Copy the shape and proportions of the pen as you would a letterform.

b – d Unsuitable shapes.

(Illus. 14a) just as if you were copying a letterform. If, by scooping away *too* much, you produce a long, thin shape (Illus. 14b) the nib will be weak, and will allow the slit to open too far when pressed, so that the ink will not reach the tip (Illus. 14c)). If the shape is too squat, and stubby as in Illus. 14d, the strong shoulders will prevent the slit from flexing enough to allow the ink to draw down from the reservoir along the slit, thus starving the tip after the first few marks.

Return the knife blade to where you started the first side-scoop (Illus. 15a, b), holding it at right-angles to the barrel. Rotate the quill until the knife blade comes into contact with the opposite side of the under-scoop. You will then be perfectly placed to begin the matching side-scoop on the other side of the pen slit. If one side does not match the other, then their strength and therefore their flexibility will be unequal.

Illus. 15: a and *b* Positioning the blade to begin the second scoop. *c* Removing less of an underscoop gives stability to a thin-walled pen.

A sliver can be taken from either side at this stage to make adjustments, but remember that you are still going through a learning process, and are not expected to produce perfect pens yet; so as soon as you have done the best you can to match the scoops either side of the slit (Illus. 14a), go on to the next step.

Illus. 16: Flattening the underside of the nib to remove excess concavity.

6 On all but the narrowest pen points, the underside of the nib will be noticeably convex, reflecting the section of the tube from which it was cut. To avoid the risk of writing with hollow strokes, or of crushing the quill point when completing the final nibbing, you will need to flatten the underside of the point by scooping away as thin a sliver as possible without weakening the pen tip (Illus. 16a). This shaving must be made in one clean continuous stroke, any hesitation will allow the knife to judder, leaving ridges on the underside of the nib (Illus. 16b). Follow-through also prevents the knife from rounding off the tip of the nib (Illus. 16c).

For the final steps, traditionally called nibbing, you will need a chopping block made from a tough piece of plastic, such as formica or perspex; if it is black, the nib can be seen more easily. Fix it to the corner of a table, or on a block which is raised enough to allow the finger to support the nib underneath (Illus. 17a) without tilting it at an angle (Illus. 17b). A flat ink-bottle top can be used as long as it is taped firmly down to the table. A harder material, such as glass, will quickly blunt the knife, and most woods do not offer enough resistance to the blade.

7 Position the hands as in Illus. 17c and support the pen (Illus. 17a). To thin the top of the nib, the knife blade is placed flat side down and, on this occasion, pushed *away* from the body. Starting a little less than $\frac{1}{16}$ in. (about 1 mm) back from the intended writing edge, ($1\frac{1}{2}$ times its width away from the termination of the slit), remove the surplus tip by slicing downwards at an angle, steadily forcing the knife blade away from you with the left thumb (Illus. 17c, d). This thins the nib, helps the final trimming (Illus. 17g, h) and leaves less vertical surface to collect ink which can produce overloading at the tip when making thin strokes.

8 Still holding the quill flat on the slab, finish the nibbing by pressing the knife blade down at 90° and cut the nib off square or oblique (Illus. 17e, g). On a strong quill like turkey, even after the nib tip has been thinned, this stroke may require considerable force, and it may help to rock the knife blade gently while pressing downwards firmly (Illus. 17f), thus concentrating the thrust upon a small section of the nib at a time.

9 Repeat this downward cutting stroke, but this time taking off only the thinnest of slivers to remove any suspicion of roughness which may have been left by the first cut (Illus. 17h).

Finally, a careful examination with the magnifying glass will reveal any faulty cuts or imperfections, but before worrying too much about further details, make a reservoir for the ink, and write with the pen. If the slit is straight, the sides of the nib reasonably symmetrical and well shaped with the underside flattened, the

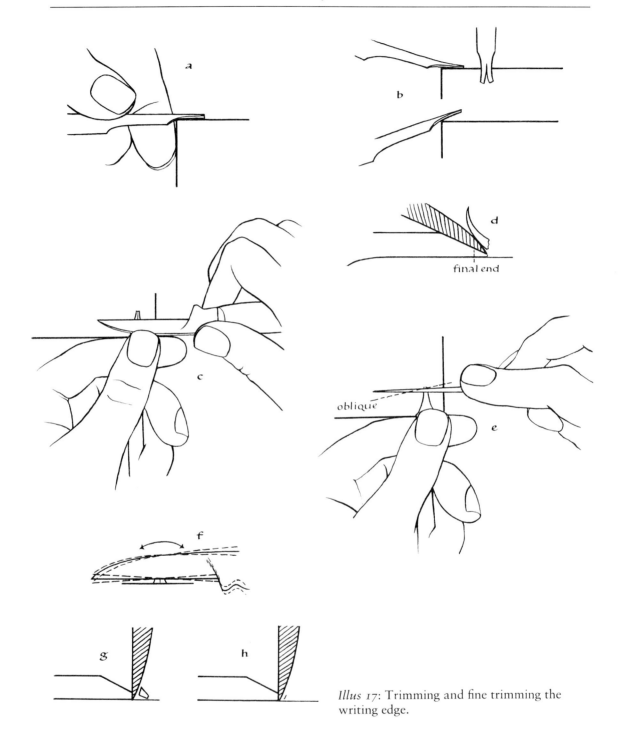

Illus 17: Trimming and fine trimming the writing edge.

pen should write, but the ink flow will need to be controlled, especially with a wide pen, which of course uses more ink at each stroke.

10 A reservoir is simply made by cutting a strip of metal (that will not rust) which is narrow enough to sit comfortably inside the quill (a strip from an aluminium drinks can is excellent) and bending it into a modified S-shape (Illus. 18). Insert it into the barrel and position it so that it holds itself in place by its own springiness. The tongue of the strip should just overlap the end of the slit which will then feed the ink to the writing edge. If it is positioned too near the tip it will cause the nib to flood; too far back and it will starve the nib.

Illus 18: Shaping and positioning the reservoir.

To begin with, the general finish and sharpness of the letters may not be as precise or as perfect as you have achieved with a metal pen, but the aim so far has been to help you reach the stage when you begin to *feel* the reason for using a quill so that the enhanced pleasure which comes from the act of writing with it will provide an incentive to improve your performance on a different level. It is almost certain that for the first time, some of the classical alphabets will begin to make 'sense' to you.

You will now be ready to practise some necessary refinements which have been purposely left out at each stage so far. Before attempting any subtleties it is a

good idea to consider briefly the kind of inks and writing surface you want to use with a quill pen – see page 34.

After practising the elementary steps of making a quill pen, use the following notes when working again through the stages 1 – 10.

1 As before.
2 As before.
3 It can be a mistake to rotate a strongly curved feather to fit the hand *after* making the slit which may thus be shifted off centre and because it 'leans' to one side, throws the two halves of the nib out of balance (Illus. 19a).

Illus. 19: a The slit should be at 90° to the writing surface. *b* Variation in barrel wall thickness needs to be compensated for.

Therefore it is important to choose a comfortable position first, then make the slit at the top dead centre of the quill as you look down on it. It is important to centre the slit for another

reason. The end grain of the quill appears to radiate (like a tree trunk) so if the knife is introduced off centre, although the slit may *start* vertical it will slew over to follow the natural grain producing the same result as Illus. 19a. If this happens, twist the barrel to align the 'end grain' of the slit at 90° to the writing surface before making the side-scoops. Another cause of imbalance, especially in strong turkey feathers, is the variation in thickness of the barrel wall which is usually thicker at its 'natural' top. If the feather is rotated for any reason the underside may need to be equalised as well as flattened at stage 6. (Illus. 19b)

The knife should be introduced only as much as is needed to *start* a clean crack. I do not recommend stabbing the knife point into the quill barrel while it is held flat on its back on the cutting slab, because it can leave an indentation on the ultimate writing edge, which will not close up tightly, nor is there much control over the length of the slit. An excellent alternative is the guillotine method of introducing a slit, which has been suggested by Norman Brown. A spade-shaped blade shaped like that of the old desk knives, which seem to be descended from the even older form of eraser knife, is rocked forward and down on the pen tip (which is supported by the 'chopping block' described earlier). This will 'concentrate the load at a point (of the blade) on a small section, just like scissors' and give an easily controlled start to the slit. If the blade is finely hollow or taper ground, it does not damage much of the underside of the quill, and 'there are Xacto blades that can be ground . . . to accomplish the same thing,' (Illus. 20). On a tough

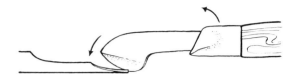

Illus. 20: The scissor or guillotine action of a finely ground knife blade with an obtuse point can be easily controlled.

wide quill, two or more slits may be needed to give the right degree of flexibility and ink flow. The guillotine method would perhaps be best for this.

You should always be ready to adjust the slit if the ink does not seem to flow well. If the ink seems scraped or squeegee-ed onto the surface, then the slit is either too short or the ink is too thick. A compromise is usually the best solution, i.e. lengthen the slit a little, as described earlier and dilute the ink a little. When using colour (or coloured ink) which contains more pigment than normal black carbon ink, or working with gesso or gum ammoniac for gilding, the pen will need to be more pliable to allow the heavier 'ink' to flow – therefore the slit will need to be lengthened, and the nib, perhaps, made more slender than you would need for a sustained piece of writing in ordinary black ink. If the pen opens too much during writing, as a temporary solution the pen may be turned on its back and the two halves forced together by pressure.

I prefer to exchange stage 4 for stage 3 and make the under scoop before forming the slit because I find it easier to centre the slit on the under scoop than the other way round, but it requires a little more confidence than the beginner usually has when using a sharp knife. I cradle the quill between thumb and forefinger of the left hand and support the back of the blade in

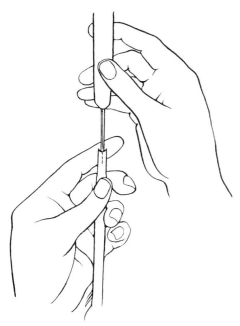

Illus. 22: A slight bevel on the side-scoops preserves the sharpness of the writing.

Illus. 21: Supporting the knife blade when the slit is made *after* the under-scoop has been completed.

the crook of the forefinger, gradually applying pressure upwards on the underside of the barrel top towards the supporting thumb, and immediately reducing pressure when the barrel cracks (Illus. 21).

4 On a tough quill, more of the under scoop may need to be cut away to help flexibility. On a more delicate one, the scoop can be started nearer the pen tip, and slope more steeply down to around halfway through the barrel giving more stability to the nib shoulders (Illus. 15c).

5 In the 'learning pen' you concentrated on copying a shape and matching the side-scoops to produce equally balanced sides to the nib. But it is also necessary to angle the facets of the cuts so that they will help preserve the edge's sharpness for as long as possible. An exaggerated bevel (Illus. 22b) would cause the edge to soften and curl too easily. An undercut facet (Illus. 22c) will soon lose its sharpness. As soon as the knife bites at the start of the scoop, it should be drawn to the tip and twisted at the same time, so that it ends at a *slight* bevel (Illus. 22a). It is exaggerated slightly in the diagram to make the point.

6 For small writing, it may not be necessary to flatten the underside of the point, as the ink will span the inside arch and can even give a pleasing concave detail to the serif, particularly on vellum. When a wider nib is needed, the flattening will be necessary as has been explained. When you flatten the underside of the nib, you can immediately gauge the maximum practicable width obtainable from a given quill (Illus. 22d). There should always be some thickness supporting the side facets of the nib (Illus. 22,e), or the pen softens and rounds off too quickly on the 'corners'.

7 Thinning the top side of the nib should not be confused with sharpening it. It should not be shaved to a sharp edge and used for writing without trimming (Illus. 17d). Again it will be too vulnerable to bluntness and softening. It is suggested that thinning the tip reduces the amount of ink gathering along the writing edge, thus helping to preserve thin strokes. I am unsure of this, but its thinness does make the final cuts much easier.

8 It took me a long time to realise fully the importance of the angle of the writing edge, thinking it sufficient to use a square-cut pen for all alphabets, and simply adjusting the angles by moving my hand. However, it is difficult to emphasize how important it is to experiment for yourself by adjusting the angle of the pen's edge, from square to sharp oblique in either direction, and gauging its effect on a given style. One of the chief advantages of the quill is its adaptability to different writing styles and personalities. A minute variation in obliqueness profoundly affects the letterform. You may discover, as I did, that some alphabets work naturally only when made with an oblique-cut pen.

It is at this stage that a strongly curved quill should be tailored to your choice of writing style or position; by adjusting the angle of the nib cut to accommodate the angle of the quill shaft and barrel in relation to the writing surface.

The shaping of the tip should be practised and its effect on your writing puzzled through. Only by cutting, writing and re-cutting, carefully analysing the result, will you acquire the confidence to change to a more comfortable angle or re-sharpen the pen, even after you have

started what is to be a finished piece. The sensitive eye is more forgiving of a change for the better within a piece of work than it is of consistent but unhappily-formed writing. The guillotine method, using the eraser-shaped blade in a rolling action to re-trim or re-align the nib's edge while supporting the pen as in Illus. 20, should give a precise and controlled result for these angle modifications.

The facets of the two side-scoops, the underside of the nib, and the final writing edge, should have a sheen which shows that there is no coarseness on the blade's edge; the sharper the cut, the sharper will be the letter.

Depending on its quality, the quill should stay sharp longest when used on well-made and prepared vellum, but even this material will blunt the edges after a time, especially when pounce or sandarac has been used on its surface.

To re-sharpen a pen in mid-line of writing is unnerving, but practice will give confidence, and it is preferable to re-trim than to change to another sharpened quill which may have an altogether different feel in the hand, and which because of its curve, may address the surface at a slightly different angle.

9 To re-trim, the ink should be wiped from the nib and a first re-sharpening can be effected simply by taking a thin sliver off the underside of the nib (Illus. 16a), just enough to remove the bluntness of the tip. This method should suffice for at least one more re-sharpening. A heavy turkey pen can be re-trimmed several times in this way. The point will eventually become too thin and pliable, however, and the side-scoops should then be re-cut, and the writing edge re-trimmed. The importance of your earlier practice in taking off thin shavings is tested when

re-trimming, because so little ought to be taken off each side and from the tip (the underside has already been done at the first stage of re-trimming) that the slit need not be lengthened until after two or three re-trims.

So little needs to be removed (and a good quill should be jealously treasured) that I have written over 72 documents with the remaining usable half (about 40 mm or $1\frac{1}{2}$ in.) of one goose-quill pen which was trimmed at least once after each piece of writing of 14 lines on vellum. After all this description, perhaps it is a good time to recall that after practice you should be able to shape and trim a pen in under one minute.

10 The reservoir not only stores ink, it controls the rush of ink to the tip. This function in conjunction with the angle at which the pen is presented to the writing surface, and the angle of the surface itself, will have a profound effect on the sharpness of the writing.

To understand this better, try writing without a reservoir in a fully-charged quill held vertical to a flat surface, then tilt the board by degrees, writing at each step and take note of the changes. You will find that generally, a fully-charged quill needed for sharp, spontaneous writing will have to be held at a shallower angle than a steel nib or fountain pen, and the board tilted to accept the ink with more grace.

For thinner inks, dipping is quite satisfactory providing the ink is gathered on the underside of the pen and collected in the reservoir. Ink coating the top as well as the bottom of the nib tends to produce clumsy strokes. The surplus can be lightly brushed off against a strategically positioned pen wiper, made perhaps from an old suede glove, without slowing the pace of writing appreciably.

For gouache (opaque water colour) 'inks' which need to be kept well stirred, like soup, a hog-hair or similar stiff brush should be used to prime the pen on the underside so that any coagulating ink can be cleaned off at the same time as reloading it.

Most of the operations which have been outlined so far, are aimed to help you make quills for fine, sharp writing – to achieve maximum contrast between thick and thin strokes. Some styles, however, do not call for this, as many of the loveliest Renaissance hands attest. The drawn, quill-pen line has been used by artists right through to the present time, with a range and vigour that suggest wider opportunities for its use as such by calligraphers today.

For varying degrees of soft monoline strokes, the pen should be tempered and made with just the same precision. Experiments can be made in adjusting the point by writing and shaping it on a very fine grade of emery paper (say 600). The nib can also be shaped with the quill knife, the underside of the tip cut away to present a thicker section of the barrel to the writing surface, whatever direction the pen is moved. A uniform thin line can be obtained by using the corner of a square-cut pen held tilted on its side. The composition of the quill and capillary attraction combine to make this method work as well now as when it was used in the decoration of the Book of Kells over 1200 years ago.

INKS

It is difficult for a beginner to grasp fully the effect which speed and ink flow have on the personality of even simple

letterforms, but speed and rhythm are essential ingredients of fine writing. The responsiveness of a quill will free you to write faster; however, the instrument has to be tuned and charged with the right type and amount of 'fuel' to be capable of spontaneous and sustained 'acceleration' (as when making a flourish). A well-formed letter made slowly, with a sparse ink-flow, is quite different from a well-formed letter written quickly with a fully-charged pen. The latter shape can be made and finished before the ink has time to spread and flood from the nib. The slowly-formed mark requires that the ink is held more in check; if the ink is held in check, the potential for 'acceleration' is suppressed too.

After using a quill, it will not be long before you start to question the handling qualities, appearance, and permanence of ready-made bottled inks. Non-waterproof inks are manufactured for use in fountain pens and waterproof inks are meant for drawing and painting.

A fountain pen ink must be 'thin' enough to flow readily through a series of baffles (the controlled leak principle), and onto the paper via a comparatively rigid nib; it must not clog the storage or feed system even when left unused for periods of time. The usual answer to both these requirements runs directly counter to the needs of a quill used for fine writing, for both technical and aesthetic reasons.

Fountain pen inks contain chemical dyes and solvents but have little gum or pigment because these might cause clogging; they have a low surface tension and so tend to spread and sink into the writing surface causing thickened strokes and feathering when they are used in a quill or steel nib which is designed to dispense ink more generously. They also tend to dry unevenly and transparently,

especially on wide letters. Waterproof ink contains shellac and is generally too glutinous for fine writing.

Because of its flexibility and direct ink supply, the quill is able to accommodate inks which do have more density and surface tension, thus affording us the choice of using opaque even colour which does not spread or sink. A quill therefore is made to handle a slow ink quickly; whereas a fountain pen is designed to dispense a quick ink slowly.

WRITING SURFACE

The third element in the partnership of ink and pen is of course the writing surface. When ink is deposited quickly and generously, the receptivity of the surface becomes more critical. Vellum, the preparation of which is described in another article, provides the right kind of traction as the third part of the trio. The confidence that follows getting these three elements in harmony gives another boost to the spirit as well as the form of your writing.

THE CARE OF QUILL PENS

A quill which is left to dry quickly after use, may shrink slightly and then distort, (as paper does after colour is applied) and a good pen can be spoiled. However, quills need not be kept soaking at all times, especially when they are needed for fine sharp writing at small sizes, when the pen needs to be kept dry and hard. However, there is a case for taking steps to compensate for over-drying especially now that many of our rooms, winter and summer, are so low in humidity. Placing the feather shaft downwards on a wet

sponge in a tall covered jar would seem to be a good compromise. A well-tempered pen should then remain in stable shape.

REED PENS

The first point to make about the reed pen is that it is not made from bamboo. Although the terms are often used indiscriminately, viewed from our perspective – that of making expressive as well as coherent letters, the characteristics of reed and bamboo are quite different.

The split-reed pen has been in continuous and general use since the days of the Pharaohs. It is still the principal writing instrument of the Arab calligrapher, and like our broad pen, it relies for its visual interest on its ability to switch from a fine line to a fat one, by change of direction rather than pressure. It can combine the delightful attributes of lightness with the pliability and strength which characterizes a well-made quill. The bamboo, in comparison, feels stiff, dull and heavy, even after it has been pared thin and slit several times. These differences, albeit subtle, reinforce the importance of developing a sense of touch and a sensitive response to the tools we use for making letters; only by doing this can our writing become sensitive and responsive too.

Tall reeds (*Phragmites communis*) grow wild in many parts of the world but, like the quill, some species are more suited for writing than others. In the East they are specially selected according to season and prepared to produce a pen which is tough enough to keep its edge well but is also flexible and light. However, an Arab calligrapher friend has found that the pale reeds of the South of France are quite as agreeable to write with as the reeds from

his native Sudan, where the upper part of a mature reed, much darker in colour, is used for pen making. So you may well be able to obtain a suitable local supply.

The principles of cutting and trimming are similar to those of quill-making, except that a single, shallow under-scoop terminating at the writing edge and made just as for a quill, should be sufficient to make a good pen without making additional side-scoops. Because the barrel wall is proportionately thicker than that of a quill, a single long slit ought to provide enough flexibility without causing the pen halves to open too much. After flattening the underside, adjust the width and trim off the sharp side edges created by the under-scoop. The nib can then be trimmed in the same way as a quill.

The aim of flattening the underside of a reed is to pare away the soft, pithy, inner lining (what the Arab calligraphers call the 'flesh') to arrive at the tough outer edge of the reed (the 'bone'). The fibres are more densely concentrated there and will keep a sharp writing edge longer.

Islamic calligraphers do not generally use reservoirs, preferring to control the ink at source by taking it from an ink-soaked pad of silk placed in a small jar, but for extended flourishes we may need to fit a reservoir as described in making a quill. To prevent the absorbent reed from robbing ink from the letters, the pen should be allowed to stand in the ink long enough to reach saturation point before beginning to write.

The reed is much simpler to cut and shape than the quill pen, so apart from its intrinsic qualities as a writing instrument, it can provide an ideal tool for experimenting with most pen-cutting techniques – assessing the effects of different angles of oblique cuts, both left- and right-handed, and it is an ideal

introduction to a deeper understanding of Alfred Fairbank's definition of writing as 'a system of movements involving touch'.

It is not easy to acquire practical techniques from books, and there are many excellent alternative methods to those described here, but it is hoped that by following the directions for knife sharpening and for tempering and shaping quills outlined above and practising the various techniques described, you will gain the confidence to take alternative steps of your own. Skill is transferable, and the ability to vary, invent and translate other methods to your needs will grow. This should be only a beginning.

Paulinus of Nola to Ausonius

translation by Helen Waddell

Not that they beggared be in mind, or brutes,
That they have chosen their dwelling place afar
In lonely places: but their eyes are turned
To the high stars, the very deep of Truth.
Freedom they seek, an emptiness apart
From worthless hopes, din of the marketplace,
And all the noisy crowding up of things,
And whatsoever wars on the divine,
At Christ's command and for His love, they hate;
By faith and hope they follow after God,
And know their quest shall not be desperate,
If but the Present conquer not their souls
With hollow things: that which they see they spurn
That they may come at what they do not see,
Their senses kindled like a torch, that may
Blaze through the secrets of eternity.
The transient's open, everlastingness
Denied our sight; yet still by hope we follow
The vision that our minds have seen, desping
The shows and forms of things, the loveliness
Soliciting for ill our mortal eyes.
The present's nothing: but eternity
Abides for those on whom all truth, all god,
Hath shone, in one entire and perfect light.

Non inopes animi neque de feritate legentes

desertis habitare locis, sed in ardua versi
sidera spectantesque deum verique profunda
perspicere intenti, de vanis libera curis
otia amant strepitumque fori rerumque tumultus
cunctaque divinis inimica negotia donis
et Christi imperiis et amore salutis abhorrent
speque fideque deum sponsa mercede sequuntur,
quam referet certus non desperantibus auctor,
si modo non vincant vacuis praesentia rebus,

quaeque videt spernat, quae non videt ut mereatur
secreta ignitus penetrans caelestia sensus.
namque caduca patent nostris, aeterna negantur
visibus, et nunc spe sequimur quod mente videmus,
spernentes varias, rerum spectacula, formas
et male corporeos bona sollicitantia visus.
attamen haec sedisse illis sententia visa est,
tota quibus iam lux patuit verique bonique,
venturi aeternum saecli et praesentis inane.

circa 380 AD
IW. scripsit 1946

Irene Wellington: *Paulinus of Nola to Ausonius*, translated from the Latin by Helen Waddell. Written in black ink on paper, Latin text and notes in vermilion. Trial for a manuscript. 20 × 13 in. 1946. By courtesy of the Crafts Study Centre, Bath.

gaudere autem quod nomina vestra scripta

Edward Johnston: Four lines written in the Foundational Hand which Johnston developed from his study of tenth-century manuscripts in the British Museum. Written in black Indian ink with a broad-nibbed pen. Size: ruled line $6\frac{3}{4}$ in. 1918. In the possession of Heather Child.

In *Writing and Illuminating, and Lettering*, 1906, Edward Johnston wrote:

'Stick Indian ink is best, and a *good-quality stick* is worth paying for; the necessary rubbing down on a slab is well worth the trouble. We can ourselves control the thickness, colour, and state of the ink, and safely add to it, e.g. vermilion and yellow ochre (to make a deep brown), or gum-water (to prevent *spreading* on porous writing surfaces).

'Jet black is the normal hue; it will also test the quality of the writing; it shows up all the faults; *pale* or *tinted* inks rather conceal the faults, and lend a false appearance of excellence. A thin ink greatly adds to the ease of writing; too thick inks do not flow freely enough. A brush is used (in the left hand) for filling the pen.'

Ink

M. THERESE FISHER

This article is reprinted (in a slightly abridged form) from the earlier
Calligrapher's Handbook.

Ink is the term for any fluid with which records are made on parchment, paper or similar substances. The importance of the part played by the ink used in writing a manuscript is often disregarded. On the right choice of ink depend the legibility, permanence and beauty of the writing. The student should take care to ensure that any ink employed has the following qualities.

It must flow freely, be permanent, and be even in colour. It should have a grittiness rather than a stickiness. It should be non-corrosive, non-poisonous, not easily erased and non-fermentable. This last requirement can be fulfilled by the addition of some antiseptic such as phenol or thymol (see Recipes 2 and 4). All ink should flow freely from the pen used, but in hot weather, overheated rooms and hot climates it is not the fault of the ink if this is difficult to control. Ink which flows easily in an even climate becomes temporarily thick and intractable in surroundings which are too warm and dry.

There are only two methods of preparing ink given in classical and mediaeval recipes.
1 Mixing gum with lamp-black: this is permanent and unchanging.
2 Treating salts of iron with tannic acid: such ink fades to that brown tint familiar in western manuscripts. Iron gall inks require a small proportion of strong acid to render them stable and for that reason may bite through the paper or parchment in time. Judging by appearance some ink has been a mixture of both kinds and so faded unevenly.

Carbon inks can be classified thus:

| Carbon blacks consisting of practically pure carbon in amorphous condition | Gas black – derived from incomplete combustion of gases and substantially free from grease. |
| | Lamp black – derived from the incomplete combustion of oils. Used for centuries before gas black was obtainable. |

To prepare Chinese ink (lamp-black): the Chinese never kept liquid ink in bottles or inkwells but prepared as much as they needed at a time. For this purpose they had a slab of marble or other stone which had a small round cavity at one end. A few drops of water were poured over the finely polished surface and the stick or cake of ink was gently rubbed against it, the ink flowing into the cavity.

Distilled water should always be used or, if it cannot be obtained, rainwater that has been boiled and run through a single filter paper, or ordinary potable water which has been brought to the boil and allowed to cool.

Liquid preparations of Indian ink are sometimes made by grinding up with water fragments of Chinese and Japanese sticks which have been broken in transit.

Lamp black has been superseded to a certain extent by carbon black which is now manufactured on an extensive scale from the natural gases issuing from the oil-wells of the USA.

Inks which will not be affected by water when dry are called waterproof inks. They are too heavy and sticky for ordinary use and do not flow freely but are convenient for outlines if the outlined forms are to be coloured afterwards.

Ink can be removed from skins or paper by very careful scratching with a sharp knife, or better still by long and careful use of a soft rubber. The surface can then be smoothed and polished with a flat ivory paper knife after which it should be possible to write again without the ink floating; but it is advisable to use very little ink or colour in the pen for such corrections. Ink that is diluted with vinegar cannot be easily erased. There are one or two good British and American typists' erasers on the market now, including one in pencil form, which are effective when handled with great care and if a soft rubber is used gently after, always with the grain and never against it. Palimpsests are vellum manuscripts from which the writing has been erased by rubbing the surface with pumice stone so that it can be used again. Many writings of classical times were undoubtedly lost this way, and as many preserved.

Edward Johnston: Initial letters, $2\frac{1}{2}$ in. high, one of several trials for the opening of a calligraphic letter to Alfred Fairbank, 19 September 1941. Written in watered blue ink. By courtesy of the Crafts Study Centre, Bath.

Ink	*Comment*

1 2697 BC. Chinese stick ink consists of lamp black baked up with some glutinous substance; the finer oriental kinds are delicately perfumed, often with musk.

Graily Hewitt gives the best and simplest method of preparing it: 'Into a clean palette slant put a salt-spoon of water and then, by watch, rub the stick for 3 or 4 minutes. If it then gives a good black, that is your gauge. If not black enough rub another minute. So then you know your need of water and amount of rubbing to repeat exactly the same density. Of course the water should be rain or distilled.'

Another authority advises that it should always be rubbed down in a palette with a tooth matt, i.e. roughened surface.

Comment: Improves with keeping. Should never be used until at least 3 years old, should be frequently rubbed with the hand to preserve the polish which is its protective coating.

New stick inks now being imported are of doubtful quality and fade after much exposure to light.

Only good Chinese stick ink rubbed down according to the requirements of the scribe using it is absolutely reliable and endures the test of time without change.

2 AD 1540. Palatino's Recipe.
Soak 3 oz. galls coarsely crushed in $1\frac{5}{8}$ pints rainwater.
Leave in the sun 1 or 2 days.
Add 2 oz. copperas, finely crushed, stir well with a fig stick.
Leave in the sun 1 or 2 days.
Add 1 oz. gum arabic and leave one day in the sun.

Comment: Made and used by the late Colonel Crosland who writes:
'I found $\frac{1}{2}$ oz. gum sufficient.
The mixture should be carefully strained, bottled with India-rubber corks – re-bottled after sediment has settled.
Phenol should be used to prevent mould. When I had it prepared by a careful chemist the mixture was finally warmed (not boiled) for 15 minutes. This infusion (without boiling) is advised in *L'Arte di Scrivere dell Encyclopedia Methodica*, Padua, 1796.
It is unlikely to fade for a long time.'

3 1672. Edward Cocker's prescription from *The Pen's Transcendency*.
Pour 2 gallons of rainwater into an earthen stand or vessel that is well leaded or glazed within; and infuse in it 2 pounds of gum Arabic, 2 pounds of Blew-galls [Blue] bruised, 1 pound of Copperas and 2 oz. of Roch [Rock] Allum: stir it every morning with a stick for 10 days and then you may use it. You may vary the quantity observing the same proportions.

Comment: Greyish when first used, turns black after a few days. Fluid and easy to use but inclined to eat into the skin or paper.
Fades a little after long exposure to light.

Ink	*Comment*
4 1904. Dr Ainsworth Mitchell's ink. (i) Dissolve $1\frac{1}{2}$ oz. of tannin in 1 pint of warm water. (ii) Dissolve $1\frac{1}{2}$ oz. of copperas in $\frac{1}{2}$ pint of water. Mix (i) and (ii) and add 1% (say $\frac{1}{2}$ oz.) of gum arabic also $\frac{1}{2}$ drachm phenol (Calvert's carbolic acid). Expose to air and sun for darkening and stir frequently. Keep in an earthen vessel covered with muslin and stir every day for a week. After darkening add 1 in 1,000 parts of hydrochloric acid. Let the ink settle for a week and decant. Warming accelerates the darkening but the ink should not be boiled.	Made, used and praised by the late Colonel Crosland, who writes: 'This ink is superior to Palatino's in appearance and permanence.'

5 1927. Edward Johnston's Recipes from the S.S.I. Record Book.

Black ink

Yellow ochre + ivory black water (a little vermilion) + gum water.	Easy and convenient to make and has not been known to fade at all even after long exposure to light.
Ivory black has a remarkable quality of absorbing colours (Church) and so makes mixtures darker than you would expect. The yellow ochre powder is a gritty 'earth' which helps.	As Edward Johnston said to the Society: 'A gritty ink is better than a slimy one.'

Red ink

Scarlet vermilion + water + gum water.	Is unlikely to fade, vermilion mostly improves with age. Edward Johnston writes: 'I find a very little (solid) Oxgall a help, it has the objection of being dark but it lasts much longer than the liquid and I am used to it. Very little must be used or it will make the colours spread and soak.'

The origin of ink is still a matter of dispute, as ancient records differ. There were only a few kinds, but in composition and appearance they preserve a remarkable identity, though belonging to countries and epochs widely separated. The basis of ink both in China and ancient Egypt was carbon derived from lamp black. A manuscript written by Chien-ki-Souen dating back to 2697 BC in which the entire process of making ink is described and illustrated was discovered in China some years ago and translated into French by Jametel in 1882.

In ancient Egypt there is a roll dating from about 2500 BC which is probably the oldest extant writing on papyrus. One of the earliest Greek parchments dating back to 2200 BC relates to the sale of a vineyard. The carbon ink of ancient Egypt was prepared in solid sticks as in China, and was used down to the fifth century: remains found in inkstands would seem to confirm that it was available in fluid form also. Among the coloured inks the Egyptians used were red ochre, yellow ochre, malachite, and to make a blue colour they ground down fragments of sapphire, haematite, emerald and topaz. They were made into cakes, presumably with gum, to permit emulsification of the pigment in water and to act as a fixative. The Hebrews reserved carbon inks for religious writings. Dioscorides, 40 BC, physician to Anthony and Cleopatra, in a dissertation on the medicinal use of herbs gives the proportion of lamp black and oil to be used as three to one. Vitruvius, 30 BC–AD 14, describes a method of preparing soot from pitch-pine mixed with gum and dried in the sun.

It is to the female wasp that we are indebted for gall ink. This was probably invented in the anterior orient, for the species of oak on which the gall wasp deposits its ova that form the excrescences known as galls grows in Asia Minor, Syria and Persia. It seems to have come into existence only during the first centuries of our era, and was used by the Persians, and mentioned by Philo of Byzantium in the second century. Byzantine ink was a different tint and may have been a bituminous preparation, probably semi-liquid bitumen used directly and without further preparation. Possibly the earliest extant document written with iron ink is an Egyptian parchment of about the seventh century AD. From then the use of iron inks spread to Europe but the transition from carbon ink, often erroneously called Indian ink, to that of galls and iron was very gradual. Astle, Keeper of the Records in the Tower of London 1803, found that black ink used by the Anglo-Saxons in documents of the seventh, eighth and ninth centuries had preserved its intensity better than that used at later dates. He came to the conclusion that it was because the earlier inks contained carbon. The earliest reference to it is made by the monk Theophilus who wrote *Diversum Artium Schedula* in the eleventh century. He describes an ink prepared from thorn wood: an aqueous extract of the wood was evaporated to dryness and the powder was mixed with green vitriol.

The word ink was derived from the Latin *encaustum*, the name given to pigment first used in baking tiles. Later it was restricted to the purple ink with which Roman emperors signed their names, the black ink being called *atramentum, ater*— black. Ink made from the pigment of the cuttle-fish, i.e. sepia, was used by the Romans, and from the Murex mollusc was obtained the famous Tyrian purple. They used also gold and silver inks which consisted of finely divided metals

incorporated with gum and covered with beeswax. Plutarch, AD 46–120, mentions red ink (to which we owe the word rubric) which was compounded of minium or vermilion. Sidonius says that red ochre was used. Wecker of Basle in 1612 describes an indelible ink compounded of lamp black and linseed oil. Various methods of preparing coloured inks were mentioned by Canneparius of Venice in 1660; Persian berries for yellow, logwood mixed with copper acetate and alum for purple. Various substances were used by the Chinese as the original source of lamp black, e.g. rice-straw, pinewood, haricot beans, tung-oil and sesame oil. Today European lamp black is made from impurities obtained as by-products in the manufacture of turpentine, oil, tar, etc.

Permanency in colours generally has reference to their ability to withstand sunlight and ordinary atmospheric conditions; carbon black excels all others in this respect. There are two inks most pleasing to modern scribes: Chinese stick ink which must be rubbed down, and Higgins' Drawing Ink from which the scribe's quill or pen is filled from a quill in the cork of the bottle. Of recipes there are a great many, a few of these are included here. It must be remembered that the test of ink is in its contact with the skin or paper and not by itself. Innumerable inks are on the market, but only by trial and error, and by constant experiment, can the one be found which expresses the craftsmanship of the individual.

Editor's note—recommended reading:
'Inks and Pigments: tools of the scribe' by Norman Brown and Alice Sink, article in three parts in *ALPHABET The Friends of Calligraphy* journal (editor: John Prestianni) – Summer 1983, Volume 8 no. 3; Fall 1983, Volume 9 no. 1; Spring 1984, Volume 9 no. 2.

Pigments and Media

DOROTHY HUTTON

This article is reprinted from the earlier *Calligrapher's Handbook*.

PIGMENTS[1]

Since the days of the prehistoric cave painter the search for colouring matter has continued throughout the ages. Whether the final products have improved in richness of hue and depth of tone is open to question. The tendency at the present day is to produce pigments by chemical means rather than from organic sources, and in the latter case to grind by machinery rather than by hand and indeed to cease to prepare those rare pigments of exquisite beauty where the demand is deemed insufficient to justify the labour involved. The illuminator is forced to select his palette from what is available.

Pigments are either:

1 of organic origin
 a) from plants, e.g. indigo, obtained from the roots of a plant in India.
 b) from animals, e.g. ivory black, obtained from the soot of burnt bones.
2 of inorganic (mineral) origin
 a) from natural sources, e.g. the earths (raw sienna, yellow ochre, etc.)
 b) from those artificially produced, e.g cobalt, viridian, French ultramarine.

[1] An asterisk denotes those colours recommended for general use owing to their brilliance and stability.

These classifications are of interest rather than of importance to the scribe. From whatever source the pigments are produced the illuminator requires of them the following qualifications:

1 They should not fade. They should withstand the action of sunlight, and here the calligrapher of the bound book has the advantage over the writer of the framed panel in that his work is not likely to be, and certainly should not be, exposed to direct sunlight at one opening for any considerable time.
2 They should not discolour or darken. This might occur either through the chemical action of the pigment itself, the combining of two incompatible pigments, the introduction of an unsuitable preservative, or the effect of the atmosphere.
3 They should be brilliant of hue and of a luminous quality.
4 They should be free from impurities, dirt, mould, 'doctorings' or fillings.
5 They should be very finely ground, smooth and tractable, having that fluid quality sensed by the hand when mixing them with their medium.
6 When possible they should be of an opaque nature. This desirable property dispenses with the addition of Chinese white which tends towards 'muddy' results.

The leading artists' colourmen supply 'first quality' powder (levigated) colours; it is, however, wise for the scribe to know something of the nature of these pigments. For example, if he cares for the durability of his work he should realize the following facts: that vermilion, cadmium and French ultramarine contain sulphur, either inherent or through the process of manufacture; that owing to the presence of sulphur they are prone to discolour or blacken when in contact with an acid; that therefore both medium and preservative must be free from acid. Should he also be so fortunate as to possess powdered azurite or malachite he should remember that they will undoubtedly fade or discolour unless enclosed within a suitable and acid-free binding. The mediaeval scribes were aware of these facts, indeed many references to the appropriate tempering of the differing pigments occur in their books of recipes.

The extensive variety of pigments available may bewilder the student. It is wise, however, for him to restrict his palette to a few dominating colours, for uses on title pages, in headings, for initials and rubrics, and later to extend his range when exploring the infinite possibilities of decoration and miniatures. A well-planned book will have a system in colour throughout, even as it has a system in lettering; this plan in colour statement will contribute towards unity and dignity. It is as well, therefore, to fix on a red, a blue and a green and adhere to them consistently throughout the work on hand, with perhaps a subsidiary colour to form a liaison. Should gold be used it should be considered here as a colour, in which case the colour scheme should be simplified to avoid over-elaboration of effect. Blue in conjunction with gold frequently looks better than vermilion with gold, which

sometimes gives a 'hot' appearance, though on such matters it is unwise to dogmatize. Colour illusion and the complementary shades of red to green, blue to orange and yellow to violet should, however, be recognized, for the illuminator may be presented on occasions with such problems. As an instance, he may be painting a coat of arms with the shield quarterly red and blue with gold charges; the vermilion will take on a pinkish hue and the blue a purplish, requiring careful adjustment. Always it should be remembered that colour is not absolute but relative, varying with its surroundings.

The following brief list of pigments is suggested from which to select an adequate palette. Other colours are on the market and could be used if they conform to the requirements already stated. Three colours, genuine ultramarine, azurite and malachite are recorded as valuable pigments though the supply is negligible.

REDS

*Vermilion** This is a compound of mercury and sulphur. It can well be considered a basic pigment for the illuminator, as it unites most of the desirable qualifications; it is intense, brilliant, opaque, tractable and reasonably permanent. The method of manufacture has altered little since the eighth century A.D. It is obtainable in several shades – in vermilion, scarlet vermilion, orange vermilion and Chinese vermilion; this latter, being the deepest shade, is considered the more reliable. Scarlet vermilion is that variety most favoured by scribes, but a mixture of vermilion and

orange vermilion is also good. If desired, a little Chinese white may be added for extra body. The brilliance of hue diminishes slightly when the pigment dries. Vermilion should not be exposed to direct sunlight owing to a tendency for black spots to appear, nor should it lie adjacent to emerald green, a 'copper' colour, as the edges of the vermilion may blacken. With these reservations it remains the outstanding pigment for the scribe's use.

Cadmium red Modern improvements in the reliability of this pigment make it a possible substitute for vermilion should the latter be unobtainable. Containing sulphur, it, like vermilion, is liable to blacken when next to emerald green.

Alizarin crimson This modern product, a coal-tar derivative, is reasonably permanent and hence replaces the vegetable madders and crimson lake of doubtful stability. Carmine, of cochineal origin, will unfortunately discolour rapidly when exposed to light.

Venetian red and light red Both pigments are native 'earths' containing iron oxide; like most earths they are permanent to light.

BLUES

Of all colours blue was the most highly prized by the mediaeval scribes. Neither expense nor effort was spared in its production. It was the colour for the Virgin's robe, the colour for the celestial firmament. Numerous references to blue pigments occur in the mediaeval books of recipes, and the subject has been extensively dealt with by Professor D. V.

Thompson.[1] The two mainly in use in mediaeval times were genuine ultramarine (lapis lazuli) and azurite (azzurro della magna). It is unfortunate that both colours are almost unobtainable today. Other blues formerly in use were indigo and bice, of which latter little is known.

Genuine ultramarine This rich pigment is made by grinding and purifying the semi-precious stone lapis lazuli. The supply has come exclusively from Persia since the earliest times but recipes for its manufacture in Europe date only from the twelfth century A.D. Even as at present produced it possesses a deep intensity of hue and is to be recommended for work of special importance. Should the colour appear purplish a touch of black or viridian with white may improve it.

Azurite (blue verditer) is a basic copper carbonate. The late Graily Hewitt stated that this true blue was mainly in use between AD 1250 and AD 1400; it is frequently referred to in documents and ranked next to ultramarine in value. It is a colour of peculiar beauty of hue, being neither too green nor too purple if correctly ground. At the present day, as sold in pans, tubes or cakes, it is useless, the colour having been destroyed owing to the presence of acid, and for this reason the artists' colourmen no longer stock the ground pigment. Should it, however, be both correctly ground and rightly tempered with parchment size free from acid the result appears to be entirely satisfactory.

[1] Daniel V. Thompson, Jr., *The Materials of Medieval Painting*, George Allen & Unwin Ltd., London, 1936.

Ultramarine ash is a delicately pale blue containing fragment of lapis lazuli and can be used if strengthened by the addition of another blue, such as Prussian blue.[1]

*Artificial or French ultramarine** First produced in France in 1828 this pigment has proved a useful substitute for genuine ultramarine. It is light-resisting but owing to the use of sulphur in its manufacture it may discolour in the presence of acid. Its purplish tinge can be moderated by the addition of viridian or cerulean and Chinese white.

Cobalt blue This is permanent, but by itself is somewhat insipid for the piercing colours required in illuminating.

*Cerulean** is reliable and permanent and of considerable body. At full strength it has a somewhat greenish metallic appearance but should a purplish blue be mixed with it a pleasing result may be obtained.

Prussian blue This pigment is not generally considered permanent and therefore should not be used by itself.

Indigo is a fine deep colour, which for artists' purposes is still produced from the root of a plant, but is known to be fugitive.

Monastral blue (now renamed pthalo blue)* The monastral colours are fast to light. Chemically they are related to chlorophyll. The colour tends to streakiness and has a metallic tinge.

The following *Mixed Blues* are here recommended though all, being mixed with white, suffer from a degree of muddiness:

i French ultramarine + viridian + Chinese (zinc) white
ii French ultramarine + viridian + a little black + Chinese (zinc) white
iii French ultramarine + viridian + a little alizarin crimson + Chinese (zinc)white
iv French ultramarine + cerulean + Chinese (zinc) white

These four mixed blues have been recorded as used in recent manuscripts by members of the Society of Scribes and Illuminators.

GREENS

Emerald green A basic copper arsenite, was first made in 1788. This intense colour is highly poisonous. It will blacken any adjacent sulphur colour such as vermilion and French ultramarine. It should only be used by itself.

*Emerald oxide of chromium or viridian** This most useful pigment has no connection with emerald green. It is both brilliant in hue and permanent to light. Being transparent it requires the addition of lemon yellow, an opaque pigment, or aureolin with Chinese white, to give it body.

Malachite is a basic carbonate of copper. This splendid and luminous colour, which is usually found in mineral deposits close to azurite was much used by mediaeval scribes. Being both brilliant and translucent it is to be preferred to emerald green which it resembles. Owing to the cost of grinding it is almost impossible to obtain and, like its copper neighbour azurite, must be tempered with size when applied.

Cobalt green This light green is slightly heavy and gritty; when mixed with lemon yellow it has a useful body. It is permanent.

Monastral green (now renamed pthalo

[1] Edward Johnston, *Writing and Illuminating, and Lettering* chapter 10, Hogg, 1906. (Later published by Pitman and A & C Black.)

green) is a dye and as such not highly suitable. It has, however, been used with some success mixed with cerulean and white.

Verdigris is fugitive, and *terre verte*, though useful for the modelling of flesh, has little strength of colour.

PURPLES

The somewhat raucous purple known today has no place in the mediaeval manuscript. Sometimes a mixture of blue and red was used but among the more frequent variants were brazil wood, haematite and even whelks. For present-day use, Indian red with white or purple madder with white is advocated. Indian red is an iron oxide and is therefore akin to haematite. The shades, however, vary considerably; the one recommended is the pre-war product which changes to a subtle lavender when white is added. Lettering in this colouring, used with discretion, forms a harmonious liaison between blue and vermilion on a page. Indian red as supplied to-day appears to be merely a deeper shade of Venetian red.

Cobalt violet resembles purple ink and is to be avoided as a colour though reliable as a pigment.

YELLOWS AND BROWNS

The various earth pigments of *yellow ochre*, the *siennas* and the *umbers* are permanent but are too heavy and dull for use except in decoration or miniature work. *Vandyke Brown* is fugitive.

*Lemon yellow**, possessing body, is a useful clean yellow for adding to viridian or white. Some scribes prefer *aureolin*, though more transparent. Both are safe colours. *Gamboge* is impermanent. *Chromes* are made from lead and will blacken.

BLACKS

*Ivory black, lamp black and vine black (charcoal)** are each satisfactory. They consist of carbon obtained in the form of soot from burnt objects, such as bones, oil or vine shoots.

WHITES

*Chinese white (zinc)** is permanent to light and will not darken. To obliterate the bluish shade when painting fine lines and dots a touch of lemon yellow can be added. Being smooth of texture Chinese white mixes well with other pigments.

Titanium white, of recent discovery, possesses considerable covering power. It is a compound of titanium oxide and barium sulphate, the proportion of these being worked out to obtain the maximum density and permanence. It is non-poisonous, and is supposed neither to be affected by acids nor darkened by sulphur compounds and gases.

Flake white should never be used; it contains lead and will quickly 'brown' when exposed to sulphur.

In the interests of the craft it is emphasized that only first-class colours should be used; tints, dyes, coloured inks, 'process white' and poster colours are unsuitable for use.

This survey of pigments for the use of the scribe and illuminator is merely a sketch; for further information the reader must refer to books mentioned in the bibliography. While of necessity the writer must warn against the attendant dangers to the various pigments, the executant should not be unduly apprehensive, though always avoiding those known to be unstable.

Editor's note: Genuine ultramarine, azurite and malachite are no longer obtainable. Azurite can be replaced by cobalt and new blue (now renamed Permanent Blue).

MEDIA[1]

Having the requisite information as to which pigments are suitable for use, the problem for the illuminator is in what form to buy them and how to apply them. First-quality colours should be purchased from one of the leading artists' colourmen, who supply them:

 a Tubes
 b Pans
 c Cakes
 d Powder 'levigated' colours.

Watercolours, ready for use, contained in tubes or pans, though convenient in form, include in their composition a percentage of glycerine. This glycerine, owing to its hygroscopic nature, is liable to attract mould on vellum. Better than tubes or pans are the old-fashioned 'cake' colours which are bound together by gum. Chinese white should be purchased in a bottle or in a tube, which thus provides protection from extraneous colouring matter. Cleanliness in all details should be observed if brilliance of hue is to be obtained. Cake colours should rest each in its own saucer, and when not in use be covered from dust. The main colours of red, blue and green should have their own brushes, palettes and waterjars. For tubes, pans and cakes no medium except water is required, and the beginner is therefore free to struggle with the preliminaries of the craft whilst employing these simple methods.

Coloured drawing inks are unsuitable for the scribe, being transparent and thin.

The application of colour by the pen presents some difficulties not experienced when using ink, the colour being inclined on the one hand to dry and thicken in the quill's slit and thus not to flow, and on the other to flood to the base of the letters, giving uneven tone. To overcome these troubles, the pen should be frequently wiped with a clean rag, the tin strip removed altogether, whilst the desk angle should be greatly reduced. For versals the quill's slit should be lengthened. Right judgment for maintaining the colour's consistency will develop with experience, but a rich, milky texture is generally found good.

As the beginner proceeds it is right that he should make his own medium for his colours. His knowledge of his materials will thus grow, and the brilliancy and clarity of the illumination to which he aspires will then increase. He should purchase finely levigated powder colours. A reliable artists' colourman will supply any pigment on the market in powder form made up in glass test tubes. For convenience these can be kept in a flat box (e.g. cigar box) lined with cotton wool to avoid glass breakage. They may even be separated with advantage into two boxes, one to contain the 'cool' colours (blue, green, black and white), the other the 'warm' colours (red, yellow, brown).

Implements required will be a palette knife (ivory rather than steel, and one not previously used for oil painting), a frosted glass mixing slab, a small glass muller, and a china receptacle to hold each colour when mixed. An excellent form of china palette contains a number of small wells with a covering lid to keep colours both clean and moist. If no lid is provided a piece of glass will serve. Plastic and enamel palettes are available but china ones are to be preferred. A glass stopper, or agate pestle, is also required.

Whatever vehicle is used for binding, the

[1] Unless otherwise stated all methods mentioned of tempering pigments have been used by the author.

powdered pigment must be completely and permanently enclosed within it, otherwise the colour when dry will dust off. Nor must the medium be too tenacious or it will shrink and crack the pigment as it dries. Experience rather than accurate measurement will dictate the correct strength.

The manner of mixing the medium and the pigment can be either:

1 To shake out a very small quantity of the powder colour on to the frosted side of the glass slab. Add whatever medium is to be used, and grind gently by a circular movement with the glass muller. Remove this mixture with a palette knife, transferring it to a small jar or china well, or

2 The powder colour can be placed in a china well and some of the medium dropped on top of it. With the glass stopper or agate pestle the powder colour and medium are thoroughly mixed. Should the powdered pigment be sufficiently ground by the maker this procedure is more economical of pigment, the transfer operation being omitted.

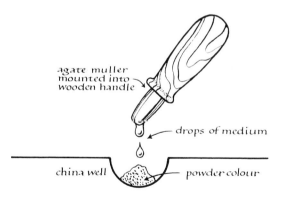

agate muller mounted into wooden handle

drops of medium

china well — powder colour

In either case the mixture, if covered, will remain liquid from a few hours to two days according to the day's temperature, and should be stirred as used.

For the calligrapher's purpose the following binding materials are sufficient to temper pigments on vellum: gum, or egg, or glue or parchment size. All these binders were used in the great period of mediaeval illumination, sometimes indeed a mixture of two together. On this subject much light has been thrown by Professor D. V. Thompson Jr.[1] in his reprints and translations of old manuscripts and by his comments thereon. It should be remembered that whatever be the vehicle employed each medium gives its own inherent quality to the work, that of egg differing from gum, and gum from size. It remains for the practitioner to discover his individual preference, unless the pigment dictates otherwise.

GUM

The use of gum is the simplest of the methods here suggested. It is known to have been used in manuscripts as early as the eleventh century and by the sixteenth century it was superseding other methods.

Gum-water is required. This product as sold by the artists' colourman is likely to contain acid as a mould deterrent, and this may eventually harm both 'sulphur' and 'copper' colours. The following recipe is therefore given:

Gum-Water:

1 part gum arabic (or senegal). For this choose clear, clean crystals.
2 parts water.
Leave to dissolve, next day strain through muslin, add a small amount of a preservative which must be acid-free. (Suggested preservative: 5% 2–naphthol dissolved in boiling water).

[1] See Selected List of Books

This gum-water solution when kept in a glass jar with glass or wooden top can be used as needed diluted with water to the required strength.

Method Mix in an egg cup water and gum-water. Proportions may be $\frac{1}{3}$ water to $\frac{2}{3}$ gum-water varying to $\frac{2}{3}$ water and $\frac{1}{3}$ gum-water. Experience will decide. If the gum is too strong the colour will not flow easily in the pen and will crack or curl off the vellum. On the other hand if it is too weak the pigment will not be held by the medium and the powder will dust off. A trial should be made by passing the finger over the test specimen. Once made this gum medium can be mixed with colour by either of the methods previously described, either on a glass slab or in a china well. It is a clean, clear medium, but has two slight disadvantages: first, it is not waterproof and should another coat be painted over it, as may occur in miniature work, the ground coat will 'move'; and secondly, the medium is inclined to be brittle and crack. Early recipes suggest the slightest addition of sugar or honey.[1]

[1] This addition of sugar or crystalline honey can be added plain or as a solution. The solution, as recommended in the anonymous fourteenth-century treatise, *De Arte Illuminandi*, chap. 19, translated by Professor D. V. Thompson, Jr., can be rendered thus:

1 tablespoon crystalline honey.

2 tablespoons water—boil gently, skimming off the froth as it appears. When clear add 2 more tablespoons of water and boil. Remove to cool. Add 1 teaspoonful 'glair' to which previously has been added 1 dessertspoonful water. Stir well. return to boil, continue to remove froth. When clear and about the same quantity as at first, remove and strain into a small pot.
<div align="right">(Acknowledgements to A. V. H.)</div>

[2] *The Book of the Art of Cennino Cennini*, chap. 131. Trans. Christiana J. Herringham, George Allen & Unwin Ltd., 1899, see *Il libro dell' Arte de Cennino d'Andrea Cennini*. Trans. Daniel V. Thompson Jr., New Haven, U.S.A., 1933.

EGG

1 *Glair (white of egg or 'clarea')*. It is known that this medium was largely employed from the eleventh to the thirteenth centuries. The process of making the 'glair' was similar to that given by the fourteenth-century monk Cennino Cennini,[2] but is quoted here from translation by Prof. D. V. Thompson, Jr. of a fragmentary treatise written at least two hundred years earlier.[3]

Method 'Both colour and glair, therefore, should always be handled very neatly; nor are beautiful things made by any other means than by clarifying and selecting the preparations. Now if you mean to handle them so, have a very clean platter in which you may always prepare the glair ... reserved for this alone ... prepare furthermore a whisk ... when you are ready ... you separate the white of the egg from the yolk;[4] and placing the white on the platter you beat that white of egg strongly, unintermittently ... until it is converted as it were into a water froth or into the likeness of snow and sticks to the platter, and loses the power of running or shifting in any direction, even if you turn it bottom side up, that is, the bottom of the platter on top and the glair underneath. But still you should know this; that if you were to beat it seven or ten times, in beating or whipping the glair, after it sticks to the platter it would be improved. Indeed that insufficient beating of the glair proves

[3] 'De Clarea' of the so-called anonymous Bernensis MS. Berne A 91.17. A fragmentary extract from a lost work of the second half of the eleventh century. Trans. D. V. Thompson Jr., 1932.

[4] Here the thread or chicken of the white would be removed.

a pitfall to many; and when it is whipped too little it becomes practically a glue and when mixed with colour it makes that colour run like a thread, and the colour is utterly ruined, and cannot even flow from the writer's pen without great difficulty; and when it is laid on parchment, it appears very unsightly ...'

The plate is then sloped, and the next day the liquid, now distilled, is poured into a vessel. It will keep a few days, then thicken and dry up. A small amount of honey or sugar solution or size can be added to counteract its strong contractile power. The author of *De Arte Illuminandi* recommends glair as the medium for vermilion with a touch of honey and earwax added.

2 *Glair and gum*. The following recipe from the fifteenth-century Strasbourg MS. translated by Lady Herringham[1] is contributed in practical form by Miss Ida Henstock:

Method 'To the liquid from one white of egg (after beating stiffly and leaving overnight to run off) add $\frac{1}{2}$ teaspoon gum arabic, $\frac{1}{2}$ teaspoon French white wine vinegar; dissolve and strain. Add $\frac{1}{4}$ teaspoon sal ammoniac previously dissolved in a minimum amount of warm water; strain. In use it should be diluted with distilled water.'

The medium lends clarity and purity to the colours; it will work well in thin gradations and is excellent for finest white hair lines.

[1] Lady Herringham, *Notes on Medieval Methods: Explanation of the Tempera Painting of the Trattato*. George Allen & Unwin Ltd., London, 1899.

3 *Yolk of egg.*

Method. Make a hole at either end of the egg to allow the white to run out, carefully pierce the sac containing the yolk which then escapes without skin or 'chicken'. To this add water varying from one third to twice its quantity as experience dictates. Mix well with a wooden instrument, strain through muslin.

Although pleasant to manipulate, this medium is more suited to decoration and miniature work than to lettering, being liable to thicken in the pen slit. Any yellow tinge from the yolk quickly disappears. Caution should be observed in the consistency of the medium, for excess of fatness gives a greasy appearance. It is excellent for any modelling, giving solidity to the form, and the underpainting will not move.

Though tender until dry, it finally becomes hard and tough.

GLUE AND SIZE

1 *Fish glue* The late Allen Vigers, the illuminator, successfully used Lepage's fish glue as a medium. Mr Graily Hewitt writes of his manner of handling:

Method 'He took clean saucers for his several colours and put little mounds of powder colour thereon and glue as he reckoned enough; mixed water with these, guessing how much, stirred up and made brush trials of results; and let these dry. Then with a brush and plain water he made some brush strokes and again let these dry. Then with his finger through a clean handkerchief he rubbed the strokes. If colour came off on the handkerchief he had too little glue and added a little more, till no colour came off. He then of course kept the palette away from dust, and it

was ready for future use when required, when he used a brush and plain water, treated it in fact like a dry cake colour from the shop.'

It must be remembered that there would be a preserving acid, probably either carbolic or acetic acid, in the bought fish glue, and that any 'copper' colours used might be affected. No signs of deterioration, however, are apparent in his panel for the Art Workers' Guild after more than thirty years of exposure to light and damp.

2 *Stale parchment size.* For calligraphers, the many possibilities of this excellent binder have only recently been explored, though its use for painters has been known[1] or suspected from early days. References to the use of size in mediaeval recipes are few and vague. Size used sufficiently warm for fluidity inevitably cockles the vellum.[2] In 1933 a valuable extract appeared from *The Art of Limming* 1573 in a note on *De Arte Illuminandi*:[3]

'Sett the sise ... in some seller or shadowyd place, or under the earthe where it may stand moyste by the space of vii daies untill it be perfecte clammy and rotten ... and you shall wel understand that al the sises the elder they be and the more clammy, and rotten they be, the better they be.'

A few years after the publication of *De Arte Illuminandi* Mr A. Victor Hughes writes in his manuscript volume 'For his Children's Guidance':[4]

'But if parchment size does go bad that does not mean that its usefulness is at an end, for it goes liquid and gets more and more sticky as it goes liquid, until finally it attains a condition in which it can be worked as a liquid medium both for colouring and gilding and it is possible that it was used in this state by former craftsmen. If some of the putrid liquid is strained and a little preservative added in that state, it seems to retain the property of size as a medium, without giving rise to further mould or decay. I have experimented with small quantities of "old" size and it appears to me to work exceedingly well and once dried out it does not appear to me to be offensive.'

As the revival of this little-known medium for calligraphy is in its early stages, its history has been dealt with here at some length.

Method 'Take a handful of clean parchment shavings cut up small. Place them in a "*bain-marie*"[5]; well cover the shavings with water. Simmer several hours

[1] A recent instance in a letter in *The Times*, 16, February, 1931, from Mr Noel Heaton. 'Some few years ago I had the opportunity of making detailed analysis of some pigments of Chinese paintings from the Stein collection ... the vehicle used for fixing the pigment was size.' He states that of the seven pigments used one was azurite and another malachite.

[2] In 1921 the writer experienced this difficulty when illuminating Blake's 'Sun descending in the west', though on re-examining the manuscript recently the brilliance of colour appeared so surprising as to encourage further experiments. That size could remain fluid when cold had not then seemed possible.

[3] *De Arte Illuminandi*, note 107, by Prof. D. V. Thompson, Jr. giving extract from *The Art of Limming* fol iir, reproduced in facsimile from the original printed in London 1573. Ann Arbor. Edwards Brothers 1932.

[4] MS. Book in two parts by A. Victor Hughes. Copies in the possession of the MS. Club.

[5] *Bain-marie*: a large saucepan of boiling water in which one stands smaller vessels containing the substance to be cooked.

until the water is reduced by at least one third. Strain off through muslin. Next day register the strength with the finger. It should be tough. Leave this in a covered jar in "some seller or shadowyd place". In the course of a few weeks a mould will form on the top. When the mould has made a surface all over decant it back into a pan, add a pinch of Beta Naphthol (2–naphthol) to the warm liquid,[1] scald the jam jar and filter the hot size back through an old handkerchief folded in four. It should be clear and pink, should stay liquid and become more so, but eventually it will dry up unless water is added now and again. It should last three to five weeks without needing new size.' (A.V.H.)

This size is suitable for many purposes, but should be kept in a moist atmosphere (such as in a bathroom). It is good for use with all pigments. There being no acid in its composition, the 'copper' colours azurite and malachite can safely be used without fear of discoloration, and indeed they are tractable in this medium when not in others. The basis of the medium being parchment, its affinity for the surface on which it is written or painted is obvious. White need rarely be added, as pigments acquire an opaque quality; a mixed muddiness is therefore avoided. If one pigment overlays another the under-coating does not 'move'. It will be noticed that the surface of lettering written with

size appears slightly raised, this being specially the case with azurite. To the heraldic artist its value is considerable as the pigment so mixed will lie happily on a gold surface. To the gilder on vellum it offers surprising possibilities.

In addition to the media of gum, egg and glue, *casein milk* and *starch* can be used but these are more generally required for wall decoration or for commercial purposes than for the craft of lettering and illuminating.

GENERAL CONSIDERATIONS

OFFSETTING

If by misadventure colours offset from insufficient strength of any of the binding media here considered, size or glair, weakened by water, can be painted over the offending part, taking care that the liquid is not so strong as to give an ugly gloss. A binding medium which is too weak is less of an evil than one too strong, which may cause cracking.

CONSISTENCY OF PIGMENT

A thick chalky substance is not only unsightly but unwise, as the late Professor E. W. Tristram wrote: 'the thinner the pigment applied the better, because the tension, contraction, and pull of the pigment are less when it is thin. If the vehicle—gum or size—is too strong and the pigment too thick it will pull away from the ground. Contraction is reduced by mixing sugar or honey or glycerine with the vehicle.'

[1] There is however a stage in the ageing of the size, if sufficiently strong and before the mould film appears, when preservative does not appear to be necessary. Indeed if the pinkish colour caused by 2–naphthol is objected to, the risk can be taken of omitting the preservative altogether provided the liquid appears clear. It is important that the size should be very strong before it is permitted to liquefy.

APPLICATION OF COLOUR

For miniature work on vellum it is advisable to use the colours in a dryish consistency and apply by stippling. A wash on vellum is difficult to manipulate.

PRESERVATIVES

The purpose of a preservative is to destroy bacteriological and also fungoid growth, though not all bacteria are harmful. Preservatives which guard against one growth may not be effective against another. It is better to use no preservative than one harmful to a pigment. As a precautionary measure vellum should be kept in a dry room, being sensitive to damp which nourishes mildew. When tempering powder colours with egg (glair or yolk), for immediate use, a preservative is unnecessary, as the medium will dry out hard and tough. The liquid yolk of egg medium without preservative will last three to four days, and will then thicken and become useless. It is true that a drop of acetic acid or oil of lavender will extend its life, but on vellum the oil is undesirable and the acetic acid might discolour certain pigments.

Should a medium, such as gum, be stored for future use a preservative is desirable. Chloroform or rectified spirit are alternative preservatives to that given on page 51. (When in store, chloroform and alcohol, being volatile, must be well sealed and kept in a cool place.)

As has been seen, 2–naphthol is a safe preservative for both size and gum. Formalin, so frequently suggested, will make the size stringy and unworkable; it may be acidic and therefore should be avoided. The late J. D. Batten when lecturing to the Society of Scribes and Illuminators on 20th April, 1928, stated that 'mildew grew on paintings only in the presence of moisture and that they could safely be washed with pure alcohol or methylated spirit, without risk of damaging the gum, that on paper this would be safe procedure though perhaps not on vellum'.

Honey and sugar solutions will not keep indefinitely in their liquid condition. It is therefore advisable to make only a small quantity at a time.

BRUSHES

Fine red sable brushes should be used, but old and fat ones that have lost their point are suitable for the purpose of feeding quill pens with colour. Modern sable brushes have not the resilience of pre-war days when the hair came from the wild animal of Russia and not from the domesticated species of Canada. It is therefore best to buy the shorter-haired brush rather than the long, as the latter soon lose their vitality. The size of brush ranging from No. oo upwards is a matter of personal preference. Brushes should be well washed in cool water as the media recommended in this chapter are inclined to rot the hairs.

RECORDS

The value of keeping records of successes and failures cannot be too highly stressed, both as a guide to the scribe himself and to others. Where one experimenter may fail in his results another may succeed. In this way some further knowledge may come to light and assist all in a nearer approach to the amazing beauty of execution of the medieval craftsmen. It is for the scribe to select that medium most suited to his needs and whereby he can express himself with most fluency.

The Borough of Lydd Kent;

The ancient Borough of Lydd-or-Lyde, has been granted six Charters, the earliest in the reign of Edward the First. Lydd owes its name to the Romans who found a considerable settlement of people on the 'Littus,' or Sea Shore: upon the Ripæ or Banks-now the East and West Rypes the town laid its early foundation. In Saxon times its name became 'Hlida'. Lydd is a 'limb' or member of the Cinque Port of Romney. The duty of

providing ships was the principal public expense of the Cinque Ports and their members In this Lydd bore its share and interesting items may be read in the Records. One entry is for the hire of the ship 'Le Ruge-Cule'-of-Brittany for the voyage to bring over the Lady Margaret; Margaret of Anjou, "who will be Queen of England", into England, 1440. Thomas Wolsey was vicar here and raised the tower of the church to its present height.

Quid autem de dignitatibus

"But what shal I saye of dignitees and of powers? the whiche ye men, that neither knowen verray dignitee- ne verray power, areysen hem as heye- as the hevene? The whiche dignitees and powers yif they comen to any wikked man, they don as grete damages and destruccions as doth the flaumbe-of the mountaigne Ethna, whan the flaumbe wulwreth up; ne no deluge ne doth so cruel harmes.

But now, yif so be that dignitees and powers beyeven to goode-men, the whiche thing is full selde, what agreable thing is ther in the dignitees or powers, but only the goodnesse of folkes that usen hem?

And therfor it is thus, that honour ne comth nat to vertu for cause- of dignitee, but ayinward honour comth to dignitee for cause of vertu." Boethius "de Philosophiæ Consolatione" trans. Chaucer

CHARLES EDWARD BASS

Irene Wellington: *In oblique praise of my father,* panel given to Lydd Town Council in memory of the scribe's father, Charles Edward Bass. Written on vellum in black, red, blue and gold. 76 × 50 cm. 1948. In the Guildhall, Lydd, Kent.

57

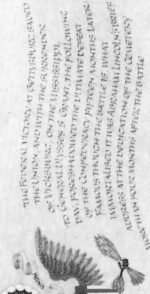

Sam Somerville: Dedicatory address. Written on slunk calfskin vellum (laminated to linen and blue calfskin leather for flexibility) in stick ink and watercolour (blue, Indian red and graded colours) with gold leaf. Scroll size: 31 × 62 cm. 1984.

Parchment and Vellum

SAM SOMERVILLE

THE MAKING AND DESCRIPTION OF PARCHMENT

HIDES AND SKINS

Man has made use of the hides and skins of animals for many thousands of years. As they are composed largely of water and protein, they decay quickly in a flayed state. The removal of surplus flesh (by scraping with a sharp flint in early times) and drying in the sun help to prevent decay but the skin becomes hard and inflexible. The rubbing-in of animal fat was the first way of softening skins for wear. Ice Age Man used them to protect his body from cold and from the abrasions of sharp rocks, etc. Eventually the need to remove all hair, flesh and fat became apparent. Specimens from around 500 BC have been found, so the process had already developed. Such processed hides or skins are generally called leathers. Much later, leather was used to write on – the Dead Sea Scrolls (c. 300–100 BC) were written partly on leather.

LEATHER

The skin of a mammal is made up from three basic layers:
1 A very thin outer layer – the epidermis.
2 A thicker layer – the corium (this is the substance of the skin; 85% of the solid fibrous protein is collagen – the same substance which produces gelatine).

3 An inner flesh layer.
There are three stages in the process of making leather:
1 Removal of hair, flesh, fat, soluble proteins, etc., leaving a lattice of softened, high-protein collagen fibres with water.
2 Tanning, i.e. treating the skin with a tanning agent which displaces the water and coats the collagen fibres, rendering the skin more resistant to decay from heat, dampness and bacteria. In the tanning process the epidermis and flesh layers are removed, leaving the corium which is tanned into leather.
3 Finishing the skin to obtain desired thickness, surface texture, moisture balance and colour (dyeing).
There are several different types of soluble protein in animal skin. Some are soluble in water (albumins), some in salt solution (globulins) and various others soluble in dilute alkalis. The manufacturing process should remove these but does not always do so completely (see later under 'Preparation of Parchment by the Scribe').

Many tanning agents have been used throughout history: oils, vegetable substances (e.g. oak bark – nearly every vegetable plant contains tannic acid) and minerals (e.g. alum).

PARCHMENT

Sometime before the second century BC, lime was employed to dehair the skin. This also removed fat and soluble proteins and led to a clean white skin without the use of a further tanning agent. It is in this process that parchment manufacture obviously has its roots. Pergamon, in Asia Minor, is the town sometimes credited with the invention of parchment in the second century BC. Although this is unlikely, some improvement or refinement in the manufacturing process was probably made there.

Parchment can be made from almost any mammalian skin, but the most commonly used have been, and still are, sheep, calf and goatskins – they have been the most conveniently accessible. The skins are first soaked in water to clean them up and then placed in vats containing lime and water, which loosens the hair and washes out some of the fats and soluble proteins. The hair can then be pulled away and surplus flesh and fat removed from the inner side with a knife (nowadays by machine). If the skin is to be split it will be done at this stage (again by machine these days).[1] The skins may then be returned to lime vats before being thoroughly washed and then stretched, via cords, on rectangular frames (in the Middle Ages hoops were used). In mediaeval times very greasy skins usually had the excess fat and oils drawn from them at this stage by the use of alkalis, applied as a paste. Lime, ashes, or sometimes alum, were used. Today, mainly with split sheepskins, whiting is used which draws out grease as the skin dries. The skins are then re-washed. While still wet the skins are doused with warm water and scraped with a large dull-edged, semi-circular knife which squeezes out further grease and oils.

As the skin begins to dry it shrinks and comes under tension. The pegs in the edge of the frame, to which the cords are attached, can be adjusted to even out the pull and prevent the skin puckering. When fairly dry the flesh side is rubbed down with pumice or lime to make it smooth. The hair side is then scraped with a large, sharp, semi-circular knife with a burred edge. (The semi-circular shape gives fairly even pressure from the knife's edge on the surface of the skin.) The surface comes away in layers of thin, wrinkled shavings, thinning the skin and making the surface smooth and even. In mediaeval times this operation was, apparently, carried out with the skin still wet. The skins are then left in their frames until dry before being cut out and finished with pumice (applied today with a fairly coarse abrasive paper).

Presumably since parchment was first made, and certainly during and since the Middle Ages, its character and quality have varied widely. The species of animal, its diet and how it was reared, whether it was killed or died naturally, its sex, age and environment all affect the character and quality of the finished parchment, as also does the care taken in its manufacture. To make good parchment it is essential that the manufacturing process (i.e. the initial soaking in water) should start as soon as possible after the animal has been killed, as decay begins within hours. Failure to do this usually results in blotchy, inferior parchment. How the final drying process is controlled is also a very important factor.

[1] The corium layer of a skin has two sub-layers. The outer layer contains the grain membrane with hair pores. It gives a distinct grain pattern on the surface for each animal species. The inner layer consists of groups of collagen fibres woven into a three-dimensional lattice. In a sheepskin, a layer of fat within the skin makes it easy to split.

PARCHMENT AND VELLUM: DEFINITIONS

In the true meaning of the word, any animal skin processed by soaking in lime, then scraped and dried out under tension, is a parchment. Vellum was originally the name for one particular type of parchment – that made from calfskin. Eventually the term 'vellum' came to be applied to any particularly fine parchment, regardless of the animal species. Today we seem to reserve the term 'parchment' for the product manufactured from the inner split of a sheepskin, and refer to all other parchment as vellum. A return to the original terminology is desirable, but unless the manufacturers were also to do so, this could cause further confusion for some people. Consequently, in this article, when listing varieties of parchment I intend to use the name used by today's manufacturers and, where necessary, to indicate what I and others, think the name for the product ought to be. In the general text of the article the term 'parchment', used unqualified, implies all varieties (sheep, calf, goat, etc.). When the term 'vellum' is used it refers only to parchments made from calfskin.

MODERN VARIETIES OF PARCHMENT

Parchment for scribes' use falls into two basic categories: skins finished for writing on one side only (the hair side) and those finished on both sides and intended to take writing on both sides. The latter are usually referred to as manuscript skins. Any character which the parchment exhibits on the surface is almost always on the hair side. Most varieties of parchment can be obtained in a variety of thicknesses but generally the thinner skins tend to come from smaller or younger animals.

When buying parchment one usually has a choice between buying pieces cut to size, or buying whole skins. It is considerably cheaper to buy whole skins even when allowance is made for the inevitable wastage in cutting a rectangular piece from a skin. It is worth the trouble to go and select one's own skins rather than rely on what someone else will select for you. Off-cuts can be bought (by weight) but if you buy whole skins and cut them yourself you accumulate a variety of small pieces anyway.

So-called 'Roman Vellum' and 'White Sheep Vellum' (both, in fact, varieties of sheepskin parchment), have ceased to be produced during the last 10–15 years. The general opinion is that this has not been a great loss to scribes.

The varieties of parchment readily available to scribes in this country, at present, are:

Manuscript Calfskin Vellum

Finished by the manufacturer for writing on both sides. Generally white, off-white or light cream in colour. Probably the parchment most used by scribes. It has a fine, firm surface on the hair side. Average size of skins 0.5–0.7 m² (6–8 sq. ft), but it is possible to obtain larger skins up to 0.9 m² (10 sq. ft), or more.

Slunk Manuscript Calfskin Vellum

The word 'slunk', as it applies to calves, means a calf which is born prematurely. It is often said that many of the small books of the Middle Ages were made from the skins of still-born calves. Although this may have been so, it seems there is little real evidence to confirm it. It has been suggested that much of this so-called 'uterine vellum' may be either a split skin or perhaps the skin of a small animal such as squirrel or rabbit.

Today's 'slunk' vellum is made from the skins of both still-born and very young calves. It is finished for writing on both sides. The hair side often shows patterns due to hair follicles, and gradings of colour, which are often visually very beautiful. The surface has a fine but slightly soft texture and when writing on it the pen often seems to lack some of that positive bite experienced on other calfskins. Skins average 0.25–0.45 m² (3–5 sq. ft), and can be very thin. Some of these small skins are very translucent.

Classic Vellum

Made from basically the same type of skin as manuscript calfskin vellum, but subjected to rather less scraping during manufacture, and generally in a less finished state. Suitable for writing on the hair side only and more creamy in colour than manuscript calfskin vellum. Skins average 0.5–0.7 m² (6–8 sq. ft) but larger skins can be obtained.

Kelmscott Vellum

Made from calfskin but intended for printers' use, and not really suitable for calligraphy. The surface is heavily filled to make it very smooth and even. The most thorough preparation usually fails to give it adequate tooth.

While on the subject of calfskins it is worth mentioning some of those intended as bookbinding vellums. They are referred to as Natural Grained Calf Vellum and Natural Veiny Calf Vellum. The surface texture is perhaps not as fine as manuscript calfskin or classic vellum but they can be very pleasant to write on. There is a good deal of variety in the colour and character of the skins – from light cream colour through to shades of brown, often with colour variations in the same skin and distinct veining. They are suitable for writing on the hair side only and average 0.5–0.7 m² (6–8 sq. ft) in size, but much larger skins are available. If one goes to choose one's own skins it is worth looking at these bookbinding vellums.

Natural Goat Vellum (Natural Goatskin Parchment)

Finished on the hair side only although the flesh side is often very smooth. Goatskin parchments have a characteristic dimpled texture on the hair side and these natural skins show a variety of creamy and light brown tones. The surface generally has a shiny or glazed appearance. Sizes range from small, fairly thin skins around 0.25 m² (3 sq. ft) up to 0.5–0.7 m² (6–8 sq. ft). Some of the small thin goatskins are very translucent.

White Goat Vellum (White Goatskin Parchment)

Similar to the natural variety but much whiter in colour. Some goatskin parchments exhibit very abrupt changes in surface character.

White Sheepskin Parchment (Split Sheepskin Parchment)

Made from the inner layer of a split sheepskin and intended to take writing on both sides. Usually fairly thin but a variety of weights is available. Generally white or a greyish off-white in colour. Has a greasy feel and appearance and sometimes the flesh side has a nasty pearl-like lustre. Does not exhibit much character, being fairly regular in appearance all over the surface. Sizes range from around 0.35 m² (4 sq. ft) to approximately 0.6 m² (6½ sq. ft).

The above are the varieties of parchment one will normally come across. There can, however, be other types and variations. I understand that kangaroo parchment is now made in Australia. It is possible during the manufacturing process to make a parchment virtually transparent; also skins can be dyed or stained. These, however, are not the types of material one would be concerned with in the general run of work.

CARE AND STORAGE OF PARCHMENT

Even after scraping during manufacture no skin is of absolutely even thickness all over. The tightness or looseness of the fibre texture also varies over the skin. The parts of the skin which originally covered the animal's spine, neck and rump tend to be much thicker, and tighter in texture than the sides of the skin which covered the animal's flanks and soft underbelly, which are thinner and looser in texture. (Hence the expression 'Belly loose, butt tight'.) There can also be local variations over the skin.

When parchment is subjected to excessive heat it tends to curl up. Dampness causes the skin to stretch. The thinner regions of loose fibre texture stretch more than the thicker areas of tight texture. This causes the parchment to cockle.

Manufacturers usually keep their stocks of parchment rolled up in groups of skins. Most scribes seem to do the same when storing skins over a period of time, though some do store them flat between boards. In any case the place of storage should be free from dampness and not too warm. Ventilation is also important. Avoid a bone-dry atmosphere – some moisture content is essential to the well-being of the skin. A thick, rolled, very dry parchment is about as manageable as a coiled spring. Centrally-heated rooms (especially electric) are not the best places for storing parchment. Storing skins rolled may simply be more convenient but I find the skin is less likely to cockle over a period of time if kept rolled.

Once work has commenced on a skin most scribes prefer to keep it flat, (between boards, often under a weight, when not actually being worked on) rather than frequently rolling and unrolling it.

Before storing skins I find it best to cut away any sharp, inflexible, horny bits at the corners of the skin first of all. The manufacturer usually removes the worst of these but occasionally misses a piece. These sharp, inflexible pieces inhibit the rolling of the skin and can contribute to cockling. They can also damage other areas of the skin if pressed against it.

A parchment that has been rolled up for some time, even under good storage conditions, tends to be awkward to flatten for working on. I leave it for a while (a few hours at least), in a cool, or even slightly damp atmosphere, to take some of the stiffness out of it. I then carefully roll it the opposite way, together with a stout piece of paper for support, round a large tube (at least 13 cm, 5 in., in diameter for thick skins), and leave it like this, for several hours at least, still in a cool atmosphere. Then I unroll and place between boards. To try to roll a stiff skin the opposite way without the support of a tube can often result in the skin buckling at some point, making an unsightly crease which can be difficult, or even impossible, to remove.

If one has to attempt the removal of a crease from parchment a reasonably successful procedure is to get the skin into a fairly damp atmosphere for a short while to relax it, and then with the rounded end

of a folder, or a finger nail, to push it out carefully from the raised side of the crease. I am told that if one can get a grip on the skin, close to and on either side of the crease, gently pulling, while breathing on the skin in the region of the crease, this can help to remove the flaw.

CHOOSING PARCHMENT FOR A PIECE OF WORK

The type of parchment chosen for a particular piece of work is governed by various considerations:
The nature of the work: panel, book, or perhaps scroll; its size; the suitability of the character of the surface for the job in question – some skins, showing patterns of hair follicles, distinct veining, or variations of colour may not suit the mood of some work, or may make fine writing less legible than it could be. The scribe's own personal tastes and preferences also come into it.

I doubt if many scribes would choose to work on a really thick, tough, relatively inflexible parchment if they had an alternative. Very thick, inflexible skins are awkward to work on. If the scale of the work is such that a really large skin is needed one may be forced into doing so. With smaller and medium-sized pieces of work one usually has a choice. If a very thick, tough skin happens to have a unique surface character which seems ideally suited to the mood of a particular piece of work it may well be worthwhile using it, otherwise, it is probably best to avoid really tough skins.

Many skins may appear (by sight or feel) to be of fairly even thickness all over – they may well be. One purpose of the scraping of the skin during manufacture is to achieve or approach this end. This must certainly have been so in mediaeval times

and before. During this great age of parchment manufacture, when most cities of any importance had their own parchment industry, most of the parchment produced for scribes' use was intended for books. For the leaves of a book to close fairly tightly (excluding light and to a large extent the atmosphere and thus effectively protecting the pages and the pigments on their surface), and for the book to function well in use, it needs to be a block of even thickness – not sloping or wedge-shaped. To produce leaves of fairly even thickness all over was consequently a very important objective for the parchmenter. However, what the scraping process does not do is change the tightness or looseness of the fibrous texture of the skin. An open texture can absorb moisture more readily than a tight texture and those parts of a skin which originally covered an animal's flanks and under parts always tend, when dampened, to stretch more than the spine, neck and rump areas, whether the skin has been scraped to an even thickness or not.

In writing this section on parchment I have taken into account the opinions and preferences of some members of the Society of Scribes and Illuminators (mainly some of the present craft members). Seldom is there just one suitable choice of material or one right way of doing something. It is hoped that what follows, and what has gone before, will give some guidance and encourage people to find out for themselves what works best for them.

PANELS

For panels most people prefer manuscript calfskin vellum or Classic vellum of a medium weight, although some favour goatskin parchment. Classic vellum is chosen largely because of its creamy colour

and the fact that its less finished state allows the scribe to do a little more to the surface during preparation. Those who favour goatskin like its texture and colour.

SCROLLS

For a scroll, intended to be rolled and unrolled, the choice has been almost unanimous – a thin to medium-weight calfskin vellum, with particular attention paid to its flexibility. The temperature and humidity conditions which prevail during the storage of the finished scroll obviously affect enormously how it functions.

BOOKS

For a conventional book, with writing on both sides of the leaf, the choice is obviously limited to the manuscript calfskins or split sheepskin parchment. Today's goatskin parchments are not finished as manuscript skins but the flesh side is often very smooth and it may be possible to make some use of goatskin. The SSI members choose a thin manuscript calfskin vellum. No one has a good word to say for present-day split sheepskin parchment, and I agree entirely with this view. Its greasy feel and appearance are disliked, as is the fact that it is extremely difficult to make a satisfactory erasure if a mistake is made.

Most people probably know that Graily Hewitt used split sheepskin parchment a lot in his work. The sheepskin parchment he used was produced by Stallard's in Hampshire and has not been made since 1939. I have to assume it was rather better than the modern split sheepskin parchment which I have come across. Even so, he made reference to the fact that he encountered areas where the ink bit deeply into the parchment – sometimes right

through to the other side. (You can see evidence of this in some of his Memorial Books.) I find that with today's split sheepskin parchment, even after preparation and the application of sandarac (see page 69), this happens frequently and I would reject its use on this score alone. One does want the ink or colour to bite into the surface – but under control.

How well a book functions on opening depends largely on its thickness, how it has been bound, and on the flexibility of the material of the leaves relative to their width. Some idea of how parchment will behave in a book can be judged by gripping a piece of the intended parchment between two blocks of wood, with a length equal to the width of the page protruding.

Illus. 1

If it sits up as at (a) or (b) it is obviously too stiff. Ideally, it ought to fall over as at (c). With modern manuscript calfskins, which often tend to be on the stiff side, even when fairly thin, it may be difficult to achieve this effect, especially with a book of small page size. Also, the translucency of the parchment (i.e. the amount of 'show-through') needs to be considered. Some 'show-through' is usually very

pleasing, and a subtle unifying factor, but if it becomes too obvious it can be distracting. Some of the slunk vellums are very thin and quite flexible but may exhibit too much 'show-through', especially with large, heavy-weight writing. Split sheepskin parchment is often quite flexible but has other disadvantages, already discussed.

The parchment leaf in a book is usually fairly well protected from the atmosphere. In a book sitting on a horizontal surface, it is under slight pressure from the bulk of the leaves above it and the weight of the top board. On a shelf, between other books, the leaves are held fairly tightly together. Over a period of time, changes in temperature and humidity will, however, cause the skin to expand or contract. The parchment leaf still has some freedom to move, and, as long as the changes in atmospheric conditions are not excessive, can usually be accommodated without undue cockling. One place where the parchment is not free to move, however, is at the spine of the book, where it is held by the sewing and spine linings. If it becomes damp and stetches here, the parchment, having no room to expand, will pucker into unsightly creases, roughly at right-angles to the spine of the book. It would seem to be sensible to arrange, if possible, for the folds of the sheets to come from a region of the skin, which, if it becomes damp, is likely to stretch least.

For a very large book, where only one piece can be cut from a skin, this usually happens automatically (Illus. 2).

The fold of the cut piece coincides with, or lies very close to, the thicker region of the skin where the animal's spine was. The fact that this reduces the flexibility at the fold (where it is needed most if the book is to function well) does not matter quite so much in a very large book as it has the

thickest regions –
tighter texture

thinnest regions –
looser texture

Illus. 2

thickest regions –
tighter texture

thinnest regions -
looser texture

Illus. 3

weight of the larger leaf to help it lie flat. For smaller books the pieces may be cut in a similar way from smaller and thinner skins, or two or more pieces may be cut from the one skin.

This usually means the spine of the skin is not included in the cut pieces. The fold of the parchment sheet is now somewhere

in the animal's flanks where the skin is thinner and of looser fibre texture. This helps the flexibility at the fold (which is desirable, especially in small books), but means that, in damp conditions, stretching of the leaves in the region of the book's spine is more likely to cause puckering. In looking at old manuscript books on parchment the most puckering at the spine generally seems to be in the medium-sized or relatively small books, made on fairly thin skin.

There is not always a great deal one can do about this. Keeping the book in reasonable temperature and humidity conditions is obviously the best safeguard. Often, when cutting pieces from a skin, one is preoccupied with trying to use the surface characteristics to the best visual advantage. Sometimes, however, a small shift of position (an inch or so) can avoid including in the region of the fold an excessively thick local area (which can affect flexibility), or an excessively thin one (which is inviting puckering at the spine of the book). It is usually a mistake, when choosing parchment for a book, to select material which is thinner and more flexible than it needs to be. These days, however, the problem is more likely to be the other way around. With books of large page size there is usually a choice and choosing the thickest which will function well is usually good policy.

Some parchment books are not sewn together in sections in the conventional way but are made up as single leaves glued or sewn to guards of paper or linen. This can help the flexibility and largely cuts out the likelihood of puckering at the spine. Obviously these guards can affect the visual appearance of the open book, and any decision to use guards needs to be given careful consideration.

The sheets of a parchment book are usually folded so that hair side faces hair side and flesh side faces flesh side when the book is made into sections. This helps to give a feeling of unity to each opening. Before folding one should consider the fact that hair sides in particular vary in character and it is worth giving some thought to 'matching' these. Remember that it is only in the centre of a section that the two pages on view come from the same side of the one piece of skin. Also, it may be worth arranging for a page of particular importance to be on an especially fine piece of parchment.

PREPARATION OF PARCHMENT BY THE SCRIBE

Parchment (and vellum in particular) is valued for a number of reasons: the soft natural beauty of the surface itself and the quality which it can impart to inks and colours set against it; its great durability under reasonable storage conditions; and the fact that, when properly prepared, it makes a very positive yet sympathetic writing surface, of such quality, when allied to a suitable pen and ink, as to allow crisp, flowing writing.

When skins are received from the manufacturer they generally require some further preparation by the scribe. When cutting pieces of parchment from a skin the need to cut on a flat surface, such as a sheet of stout millboard, is obvious. Unless one uses a metal-edged template (as the manufacturers do), a heavy metal straight-edge is essential, as is a sharp knife with a stout blade – thick parchment can be quite tough.

Further preparation of the surface cannot alter the overall character (apart from possibly modifying the tonal quality), but it can, and is intended to, change the surface qualities.

REMOVAL OF GREASE

When skins have been stored for some time, especially if they have been stored in a warm atmosphere, any grease or soluble protein still residing in the skin tends to come towards the surface. Any grease in the skin's surface must be removed. Pumice powder is usually employed to do this – it is also mildly abrasive. French chalk and whiting will also absorb grease but tend to clog the surface – they have no noticeable abrasive action. A greasy surface is extremely unpleasant to write on and cannot give crisp writing. Also, pigments will not bind to it securely.

RAISING OF NAP

Most skins, when they come from the manufacturer, are fairly smooth and many have a slightly shiny or glazed surface, due largely to soluble protein not removed during manufacture and probably contributed to by the sliding action when groups of skins are rolled and unrolled a number of times. In looking at the surface of the pages of many old manuscripts one notices that the parchment surface (and often the pigment on the surface), has a slight and not unpleasant natural polish. This has most likely been caused by the sliding action of each page over the surface of its neighbour each time the book has been opened or closed – perhaps many hundreds of times. I think one can, however, be fairly sure that this polished appearance of the parchment surface was not there originally when the book was written.

For ink, or colour, to flow evenly onto the surface and to stay there, and for the pen's edge to transmit that satisfying feeling of slight drag (which has a marked effect on the character of the letter form produced), the parchment surface needs to have some tooth. This is usually referred to as the nap and has been likened to the surface of velvet – it is not a roughness but an even texture which is a direct consequence of the fibrous nature of the material. Some scribes aim to bring up a strong nap on the surface by long and careful preparation, while others prefer it to be much less pronounced. Whatever the preference, it needs to be there to some degree to achieve sharp writing. Also, colour or ink which is IN the surface is much more likely to stay there than colour which is merely sitting ON the surface. This fine nap also helps colour to lie evenly over the surface. The tendency for pigment particles to congregate more in one place than another as the colour dries is alleviated, in part, by particles of pigment being held within the surface nap. (The consistency of the colour, the medium used to bind the pigment, and the slope of the working surface are other relevant factors here.)

Although pumice powder is mildly abrasive its action is not usually sufficient to raise adequate tooth on its own. Scraping with a long, sharp blade with a shallow curve, its width held almost vertical to the surface, is one way of raising a nap (an old-fashioned razor is a good tool). Whatever type of blade is used, its edge, apart from being sharp, should be free of any nicks – any such irregularity on the knife's edge will leave a noticeable ridge on the parchment surface. Surgical scalpels are too small and not stout enough (especially the interchangeable blade variety) to tackle the preparation of a large, tough parchment skin, although they are useful for local scraping, e.g. when erasing a mistake. Using various grades of 'wet-and-dry' abrasive paper (used dry), or fine flour paper, is another way of raising the nap and this is the technique employed by most modern scribes.

Having raised this nap, the fine texture created holds inks and colour within its structure, but at the same time slight capillary action between the fibres of the nap (possibly due to the ends of fibres being frayed out) can cause the ink to spread slightly, killing the sharpness of the writing. Any pumice powder (which soaks up moisture) still on or within the surface contributes to this spreading effect. (As the main function of pumice powder is to soak up grease from the skin's surface, it must be thoroughly cleaned off afterwards. A large soft brush helps here.) To counter any other spreading effect a *light* dusting of finely-powdered sandarac (a gum or resin which, when dried and ground has the property of repelling water-based liquids) holds the writing sharp.

NOTE: The dust created by preparing parchment and by the application of pumice is very fine and tends to go everywhere in a room. I tend to do most of my preparation outside, if weather permits.

Whichever method is used (sanding or scraping), reasonable care needs to be exercised. It is easy (especially when scraping with a knife) to overdo it and roughen the surface. When sanding, the skin is usually held steady with one hand. If abrasive paper is used recklessly near the edge of the skin, or if it is moved quickly towards the hand steadying the parchment, it is easy to catch or drag the skin which can result in buckling and a crease in the skin. Although abrasive paper is sometimes moved in a circular motion to deal with local areas, it is generally safer to work away from the hand holding the skin. Also, sanding in the one area for a time generates heat which can cause the skin to develop a slight bulge. Working gradually over the whole surface initially seems best and afterwards dealing with local areas which require further attention. A magnifying glass can be a help in checking what is happening on the parchment surface.

USING SANDARAC

After preparation any ruling will be done, and sandarac used immediately prior to writing. As sandarac's ability to repel water-based liquids is very strong, very little is needed. It is ground to a fine powder and usually contained in a small bag of fine linen or similar material. (When finely ground, sandarac is off-white in colour; if not so finely ground it has a pale lemon tinge.) Prior to writing the bag is gently dabbed across the writing area. Too much sandarac can make writing difficult, in some cases repelling ink from the region of the pen's slit, leaving a fine white line down the centre of the stroke. After applying the sandarac I use a soft brush to waft away any excess. I feel it is only the sandarac grains in between the fibres of the nap which serve any useful purpose – anything sitting up on the surface simply gets dragged around by the pen's edge.

TREATMENT ACCORDING TO TYPE OF PARCHMENT

I give below a rough outline of what I usually do, at present, and then give alternatives used by other scribes, where their methods differ significantly from my own. In some cases I give a very rough indication of the grade of 'wet-and-dry' abrasive paper used. Treat this as a rough guide only – it is not possible to specify exactly. The grade which will achieve the desired result depends on the condition of the surface itself and how one uses the abrasive paper. In all cases when preparing parchment, work on a smooth, flat, clean surface.

Manuscript Calfskin Vellum, Classic Vellum, Natural Grained or Veiny Calf Vellum

Hair side: Major surface roughness (if any) removed by careful scraping with sharp, curved blade. Pumice powder rubbed over surface (I tend to use fingers but it is obviously much more sensible to use a pad of some sort, as this saves the fingers) – then thoroughly cleaned off. Nap raised by working over the surface with a medium to fine grade of 'wet-and-dry' (perhaps 240–320 grade depending on surface). All dusty residue brushed away. Then a further application of pumice but only if I feel the skin really needs it, i.e. if it seems to be fairly greasy intially. Before writing, a light dusting of sandarac.

Preparing a surface by scraping can often take longer than sanding methods but is sometimes well worth the trouble. If I have a fairly thick skin with a very hard surface which is slightly rough to the touch, I usually prepare initially by scraping, working gradually over the whole surface.

In mediaeval times (and before) abrasive papers, as we know them, obviously did not exist. Any preparation by the scribe (or someone other than the scribe employed to do it) would have been with a knife and various pounces (chalk, pumice, powdered glass, cuttlefish, etc.).

Other suggested methods:
1 Pumice powder – cleaned off – a dusting of sandarac.
2 A combination of scraping with a knife and rubbing with flour paper, followed by application of pumice and then sandarac before writing.
3 Pumice powder rubbed over the surface with 'wet-and-dry' folded over a block – cleaned off, and this operation repeated several times. The preparation finished off with a new piece of 'wet-and-dry'. Sandarac before writing. (In this method the degreasing of the skin and the raising of the nap are combined in one operation.)

Flesh side: Unless one makes a manuscript book it is possible to go through one's calligraphic life without touching the flesh side of a skin. But even if I intend to work only on the hair side, I always look at the flesh side first and remove any obvious roughnesses with a sharp blade – also if it looks greasy I will clean it with pumice. The flesh side is usually relatively whiter than the hair side and has much less character. Often the surface is very smooth (occasionally it has a waxy appearance) and it is much more difficult to bring up significant tooth or nap without making the surface rough. Writing on the 'softer' flesh side usually lacks much of that satisfying tactile feel of the pen's edge biting the surface, generally experienced on the prepared hair side.

Working away on the flesh side with a relatively fine abrasive paper seems to achieve very little other than to create lots of dust. On the other hand, any prolonged very abrasive treatment can easily roughen the surface unduly. The best preparation I have been able to achieve is to clean the surface with pumice and then work over 'quickly and lightly' with relatively coarse 'wet-and-dry' (perhaps 240 grade or coarser), or to use a finer grade of 'wet-and-dry' (240–320) in combination with pumice. I use sandarac before writing and on the flesh side I tend to dab down quite strongly with the sandarac bag before brushing lightly away – where there is much less surface texture to trap the sandarac grains, a little gentle force helps.

Slunk Manuscript Calfskin Vellum

Hair side: These skins, being from younger animals, have a more delicate and softer surface than other varieties of calfskin. Generally they tend to be less greasy. Often, I do not use pumice at all on these and simply rely on using fine 'wet-and-dry' (perhaps 320–360 grade) and then sandarac before writing. These skins do not stand very abrasive treatment – nor do they need it. Occasionally, I have bought slunk skins which have already had a fine surface nap, and have used sandarac only.

Flesh side: Pumice (if necessary) followed by fairly fine abrasive paper, then sandarac before writing.

Goatskin Vellum (Goatskin Parchment)

Hair side: Goatskin's dimpled texture and slightly soft surface, make it almost impossible to raise a genuine nap. Any very abrasive treatment tends to make the surface rough. Goatskin parchments tend to have a slightly shiny or glazed surface. This shine can be removed, at least in part, by the use of pumice, or by very careful sanding with flour or fine 'wet-and-dry' abrasive paper. I usually give a few applications of pumice, then, depending on the surface appearance, I either leave it as it is, or work over carefully with fine abrasive paper. Then sandarac before writing.

Other suggested methods:
1 Application of pumice, then flour paper over a block, followed by careful scraping with a sharp blade if necessary. Sandarac before writing.
2 Flour paper or fine 'wet-and-dry', then wipe with a damp cloth. Sandarac before writing.

Wiping with a damp (not wet) cloth is a treatment quite often suggested for parchment with a shiny or glazed surface, such as goatskin. This glazed appearance is partly due to soluble protein, which has not been removed during manufacture, coming to the surface. One type (the albumins) is soluble in water and wiping with a damp cloth can skim some of these off, killing, at least in part, the surface shine. If this method is employed it is probably wise (especially with thin parchment), to fix the skin at its edges to a rigid support until quite dry to avoid the risk of cockling.

Sheepskin Parchment (Split Sheepskin Parchment)

Although there is no hair side as such, there is still a difference between the two surfaces, but it is much less pronounced than the difference between the hair and flesh sides of a calfskin. The general dislike of this material by scribes has already been mentioned. I have never used it for a finished work, but I have 'tried it out'. For anyone who chooses, or is forced to work on it, the best preparation I have been able to come up with is to treat the surface (either side) with a few applications of pumice and then work over very lightly with fine 'wet-and-dry'. This does not give much tooth but I find that any very abrasive treatment can quickly reduce the surface to a loose, rough texture. Sandarac before writing is some help. The tendency for ink to bite into and even through split sheepskin parchment has already been mentioned. I find that this tendency is reduced if one writes with watercolour or designers' gouache rather than ink which is much thinner and more fluid.

No matter how well the surface of a skin is prepared one cannot expect sharp, flowing writing if the pen and ink used are not up to the task. Conversely, a good pen

and ink cannot work miracles on a poor surface. The three factors – pen, ink and surface must be considered together. A freely-flowing quill with the ink flooding from it can produce superb, crisp writing on the rejective controlling surface of a well-prepared skin, dusted with sandarac. On an unprepared surface, or a poor paper, the result could be disastrous – the ink flooding onto the surface out of control. Also, a hard and relatively inflexible metal pen with a reservoir, shedding its ink sparingly, may work well enough on some papers, but on a prepared parchment surface with sandarac it can be useless. These examples are not meant to imply that a quill cannot be used on paper, or that a metal pen cannot be used on a parchment surface – they can. The point being made is that whenever the surface is capable of exercising great control over the spread of the ink then the pen can be allowed to flow very freely. When, however, the nature of the writing surface is such that it cannot control the ink so well, then the flow needs to be held back, i.e. controlled more by the pen. A metal pen has been used successfully on parchment by some people, but it needs to be allowed to flow more freely than on paper.

STRETCHING OF PARCHMENT

Anyone who has worked on parchment knows that the skin, which probably starts out fairly flat, may well be full of heights and hollows at the end. The cockling is caused mainly by the local dampening of areas of the skin due to the writing and the application of areas of colour. The parchment may need to be flattened before framing. It can be dampened on the back, then laid out on a flat board and fixed securely at the edges. As it dries the skin is

pulled flat. When dry it can be removed and trimmed for framing. I am sure most people have seen large parchments framed under glass, where, even if the skin has been flattened before framing, no provision has been made to hold it flat. Changes in temperature and humidity over a period of time have caused the skin to cockle to an undulating surface – often touching the inner surface of the glass. Apart from being visually annoying, this can, and often has, damaged the work.

One way of providing some protection against this happening is to have the frame sealed – in a sense placing the parchment in its own mini-environment. Even so, temperature changes over a period of time will still have an effect on the skin. Having the dampened skin permanently stretched over a rigid support is another possibility. Unless it is subsequently subjected to very high humidity conditions (sealing the frame would again be some protection against this), the skin will remain fairly flat. There is, however, a valid objection to treating a skin in this way. Much of the appeal of parchment comes from the character of its surface – it has life, and sometimes the vein structure is very pronounced. Pulling it very flat, under tension, can literally pull a lot of the character out of the skin and leave it looking rather dead. I do not know the ideal solution to this problem. At present I settle for stretching the skin over a rigid support but attempt to control the dampening to relax the parchment just a little so that on drying it is not pulled drum-tight.

ORDER OF WORKING

If one is going to have a parchment panel stretched it raises the question – before or after the work is done? I know some

scribes do have the skin stretched before commencing work, but most of us would prefer not to attempt writing on a hard, unyielding surface. Having some padding under the parchment (either a wad of soft paper or some other yielding material), provides the necessary give. Also, it is very awkward to write near the top of a large stretched skin.

Some people prefer to do any gilding before the writing. This is usually because they find that sandarac tends to make gold leaf stick to the parchment surface. I have not found any particular difficulty with this but it may depend on how well the local application of sandarac can be controlled, or how much is used. All this, of course, raises the question of order of working. If the whole work, including the application of gold, is completed before stretching then one has the problem of having to dampen and stretch a skin which has gilding on it. This can be done, with care, but a lot will depend here on the technique used to dampen the skin. If the skin becomes too damp problems can arise with gilding (e.g. softening of gesso).

Although writing on a hard surface is unpleasant, and often difficult, it is not such a problem if the writing is small (i.e. if the pen's edge is fairly narrow). A fairly hard flat surface is also fine for gilding and laying areas of colour. Whenever a gilded area is to be near, or right up against, colour (e.g. as in heraldry), then the gilding needs to be carried out before the colour work. If the colour were laid first then the gold leaf would almost certainly stick to the gum, or other binding medium, in the colour.

From the above it is clear there are a number of technical considerations which influence the order in which various stages of a piece of work are carried out. I can illustrate the principle best by giving a

rough outline of my own general order of working:

Firstly I do the writing and then any colour work that I feel inclined to do at this stage (providing it is not adjacent to an area to be gilded). Then I dampen the skin and stretch it over the rigid support. Then comes any gilding followed by the completion of colour work, including that adjacent to gilded areas.

The order in which one carries out a piece of work is obviously not governed solely by technical considerations. How one conceives a design and the way the ideas build up is different for different people. If you can work very closely to a final design rough you may be able to follow an order of working something like that outlined above. Often, however, decisions are made while working on the finished piece and then it is a matter of solving any technical problems as you go along. It is often said that good craftsmen see the problems before they actually arise. Even so, there is usually a way out of most difficulties, e.g. although one would not normally choose to do so, it is possible (though rather a nuisance) to gild close to an area of colour by accurately cutting a mask out of thin release (or other) paper.

STRETCHING PARCHMENT FOR PANELS OVER A RIGID SUPPORT

General Considerations

Before outlining any stretching method it is worth considering again the physical characteristics of a parchment skin:
The thicker regions of tight texture along the spine and near the top and bottom of the skin, will, when dampened, tend to stretch least. The thinner regions of looser texture along the flanks will tend to stretch more, particularly at the edges of the sides where the skin is at its thinnest (Illus. 4).

thickest regions thinnest regions

Illus. 4

× ×

Illus. 5

thickest regions thinnest regions

Illus. 6

spine edge

Illus. 7

A large rectangular piece cut fairly symmetrically from the skin (Illus. 4), tends, when dampened, to take up the slightly concave shape, shown much exaggerated, in Illus. 5. This is mainly due to the edges of the skin stretching more than the flanks and spine. Sometimes this causes the parchment to pucker slightly at X, Illus. 5, but this can be pulled out when stretching over the support.

Pieces cut from the skin in the region of the animal's flanks usually stretch fairly evenly, provided that the thick spine and the relatively thin outer edge are not included in the piece (Illus. 6,A).

If these regions are included in the piece (Illus. 6,B), then it tends to stretch in a lop-sided fashion when dampened, as shown, again much exaggerated, in Illus. 7.

How noticeable these effects are depends on the general thickness and nature of the parchment and on how damp it has become. Sometimes, especially with thicker skins, it is barely noticeable; at other times, usually with thinner skins, it is much more pronounced. In practice, local variations in the thickness and fibre texture of the skin, cause the shape of the dampened parchment to be much less regular than the shapes indicated in Illus. 5 and 7 – they are rather idealised. The general tendency is, however, to take up roughly these sorts of shape.

It may appear at first sight that the tendency for a rectangular piece of parchment to take up, when dampened, the shapes shown in Illus. 5 and 7, will cause distortion of straight lines of writing written on the dry skin. In practice this effect, if it occurs at all, is minimal. The thickness and fibre texture seem to remain fairly constant, in most skins, over the region of the animal's flanks. Most of the extra stretching takes place close to the edge of the skin, which is usually the piece turned over the rigid support, or the margin areas of the work.

Stretching Procedure

Some people stretch their own parchment and have their own methods. Others have it stretched by someone else. For anyone who has never attempted the operation, and would like to try, I offer the following as a simple method which requires only basic equipment. It would hardly be acceptable as a conservation technique and I do not suggest using it to flatten old parchment panels.

Let us assume that the writing has been done, and perhaps much of the colour work as well. The margins of the work will already have been considered during the design stage. A final decision is now made (probably with the help of 'L-shaped' pieces of card). It must be remembered that the frame will overlap the stretched parchment, usually by about 5 mm ($\frac{1}{4}$ in.) (If it is intended to have a card mount in addition to the frame this must also be considered at this stage.)

When cutting a piece from a skin, at least 40 mm ($1\frac{1}{2}$in.) should be left all round, beyond the overall size of the work (including margins), to allow the parchment to be turned over and attached to the back of the rigid support.

If the visual margin area decided on is indicated by the dotted line (Illus. 8a), then the position of the rigid support is shown by the solid line (the width of the frame overlap outside the dotted line). This solid line is then transferred to the back of the parchment by pricking through at the corners and then ruling the lines on the

needle or fine point

width of frame overlap

position of rigid support

additional line

a FRONT b BACK

Illus. 8

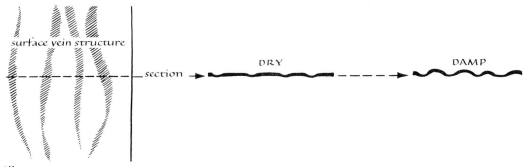

surface vein structure

section →

DRY

DAMP

Illus. 9

back. An additional line about 5 mm ($\frac{1}{4}$ in.) outside the line marking the position of the rigid support is now drawn (broken line Illus. 8b). The reason for this additional line is:

Although parchment stretches when dampened, sometimes the vein structure can be responsible for making it appear that the skin has shrunk, especially if the skin is fairly thin. In a parchment with pronounced veining (Illus. 9) the fibre texture is tight where the veins are and when dampened stretches little. The parchment between the veins stretches much more, but because of the restraining influence of the vein areas it has no room to spread out – so it bulges up – in effect drawing the skin in. So although the skin stretches, its linear dimensions are reduced. If these corrugations are roughly parallel to the edge of the skin when it comes to positioning the rigid support on the back of the dampened skin, the line indicating where the edge of the support should be can be hidden under the support itself. The additional line drawn (Illus. 8b) is still visible and helps in positioning the rigid support. It also gives a visual indication of how much the skin has been drawn in. It is gently pulled out to its proper position when the edge of the dampened parchment is being drawn over the rigid support (Illus. 17).

Sometimes this 'shrinking' effect is local and sometimes, especially with very thin skins (e.g. some slunk skins) the effect can take place over virtually the whole skin. After stretching, as the skin dries, this puckering is largely pulled out.

If these corrugations in the parchment happen to be more or less at right-angles to the edge of the skin, the guide lines on the parchment marking the position of the support can usually still be seen, but the wrinkles have to be pulled out gently when the parchment is being drawn over the support (Illus. 10).

Next, the support itself has to be made. The main consideration is that it should be rigid (drying parchment can exert a very strong pull). Good quality plywood (preferably of marine quality) is about the

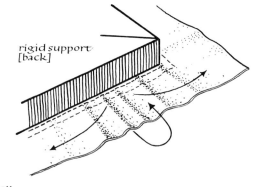

rigid support [back]

Illus. 10

best easily obtainable material. For small panels 6 mm ($\frac{1}{4}$ in.) ply is usually sufficient, but for larger work at least 9 mm ($\frac{3}{8}$ in.) is advisable. I usually keep some pieces of plywood in stock for a time. Plywood is supposed to be flat, but in practice, as it matures, it usually develops a slight camber and one can use this to advantage. I select a piece and arrange for the slightly convex side to be towards the parchment – this helps to counteract the pull of the drying skin.

Before marking out and sawing the plywood to size one should bear in mind that the line drawn on the back of the parchment, marking the position of the rigid support, is drawn on the dry parchment. When dampened the dimensions of the rectangular shape will increase. As one is intending to dampen the parchment only very slightly this increase is usually quite small. How a skin will behave when dampened is never entirely predictable and making allowance for this overall stretching, when cutting the support, is partly guesswork, but in time one can become quite good at it. As a general guide, for smaller pieces of work on medium-weight skin, adding perhaps 1.5–3 mm ($\frac{1}{16}$ in.–$\frac{1}{8}$ in.) to the overall dimensions of the support will be about right – for larger pieces of work 3–6 mm ($\frac{1}{8}$ in.–$\frac{1}{4}$ in.) is a reasonable guess. If the parchment is fairly thin a little more may be allowed. In deciding on margins for a piece of work a very small adjustment can make a great deal of difference visually. Having gone to the trouble of deciding on the best balance of space around the work, one is hardly justified in subsequently ignoring anything which can upset that balance. If a small amount of the intended margin space is lost during the stretching, it can be compensated for when the work is being framed by packing around the

support and making the frame the required amount larger. It is however, much better (and saves unnecessary work) if you can get it right first time. Having cut the plywood to size, it is advisable to line it with paper to help stabilize it. Firstly, I coat the plywood all over, both sides and the edges, with dilute PVA and allow to dry – this acts as a seal.

The back of the plywood, (i.e. the side which will be away from the parchment – the concave side if the plywood has developed a warp) is lined with a few layers of thin paper, which are trimmed off flush with the edges of the plywood (Illus. 11a).

The front of the plywood is then lined with a thicker paper which is turned over, covering the edges of the plywood (Illus. 11b).

Thin paper when dampened stretches more, and therefore on drying pulls more than thick paper. At this stage one is working towards countering the eventual pull of the drying parchment on the front of the plywood support. If machine-made paper is used for the linings it is generally best to have the direction of the paper grain parallel to the shorter edge of the support.

Although the main purpose of this stretching procedure is to keep the skin flat, consideration should also be given to providing as much protection as one can for the parchment. With this aim in view it is sensible to have a piece of museum board (an acid-free rag board for conservation use, available in different weights – generally white or cream in colour) between the parchment and the rigid support. This is cut to the size of the support, but does not need to be glued to it. It is sufficient to hold it in position on the front of the support with a few spots of PVA near one end (Illus. 11c). The

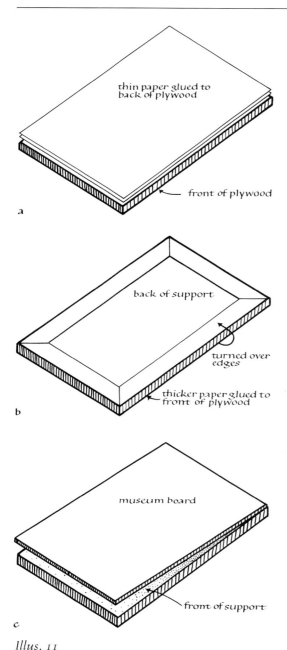

thin paper glued to
back of plywood

front of plywood

a

back of support

turned over
edges

thicker paper glued to
front of plywood

b

museum board

front of support

c

Illus. 11

parchment under slight tension, will eventually hold it in place.

To carry out the actual stretching one needs:

Two stout wooden boards (drawing boards or plywood will do), at least 75–100 mm (3 in.–4 in.) wider and longer than the rigid support, and also the following of the same size as the boards – A piece of release paper (one of the thicker varieties is best),
A piece of stout polythene (not the thin crushable type),
Several pieces of blotting paper (white).

The intention is simple – to dampen the parchment just enough to relax it slightly and make it supple. Place the rigid support in position, then turn the edges of the parchment over the support and fix them down on the back. To carry this through without encountering too many problems along the way the following procedure is reasonable:

The release paper is placed on top of a piece of dry blotting paper (which has a cushioning effect) on one of the boards and the parchment is placed, face down, on top of this (Illus. 12). (Working on a board means the whole assembly can be swung around and this makes things much easier when it comes to turning the parchment over the edge of the support and mitring the corners.)

The parchment now has to be slightly dampened on the back. It could simply be wiped over with a damp cloth or sponge, but parchment tends to begin to roll itself up when you do this (especially if it is thin, e.g with slunk skins). It could be weighted down or pinned out, but it is still not easy to dampen the skin evenly using this method – being exposed to the air one region can be absorbing moisture while

78

another is already beginning to dry. Having the whole of the back of the skin in contact with a damp source and letting the moisture penetrate slowly is much easier to control. (Humidity-controlled cabinets come to mind but few of us would have ready access to this type of equipment.) It has been suggested to me that using felt which has been soaked in water and then allowed to dry off, is a possibility – it has the advantage of being re-usable. To date, I have used blotting paper (the acid-free type intended for conservators' use) to dampen the back of the parchment.

A piece of blotting paper is soaked (if it is large, roll it up before soaking – it tends to fall apart under its own weight otherwise) and then unrolled on top of a piece of dry blotting paper to draw excess moisture from the damp piece. It is at this stage that one has the first opportunity to exercise some control over the dampening process. If the blotting paper is still too damp it can be left aside for a while (opened out) to dry out. When stretching thin skins I almost always do this.

When one is satisfied with the dampness of the blotting paper (as well as can be judged), it is unrolled onto the back of the parchment (Illus. 12). If the skin is thick a second piece of blotting paper, similarly dampened, is unrolled on top of the first to give a reasonable source of moisture. No matter how thick the skin avoid rolling the blotting paper onto the back of the parchment while the blotting paper is still very wet. Drenching the back of the skin can result in too much moisture soaking right through the skin quickly, in places, and making the surface on which the work was carried out, very damp. When these regions subsequently dry the surface texture of the skin is 'pulled together', leaving a slightly sunken, smooth, shiny

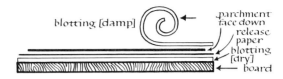

Illus. 12

area which, in some lighting conditions looks much deeper in tone than the rest of the skin.

If the skin being stretched is very tough and thick (I would generally avoid using a skin of this type) then extra layers of damp blotting paper can be added to give an additional source of moisture. The parchment will take in the moisture available in its own time – even very thick parchment can become quite supple.

The dampening can also be controlled to some extent if the second piece of blotting paper to be laid on top of the parchment is dry. This takes some of the moisture from the damp piece which is in contact with the back of the parchment, and holds back the dampening of the parchment. This is useful with thin skins.

A piece of polythene is then laid on top, followed by the second wooden board. A few weights placed on top help to press the damp blotting paper lightly into contact with the back of the parchment (Illus. 13).

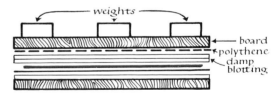

Illus. 13

The polythene prevents the top board from becoming damp and sends the moisture where you want it – towards the back of the parchment.

Everything is now left for a while. How long depends on the nature and thickness

of the skin and the dampness of the blotting paper. For thin skins 10–20 mins. might be long enough; for thicker skins maybe 30 mins. or longer. By removing the top board and peeling back the blotting paper a little, one can judge if the skin is losing its hardness and becoming slightly supple.

Ideally, the moisture should penetrate slowly through the thickness of the skin. The whole substance of the skin needs to be slightly damp. If the front surface of the parchment remains bone dry obviously it cannot stretch. If, however, the parchment is allowed to become too damp and moisture penetrates to make the front surface very damp, the gum or other binding media in the colours and ink may soften and tend to stick to whatever surface they are touching. The release paper is an insurance against this happening.

When the parchment is supple, without being too damp, stretching over the support can begin:

The top board, polythene and top layer(s) of blotting paper are removed. The rigid

support is slid into position (museum board downwards) as the layer of blotting paper next to the parchment is rolled back (Illus. 14). If this layer of blotting paper is simply rolled away, the exposed skin has a habit of rolling itself up, especially if the parchment is thin.

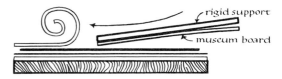

Illus. 14

The position of the support is then adjusted relative to the guide lines marked on the back of the parchment. If the parchment has been cut symmetrically from the skin (Illus. 4) or from the flanks (Illus. 6a) it will probably stretch fairly regularly and the rigid support can be placed symmetrically relative to the guide lines on the parchment (Illus. 15a).

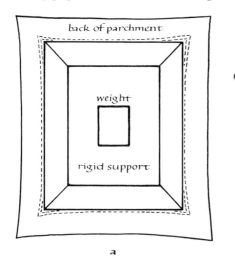

a

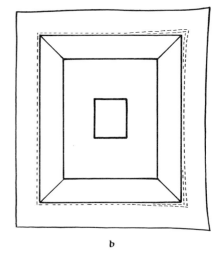

b

Illus. 15

If the spine or very thin outer edge of the skin has been included (Illus. 6b), the parchment may stretch in an uneven way. Again, however, the support should be placed in a symmetrical position relative to the guide lines (Illus. 15b), relying on the fact that invariably the additional stretching (causing the distortion) takes place largely in the thinner, turn-over, or margin areas of the parchment skin. When the support is in position a weight placed on it prevents it from shifting relative to the parchment.

The corners of the parchment are then cut out with scissors (Illus. 16a).

It now remains to turn the edges of the parchment over the support and fix them down. They can be tacked down, or fixed with staples (non-rusting) if the thickness of the support will allow but I prefer to glue them down with PVA.

It is only the edge of the parchment which needs to be glued to the back of the support. A strip of card or millboard slightly wider than the combined thickness of support and museum board, placed as shown in Illus. 16b, with a piece of paper under the parchment makes the gluing easy to control. The edge of the parchment is then drawn over onto the back of the support. Begin at the middle of the side and work out towards the ends (Illus. 16c). If there are any creases at the edge of the skin (e.g. as in Illus. 10), draw them out at this stage (the parchment is quite supple and this is easy to do). If the line on the parchment marking the position of the edge of the support has been drawn under the edge of the support due to wrinkling of the skin (as in Illus. 9), then pull it gently out to its proper position (Illus. 17), before turning the edge of the skin over the support. Pull gently – undue force is not necessary or advisable.

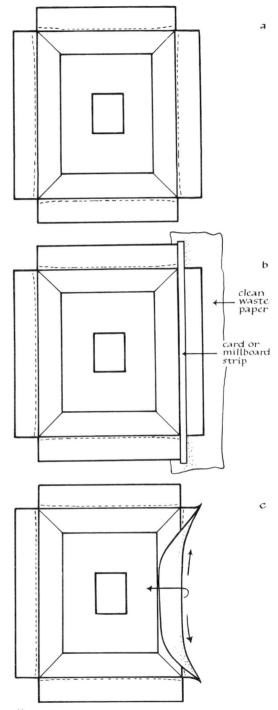

a

b

clean
waste
paper

card or
millboard
strip

c

Illus. 16

81

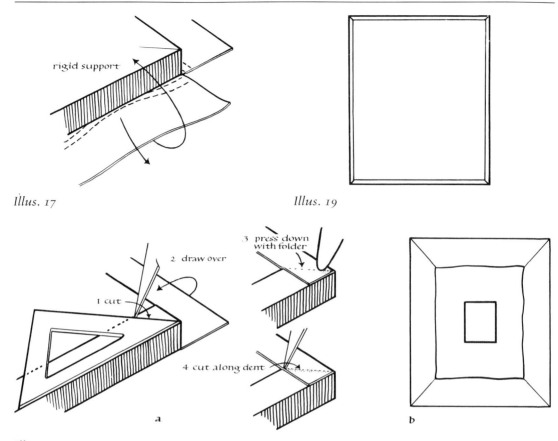

Illus. 17

Illus. 19

Illus. 18

Other than when removing creases, there is no need to exert any force at all when drawing the parchment over the edge of the support. The skin has already been relaxed and will draw itself flat as it dries. When the whole edge has been turned over it is firmly rubbed down with a folder.

The opposite edge is glued and drawn over in the same way. The corners are cut away at 45° and then the top and bottom edges are glued, drawn over and mitred (Illus. 18a, b).

A further thin paper lining stuck on the back secures the turned over parchment edges, and completes the process.

The work is then lifted clean away (do not slide it off the release paper) and left, face up, to dry out naturally.

Sometimes when the work is turned face up it already looks reasonably flat. Sometimes there is obvious wrinkling – especially if a thin, veiny skin has been allowed to become too damp. These wrinkles will pull out as the skin dries.

The advantages and disadvantages of stretching parchment have already been mentioned. Stretching the skin flat (not necessarily tight) over a support does, however, open other doors, e.g. the possibility of using the natural translucency of some parchments to allow shapes, or coloured areas, applied to the

face of the support to show through slightly, and modify the visual effect of the work. This, together with the dyeing or staining of parchment, is beyond the scope of this article.

CONCLUSION

In considering parchment as a material on which to write, some reference has been made to its physical make-up. How a pen and ink can be expected to behave on its surface, and how the material itself is likely to react in different situations depends on these physical characteristics and also on the properties and behaviour of the other materials and tools used. Little of what has been said in this article can be regarded as a hard and fast rule. To follow slavishly, without thinking, a method or technique advocated by someone else is almost certainly not a good idea. It is, of course, worth trying other people's methods (how else would one start?); but at the same time it is important to think of what is happening and what one is trying to achieve. An understanding of the materials and tools used, and of the technical and aesthetic considerations which have led someone to do something in a particular way, is much more likely to bring one's own work to a satisfactory conclusion than simply following another person's methods and techniques.

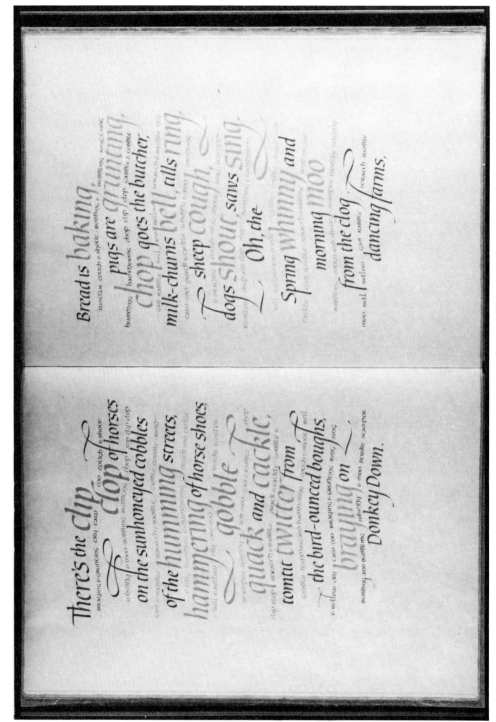

There's the clip
BRAXING E GRUNCING CRU CRU CRU COO COCKLD E SHACK
clop of horses
CLOP CLOP E CROO GOBBLING BLEATING CHOP CHOP CLIP CLOP
on the sunhoneyed cobbles
TAKE E RATTLE QUACK E CACKLE E COO GOBBLE RING
of the humming streets,
BLEAT E RATTLE CLIP CRU CRU WHIZZ VU E RATTLE TWEETER TWITTER
hammering of horse shoes
COO CRU CRU WHINNY BRAYING GOO COO RATTLE TWITTER
gobble
SCRATCH RATTLE QUACK COO HA VU E RATTLE SCRATCH
quack and cackle,
CLIP CLOP E SCRATCH RATTLE QUACK E CACKLE GOBBLE O
tomtit twitter from
GOBBLE HAMMERING COO HAMMERING NEIGH SHOUT BELL
the bird-ounced boughs,
E BELLOW CRU CRU COO BRAYING E GRUNCING RING SING
braying on
BLEATING AND BUBBLING TWEETER E COO SCRATCH SCAMPER
Donkey Down.

Bread is baking,
CLUCLER COUGH E SHACK BUBBLE O BUBBLING RING E SING
pigs are grunting,
HUMMING BAROTHRONIC CHOP CLIP CLOP CACKLE E COBBLE
chop goes the butcher,
SAY RATTLE BELL CRU CRU SCRATCH RATTLE ON
milk-churns bell, rills ring,
CRU COO SHACK E CACKLE WHINNY E COO BLEATING
sheep cough,
CRU CRU WHINNY BLEAT COO WHIZZ E COO WHINNY BUBBLING
dogs shout saws sing.
RATTLE BRAYING COO CRU CRU WHINNY BUBBLING
Oh, the
BELL BELLOW BLEAT E COO HAMMERING COO
Spring Whinny and
CACKLE GOES SHACK COO WHINNY CRU COO SHACK
morning moo
BUBBLING NEIGH E COO WHINNY RATTLE WHINNY
from the cloq
COO BELL BELLOW COO E RATTLE SCRATCH RATTLE
dancing farms,

Sam Somerville: Quotation from Dylan Thomas, *Under Milk Wood.* Opening from a six-page manuscript book written on Japanese paper in various shades of green, brown, blue and Indian red watercolour. Page size: 30 × 42 cm. 1980.

Paper

PETER BOWER

Papermaking is an old skill, and paper a material we all use every day. It is a simple process, but having evolved over two thousand years hides a considerable complexity.

Essentially the process has changed little since those early days. Macerated fibres, in suspension in water, are formed into sheets on a sieve-like mould, the mould being shaken to mat the fibres together. The modern handmade and machine-made processes use the same technique.

There are three basic forms of paper: handmade, mould-made and machine-made. With handmade paper, the sheets are formed individually by someone working at a vat, with a mould and deckle. With mould-made paper, the sheets are formed individually but on a machine. Modern paper machines form the paper as a continuous web, from wet pulp at one end to dry paper at the other. Mould-made papers have some of the characteristics of both handmade and machine-made papers.

As there are few papers made specifically for calligraphers, in the West, any well-sized, strong paper with some nap, that is capable of erasure, can be recommended. I would always recommend handmade paper, because of its quality and its qualities. The maker, being directly involved with the materials at all stages of the process can take time and care to ensure a strong and durable sheet, satisfying and challenging the demands made on it. The variables inherent in the process contribute a distinctive character to every sheet, giving a vitality to the work.

A BRIEF HISTORY OF PAPERMAKING

Paper originated in China, the date most often given being AD 105, but earlier paper has been found, and it was to be 500 years before the secrets of its making were to be exploited by other peoples. Even in China it was to be 200 years before the new material was generally accepted as a substitute for wood, bamboo and silk as a surface for writing on. Papermaking spread gradually, reaching Japan, via Korea, at the start of the seventh century. The westward movement was slower, arriving in the Islamic world via Samarkand in 751 and Baghdad in 793. By 900 paper was being made in Egypt by Chinese methods. From the Arab world the skills spread to Europe, firstly to Spain, and then across the whole of the continent. The earliest European manuscript on paper so far found is a deed of King Roger of Sicily written in Arabic and Greek, and dated to 1109.

Over the next four centuries papermaking spread into France, Italy, Germany and Switzerland and arrived in England in the 1490s, with the establishment of a small mill in Hertfordshire by John Tate. Paper had been in use in England for nearly 200

years, imported from the Continent. This is a common feature of the spread of papermaking, first the use of imported papers, and then, with demand increasing as people became aware of its usefulness, the setting up of a local manufacture. Although Tate's paper was good and used by Wynken de Worde for his printing, his mill failed. It was to be 1589 before the goldsmith John Spilman was granted the monopoly of collecting rags and making paper at his mill in Dartford, Kent.

The steady supply of rags for papermaking has always been a problem for the makers, and by the eighteenth century the search was on for alternatives. In 1719 Réaumur commented prophetically on the wasps who made paper nests from wood, and by the 1760s Jacob Christian Schaffer in Germany was experimenting with a variety of plant materials. Oriental papermaking had been using such materials since the beginnings of the craft.

Despite the researches of Réaumur, Schaffer and others, all of whom were working by hand, the development of new materials for papermaking seems bound up with the development of the papermaking machine. Such a machine was first invented in France in 1798. Despite the popular belief that it was the rapidly increasing demand for paper that led to the invention of the machine, it must be said that Louis-Nicolas Robert, the inventor, tells that it was the quarrelsome attitudes and restrictive practices of the handmade makers 'who were influenced and made truculent by the revolution', that led to his being asked to make a machine, basically to do without their services.

The idea was to be really developed in England where, by 1804 the first book printed on machine-made paper had been published, and the industry was to begin the vast changes that have led to the current easy availability of paper. The modern machine is simply a faster, larger and more sophisticated Robert machine. Some statistics will put these great changes in perspective. In 1800 the annual consumption of paper in England was about $2\frac{1}{2}$ lb a head. In 1970 the equivalent in the British Isles was about 340 lb.

MAKING PAPER BY HAND
Papermaking is essentially the separation of cellulose into individual fibres by the breaking-down of vegetable matter, and the washing-out of non-cellulose materials. The fibres are then rearranged into thin flat sheets, which makes use of the fact that cellulose likes to bond to cellulose. The papermaker effects this rearrangement by holding the fibres in solution in water, dipping a sieve-like mould into the solution and pulling it out, letting the water drain off through the mesh and leaving the pulp on the surface of the mould as a sheet of paper.

Though cellulose can be obtained from many different fibres, the traditional European source was cotton and linen rags – mostly replaced today by cotton linters. Linters are the short fibres left after the long fibres have been removed for use in the textile industry. They are very useful fibres, producing a strong, permanent and durable paper, capable of varied usage.

Preparation of the stock, rather than the formation of the sheet, by hand or machine, is the major influence on the life and durability of the paper, and plays a major part in how the sheet will behave.

Rags must be sorted for quality and cleaned and boiled, to soften and prepare the fibres for breaking and beating. After boiling, the rags are rinsed in clear water before passing to the breaker, which both continues the cleaning process and begins to break the fibre down.

Both breaking and beating take place in oval troughs, divided by a centre wall and having a heavy barred roll placed midway down one side of it, above a similar bed plate. The breaker both crushes and grinds the fibre so that the original weave of the fibre is lost, and any remaining dirt is washed out via a drum washer and dirt trap. The beater is very similar to a breaker, but the bars are arranged differently, and there is no cleaning equipment.

The quality and characteristics of the finished paper depend to a great extent on the treatment of the fibres in beating. In the early stages the fibres become more flexible. As the roll is gradually lowered, getting closer and closer to the bed plate, the fibres begin to break up and hydrate – taking up more and more water, producing what is known as 'wet' pulp. This drains more slowly on the mould during the formation of the sheet, helping to give a close and even result.

From the beater the pulp moves to a 'stuff' chest, and then passes through a 'knotter', which gives a final cleaning to the fibre, before the pulp passes to the vat where the paper will be made.

The vatman dips the mould into the pulp, taking up more pulp than is needed, and by shaking the mould, 'throws' the excess pulp off the far side of the mould, which is then shaken sideways, sending another wave to spread and interlock the fibres, orientating them in every direction. The thickness of the sheet is determined by the consistency of the pulp, the skill of the vatman and the depth of the deckle, a wooden edging frame which sits on the top surface of the mould.

The wet sheet is couched (transferred) from the mould onto a woven woollen felt with an even rolling motion. The coucher places one edge of the mould along the edge of the felt and, with an even pressure, presses the mould down onto the felt and off again, transferring the wet sheet onto the surface of the felt. The coucher passes the mould back to the vatman and lays down another felt, ready to couch the next sheet, slowly building a post (pile) of felts and wet paper which are then pressed.

Pressing removes as much of the water as possible before drying, and helps to compact the fibres into a strong tight sheet. Various pressing sequences are used depending on the desired finish and use of the paper.

Paper is dried, either by being hung in the air, in the natural airflow, or by being passed over heated drying cylinders – which is much faster. After drying, the sheets are cured, the stacks of paper standing under light pressure, and being exchanged regularly, so that air gets through evenly to them all, and cockles do not form.

If no size is added to the pulp during making (internal sizing), or added to the paper after it is dry (surface sizing – usually gelatine), then the paper is known as waterleaf. Without some measure of sizing, paints and writing inks would bleed, giving a furred edge to the image. Most handmade papers are sized internally now. The main disadvantage of internal sizing is that it gives no increase in the surface strength of the paper, unlike gelatine sizing.

The finish of paper is of great importance to the calligrapher. Traditionally the word 'finish' refers to those processes which affect or alter the surface of the dry sheet of paper. Paper has no intrinsic surface of its own. When wet it picks up textures from whatever it comes in contact with. But every stage of the papermaking process, from the choice of a particular fibre and its beating, through all

the stages of manufacture, to the use the paper is designed for, will have a bearing on the final finish.

Handmade paper is traditionally prepared in three main finishes:

ROUGH, the post of felts and wet paper is pressed once in the vat house press and the sheets are then dried and cured. The texture of ROUGH sheets comes from the felts.

NOT, the natural finish of the paper as given by the top layer of fibres in contact first with the couching felts and then other sheets of the same paper in a second and third press.

HOT PRESSED, (or HP), originally produced in a screw press using burnished and heated metal plates, this surface, the smoothest of the three, is now approximated by the use of glazing rolls.

WATERMARKS

The earliest use of watermarks in paper comes from thirteenth-century Italy. There is considerable disagreement about the original functions of watermarks. Were they trade marks, indications of paper sizes, paper qualities, symbols of magical or religious significance, or simply a convenience to identify a particular pair of moulds, or individual makers or mills? Nowadays watermarks are used as trade marks, for security purposes or for commemorative papers.

Watermarking a sheet takes place during its formation and watermarks vary from simple wiremarks to complex pictorial light and shade marks.

To construct a watermark, a preliminary line drawing is made on paper, then fine wire is laid down onto the drawn lines and where the wires meet or cross they are soldered together. The completed mark is then sewn down onto the wire surface of the mould. For a light and shade mark, a mould is taken of a shallow relief carving, wire is shaped in this mould and again sewn down onto the papermaking mould. The pulp forms in an even thickness on the surface of the mould, so that any variation in the surface of the mould will produce an equivalent variation in the pulp, which will show when the paper is held up to the light.

SIZE AND WEIGHT

There are two systems for measuring the size and weight of papers.

TRADITIONAL SIZES

The traditional measures come in a considerable range of sizes and proportions.

The basic names and sizes are:

Antiquarian	53	× 31	inches
Atlas	34	× 26	inches
Colombier	$34\frac{1}{2}$	× $23\frac{1}{2}$	inches
Crown	20	× 15	inches
Demy	$22\frac{1}{2}$	× $17\frac{1}{2}$	inches
Eagle	42	× $28\frac{1}{2}$	inches
Elephant	27	× 20	inches
Foolscap	$13\frac{1}{2}$	× 17	inches
Hand	16	× 22	inches
Imperial	30	× 22	inches
Medium	18	× 23	inches
Post	$19\frac{1}{4}$	× $15\frac{1}{4}$	inches
Pot	$12\frac{1}{2}$	× $15\frac{1}{2}$	inches
Royal	20	× 25	inches

This basic range is further complicated by Double, Quad, Large, Small and Half variants, eg:

Double Crown	30	× 20	inches
Half Imperial	15	× 22	inches
Large Post	$16\frac{1}{2}$	× 21	inches

The traditional paper sizes are sold at weights measured in lb per ream, (500 sheets), e.g: Imperial (30 × 22 inches) 90 lb. This means that one ream of 500 sheets of Imperial weighs 90 lb. The same paper in a ream of Medium (18 × 23 inches) would weigh 70 lb.

The thicker the paper the heavier the weight and, with practice, one can judge the suitability of papers for various uses from the weights and descriptions given by suppliers.

Owing to the wide range of names it is a good idea to give both the name of the size and its actual measurements when ordering handmade and mould-made papers, which to a great extent use the traditional sizes, whilst the machine-made industry for the most part uses the metric system.

METRIC SIZES

The Metric system avoids any of the traditional complexity by basing all the sizes on a common proportion, each size having the same proportion as every other. These are numbered down from Ao (841 × 1189 mm) to A10 (28 × 37 mm). By cutting Ao in half, one gets two A1 sheets, each 594 × 841 mm. By cutting A1, one gets two A2 sheets, each 420 × 594 mm, and so on.

Weight is measured as grams per square metre (g/m² or gsm). No matter what size the sheet, its weight (or grammage) is indicated by the same figure.

CHOICE OF PAPER

Calligraphers working with paper should use the highest-quality materials available, matching the quality of their work to the materials used. In choosing the right paper to work on, many aspects must be considered, some of them technical, some aesthetic, and some the complex products of personal experience and feel for materials. There are some simple tests that can be done to gain familiarity with the characteristics of particular papers, when choosing one to work on.

Non-destructive tests for strength, finish and brilliance

Hold the paper between thumb and forefinger and give it several quick shakes. The higher the relative tone, the better-bonded and stronger the sheet will be. A large thick sheet will give a deeper rattle than a small thin sheet. The texture and finish can also be felt, and seen effectively by looking along the surface of the sheet. The brilliance, or light-reflecting capability of the paper, important when using transparent colours, can be seen by moving the paper around in front of a light.

These next tests involve a measure of destruction

When testing for strength, a handmade paper may be torn in any direction; with mould-made and machine-made papers it will be necessary to tear across both directions of the sheet. These papers have a grain, the fibres being aligned inside the sheet in the same direction as the paper travelled through the machine during its making. It will tear more easily with the grain than across it.

Sizing can be judged by watching the absorption of a small drop of water on the surface of the sheet. Folding the paper will also tell you about the surface strength of both the paper and surface sizing, if it is present.

One should examine a piece of paper before starting to write, as there is a perceptible difference between the wire

side and the felt side of a sheet, arising from the manufacture of the paper. The choice of side is important with writing, as the felt side gives a smoother surface. The surface also influences the contrast and brilliance of colours, as rougher textures hold more shadows. The colour of the paper will also contribute to the appearance of what you have written, especially if the inks or paints are translucent.

It is advisable to buy more paper than you actually need for a job, especially with toned or coloured papers. As paper is made in batches, there can be noticeable differences between different makings of the same paper.

ADAPTING PAPER TO YOUR OWN REQUIREMENTS

Because very little paper is now designed and made specifically for calligraphy, calligraphers may wish to adapt existing papers to suit their own needs. Paper can be resized, recoloured and refinished. Do not be afraid to experiment with all these processes in order to discover what is possible.

With the growing interest in handmade paper in Britain, it is to be hoped that more specialised calligraphy papers will be developed. At the time of writing, there are many amateurs and artists making their own paper. Some beautiful and distinctive paper is being made, but owing to the lack of experience of many of these makers, the permanence and durability of some of these papers are questionable.

SIZING

If you wish to resize existing papers the following method may prove useful.

Use a good animal skin size, preferably in powder form as this is easier to use. Soak the powder in cold water overnight. When it has absorbed the water and formed a jelly, add boiling water and stir well. The liquid should be as warm as possible all the time you are working with it.

The solution for good cotton papers would be between 4% and 8% gelatine in water. Alum may be added to the size in a 1:10 alum/size ratio, but remember that alum is acidic. Its purpose is to improve the bite of the size on the fibres, but it can contribute to the deterioration of paper. A drop of formalin can be added to prevent mould and harden the size. Two separate sizings with a thin solution are better than one thick sizing, giving a more even distribution over the surface, and aiding in the parting of the sheets after pressing. It is well worth sizing several sheets at a time.

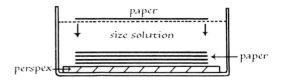

Illus. 1

Pour the warm size solution into a large flat dish or tray slightly larger than the sheet of paper to be sized. Lay a sheet of Perspex on the bottom of the dish, to act as a base for the sheets. Lay one sheet gently down onto the surface of the size and slowly immerse it, bringing it to rest on the Perspex. Repeat the process until there is a pile of paper on the bottom, all submerged, taking care to lay each sheet as nearly as possible on top of the previous sheet.

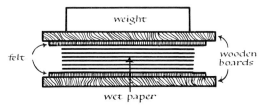

Illus. 2

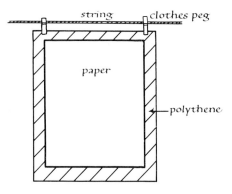

Illus. 4

Carefully lift the Perspex and the paper out of the size, cover with a felt and a wooden board. Turn the whole stack over and replace the Perspex with another felt and board. Give the whole pile a press. For small sheets a bookbinder's nipping press is useful. For larger paper, weight the whole stack down, taking care to get an even weight distribution.

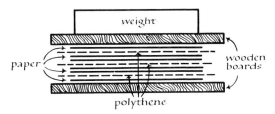

Illus. 3

Remove the sheets from the press, remove the top board and felt. Separate the top sheet carefully, lay it down on a clean surface, place a sheet of thick polythene on top, about 50 mm (2 in.) bigger all round than the paper. Lay another sheet of paper on the polythene, making sure that it is exactly above the first sheet, repeat till you have a pile of polythene and paper in layers. Give the pile another light press and then separate and hang up to dry. (Illus. 4)

It is possible to paint the size solution onto the surface of the paper, but I would recommend the above process as giving a more even distribution of size, over the whole sheet. With very thin sheets cockling may occur. This can be avoided by drying the sheets in spurs of four or five sheets at a time, making sure that the order of the sheets is regularly changed so that they can dry out evenly.

COLOURING

Colouring an already-made sheet of paper is not strictly dyeing it, rather staining it. The bite and effectiveness of the dye will depend on the paper used, whether it is sized and the strength of the dye. Some dyes will colour the surface of the sheet only, which may lead to a problem if a writing fault has to be erased. I would suggest a soft-sized sheet, or an unsized waterleaf sheet, resizing them with the methods previously described.

Many people are tempted to use natural dyes such as onion skins and lichens for colouring paper, because of their beautiful qualities of tone and colour. But these dyes will rarely be light-fast, as one cannot use the mordants (fixing agents) that one would use with textiles, as they are metallic and would increase the risk of deterioration.

There are three kinds of dyes that can be used for colouring paper:

Acid dyes, Basic dyes and Direct dyes. The best are Direct dyes. They have a direct and substantive affinity with cellulose and are well-retained by paper fibres. They give duller shades than basic dyes but are much more light-fast, they fix themselves without the use of mordants and should be added cold.

Make a solution of the dye and use a dish similar to the one used in the sizing process. Some experimentation will give you ideas as to the various strengths you may want to work with. Firstly, lay the paper on the surface of the dye and gently immerse the whole sheet, letting it lie on the Perspex sheet at the bottom of the dish. Repeat for the number of sheets required, then leave to soak. Exact times cannot be given, but a little experimentation will give you more idea of what is possible. Lift out the whole pile and separate the sheets into another pile, interleaving them with dry blotting paper, and give them a firm press.

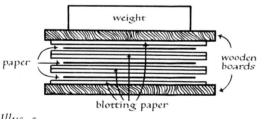

Illus. 5

This soaks up excess dye, aids in an even distribution of dye, and stops mottling of the colour. Remove from the press.

Place a sheet on a piece of Perspex, with another sheet of dry blotting paper on top, and with a roller, press the paper down onto the Perspex. Remove the blotting paper and leave to dry. Drying in this way will help to keep the sheet flat. When it is dry, just peel the paper off.

During the making of paper there are many varieties of finish and texture that can be given to the surface. Once the paper is dry there are only limited options. But there are some things than can be done to adapt the paper to one's own requirements.

The best way to burnish a sheet of paper is also the most laborious. It involves laying a sheet on a hard and polished surface of wood or stone and rubbing the surface with a polished stone in a circular motion, aiming for a consistent finish. This ancient process gives a surface well suited to writing. The degree of polish will vary depending on the fibres of the paper and can be varied to suit your needs. One advantage for calligraphers is that with this process the surface closes up, making it easier to write on. The paper should become smooth but not slippery, retaining a measure of nap.

If you have access to an etching press the paper may be treated by interleaving sheets with glazed card and running them backwards and forwards through the press several times. This will render even quite rough paper much smoother for writing.

Some of the older rag and gelatine-sized papers still available may well need some preparation for writing. Any of the many methods of preparing vellum for writing can be used to prepare gelatine-sized papers. The size comes from boiled-down animal skins, so one is in essence working with the same surface.

CARE AND CONSERVATION OF PAPER

The durability of any work depends on two factors. The quality of the materials used, which is under your control, and the conditions under which the work is kept once it has left the studio, which usually is not.

With any work of art on paper, it is the quality of the paper that is the major factor in its life expectancy. Most hand-mades and mould-mades should be capable of lasting hundreds of years if care and attention are given to their keeping. Paper is always sensitive to its environment, primarily because it absorbs moisture drawn from the air. The amounts depend on the nature of specific papers.

Internal factors affecting the life and condition of papers result from the choice of raw materials and their processing, and include acids, iron and copper salts, lignin residues, bleaches and acid sizing. The major external factors are extremes of temperature and relative humidity, strong light, atmospheric pollution, the inappropriate use of mounting materials, and careless handling.

If a paper contains impurities and is kept badly, the internal and external causes of deterioration can combine and amplify each other, increasing the rate and extent of degradation of the work.

Paper should be stored flat, away from extremes of temperature and relative humidity. If cellulose is kept rolled up for long periods, it will not want to lie flat again. Rolling can also cause damage by creasing and cracking the surface of the paper.

The effects of temperature and humidity are particularly noticeable with central heating, where temperatures are often high and relative humidity low during the day,

the reverse being the case at night. High relative humidity may cause paper to stick together and may foster the destructive growth of moulds. Too dry an environment can be equally destructive, causing paper to become brittle. Ideally paper should be kept in an atmosphere of 20–22° C, with 50–60% humidity.

Ultra-violet light is present in both sunlight and artificial light, and causes complex photochemical changes in paper and pigments, accelerated by oxygen and moisture from the atmosphere. Paper will discolour and there may well be fading of pigments in inks and paints. The wood-based acidic papers will yellow and become brittle, whilst cotton and linen papers will whiten. Avoid placing works of art in strong light, direct sunlight or spotlights.

The main atmospheric pollutant for paper is sulphur dioxide which, in the presence of water, forms sulphuric acid. Paper will thus absorb acid from the air with the moisture it takes in, a process known as acid hydrolysis.

The presence of acid breaks the links in the chain-like structures that make up cellulose and thus weakens the paper. Acids are present in paper either from acid hydrolysis, as residues from the manufacturing process, or formed during the growth of the plant from which the fibres have come. The lignin content of wood-based papers can be very high, and many of the chemicals used in manufacture are also acidic, especially bleaches and some sizing agents.

The most archivally sound papers are made from raw materials as close to pure cellulose as possible, such as cotton (95%) or linen (flax, 75%). Most machine-made papers are made from wood pulps and can be highly acidic. Most handmades and mould-mades are archivally sound, but if

in doubt always ask for the pH of a paper. This is measured on a scale that runs from 0 which is strongly acidic, to 14 which is strongly alkaline. Neutral is pH 7, and this is the measure to go for.

When preparing work for display, mounting is important. Use acid-free conservation boards, sometimes called museum boards. If window-mounting (between two boards, one of which has a rectangular, or sometimes shaped, hole cut out of it to frame the image), remember that the back mount should be hinged to the front mount to give extra support. Acid-free mounting hinges should be used. Few handmade papers are actually flat, this is part of their character and may be lost if compressed too much during framing.

The adhesives used for mounting should be starch glues or the water-soluble CMC (Sodium Carboxymethyl Cellulose). Most modern chemical adhesives are almost irreversible and may cause staining and deterioration in the paper. By sealing a work under glass with archivally sound materials, you can do a great deal to ensure the preservation of the work. The back of the framed piece should be taped with an archivally sound tape to prevent the penetration of dust and insects, but should not be hermetically sealed as this may cause condensation.

CLEANING, ERASING, FOLDING, CREASES, etc.

There are some specialist paper cleaners on the market, but most paper can be cleaned using rubbers, breadcrumbs or pounce. The simplest way to erase mistakes on many papers is to scrape off the offending ink with a very sharp knife. Then with an agate burnisher, gently burnish the fibres

down again. With surface-sized paper the scraping may well cut through the size to the unsized fibres beneath. The pencil type of typewriter eraser, lightly used and followed by a light burnish, may be more effective with these papers. Internally sized papers do not present this problem as every fibre is coated.

For folding, a good method is to lay the paper on a flat smooth and clean surface, bring the edges of the sheet together and starting in the centre of the fold rub it in both directions with a bone folder. Turn over and rub on the other side.

A creased sheet of paper can sometimes be returned to its former condition successfully. But if the actual surface of the sheet has been cracked, the mark of the crack will remain. The sheet may be flattened by ironing gently with a warm iron between layers of wet blotting paper and then again with dry blotting paper until the sheet itself is quite dry.

One last thing must also be said: that any paper can be worked on. Think of the paper as an integral part of the work and not only as a surface to carry your words and images. It is valuable, and enjoyable, to experiment widely with many papers, developing your work through a continuous growth of knowledge and understanding. It is a question of matching the surface, texture, colour, weight, sizing – all the details of the paper – to all the details of the tools and other materials used – brushes, nibs, quills, canes, inks, paints. The choices must be appropriate to each other, and above all to the work contemplated, and to your vision of the work in hand.

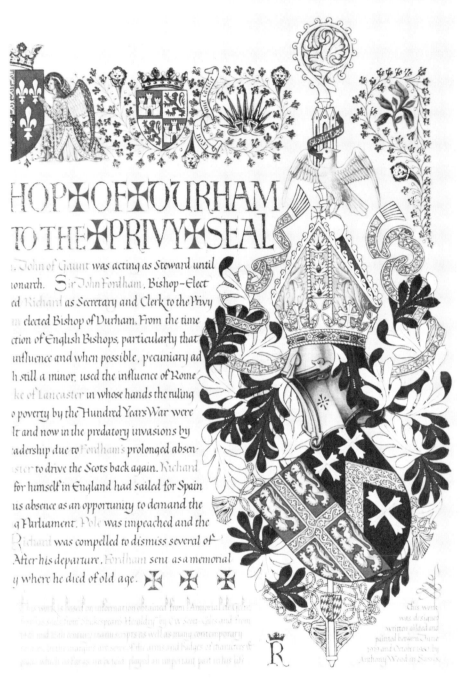

Anthony Wood: Armorial Bearings of Sir John Fordham. Written and illuminated in gold, aluminium and colour on a stretched calf vellum panel. $19\frac{1}{2} \times 25\frac{1}{2}$ in. 1980.

95

Alison Urwick: Letters on papyrus to show texture of material. Actual size. 1985.

Papyrus

ALISON URWICK

The O.E.D. definition of Papyrus is firstly: An aquatic plant of the sedge family, the Paper Reed or Paper Rush (*Cyperus papyrus* or *Papyrus antiquorum*) formerly abundant in Egypt.

Secondly: A substance prepared in the form of sheets from the stem of the papyrus plant by laying thin slices or strips of it side by side with another layer crossing them and usually a third layer again parallel to the first, the whole being soaked in water pressed together and dried; used by the ancient Egyptians, Greeks and Romans as a writing material.

The original development of papyrus in Egypt goes back some four thousand years and much of our knowledge of this ancient civilisation is derived from the hieroglyphic writings on papryi. Stimulating examples can be seen in the British Museum.

Today papyrus is again being hand-made in Cairo and plain sheets of it can be obtained. This is a beautiful and interesting material of proven durability, it has a textured and slightly translucent surface and a warm creamy colour. Reed, quill and metal pens will write on it without the ink and colour spreading. Corrections can be made with a hard eraser or sharp knife, but care must be taken not to damage the surface. At the time of writing (1983) papyrus is available in sheets at a price comparable to vellum. However, the plant no longer grows wild in Egypt so supplies are limited and care must be taken to buy true papyrus, as other plant fibres used in some Egyptian workshops are not durable.

Ann Hechle: Quotation from *The Twelve Days of Christmas*. Hanging of unbleached calico. Background texture painted in stone colour emulsion put on with a roller. Letters painted in red and black acrylics. 1977.

98

Painting Letters on Fabric

ANN HECHLE

Lettering can be applied to all kinds of material: the natural fabrics – cotton, linen, silk; the synthetics; or a mixture of the two – for example, silk/polyester, cotton/nylon. Most manufacturers of suitable paints give instructions for the treatment of materials: cotton for example, may need to have the dressing washed out before any paint is applied.

A brush is the usual tool for painting letters onto fabric – though felt-tip pens have been used successfully. In batik work, a stiff brush or a tjanting (a special batik pen) can be used with hot wax to apply letters to the fabric before it is dyed.

A variety of paints are suitable for use on fabrics, such as designers' gouache and acrylics, both of which are available from good artists' colourmen in a wide range of colours. The important factor in choosing paint is whether or not it needs to be washable. If not, the choice of paint and diluting medium is much greater.

It is also important to find a combination of paint and medium which is fluid enough to release the colour evenly through the brush, to be absorbed into the fabric and yet not to bleed outside the limits of the brush-strokes.

Certain acrylics seem to fulfil these requirements. They cover reasonably well and stay where they are put. The manufacturers claim other desirable qualities. They are stable and flexible and the colours are permanent. They are also washable. Although acrylics are soluble in water when taken from their containers, or freshly on the brush, they become, when dry, a clear film that is water-resistant.

Such acrylics come in two forms: in tubes, of the consistency of oil-paint; or in jars, where it is more fluid. The latter flows more readily from the brush, covers better and more evenly, and is therefore more suitable for painting on fabric.

Whether thicker or thinner, the paint should be mixed with a medium. This may be matt or gloss, according to the demands of the work.

Ann Hechle: Quotation from *The Lady of Shalott*. Letters painted on a curtain of unbleached calico in acrylics in shades of brown. Letter size: 3–4 in. high. 1975.

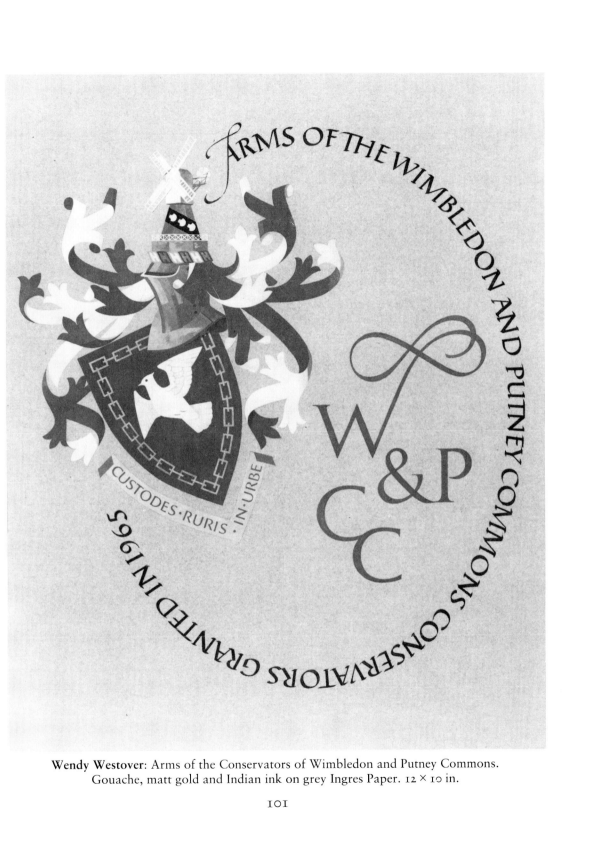

ARMS OF THE WIMBLEDON AND PUTNEY COMMONS CONSERVATORS GRANTED IN 1965

CUSTODES·RURIS · IN·URBE

W&P CC

Wendy Westover: Arms of the Conservators of Wimbledon and Putney Commons. Gouache, matt gold and Indian ink on grey Ingres Paper. 12 × 10 in.

roman

abcdefghijk
lmno
pqr
rstuv
w
xyz

keep your eye on the

compressed

but still **roman**

abcdefghijklmno
pqrstuvwxyz

moment (ag
moment {ag}
inter stroke spaces

lateral compression

The phrases of his pleading
Were full of young delight;
And she that gave him heeding
Interpreted aright
His gay, sweet notes,—
So sadly marred in reading,—
His tender notes.

SECOND VERSE

Italic

And when he ceased, the hearer
Awaited the refrain,
Till swiftly perching nearer
He sang his song again
His pretty song:—
Would that my verse spake clearer
His tender song!

THIRD VERSE

Italic

abcdefghijklmnopqorst

uvwxyz

roman arches | roman arches

m m m m

m n r
1. Lateral compression
2. Branching of arches
3. Lengthened ascending & descending strokes

italic arches
think of a lancet window

roman

I heard a linnet courting
His lady in the spring:
His mates were idly sporting,
Nor stayed to hear him sing
His song of love.~
I fear my speech distorting
His tender love.

FIRST VERSE

cursive

1234567890?1234567890!

Ye happy airy creatures!
That in the merry spring
Think not of what misfeatures
Or cares the year may bring;
But unto love
Resign your simple natures
To tender love.

Last Verse
of
Poem by Robert Bridges
Irene Wellington

Irene Wellington: *Just like one who wants to learn to write*, examples of different hands (with constructional diagrams from one side of a fold-out, containing seven pages on each side) designed as a gift for Lord Cholmondeley, 7 June 1948. Written on paper in black ink with pink, blue, red and yellow watercolour. Size of fold-out when open: 18 × 91 cm. By courtesy of the Dowager Marchioness of Cholmondeley.

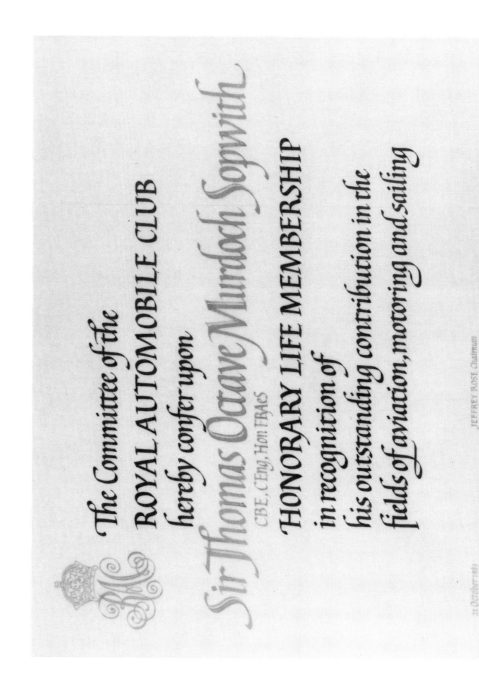

The Committee of the
ROYAL AUTOMOBILE CLUB
hereby confer upon
Sir Thomas Octave Murdoch Sopwith
CBE, CEng, Hon FRAeS
HONORARY LIFE MEMBERSHIP
in recognition of
his outstanding contribution in the
fields of aviation, motoring and sailing

21 October 1983

JEFFREY ROSE Chairman

John Woodcock: Presentation address for the Royal Automobile Club. Blue gouache and black ink on vellum. Bright aluminium frame. 19 × 22 in./48.7 × 56.7 cm. 1983.

Formal Scripts

JOHN WOODCOCK

If the word 'design' is applied to a script, our inheritance of the Latin alphabet, which gradually evolved over many centuries, immediately conditions the word. It is only on the most personal, introspective occasions that it can be considered as meaning the creation of totally new basic forms. On the majority of occasions where legibility is a prime consideration design will mean an interpretation of detail around existing 'skeleton' letter forms.

The essential nature of an alphabet is that the letters of which it is constituted can be used to form words and sentences which convey ideas. This presupposes recognition and understanding of the letterforms by the reader, and the ease and speed of recognition will obviously facilitate that understanding. The less the reader has to guess at, or to learn a new system of letter symbols, the quicker will be the conveyance of the sense of the words. So formal scripts will be based on alphabets which a reader may be expected to know well. The fewer idiosyncrasies of form which interfere with the recognition of the essential shape of individual letters and with the totality of the word and sentence, the easier the reading.

Whatever the technology, the individual letters of typefaces are naturally multiplied in exactly similar form. This results in an anonymity whose virtue lies in the lack of interference between words and reader. Calligraphy inevitably introduces variations of letterform, intentional or not, whose virtue lies in the immense range of possibilities between the purely decorative and the positive visual characterisation of the sense of the words. Control over this choice is essential.

The amount of printed reading matter surrounding everyone gives rise to a familiarity with certain families of letterforms (typefaces usually) which will have formed a visual imprint of quick recognition in virtually all readers' minds. Depending on the nature of the work in hand, it might be the scribe's intention to write letters bearing such close visual relationship to these familiar forms that speedy recognition and reading would ensue. Or it might be the intention to write letters which would slow down and allow a savouring of the sense of the words – a simple example being the oft-quoted use of italic rather than roman lower case for poetry, which is normally read more slowly than prose. On less formal occasions it might be the scribe's intention to give readability, or even legibility, a secondary role and to make the 'picture of the words', colour and texture, the 'mood' of the whole the prime purpose; an abstract visual impression of the general sense of the text, with the certainty of deciphering available at a lower level of consciousness. In this case a less familiar, even esoteric model from history might be chosen for its particular connotations; or the character of the tool to be used, the

ground and the medium, might be allowed to have their natural effect on a chosen basic letterform and its disposition, to the benefit of the whole mood.

So the starting point of the 'design' of the script will be the clarification in one's mind of the intention – and the design requirements of the work in hand. Or if, perhaps, a script is being designed as a sort of abstract exercise, what will be the kind of occasions for its use – formal or informal, ceremonial and public, or private and anonymous? Based on these decisions there will follow the choice of an appropriate 'skeleton form' chosen from our traditions and this will be fleshed out, adapted or detailed according to purpose, tool and medium, or just on account of the natural inclinations of an individual scribe's personal hand-motions.

The purpose of the proposed work will probably give some simple indications of choice of letterform, based on requirements for readability suitable for the occasion. For a mass of text to be read quickly, a roman form of letter will be more readable than, say, a 'Gothic' black letter because we are more used to the former. A fourteenth-century reader would doubtless have found the reverse to be true. If quick reading is not a criterion, the 'classic', literary feel of a roman letter may still suit the sense of occasion, or it may be that a darkly-textured piece of writing sets a better mood.

Generally, any amount of text is more readable in lower case than in capitals, not because we are unfamiliar with the shape of the capitals but because we do not normally read them in any quantity. The lower-case, with its ascenders and descenders, makes up the word outline with which we are most familiar, so much so that our eye does not rely on positively identifying the constituent parts of the

word when reading at speed but relies on a memory of the word outline, or even takes in a whole phrase made up of several familiar outlines. Thus, if we read too quickly, we can make errors of identification and sometimes mistake one word for another, or gloss over a mis-spelling. In one way, the shapes of individual capitals are more distinctive as units than the lower case, but we tend to require to 'spell out' the word letter by letter so it is a slower reading process – more formal. The word's distinctive shape in capitals depends less on outline than it would in lower case – its differences lie within the boundaries of the constant letter height. Because of these qualities, capitals remain perfectly legible when quite widely spaced – maybe to form a particular, rather grand and formal texture in an inscription, or used as emphasis with a more quickly-read lower-case text. But lower-case letters, similarly spaced, rapidly become less readable than when spaced closely enough for the word's distinctive outline to be quickly identified. In a way, the 'counters' (or voids) within lower-case letters occupy a more dominant role in relation to the letterforms themselves than they do in capitals (unless of an unusually heavy weight).

It has been stated already that the starting point of a 'design exercise' is likely to be the selection, as a basis, of an alphabet (or the part available) already evolved in history. It is not within the scope of this essay to present a historical background, but it must be obvious that some knowledge of our traditions is as essential as a feeling for the artistic mood of our own time.

The history of lettering demonstrates a number of cycles between the pinnacles of highly-developed and socially accepted script (which has reached that point

because of a variety of influences – social change, practical use of the script, medium), and the troughs of change. The same factors have usually led the alphabet through degrees of informality towards another point of formality. Various degrees of mediocrity or excellence may be discerned in these developments and scripts may have characteristics worthy of extracting and developing, provided that the basic principles of an alphabet are always borne in mind.

The alphabets chosen here as examples come from periods of high development, roman capitals and lower case and italic having endured a multiple exposure to a variety of influences. The major one, perhaps, was the Renaissance and the invention of typecasting and printing which resulted in the forms current at that time being perpetuated (not without an element of chance – our norm might well have been black letter) and ensured that they are the forms with which we are so familiar today and on which our standards of legibility still largely rest.

There can also be traced an undercurrent of relationships of aesthetic 'style' with other social and artistic endeavours of a period, so that an alphabet will subtly announce its connections just as, say, architecture does in a more obvious way.

It is also helpful to understand, if possible, the practical demands and mode of production of a chosen historical example. Is it, for instance, a lectern book to be read by more than one person in turn, in dimly-lit surroundings, and has the scribe made accommodation for this in the size and weight of letter and its line-spacing? We can relate these factors to our own purposes, appreciate the essential forms of what we are studying and avoid slavishly copying writing habits and detail

which is irrelevant. It should also help in the difficult task of giving a contemporary air to our resultant letters without straining after an imposed modernism.

Letters used for pages of text and for road signs may well have a common ancestry but their detailed design should reflect not only the difference in manufacture, but the difference between the act of holding a page in the hand to read at rest, and the act of gaining necessary information in a fraction of a second when approaching at high speed, in tense circumstances and in variable light.

What we make of the 'skeleton' model will naturally express the fact that the broad pen is one of the most clearly formative of letter-making tools, but what we form with its aid does need to be done with intent and control. Calligraphy today is at a point of great interest and of great possibilities of development but we do need to note the experience of modern technology in terms of the seduction and the possibilities of the tool. So far, the immense capabilities of computers have been used disastrously to veer between the ideas of producing totally new forms and of merely reproducing forms more appropriate to conventional typeface generation, with little reference to the essentials of letterforms. In a different way the pen or brush has such seductive qualities and dangers.

LETTERS AND WORDS

Each letter in an alphabet, and thence each word, is made up of a certain unique combination of straight and curved strokes in skeleton form. The writing implement will add variations of thickness, and detail such as serifs. Any movement of the pen

which detracts from this uniqueness of shape will give rise to possible confusion and loss of legibility. This characteristic may be demonstrated obviously by comparison between such a word as 'minimum' written in roman and gothic characters. In the latter case, the over-simplification of the structure of individual letters results in great illegibility in the word as a whole.

minimum
minimum
minimum

Illus. 1: It will be noticed that the tops of the letters are more influential in the cause of legibility than the feet. A slight emphasis on the first and last serifs of compound letterforms also helps when there are no ascenders and descenders to delineate the word outline.

The combination of shapes within a lower-case word is, of course, made more distinctive if there are letters with ascending or descending strokes, such as b, d, p and q.

The designing of an alphabet becomes a balance of distinction and unity amongst its component strokes. Letters of closely-related shape such as c and e must have their similar parts made with a similar pen movement otherwise no family likeness runs through letters of the alphabet, but this must be balanced against the basic requirement of legibility that the maximum distinction shall be retained for each individual character. Therefore, for instance, the serif of the c and the upper bowl of e must be as dissimilar as possible

within the limits of the satisfying balance of the letter as a whole and the aforementioned family likeness.

If continuous, easy reading is the aim, no letter should be so unusual in shape as to draw attention to itself at the expense of the word outline and the eye's easy movement along the line.

SERIFS

The general sense of balance of the letters and the movement of the eye left to right along the line may be enhanced by serifs, but great care is required in their design as also in the relationship between the length of ascenders/descenders and the x-height (the height of the main body of lower case, such as letter x), and of ascenders/descenders to the height of capitals. Unusual proportion (that is, more than double the x-height) of ascender and descender tends to lead the eye away from its essentially left-to-right movement. Serifs, as well as being a practical way of neatening ends of strokes, help define individual letters' 'territory'. They decrease irradiation in smaller sizes of fine weight, thus adding to legibility. However, the broad pen naturally makes very distinctive serif shapes which, especially if made in a continuous movement with a main stroke and written at speed, are often over-emphasised at the expense of legibility.

Comparison with pointed brush or chisel roman shows that the pen tends to make heavier serifs. In the smaller sizes or when writing freely it is not easy to avoid weakness of form or a detached quality in relation to the main strokes.

Confusion between the serifs and the main constructional curves of the letter easily takes place in semi-formal or condensed alphabets.

The angle of the pen's edge to the

chisel brush pen

* little difference between arch form and serif

× high pen angle gives over heavy serifs (which here are exaggeratedly curved filling in the counter space)

Illus. 2: Each tool gives its own character to the serif. It is useful to bear in mind the comparative scale of serifs: the pen serif easily overbalances the main parts of the letter.

Emphasis on main verticals.

Emphasis on minor strokes.

Illus. 3: The pen angle will, however, be a higher one for italic and 'Rustic' alphabets.

Illus. 4: A formal roman letter with arch form requires, for strength of construction, that the arch be upright and symmetrical. If the pen is allowed to slide away on its thin stroke, a weak asymmetrical shape can result.

Illus. 5

horizontal line is important in this respect; if held at an angle of 20°–40° the edge will naturally give a slightly greater emphasis to the main verticals than to the serifs or minor horizontals in an upright roman lower-case.

When writing freely and with speed the pen angle easily wanders and there arises a weakening of curved strokes due to the pen's tendency to strike off in the line of least resistance to the broad edge. This is exacerbated by too much pressure of pen against paper or vellum or by tension in the fingers holding the pen. The pen must be held in a controlled but relaxed manner. Faults of abrasiveness of pen against writing surface or of ink-flow, if allowed to continue, usually emphasise the above faults.

Strokes of full width or the finest are easier to make than ones which gradate between the two – these are the ones where weaknesses of form usually occur.

This gradation from thick to thin is what produces the quality of 'sharpness' which is so typical of the product of the broad pen. It does require, however, the pen to be cut to as fine an edge as the writing material sensibly allows. The traditional combination of vellum and quill allows this quality to reach its peak. It does also allow weaknesses of form if the thinnest stroke is extended, as at the junction of gradated thick stroke and thin in curved letterforms.

The designing of an alphabet includes due consideration of these various aesthetic and practical problems and the rejection of those qualities which are

superfluous to the particular purpose of the script. This reduction to a simple basic form, clothed easily and naturally by the writing instrument and working towards a defined objective may well result in the accidental qualities of personality and beauty. Like 'personal style' in drawing, the same quality in calligraphy will look forced if striven for – it will only arrive naturally when the application of skill and control can be applied in a relaxed manner to the base of a clearly defined intent, using soundly constructed letterforms in an appropriate arrangement.

To sum up, a check list of preliminary decisions as guidance for the choice of an alphabet might be as follows:

What is the intention of the work: is the occasion a public and formal celebration or a personal and private reaction? Is it composed of a mass of text to be read quickly and easily, or a few words, or individual letters even, expressing character primarily?

Therefore, is the script to be formal and legible, based on classic traditions, or informal – legibility less important than mood? Or something in between?

Thus, what should be the chosen model script? what is its basic skeleton form? what detail will the pen, naturally and simply used, give to that skeleton?

Are the material, medium and tool traditional – their preparation giving to the letters the pen's essential sharpness? or are they untraditional, chosen to add expressionistic mood to the words perhaps? and, if so, what qualities does their combination naturally require of the script?

THE ALPHABETS

The provision of these alphabets is an attempt to provide models of basic letterforms in general use, which can be simplified, elaborated or otherwise adapted for given needs. They can also be developed in detail by personal study of variations of the historical forms from which they are derived.

As models, they attempt to demonstrate qualities such as consistency and strength of structure in a formal (slowly written) way. Once understood, they may then be developed in a freer, more rapidly written way, emphasised perhaps by an appropriate tool, medium and surface.

Their study and mastery should also, through experience of the pen as a letter-making tool, foster an appreciation of letters generated in other media by other technical means. The essential simplicity and forthrightness of the broad pen, the degree to which it gives form and proportion to a letter by its very shape, provides its fascination, but its directness makes it a difficult tool to use well without a clear mental concept of what one is trying to make it do. The slanted-pen alphabets illustrated suggest a repertoire of technically fairly simple forms of general usefulness for the legible massing of text matter. More expressive variants should more wisely be left until these basic forms are understood.

SKELETON FORMS OF ROMAN CAPITALS AND LOWER CASE

Two of the high points of development and use of Roman capital letters were in the classical Roman period around the first century AD and in Renaissance times around the fifteenth century. The latter period is the one of special significance in

that the forms were not only revived in a scholarly way through conscious study of the pen but became preserved through printing technology. Both were periods of great interest in science (as far as it was developed at the time) and associated theorising. There is plenty of evidence remaining from the Renaissance of the theories of proportions of letters largely based on geometry and often highly impractical for everyday use, but showing an obvious fascination for the 'rediscovered' classical Roman letters. There is no evidence about the 'theory' on which the Roman letters themselves were based except what is clear from the remaining artefacts. Those inscriptions or manuscripts using Roman capitals executed in a formal manner, and emanating from centres of culture, demonstrate a common ancestry, evidently based in skeleton form on simple geometry. The re-statement below of these proportions must be accepted as another theory which may be of guidance as a basis of work. Like its predecessors it is of obvious relevance to the more simply-based geometrical letters, yet becomes cumbersome if one tries to give a completely mathematically acceptable reasoning for the more complex letters. It is at this point that I believe the appreciation of balance of area, shape and proportion becomes the only worthwhile guide, and it is at this point also that personal preferences come into play.

The skeleton forms remain relevant if written by a monoline implement – or with a broad pen, so long as the thick strokes which are applied to the skeleton remain of the order of 1:7 or 8 relative to the height of the letter. If these proportions are much increased, then the necessity of balancing the positive weight of strokes with the counters will involve varying

degrees of departure from the basis of the proportions, particularly in lower case.

Illus. 6: In the exaggeratedly heavy versions, it will be seen that the counters of E and e suffer by comparison with the area within D and d and require some departure from the principles of proportion mentioned later. In typography, 'small caps' (true variety) will be of quite different detailing from the normal caps for similar reasons (plus others of a technical nature).

Skeleton Roman capitals
As noted above, the theory of proportions is a rather simplistic aide-mémoire. Subtle variations are obviously needed for more or less simple or complicated reasons of 'balance' related to principles of visual perception. For instance, the appearing centre of a rectangle is above the mathematical centre; therefore the cross-bars of EHB and the mid-point of KSX will be slightly above the mathematical centre. This will also make the base of E and B slightly wider than their top. By contrast the cross-bar of A will be lower than the centre of its height; it will more or less divide equally the area of its counter. If the lengths of E's horizontals are made exactly equal, the centre one will appear to protrude, therefore to compensate visually the bottom is the longest, the middle the shortest, the top in between. And so on, to ever more detailed and subtle

Illus. 7

a Round – based on the circle O Q C G D
D falls short of the full width of the circle and, by its departure from the circle, encloses a shape of equal area to the circle. C and G by their imaginary extension do likewise.

b Rectangular/diagonal H U N T Z
Based on a rectangle of equal area to the circle.

c Half-width, round or rectangular
B P R S E F L
Based around a circle of half the height (therefore half the width) of the large circle. This is the point at which the simplistic notion of areas related to the circle becomes too complex for ease. By trial and error one may find right-appearing widths/counters and, for convenience, relate them to the first set of widths-to-height proportions.

d Triangular A V X
For convenience, remember as the same overall width as group b.

e Multiple M W
M is not the same as W upside down. If the centre 'V' of M is made the same width as V, the near-upright outer strokes bring the whole width to that of the circle. Note that the two outer angles are smaller than the centre one, whereas in W the three angles are much the same.

f Intermediate K Y
A width between those of group *b* and *c* seems to be right. Try making them the width of *b* or *c* and see what happens: for convenience, then, a 'three quarters' proportion.

g Thin I J
They are obviously of no significant width in terms of proportion. The tail of J is to distinguish it from its related ì sound. As this whole demonstration is based on the circle, it is convenient to think of the tail as a part circle; a quarter of the group *c* letters' circle, perhaps.

ABCDEFGHIJK
LMNOPQRSTU
VWXYZ & ᴿᵁ
&Q

Illus 8

accommodations within the simple basic theory. It is necessary to consult other books to study in detail the degrees of subtlety which may be given to the drawing of the roman letter, but authors of such works have a tendency to make rules, often depending on their preference and the historical models studied. It is wise to look at some of the very lively interpretations of the Roman letter executed in provincial centres of the Roman Empire as well as the oft-quoted Trajan column, and to study later variations on the theme.

A monoline skeleton alphabet is worth practising in two ways. Firstly, with a pen which gives the required weight of line at one stroke. This will obviously develop a facility in drawing the correct shapes with the immediacy which, later, the broad pen adaptation requires. Secondly, using a monoline pen which gives about half the eventual weight of line. This requires the kind of drawing where the desired shapes are built up from a sequence of strokes. It makes one aware of the niceties of slightly varying outlines which define the counter (inside) spaces of the letters, and of varying

thicknesses of line at junctions of letter strokes. It is the way in which the illustrations of skeleton alphabets were drawn.

If one adopts as a basis a shape other than the circle, an oval say, the round letters will obviously follow its particular form, whether more or less pointed or squarish, but if it is much condensed in width the geometrical theory will have to be variable. Should the oval be less than half the width of a circle, it will be seen by experiment that to make letters of group *e* (M and W) much the same width and then to add any appreciable thickness of stroke to the skeleton becomes a ridiculous task.

Skeleton Roman lower case

The history of letterforms demonstrates that the lower-case alphabet developed gradually from the capitals. The uncial letters demonstrated later show several letters at an intermediate state of this development. Obviously, if lower-case letters are to be used with capitals their proportions and detailed design should have a great deal in common. To achieve this we may propose a theory based on the

Illus. 9
a Round letters o c e d b p q

b Letters whose width is based on a rectangle equal in area to the circle, some including a part circle.
n u h a v x y z

Illus. 10
c f t k j s

d Double width of rectangle. m w

e g arrived at its 'normal' roman form (as distinct from the alternative round g) by a rather complex development from capital G. For reasons of visual balance it is not sufficient to draw it round two small circles between the top of x and the depth of the descender. It needs to be contained within a truncated cone, the top circular, the base oval in form.

circle in similar fashion to that for capitals, but which will obviously vary in detail. As the lower-case letters are not so directly related to simple geometrical shapes it is also more difficult to avoid a more convoluted and less useful system.

There are other letters which obviously have parts of their forms related to the circle: f j k r s t – it may be convenient to think of these of similar width to group *b*

(n, u, h, a, etc), but in practice they may well need to be a little narrower. Lower-case seems on the face of it to be a smaller version of the capital but basing it on two small circles within the x-height makes it appear unrelated to other lower-case letters, and with any degree of stroke weight applied to the skeleton one rapidly runs into trouble balancing that weight to the counter space.

So all these may be thought of as a group of the same width, and k can be included with them. Lower-case m and w, unlike the capitals, are double the width of n and v. Lower-case i and l are obviously thin, single-line letters. Lower-case l with a curved base is sometimes included with the group *c* letters but this seems to make what is, in modern usage, a serif into a tail (which is historically correct in that the lower stroke of capital L became gradually abbreviated) but seems something of an anachronism when related to the generality of letterforms in current use.

The lengths of ascenders and descenders are related to the height of the main body of lower case (or x-height) and to capitals. It would be a neat theory if the capitals and ascenders and descenders were twice the x-height. This would give sufficient 'typical outline' to a word to make it distinctive. If, however, this is done in a mass of text it will be seen that the capitals stand out slightly obtrusively and that the ascenders and descenders exaggerate the word outline in a way slightly disruptive to the easy left-to-right movement of the eye. Therefore, if the ascenders and descenders are made to extend by two-thirds or three-quarters of the x-height and the capitals slightly less, this will make the balance about right. If the ascenders are equal to the x-height, then the top of the capitals will be right at about three-quarters the height of the ascenders.

or

Illus. 11: Relationship of ascenders and descenders to capitals. Ascenders and descenders are two-thirds or three-quarters of x-height. The top of capitals should be slightly below that of ascenders.

abcdefghijklmn
opqrstuvwxyz

Illus. 12

NUMERALS

In typographic terms, numerals are of 'ranging' or 'non-ranging' varieties, based on the same skeleton form and, where appropriate, on the circular or part-circular forms of their related capitals and lower case. The term 'ranging' applies to numerals that are all the same height as capitals. 'Non-ranging' describes those that have 'ascenders and descenders' thus matching the general texture of the lower case. Each form is appropriately used when solely, or mostly, within a context of capitals or lower case respectively.

Through the conventions of typographic

ABC 1234567890 'Ranging'

Axbp 1234567890 'Non-ranging'

Illus. 13

usage, it is usual with 'non-ranging' numerals to see 1, 2 and zero equal to the x-height, the remainder having ascenders and descenders (usually of less height than those of the lower case – they are difficult to 'read' in quantity if they extend by the same amount). They are mainly half the width of the capital O circle, the zero being made an oval to distinguish it from O.

SLANTED-PEN CAPITALS, LOWER CASE AND NUMERALS

These are based on the preceding proportions of skeleton forms. It is usual to write them with the nib held at an angle to the horizontal of 20°–30°, thus giving an emphasis, a natural strength, to the uprights rather than minor horizontal strokes. (The pen holder being held at 65° or so to a board balanced at about 45°. This gives comfort in use and aids fluency of pen movement.)

The width of nib related to x-height may obviously be varied to suit the occasion, giving either a thin, virtually monoline stroke or one about a third (or even a little less) of the x-height. For

practice purposes it is suggested that the traditional proportion of four, or four and a half pen widths to x-height is good in that it avoids excessive problems in design of letter weight-to-counter yet allows the pen character of thin-to-thick variations of stroke to be obvious enough to point up faults of letter construction. But it is not an inflexible rule any more than are the rules of proportion.

Letters that are formally written as distinct from an informal, cursive hand, will naturally require the pen to be lifted to avoid strokes unsympathetic to ease of control of the pen. Thus, strokes which are difficult and to be avoided are those which push against the thickness of the nib and those contrary to the natural left-to-right movement of writing. Some varieties of serif will also desirably involve a pen lift. For instance, Illus. 15 indicates desirable points of lift and order of strokes:

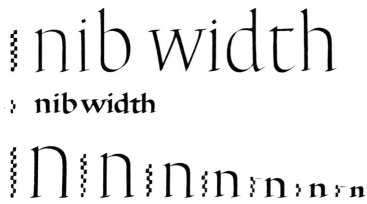

Illus. 14: Effect of width of nib to x-height on the weight of the letter.

Illus. 15

These serifs are suitable for slowly-written letters involving a number of pen lifts. Although more complex in construction than the alternative forms shown in Illus. 17, it is suggested that the necessarily deliberate method of writing develops consideration of 'strength' of forms and relationship of serifs to main strokes to begin with; once these have been absorbed it is easier to progress to more informal varieties.

The rule that a consistent 30° (or whatever) angle is adhered to may, like other rules, require to be broken occasionally for the sake of refinement. For instance, capital N would have three fairly thick strokes under the rule of consistent angle. It seems better to relax the rule in the case of the uprights to avoid the meeting of several heavy strokes and to be consistent with the general nature of thick joining thin that is an essential part of the rest of the alphabet. Conversely, to avoid a multiplicity of thin strokes, the pen needs turning in one or other direction in the case of Z (a flattening of angle for the centre stroke is my preference). These points are marked with an asterisk.* The

ABCDEFGH
IJKLMNOPQR
STUVWXYZ&

Illus. 16a

117

first A shows the letter drawn with 'double pencils' (two pencils bound together with tape or elastic bands). This is a useful way of illustrating the basic structure of a letter but it does not show the contrast between 'counter' and letterform as clearly as pen and ink do.

Serifs which do not need a pen lift are those at the end of curves, the top of C for example, or horizontal straight strokes, where a flick of the pen is sufficient conclusion rather than a completely separate stroke.

Aabcdefghijkl
mnopqrstuvw
xyz ry ra ffi ?!;-
bp 0123456789

Illus. 16b

AKMXZ
bmpry

Illus. 17: Alternative, simpler serif forms, used at similar points of the alphabet for consistency, with fewer pen-lifts involved.

118

Some general points of difficulty to watch out for are:

Illus. 18:

a symmetrical arch form, beginning at the base of the serif, thickening immediately from a fine thin

b serifs extending equally each side of the main stroke. In this form of serif the pen stroke is virtually a horizontal. The curve (slight) into and away from the serif is achieved by fluency rather than a definite curving movement of the pen.

c curve flattening towards the meeting of the uprights; otherwise a heavy conjunction results

d serif only on one side so as not to confuse the letter outline

e arch form, the reverse of n

f x-height

g pen lift if desired

h symmetrical arch but wider and flatter than other arch forms

i visual centre of balance of the whole shape

COMPOUND ROMAN CAPITALS AND VERSALS

'Versals' originate from the mediaeval habit of using compound letters as initials to verses, chapters and titles.

The two are grouped together because they share an essentially similar method of construction; that is, a number of single pen strokes are used to build up the thick strokes – although the detail may be sufficient to make them appear different alphabets when finished.

They are based on the same roman skeleton forms. In the case of the roman capitals, the subsequent detailing follows that of lapidary inscriptional letters, that is a subtle refinement of entasis and serif curve, and an angled 'stress' of round

letters. The ratio of thick and thin strokes to height of letter may also echo the same models. Versals have a vertical stress to round letters and sharply defined angles at the meeting of serifs and main strokes. The change from thick to thin on curved strokes tends to happen fairly abruptly. In fact this last characteristic can easily look archaic if not used in an appropriate context, and there are particular letters (sometimes with alternative Uncial-like skeletons) which emphasise this quality. Some are shown following the alphabet of Versals.

For Versals the nib angle is either parallel to, or at right-angles to the writing line. For roman capitals my preference is to hold the pen at an angle of about 20°–30° to the writing line, except for

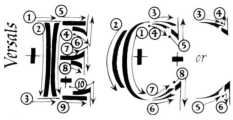 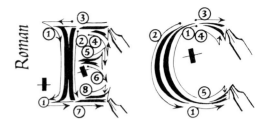

Illus. 19

A B C D E F G H I J K
L M N Q P R S T U V

W X Y Z Roman

Versal A B C D E

F G H I J K L M N O P

Q R S T U V W X Y Z

J K R S D R M T W B

Illus. 20

R P B L ALPHABET

Illus. 21:

vertical and diagonal strokes and their serifs (where the pen is held at right-angles to the writing line) or for finishing serifs to horizontals (where the pen is turned on its corner). Both alphabets are normally slowly written (drawn almost), formal, with frequent pen lifts dictated by the construction.

The pen width chosen should be such that the thicks are achieved largely by two strokes, the second touching the previous one. A third single, flooding, pen stroke may be necessary towards their extremities, but this infilling should be kept to a minimum, for the sake of directness and freshness. If a heavier weight of letter is desired, a more flexible pen with a longer slit may be used on a flatter drawing board to facilitate the flow of ink or colour. This avoids the use of extra parallel strokes to achieve the thickness of letters.

The method of construction led to typically decorative variants in mediaeval examples, the best simply and vigorously executed.

The method may suggest variations which show the construction to advantage in more modern-looking letterforms (Illus. 21).

ITALIC CAPITALS AND LOWER CASE

These alphabets mostly derive directly or indirectly from roman capitals and lower case – a case of the previously mentioned cycle of a slowly written formal hand undergoing changes resulting from speed and fluency and then becoming another formal hand. The differences in the capitals compared with the roman are relatively slight. They are largely those due to the alphabet being based on an oval rather than a circle, with the resulting changes of shape, proportion and, usually, of slope derived from the effect of writing at speed.

The lower case shows similar changes, but it has also developed its own distinctive letterforms which help distinguish it in character when used together with roman. These are simpler forms of a and g, k with a looped bowl, f with a flourish tail and sometimes a round form of y.

Italic usually has a slope of about 10°–15°, but not always: it should be noted that its relative narrowness and distinctive arch-forms are sufficient to distinguish it from roman. There is another variant which typographers have labelled 'sloped roman', a narrow-width, sloping letter that retains roman arch-forms. As this is a slightly more formal letter, perhaps it is appropriate that it should have the more formal 'beaked' type of serif at beginnings of some letters, with the simpler, more cursive hooked serifs for the 'true' italic (see overleaf). But there are no strict rules about this any more than there are for many other factors of letter design. The roman forms of g and y are often used in a formal italic which yet retains cursive characteristics, but the roman 'a' looks very uncomfortable in an italic context.

The essence of the italic arch-form which is such a distinctive element of the letterform is that it is produced by one stroke of the pen together with the letter's upright strokes (Illus. 22). It involves a pushing-upward pen stroke at one point – something previously advised against as producing tension between nib and writing surface. The angle of the letter, and the nib held at a higher angle (about 45°) of thin to horizontal line mitigates this difficulty a good deal, as does the usually lighter proportion of thick stroke to x-height compared with roman. If it interferes with easy fluency, the apparently quickly written form may be achieved in a more formal way involving more pen-lifts.

a *b* *c*

Illus. 22: *a* Usual italic construction in one pen stroke.
b Larger sizes and heavier weights may more conveniently be constructed in more than one stroke.

c Comparison of cursive italic and 'sloped roman' arch forms.

ABCDEFGHIJKL
MNOPQRSTUV
WXYZ&EQTL

abcdefghijklmnopqr
stuvwxyz ykgh &

Illus. 22a: Cursive italic alphabets.

122

abcdefghijklmn

opqrstuvwxyz &

Illus. 22b: A 'sloped roman' alphabet. Capitals for this alphabet would be the same as for the italic alphabet above, but with flatter curves consistent with the flatter oval base-form.

It is especially important in italic writing to avoid any pressure of pen on writing surface which prevents the occasional pushing strokes taking on their proper shape. Although speed had a great deal to do with the evolution of the oval base form, the letterform gave rise to numerous more formal variants. It is therefore possible to write slow italics, with many pen lifts: however, the 'reverse' curve (as at the bottom of a and u), remains difficult to execute unless written with some speed.

There is another aspect typical of italics as a family which is also a by-product of speed. This is the tendency for ascenders and descenders to be longer than the roman, and it is then a natural extension of this tendency for flourishes to be developed at the extremities. Both these kinds of extension need to be developed with care: longer ascenders and descenders normally demand more line spacing to accommodate them if they are not to disrupt the movement of the eye along the line. A flourish will usually 'grow out of' an appropriate part of a letter if it is to look right; moreover, the part of a letter which by extension will not lead to

confusion of its essential shape, but may even reinforce it. Or by extending a minor part of a letter before reaching the emphasis of the flourish, leaving the essential basic letter undisturbed. Or the extension may take on a change of direction which acts as a link between letter and flourish, where the two in a continuous line might lead to confusion of recognition. Flourishes need a developed sense of organisation to be written freely, or careful design at the 'rough' stage of a formally written piece.

The skeleton form may, of course, be based on a variety of ovals provided that consistency is applied in forming the related shapes. It is relatively easy to devise an alphabet of lower case based on a sharply pointed 'oval', but then very difficult to devise an appropriate, accompanying set of capitals, especially if using a pen width wide in proportion to x-height. It then becomes difficult to avoid using a contrasting, gothic-style, set of capitals.

Although much affected by the different tool employed, the italic exemplars of sixteenth-century writing masters executed

'y' or 'if'? K or R?

Illus. 23

ˈabcdefghijklmnopqrstuv
wxyz& ABCD

Illus. 24

on woodblocks may be studied to good effect if a pointed italic is being considered. The lozenge-section graver often gives a natural pointedness to arch-forms, and to the spaces between them and uprights, which has a beneficial consistency.

UNCIALS

The evolution of these letters was largely complete by the fourth century AD, taking their forms from Roman capitals but allowing the influence of the broad pen to modify some of the angular characters to rounded versions. In a later period these changed again (half-uncials) to become the forerunners of a fully-developed roman lower-case alphabet. The typical rounded nature of many of the letters is very natural to the pen, although the somewhat archaic forms need using with care, in a sympathetic context.

The letters may be written with an angled pen or with the pen held vertically. The former method is recommended for study and practice at first as it is more comfortable to write with the pen at an

ABCDEFGHIJ
KLMNOPQRS
TUVWXYZ Q

ABCDEFGHIJ
KLMNOPQR
STUVWXYZX

Illus. 25

angle. The latter method makes letters that can look very grand, as they often do in the early copies of the Bible for which they were used, but some serif forms need great skill in pen manipulation. Letters such as D, F, G, H, K, L and P show the first suggestion of extension towards ascenders and descenders but the alphabet is essentially one of capitals.

The alphabets shown are selected to suggest a basic repertoire of letterforms to suit a wide range of needs but which are essentially, and fairly simply, pen-made forms. Sophistication of detail and subtleties of construction will naturally be made according to the choice and the individual hand movements of each scribe. It is suggested that these should not be allowed to detract from the essential directness of the pen as a letter-making tool nor to distract the reader from the letter's and the word's essential forms without very careful examination of the motive. Letters are, after all, basically meant to be read.

J·S·BACH CANTATA CLXX

VERGNÜGTE RUH', BELIEBTE SEELENLUST
CANTATA FOR THE SIXTH SUNDAY AFTER TRINITY

ARIA VERGNÜGTE RUH', BELIEBTE SEELENLUST RECITATIVE DIE WELT DAS
SÜNDENHAUS ARIA WIE JAMMERN MICH DOCH DIE VERKEHRTEN HERZEN
RECITATIVE WER SOLLTE DICH DEMNACH ARIA MIR EKELT MEHR ZU LEBEN

Vergnügte Ruh', beliebte Seelenlust,
Dich kann man nicht bei Höllen-Sünden,
Wohl aber Himmels-Eintracht finden,
Du stärkst allein die schwache Brust,
Drum sollen lauter Tugendgaben
In meinem Herzen Wohnung haben.

Die Welt, das Sündenhaus,
Bricht nur in Höllenlieder aus
Und sucht durch Hass und Neid
Des Satans Bild an sich zu tragen.
Ihr Mund ist voller Ottergift,
Der oft die Unschuld tödtlich trifft,
Und will allein von Racha sagen.
Gerechter Gott, wie weit ist doch
Der Mensch von dir entfernet:
Du liebst, jedoch sein Mund
Macht Fluch und Feindschaft kund
Und will den Nächsten nur mit Füssen treten.
Ach! diese Schuld ist schwerlich zu verbeten.

Wie jammern mich doch die verkehrten Herzen,
Die dir, mein Gott, so sehr zuwider sein,
Ich zitt're recht und fühle tausend Schmerzen,
Wenn sie sich nur an Rach' und Hass erfreu'n.
Gerechter Gott, was magst du doch gedenken,
Wenn sie allein mit rechten Satans-Ranken
Dein scharfes Strafgebot so frech verlacht,
Ach! ohne Zweifel hast du gedacht:
Wie jammern mich doch die verkehrten Herzen.

Wer sollte sich demnach
Wohl hier zu leben wünschen,
Wenn man nur Hass und Ungemach
Vor seine Liebe sieht?
Doch weil ich auch den Feind
Wie meinen besten Freund
Nach Gottes Vorschrift lieben soll,
So flieht mein Herze Zorn und Groll,
Und wünscht allein bei Gott zu leben,
Der selbst die Liebe heisst.
Ach, eintrachtvoller Geist,
Wann wird er dir doch nur
Sein Himmels-Zion geben?

Mir ekelt mehr zu leben,
Drum nimm mich, Jesu, hin,
Mir graut vor allen Sünden,
Lass mich dies Wohnhaus finden,
Woselbst ich ruhig bin.

Gerald Fleuss: Text of *Cantata CLXX* by J. S. Bach, with notes in the form of a gloss. Chinese stick ink and gouache on vellum. 93 × 52 cm. 1982.

Layout and Presentation of Manuscripts
with notes on simple bookbinding

JOHN WOODCOCK

with quotations from
SAM SOMERVILLE

PRESENTATION: A DEFINITION

The word presentation may be interpreted in a number of ways. It is here being taken to mean on the one hand the design of the words which are to be written and on the other hand the method by which that design is to be mounted, framed, bound as a book or otherwise displayed.

The design of scripts has already been discussed in another section of this book; design in that sense being the choice of a suitable basic letterform and the detailing required by the nature of the work and the tradition of the chosen alphabet – a part only of the total concept of the finished piece. The total concept must obviously encompass the way in which the letterform is to be used to achieve the desired effect – the letter-spacing within the word, the word-spacing within the line, the line-spacing, the margins – the use of colour, gold and decoration and then the presentation, in the other sense – the way the piece of work rests in its intended environment.

At first, the initial concept in the mind may seem rather vague or, on occasions, crystal clear. This will be largely to do with one's reaction to reading the words and one's emotional reaction to their sense; partly based on the way one's visual imagination works; partly on one's brief, which may be a clear direction by the client towards a simple result, or which may be an uncertain intention on the client's part. Alternatively, if the work is private and experimental, there should be some feeling towards an unknown goal. Even in the last case, it would seem beneficial at some stage (as soon as possible and certainly before actually starting the final work) to define one's objective. I believe it is valuable to know something of one's own thought processes – in my own case the first ideas which spring to life crystal clear on first reading the brief are those which are usually *not* able to be translated to a life on paper in the imagined form and are the ones which cause most difficulty in the end.

Writing a brief oneself is a valuable way of showing up what is not clear before starting work: some decisions may have to wait until later but it is best to be forewarned of what they are.

FUNCTION OF THE WORK

So, what is the function of the work? Presumably there is a defined text, or if not it obviously needs to be decided on to start with. Is there a predetermined form: presentation address, poster, book, bookplate, invitation card, public sign,

private diary, print or original for wall display, letterheading, etc.? Some of these may have a format dictated by their use and its constraints. The poster may be intended for a public site and expected to conform to the 30 × 20 in. norm (A2 for metric sheets of paper), or it may be one to be displayed on internal walls of a building to a limited audience in which case the usual portrait-way shape and size may be ignored.

A presentation, if in book form, may sensibly take its format from, say, an available size of hand-made paper, of suitable weight and surface, folded into the required number of 'sections'. It is not necessarily limited by considerations of sizes that can be held easily in the hand, nor by the economic constraints affecting the page size of a printed novel. If the book is to be of vellum it can be of a page size suitable to the sizes and weights of skins available (and the parts that are usable) and to the method of binding suitable to such material. Delightful to work on if of good quality, and prepared well by the scribe, vellum is nevertheless notoriously difficult to bind into a book whose pages will open smoothly. What materials can be used to cover the binding and fit in with the general idea of the book as a designed unit and a satisfying whole?

If an invitation card is to be sent by post, what are the available sizes of envelopes into which it will fit nicely and therefore present itself well on delivery? Does the available 'stock' of envelopes match the colour and surface of the card and are both card and envelopes economic and available at the right time? It is better to sort out these points at an early stage.

A framed broadsheet may have a site designated which will impose a reading distance and suggest something about desirable writing sizes.

These are largely practical and functional considerations that should be part of the initial conceptual thinking about the work if a beautiful visualisation is to be fully realised and not be cramped and spoiled by later problems. The practical and functional aspects of a proposed work are not just that; they affect the aesthetic qualities of the work and the end result.

THE WORDS

The words will be the starting point of visualising the design as a whole. They may be a mundane announcement of some fact or occasion; what is the nature of the announcement, or of the person or organisation wishing to disseminate the information? They may commemorate a formal celebration. Should the piece of work look grand and austere, joyful and decorative, logical and clinical, or what other quality should it have? The organisation may be grand in a traditional sort of way but the announcement may be about a light-hearted and playful occasion, so which mood dominates? Definition of the factors involved (the source of the words; their particular meaning and nature; the occasion of the communication; the recipient of the information) will determine two crucial elements of the design in a broad, preliminary sense – the choice of suitable letterform(s) and the way in which the words are disposed in space. Either, or both together, may be used to convey the information efficiently and at the same time emphasise the mood of the words. This will apply whatever the nature of the words' meaning or whatever the occasion of their presentation.

THE LAYOUT

The starting point, again (it cannot be overstated), is in the words and their sense. Bearing in mind the general effect aimed at, one's first step will be a pencil try-out of how the words can be distributed into lines so as to emphasise their sense. This may have been already indicated by the author, when he provided such elements as a title, sub-title, introduction; or, by studying the sense and punctuation, we may arrive at divisions of the words into lines and masses of lines. Occasions where emphasis is desirable and possible, and occasions where straightforward, continuous reading is preferable, will suggest themselves. There will be various permutations and when it has been decided which is best the next stage will be to decide on varieties of emphasis to be applied through the choice of letterform size, weight and colour. A simple statement may need no more than one size of a particular hand and will be a simple calculation of x-heights, line-spacing, lengths of line and margins. It is a good rule to begin by making rough try-outs of disposition of words and lines on this simple basis. Again, the permutations can be studied and a complex text thus kept under control and a unity of design preserved, whereas if one begins with too many possibilities of change, it can rapidly become a problem of how to give disparate elements a necessary degree of co-ordination and design structure.

Degrees of emphasis may be achieved, in increasing complexity: from one size of one alphabet; through one size in two weights; that plus colour; a mixture of capitals with capitals and lower case; to a mixture of alphabets; and so on. Then there is the question of the words' disposition in space. There are no easy formulae for the preliminary stage of the design: the combining of the words within the space allocated for them – the size of the letters, space within words and between lines and the space around the whole are inevitably matters of considerable trial and error at a rough state. The experience which will lead to some short cuts to a successful design can only be built up the hard way – that is through personal experiment – but this can be helped by good advice and can certainly lean on others' successes or failures in the shape of sharp observation and the imagining of their initial problems.

TEXT AREA AND MARGINS

There are some simple pointers to bear in mind at the initial stage of considering the text as an abstract composition in space, once the sense of the words has provided a starting point. A simple exercise is to place a dot at the mathematical centre of a rectangle. Viewed from a distance, the dot will apparently be lower than the centre. Compensation for this optical illusion means that most bottom marginal spaces of a design are larger than the top. Not all occasions, of course, will call for the design to be in the apparent centre of the area; a less formal or less traditional design, one calling for tension in the arrangement (a liveliness perhaps) rather than repose, may be better with a consciously off-centre arrangement of space around it (and maybe within). A dot (to consider the simplest form) or any mark or shapes placed on a rectangle will set up visual 'forces' or relationships with the spaces around and with the containing edges and corners. These need to be balanced, whether tension or repose is the intention. The way a rectangle on which work is to be placed is subdivided is

important, as major divisions of the 'field' will be very apparent to the eye at first sight.

Traditional sizes of paper are commonly of proportions using 'simple' numbers – 3:2, 4:5 etc. Their ratios change when folded in half, however. Proportions introducing 'irrational' numbers such as $\sqrt{2}, \sqrt{3}$, etc. allow more constant mathematical inter-relationships within and between sheet sizes. 'A' sizes of paper are an example of the latter kind of proportion. When folded in half the ratio remains the same.

A much favoured ratio known as the 'Golden Section' can be used to produce a number of integrally related areas. This has been used since Greek times and was much used as a basis of composition during the Renaissance. Starting from a square ABDC, a 'Golden Section' rectangle CDFE is produced as shown.

Illus. 1

Asked to produce a 'preferred' division of a rectangle, it has been shown that a majority of people opt for a point around the line AB.

A mathematical system of relationships – the Fibonacci series (viz. 1, 2, 3, 5, 8, 13 . . .) seems to be closely related to the underlying structure of many natural forms such as plant and tree branching and the construction of spiral shells.

Book pages

The phenomenon mentioned above of apparent centre rather than 'true' centre also comes into play in the case of book pages. The important single factor about a book is that most of its pages (apart from pages such as the title) will be viewed as double-page spreads, so the margin between the text on the two pages needs to be such that the outer margin round them both is sufficient to 'contain' the whole visually. These are the considerations if you want to design a formal, traditional sort of book. If not, an asymetrical balance of text areas against space may have to be arrived at through trial and error, with or without the aid of mathematical principles and, finally, relying on the eye's judgment.

Many mediaeval manuscripts suggest that the scribe had a rule-of-thumb system of proportions for margins as an aid to the page layout. More recent scribes have proposed simple formulae varying between the Johnstonian ratio of $1\frac{1}{2}$:2:3:4 (for inner, top, side and bottom margins of a single page, thus making the combined inner margin of a double-spread equal to each outer margin) and those formulae which relate the text area to a fraction of the page height and then propose a ratio based on that measurement. It should be remembered that these give a generous,

even luxurious proportion of margin to text compared with what we are used to in everyday circumstances, but this may well be appropriate for a grand text – a jewel to be savoured – or a decorated and gilded piece which needs protection from fingers turning the page. Typographers such as Jan Tschichold have delved further into the mathematics of these ratios and Sam Somerville wrote an excellent examination of Tschichold's theories for the SSI Newsletter 27 of Spring 1983, part of which is reprinted below:

Page Layout: Some Considerations
When designing a manuscript book (or any piece of calligraphy), the most useful aid is, almost certainly, a critical eye. It is unlikely that any rule or system for layout could be devised which would give a satisfactory solution in all cases. However for anyone attempting their first manuscript book, some help in making a start can be useful – at least it can give one something to criticise and build on.

Jan Tschichold
Jan Tschichold in his article in 'Calligraphy and Palaeography', titled 'Non-Arbitrary Proportion of Page and Type Area', provides a useful starting point from which to consider book page layout.
In this article he says –
'I have measured up many medieval manuscripts. By no means all of them follow any law exactly; even at that time there were books made in poor taste. Only those manuscripts which were evidently laid out with deliberation and artistry are significant. In 1953 I at last succeeded after much effort in reconstructing the Golden Canon of late Gothic book page layout, as it was used by the best scribes.'

He precedes this by a discussion of page proportion in which he says:

'The geometrically definable 'irrational' page proportions 1:1.618 (Golden rule), 1:$\sqrt{2}$, 1:$\sqrt{3}$, 1:$\sqrt{5}$, 1:1.538 (rectangle from the pentagon) and the simple 'rational' proportions 1:2, 2:3, 3:4, 5:8, 5:9 I call clear, intended and well-defined, all others being unclear and arbitrary. The difference between a clear and an unclear proportion, though often very small, is noticeable.'

Whether or not Tschichold's statement, printed above, is absolutely sound or not is open to argument. I quote it merely to give anyone who has not read his article some idea of the way in which he thought about book page proportion. . . .

Diagonals
The construction, which can be applied in principle to any page proportion is based on the diagonals of each page and also on the diagonals of the opening as a whole (Illus. 2).

Illus. 2

A point is chosen on the diagonal of the right-hand page between X and O (Illus. 3), and this marks the top left-hand corner of the text area. From this chosen point, P, a line is drawn parallel to the top edge of the page to meet the diagonal of the opening as a whole at A. Then from A a line is drawn parallel to the right-hand edge of the page to meet the diagonal of the page at B. BC and PC are then drawn

to complete the rectangle PABC which defines the text area. It is worth noting that the bottom left-hand corner of the text area (C) always lies on the line joining O to the bottom of the centre fold.

Illus. 3

The results of this simple construction are that, regardless of the page proportion, or where the point P is chosen on the diagonal between X and O –

1 The text area always has the *same proportion* as the page.

2 The text area is always distributed within the page so that, the outer margin is twice the inner margin, and the bottom margin is twice the top margin.

3 The ratios; inner margin to top margin, and outer margin to bottom margin, are always the same as the ratio of the width of the page to its height.

Simple ratio

Tschichold (and apparently many of those responsible for the overall layout of some medieval manuscripts) believed that the page proportion itself should be some simple mathematical ratio, and also that the starting point for the construction (the point chosen between X and O) should not be chosen in an arbitrary way, but should be measured down from the top

edge of the page a distance equal to some simple fraction of the height of the page. The particular fraction chosen (1/12, 1/9, 1/7, 1/6, etc.) simply varies the amount of text area to margin area.

As far as the basis of the simple geometrical construction is concerned the story could end here. However, a way of achieving a page layout (identical to that given by Tschichold's simple geometrical construction) by giving certain fixed proportions to the inner, top, outer and bottom margins is often stated. Unfortunately, it is frequently misunderstood and applied in situations to which it does not relate. The proportion method can be used provided one is aware of the conditions under which any given set of proportions applies. . . .

Thus, if this construction is applied to a page of proportion 3:4 then the ratio – inner: top: outer: bottom margins is always $1\frac{1}{2}$: 2: 3: 4 regardless of how many parts the page height is divided into to begin the construction. Achieving greater or less margin by the proportion method is simply a matter of choosing larger or smaller units of measurement to attribute to the $1\frac{1}{2}$: 2: 3: 4 margin proportions.

The important point is that the ratios $1\frac{1}{2}$: 2: 3: 4 for margins applies only to a page of proportion 3: 4 and to no other proportion.

If a page of different proportion is chosen, the ratios for the margin changes. The same principle applied to a page of proportion 2:3 gives the ratios for inner: top: outer: bottom margins as 2: 3: 4: 6 (or 1: $1\frac{1}{2}$: 2: 3). This again applies only to a page of proportion 2:3 and to no other proportion.

Consequently, to set margins for a page using a set of margin ratios would require *a different set of ratios for every different page proportion.* All this assumes one's intention is to achieve a layout which is in accord with Tschichold's method, in which case the geometrical construction is quicker and lends itself more readily to

margin plus text area variation.

In a number of articles referring to book-page layout I have seen the ratios $1\frac{1}{2}$: 2: 3: 4 advocated for determining margins for pages other than of proportions 3:4. Using a set of margin ratios to determine text area and margins for a book page of a proportion for which the ratios were never intended, and thus have no significance, may, in some cases, produce an acceptable result, but this is obviously a matter of chance – it is as likely to produce an unsatisfactory layout. ...

By now, I imagine, some of you are beginning to think that I do everything by numbers – this is not so. In fact, I do not think that Tschichold's simple construction gives an ideal layout in any situation. I do, however, think it is a reasonable starting point, and if one is going to begin by using it then it is important to understand it fully.

Visual judgement

The idea of determining text area and margins for book pages by a rule is probably a reasonable starting point for someone attempting their first manuscript book. There are, however, many things to question about it and in practice the final layout is arrived at by using one's eyes and critical judgement.

Generally, I feel that a book opening is visually more satisfying and the whole looks more unified if the combined inner margins, instead of being equal to the outer margins, are visually *slightly less*. I think at this point it is worth drawing attention to the physical make-up of a book and how it conditions how we see it. When a book lies open there is a physical division between left-hand and right-hand pages – namely the channel or valley created by the sewing which ties the whole book together. We view the opening as a whole but we still accept them as individual pages. For example, Illus. 4 gives, not a perfect, but an acceptable layout for a book opening. If this were a

panel written in two columns we would never accept it as it stands. We would want to draw the two text areas together and use the margins to isolate *them* from the edges of the paper area within which we work. Doing this would probably mean dropping the text area within the area of the paper or altering the text area completely to suit the different situation. The simple fact is that we are conditioned, somehow or other, to look at books in a special way.

Illus. 4

I also feel that the text areas in books sit more happily within their surround if the bottom margin is somewhat less than twice the top margin. The need for some sort of adjustment to the proportion and positioning of the text area within the page becomes more apparent as the proportion of margin to text increases, (i.e. as the page height is divided into a smaller number of parts in determining the starting point for the construction).

In his article, Tschichold cites, as an example of the use of the construction which he discovered, a small late fifteenth-century Italian manuscript, a page of which is reproduced in Plate XX at the back of *Writing and Illuminating, and Lettering*. In this particular manuscript, the page height has been divided by 6 to give very generous margins. On checking

this, I find that the text fits almost exactly into the area defined by Tschichold's construction except for the inner margin which is rather less than the construction gives. Perhaps, this is an example of someone modifying a 'rule' to suit the visual demands of the seeing eye. . . .

Solving the problem
None of the ideas outlined above can, by itself, be regarded as providing a solution to book page layout. They are simply ways of thinking about the problem. . . .

Visual margin loss
There is one other important factor which can affect the visual appearance of margins in a book, i.e. the amount of inner margin which is visually lost due to (a) the thickness of the book and the flexibility of the material of the pages and (b) the way in which the book is bound.

In a thin single-section book which opens fairly flat (Illus. 5a), there is no loss of inner margin and the full width is seen visually.

In a very thick book, especially one bound with a tight back (i.e. with the covering material stuck to the spine of the book), the width of the inner margins as seen visually is greatly reduced (Illus. 5b).

Using a hollow back, which allows the spine to throw up, somewhat reduces the visual loss of inner margin (Illus. 5c).

When a thick book with a hollow back is opened away from the centre (Illus. 5d) the tendency of one board to lift up helps the visual appearance of the inner margin.

In all these cases, some allowance has to be made for the visual loss of the inner margin. Unless a dummy book is to be made, one has to make the best estimate one can. Obviously, the more experience one has of the way books of different thicknesses and of different page sizes, made of different materials and bound in different ways, behave on opening, the more reliable a guess one is likely to make.

In conclusion, it is worth repeating again that all the ideas put forward here

Illus. 5

are merely guides. At best they can point one in the right direction – the critical seeing eye will always be the judge of how successful we are.

Broadsheets

If the work is to be a broadsheet, that is a single sheet of some sort as distinct from a book page, the usual traditional and formal arrangement will be to have the mass of text in the visual centre of the sheet, the side margins being equal. The previous considerations of relationship of top to side to bottom margins will apply and this sort of arrangement manifests itself in the Johnstonian ratio of $2 : 2\frac{1}{2} : 4$ (top, side, bottom). The same comment as before applies to this 'rule' – it is a starting point if what is required is a formal, static, traditional sort of layout. If something less static is thought to be desirable either the proportion of margin to text can be reduced (perhaps with compensating

changes to line and word-space) to make the mass of text more dominant or dramatic, or an asymetrical arrangement of text and margins (and maybe parts of the text to each other) may be devised, again with the eye the final arbiter of what is in 'balance'.

It may seem that although this theorising about proportions of space to writing is complex, all that is necessary is that one plumps for one of the theories and goes on to the next stage of preparing to write the letters. But the proportions of marginal spaces need also to be related to the number of words per line. Let us not forget that all this is meant, in the final result, to help the reader to read and understand the words.

LETTER-SPACING

It has already been argued (in 'Formal Scripts') that capitals may be fairly widely spaced without any great loss of readability. Lower case in the mass needs to be closely enough spaced for the word outlines to be obvious. Capitals must be spaced so that they appear to have equal areas between them. This is not a matter of measurement of the linear distance between their extremities (or even worse – putting all letters within similar areas). Poor signwriters continue to offer us

examples of this practice, presumably on the grounds that it is an economy of time and effort to position letters thus at the scale at which they work, but their examples indicate that it gives an unsatisfactory result. Groups of capitals which have straight sides and counter (interior) spaces totally enclosed by their sides can have their inter spaces (those between letters) measured, so can round letters which are enclosed, and obviously it is easy to arrive at a measurement for interspaces between the two groups, and this may be advisable when beginning to rough out an inscription, as a way of training the eye. But inevitably there soon arises the situation of placing letters like E and S, which do not have totally enclosed counters (yet do have a counter of their own) against other letters, enclosed or not. Here the eye becomes the only final arbiter of the correctness of the letter-spacing, with an area between them equal to that between letters already positioned.

The wider the letter-spacing the less do small variations of letterform affect the total area of space, so it becomes more difficult to judge whether the area is just right. If in doubt, at the rough stage, a transparent overlay may have the inter letter space area traced onto it in the form of a simple rectangle and this can be moved along the line as a final check on the correctness of other spaces, being easily compared with more complex areas.

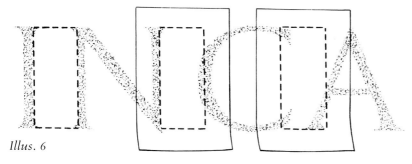

Illus. 6

Increased letter-spacing for an odd word can be used to give it a slight emphasis in the midst of a mass of text, much as italic is used in a mass of roman text for the same purpose.

The lower limit of letter-spacing is obviously set by certain combinations of letters in the words one has to use in any given circumstance. Awkward combinations of letters such as TY, LA, will have a minimum space before their extremities touch and other combinations in the same piece of writing must normally be opened out to match the area of these. In certain circumstances, such as a freely-written variant of capitals in a relatively informal arrangement, the extremities of awkward combinations may be deliberately allowed to touch or to form a ligature, or sometimes if there is a variation from constant height, one extremity may be tucked under or over the next.

Lower-case letters are normally spaced as close together as is reasonably possible consistent with evenness of spacing. This is to reinforce the word outline which is so important to easy reading. Priority should be given to this at the expense of the occasional slight gap made by awkward lower-case combinations of letters such as ry, fl, ta, but with care the hole in the regular pattern of the line made by such combinations can be minimised by running them together or slightly abbreviating them in width. So, an average letter-space for lower case might be considered half the width of an n. This should be quite sufficient for evenness of pattern along the line – more space gives an emphasis to the word as it needs to be 'spelled out' by the eye rather than viewed as a unit; it seems in fact to be deliberately letter-spaced.

WORD-SPACING

Word spaces need only be sufficiently larger than letter spaces to separate the words in reading along the line. If they are larger than they need to be, a hesitant movement of the eye along the line will result, with words tending to be isolated rather than forming a phrase and sentence.

LINE-SPACING AND LENGTH OF LINE

Normally, line-spacing needs to be sufficient to separate lines one from the other clearly enough to avoid confusion. Thus if an inscription is totally in capitals, the minimum line-spacing needs to be greater than the word-space, so that the white space between lines is sufficient to prevent the eye dropping to the next line between words. The emphasis of the pattern of the letters will therefore be on the horizontal line to the benefit of easy reading. If ease of reading is not the prime consideration, of course this 'rule' may be relaxed: maybe the overall massing of letters in a dramatic way is thought to echo best the sense of the words, and lines touching, or almost so, may be used deliberately. There is an obvious danger here. To propose an extreme situation; if the words are letter-spaced and lines almost touch, the vertical direction of movement will completely destroy the unity of the horizontal line and illegibility will result.

Lower case, or a combination of capitals and lower case will require line-spacing which takes account of the extension beyond the x-height of capitals, ascenders and descenders. Thus a norm of two x-heights may be reasonable, so as to avoid the descenders of one line clashing with the ascenders of the next. More line-spacing

will increase the effect of the horizontal units of lines; less may occasionally be used if careful planning is carried out to avoid ascenders and descenders clashing, and is often preferable for short passages of text.

All these variations will have their effect on the marginal spaces and it is no use planning one without careful consideration of the other. More line-spacing will usually call for wider margins. Unusually, a layout could be planned deliberately with wide line-spaces and comparatively small margins (the same, or a little more than the inter-line space, say) so as to make a point of the particularly emphasised pattern of horizontals which would result. But it must be remembered that this might make it difficult for the eye to link the word at the end of one line with the word at the beginning of the next and this could result in induced pauses at the end of each line. Will the sense of the words allow this or not?

This brings us to the point of considering the sense of the words again, something which must never be lost sight of. The sense of the words will have a relationship with the decision about how many words are allowed to a line and this in turn will relate to the size of letters chosen and to the nature of the whole design. In the case of a mass of continuous reading matter, there will have to be a decision about how many lines this is divided into and this will obviously relate to the shape of the text area. Short lines of, say, four or five words to a line will tend to be read quickly and rather jerkily as the eye movement zigzags down the page. Variations in word length will tend to make discrepancies between the length of lines and if the left-hand edge of lines ranges one above the other, there will tend to be a raggedly uneven right-hand edge of

line endings. It is difficult to make such short lines even in length without resorting to such absurdities of spacing and uncomfortably frequent, or even absurd, word breaks as are commonly seen in newspaper columns. The nature of a newspaper's make-up, with many varying sizes of stories and comment make these narrow columns and, thus, short lines desirable even at the expense of patchy spacing; a formal manuscript is quite another matter.

An over-long line makes it difficult for the eye to return to find the right place at the beginning of the next line. This effect can be mitigated by adjustment to the line-spacing to a certain extent, but more than twelve or thirteen words a line can become tiresome. If the passage is a short one, lines may be centred above each other in a column but this is tiring to read in any amount and the above considerations of spacing will apply. A short text (whether lines are centred or not) or a text where the sense needs deliberation may well have its line divisions carefully worked out so as to coincide as nearly as possible with the divisions of phrases, avoiding the slightly uncomfortable jump from one word at the end of a line to the next word which is closely associated in sense at the beginning of the next line.

CONSTRUCTING A 'GRID'

In a book, there will be preliminary calculations about the ratio of margins to text area, as previously mentioned. These may have to be considerably adapted in the first place if margins are intended to accommodate subdivisions of the text such as subheadings, references, illustration or decoration. These may need what is, in effect, a separate column. The main text itself may need more than one column if

the page is large and one column would result in an uncomfortably long reading line. Multi-columns will usually be of the same width if they accommodate continuous text. If they are unequal, it will probably make sense visually if they bear some simple mathematical relationship to each other, and the inter-column white spaces to the outer margins. These simple ratios will be appreciated by the eye, perhaps unconsciously, on first viewing the page. So a 'grid' will be constructed which will be modified to accommodate the given text, to give a sense of continuity to succeeding pages and, thus, unity to the whole book as well as acting as a guideline to placing matter other than text such as title, decoration, heraldry on the page. It must be reiterated that any such mathematical theory of arrangement must remain a convenience, a 'design tool', rather than a theory for its own sake. Theory, however attractive, must not take priority over the organisation of text considered from a functional viewpoint.

It is more obvious that such a base structure is needed for book pages where continuity is an evident requirement for the achievement of a unified design sequence. In the case of a broadsheet or scroll, what is needed is a one-off solution rather than sequential structure. The relationship of various sizes, weights, colours and areas of differing texture may require binding together visually by a network of related white spaces with some common factor. It will probably be a considerable help to have some underlying relationship between line spaces (and thus with x-heights) – in effect a horizontal grid. For instance, the unit of space from the base line of one line to the next in the main text area may be in a ratio of 2:1 or 3:2 to the equivalent spaces in subsidiary areas of smaller writing which is less

important in sense. The same unit of measurement may be conveniently adapted to a title and sub-title, using, say, capitals sitting on lines 3 units and 2 units apart. One has to be careful in this kind of situation when mixing lines of capitals and lower case. Due to the difference between same-height capitals and variable-height lower case (because of the extension of ascenders and descenders) the white spaces between lines can be visually unequal though carefully related to spacing of line depths. In this case some adaptation to letter heights and/or to line-spacing usually puts the matter right. The tighter the line-spacing the more obvious this kind of visual difference will be.

The chosen units of line-spacing forming this horizontal grid, and the related one delineating marginal spaces, will also have a fairly evident effect on the placing of initials and heraldry or decoration. Initials may conveniently stand on the base line of line 2 or 3 (or whatever) of their related text area. If they reach the height of capitals on line 1, they will have a direct association with the scale of writing used for the text. Heraldry or decoration may similarly have a relationship of scale which may be more complex than that just mentioned, but nevertheless use of a grid will act as an aid to the achievement of unity between various parts of the composition. The larger subdivisions may have already been given a simple mathematical relationship as mentioned earlier.

DRAFTING

Should the text be a complicated one, with a variety of possible divisions and subdivisions whose variance it is desired to express in terms of different sizes, variations of letterform, colour, etc., it is particularly important to do rough drafts

of the proposed sections (and probably cut out and paste together in numerous permutations). In this way not only may the sense of unity amongst the variety be checked and preserved, but often the change of a colour here, or a different size or weight of an initial there, or some other detail on which a satisfying whole can depend, may be changed at this rough stage. One then has the necessary confidence to proceed with the production of the final version with fluency, uninhibited by concern over major spacing decisions. Although the size and texture of words in a space may be the major element of decision, these roughs should at the same time attempt to define the exact colour of the final work. If the balance between one section and another is not quite right it may be that a change of colour will be a solution, darker or more intense colour giving emphasis to a part that looks light or weak.

All the foregoing aspects of dividing up the text according to its sense (giving emphasis perhaps to selected parts) – deciding line length and size of writing, adjusting letter-, word- and line-spacings; judging marginal spaces sufficient to contain visually the pattern of solids and voids of the text – all these need to be considered at one and the same time in formulating the design. It is obviously quite a complex set of decisions even for a relatively simple text and even when the simplest means are used, say, only one or two sizes of writing. There is no short cut; many trial-and-error rough layouts must be made until a satisfying design is found. Theory may help to formulate a hypothesis as a start; only a critical eye developed through first-hand experience and, at second hand, through questioning observation will be the judge of the proposition.

MARKING OUT MEASUREMENTS

Having at length decided on the disposition of lines, spaces and margins, one is faced with the practical problem of marking out the measurements on the writing surface. If this is not done accurately it will be difficult to adjust as one is writing, when concentration tends to be focused on the flow of shapes along the line. Only as a beginner should one be dependent on double lines defining the x-height, and it is particularly important that these intervals (as distinct from just a base line on which to write) are ruled up accurately. The price of inaccuracy is uneven x-heights which look disastrous and cannot be compared to the slight unevennesses natural to fluent writing, with the variations distributed over the page.

Basically, there is a choice of two methods of ruling: pencil or impression. Rubbing out pencil guide lines tends to leave a disturbed surface on softer papers, can take off some of the ink or colour lying on a harder surface, will dull gilding, or may leave an unpleasant shininess on vellum. So the aim is not to have to erase if at all possible. Ruling must, then, be done after any pouncing or scraping preparation procedures and preferably be left after the writing is finished. A finely-pointed hard pencil, lightly wielded on harder surfaces, or a softer pencil, frequently sharpened, on softer surfaces, will give a just visible guide line which can remain after writing and be virtually invisible.

If the writing is to be photo-mechanically reproduced (see pages 223–8) for printing, the use of a light, 'cold' blue pencil makes it unnecessary to rub out guide lines as the film used in process cameras is not sensitive to this colour. This is known commercially as 'non-reproducing blue'.

If vellum is being used, or a fairly heavy weight of paper there is the alternative of lightly scoring the guide lines. With light at the correct angle these impressions are just visible enough without being obtrusive when the writing is done. A smooth, not too-pointed tool is needed for this – a slight impression rather than a cut is obviously required. If much of this ruling is to be done it is worth making a tool specially. It can be concocted from a steel pin set into a wooden handle and bent so that the 'heel' forms the impression.

Illus. 7

The intervals of marking out must be done from a rule, accurately. Repeated measurements such as line-spaces are best done with dividers for accuracy.

If the work is a broadsheet, mark the margins first and then the writing lines, ruling with the aid of a T-square, parallel motion, or ruler and set square, so that lines are parallel to the top edge.

If the pages of a book are to be ruled it is important to achieve a consistent accuracy on all pages. The most convenient way is to mark the measurements with ruler and dividers along the edge of a strip of thin card. It is sensible to place horizontal marginal and column measurements on one side of the card, vertical margins and line spaces on the other and caption each side clearly to avoid confusion.

These measurements may then be transferred to the page either with a sharp pencil (observed from vertically above) or by means of pricking through the card onto the page with a fine steel point (or several pages at once if care is taken to keep the point vertical, and the material is not too thick). The margins and writing lines may then be ruled with pencil or by impression, as before.

It is important to start with a perfectly straight edge at the top and to keep everything square. If a book is being made the sheets should first be cut straight along the top edge: the fore-edges and bottom will be most conveniently trimmed after the book is sewn (or the bottom possibly left as deckle if hand-made paper is used).

If a broadsheet is to be stretched over a backing board, remember to leave an allowance for the turnover but start ruling from an indication of the top edge-to-be.

If a vellum book is being produced, remember to arrange the skins in sequence hair to hair, flesh to flesh sides.

BINDING, MOUNTING AND FRAMING

The need to consider in advance how formal calligraphy will be bound as a book, rolled and secured as a scroll or mounted and/or framed as a broadsheet was mentioned earlier. The permutations of basic methods are infinite and the detail of method and materials will affect the degree of preplanning necessary. If unconventional materials seem appropriate a complete dummy may be necessary to test their successful functioning. The following notes on methods of presentation are therefore offered as basic instructions for a simple binding or scroll. In the case of framing and more complex binding methods which may need the services of a professional bookbinder, some general comments are made which need to be borne in mind.

BINDING

Binding may be defined very simply as a method of holding loose sheets of paper together. When they have been gathered together ('gathering' appropriately is a technical term for the collecting together of sheets in the order necessary to form the proper sequence of pages in the book) and secured, it is natural that some protective cover be provided. It is necessary that securing (usually sewing) and covering should allow the book to open well for reading. Both the securing and the protecting can be of the simplest or the most elaborate kind. The nature and context of the work will themselves suggest what choice to make between these extremes.

If the work is to celebrate something of importance or to contain a large number of words or to be monumental in the sense of a desire that it should be preserved for posterity, the whole thing may rightly be grand in scale, vellum may be the material chosen, with quantities of raised gold. The vellum and the gilding may both require special accommodation in the way the binding is executed. It will need the services of an experienced binder to cope with elaborate processes and it is essential to discuss with the binder what measures the scribe needs to take in the preliminary stages. Vellum pages must lie together in sequence, hair side to hair side and flesh side to flesh side; some particular adjustment on the margins may need to be made to allow for the method of sewing chosen and for trimming pages when sewn; a quantity of raised gold must not be placed in a similar position on many subsequent pages.

Should the work, on the other hand, be of a simple form it might be appropriate for it to be presented as a book rather than a framed broadsheet even though the text

were short. For example, a presentation address might be designed on one double-spread of a book and be the more convenient in storage. The instructions below will allow the scribe to carry out such a simple binding. The methods described are kept very simple so that a minimum of equipment is required.

The methods may obviously be elaborated and be more positively decorative by the use of a variety of coloured sewing materials, with covering materials to match, or a greater number of ribbons to secure the cover to the sewn pages.

The materials to form the pages of the book must be chosen carefully in all cases. When open it is desirable that the book should lie reasonably flat (see Illus. 13, page 239[1]) so the ratio of weight of vellum or paper to size of page must be carefully calculated to avoid the pages standing stiffly erect. If mould- or machine-made paper is employed remember that the grain should run from top to bottom of the book. This latter factor applies also to card used for covers. The grain direction may be gauged if a square of card or paper is flexed along opposite axes. The grain will run along the direction of least resistance. Or paper may be torn in two opposite directions – the grain direction is at right-angles to the tear which has most fibres projecting along its edge. Or a square of paper dampened on one side will curl up along the grain direction. Hand-made paper does not have a grain, or at least such a minimal one that it has little significance to the direction in which the paper is folded. Grain direction is important in two ways: it affects the ease of flexing of the pages along the folds: it may also allow a slight curvature of the

[1] Binding of manuscripts.

card that forms the boards – any curvature should be towards the book's fore-edge in order to afford better protection to the pages. Should dampness affect paper with a grain that runs across the page (not up and down), there will be cockles across the folds of sections which will make the pages difficult to open.

A single-section book with cover attached by ribbons

Tools and materials required: Scalpel or thin-bladed trimming knife. Steel rule or straight-edge. Bookbinder's (or heavy sewing) needle and bookbinder's thread or equivalent (matching colour of the pages). Ribbon (or equivalent: see text). Trimming mat or spare card for cutting on. Dressmaker's bodkin (needle with large eye and blunt point) if ribbon is used, and bookbinder's folder (a flat knife-like tool used to smooth down folds accurately) are useful. Adhesive (PVA or wax stick). Covering material (see 2 below).

1 Make a single section of the appropriate number of pages (the maximum number of leaves that will allow easy opening will depend on the weight of material and the size of page). Allow one extra folded sheet on the outside for endpapers (for attaching to the cover). The tops of the pages should already have been trimmed straight before ruling commenced. Hold the tops level and sew with bookbinder's thread, silk, or an equivalent material of good strength, as in Illus. 8a. Pull the sewing tight, *along* the length of the fold to avoid tearing the pages. Tie the ends in a reef knot over the long centre stitch. Cut the ends of the thread (not closer than 3 mm or $\frac{1}{8}$ in. to the knot, otherwise the knot may work loose). Holding the sewn book flat, trim the fore-edge and bottom (unless deckle is required to remain), the cutting blade at an angle to direction of travel but vertical to the top of the

Illus. 8

straight-edge. The blade must be very sharp. Put most weight on the straight-edge, cutting a little at a time rather than trying to cut all at once.

2 Cut covering material, allowing for 'squares' (see Illus. 8c) if the thickness of the book makes them seem desirable. They are a device to give some protection to the edges of the pages, but may appear superfluous on a very thin book. Allow also for the material to fold over the spine, and over the outer edges.

If the material of the pages is paper, a matching paper of slightly heavier quality would be appropriate, or one of contrasting colour (maybe to match colour inside the book). If the latter, it may be wise to choose the covering material first and mix the colour to match – the other way round would probably be difficult.

If vellum is being used for pages and cover, it will be reluctant to fold and stay flat unless the skin is fairly thin. So in place of the flap at the fore-edges it may be better just to cut the cover parallel with the edge of the pages (allowing a 'square'), or to allow the amount folded over to be sufficient to accommodate another slotted ribbon to hold the flap in place.

3 Mark the front and back cover (Illus. 8b) and endpapers for the slits to accommodate the lacing material which will join the two together. The number of slits chosen should allow the lacing material to terminate top and bottom between cover and endpaper. Choice of lacing material will depend on the page and cover material used. If vellum or stiff paper, the same material may be cut in a strip for lacing (for such a small book there will not be a great strain involved). Ribbon, or some contrasting material (and colour) may also be

chosen. Cut the slits *accurately* with scalpel or thin-bladed trimming knife. If ribbon or heavy-weight vellum or paper is to be used as lacing material, the slits may have to be fractionally longer than the width of the lacing, and may also need a double cut to give a positive width of slot to accommodate the lacing's thickness (make a test before cutting to find out just how much is required).

Place the cover over the book and thread the lacing material through the slots: if ribbon is used it will be found convenient to use a dressmaker's bodkin or if paper or vellum, a folder or knife may be used to open up the slits to facilitate threading.

4 Cut the ends of the lacing material fractionally shorter than the top and bottom edges of the book pages and apply a minimum of glue to the ends just to hold them in place. A PVA or wax type 'stick' glue will be appropriate for most materials.

Various permutations of lacing will readily suggest themselves: not only the number and spacing of slots with resultant pattern of loops showing on the cover and 'in reverse' on the endpapers, but lacing running horizontally from the front, round the spine and along the back is a possible variation.

A single-section book sewn onto a zigzag
Materials as before but including millboard for the cover (caliper, or thickness, according to the length of the book and page size). PVA adhesive. Glue brush. Folder. Moisture-resistant/proof interleaving (e.g. silicone 'release' paper or cooking foil). Some simple means of applying even pressure across the area of the open book (smooth clean boards, say

5 mm (nearly ¼ in.) ply with an object(s) of approximately 4–5 kg (9–10 lb.) to supply pressure). Covering material (vellum, bookbinder's cloth, paper, etc.). Material to line the 'case', possibly (see later instructions). (Card for cover and means of pressing may be ignored if 'limp' vellum covering is to be used.)

The object of this kind of construction is to give a line of hingeing removed from the sewing at the spine if the material is too stiff to form a good double curve of 'opening contour' (see Illus. 13, page 239) of its own nature. Heavy papers or some vellums may fall into this category though, strictly speaking, if previous arguments have been taken into account a page material will have been selected which does lie flat as a page. However it may be that circumstances dictate a less than perfect weight of page: a small size of book may be required or a thickness of material which will avoid 'show-through' of, say, heavy decoration or writing, from one page to the next. If these circumstances apply, consideration will have to be given to the number of pages which it is sensible to use as a single section before it springs open unpleasantly because of the number of folds at the spine – if this is likely to happen it may be better to have a number of small sections which open more pleasantly (see Illus. 14 and accompanying instructions).

1 Assemble the pages in a single section as before, remembering to include endpapers outside.

Make a zigzag of similar (at least in colour) material to the pages. It will be the same height as the pages and needs folding (an even number of 'leaves') to match the thickness of the book. Its width may vary a little with the scale of the book, but the function of this dimension is to accommodate the sewing which attaches the cover. So it only needs to be about 6–8 mm ($\frac{3}{16}$ to $\frac{5}{16}$ in.) wide if silk is being used for that operation. If thicker cord, or ribbon, is being used for lacing, obviously the width will be adjusted accordingly.

Measure the zigzag units and fold *accurately* with folder and straight-edge.

2 Sew the pages to the centre fold of the zigzag, with its first and last 'leaves' pointing away from the book (Illus. 9a). The sewing will probably be more conveniently done if both pages and zigzag are marked for sewing thread positions, held with a clip and the holes pre-pierced, as holding both units whilst sewing accurately might be difficult. Trim edges as in previous method.

3 *The 'case', or cover*
There are numerous variations possible in the detailing of the cover (or case as it is called when made in a separate operation and subsequently attached to the book). The favoured variation needs to be decided at this point. Some permutations are as follows:
a 'Limp' (unstiffened) cover made of vellum (or similar weight of paper or thin card). This is measured out and folded to the dimensions of the case (Illus. 9b). (You may therefore ignore the following instructions about making it from card and covering material.)
b With or without flaps.
c With endpapers glued to the inside of the cover, or if the endpaper material is stiff enough, tucked inside the flaps without glueing. There is no need for endpapers to be glued to the inside of the cover for constructional strength, as the book is held to the cover by subsequent oversewing, though if flaps have been dispensed with, glueing down endpapers may seem necessary to cover

up the inside of the boards of the cover (see below).

As previously mentioned, card has a grain similar to machine-made paper, because it is made in a similar way. Card normally available for binding use is designated 'strawboard' or 'millboard'. The first, as its name suggests, consists largely of cellulose fibre originating from straw. It is fairly strong in tension but weak and brittle in torsion, so is best avoided. Millboard is made from a mixture of re-used strong fibres and is much stronger and therefore advisable for more permanent specifications. Card is available in a variety of 'calipers', usually expressed in microns, and the choice must be related to the protection of the pages by their binding coupled with the aesthetic appearance, 'feel' and balance, of the thickness of boards to the rest of the book.

Having taken all the above into consideration, cut the card and covering material of the case according to your favoured variation of the diagram (Illus. 10) and construct the case. When the covering has been glued and the boards and stiffeners placed in position on it, the corners must be mitred at 45° with knife or scissors. The mitring cut should be fractionally further from the corner of the card than the thickness of the card itself. Then the top and bottom edges of covering are turned in, pulling squarely over the edge of the card with the aid of the folder and pressed firmly into place. (Illus. 11).

As soon as the covering material has been applied and smoothed firmly into place with the folder (applied through protective paper if the surface of the covering material is likely to be marked), press flat between boards and weight.

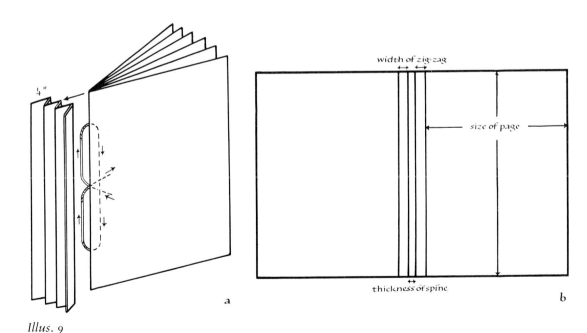

Illus. 9

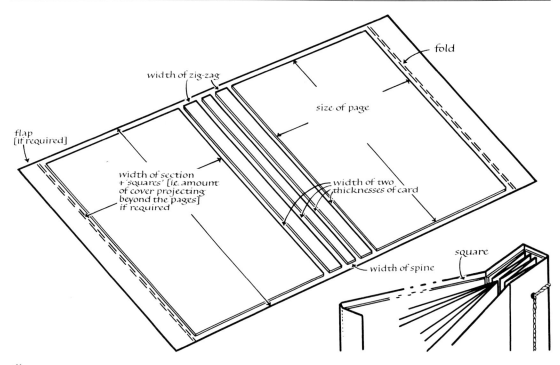

Illus. 10

Illus. 11

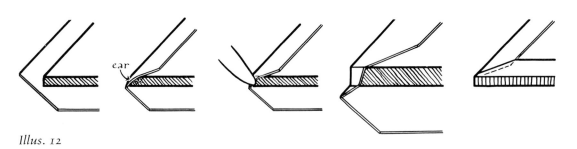

Illus. 12

Turning in top and bottom edges leaves a little 'ear' of cloth projecting at the corners. This should be pressed down with the thumbnail or folder alongside the card before repeating the turning-in process with the two fore-edges. (Illus. 12) Press again for a few minutes then stand up to dry.

When dry, trim the turned-in covering material so that it shows an equal amount all round (taking care to cut through only the covering material).

When dry, the boards may curve outwards as previously described. This can be counteracted by lining the boards with a material and adhesive equal in 'pull' to the covering. If a variation of the binding with pasted-down endpapers has been chosen, this process will pull the boards towards the book. It must be judged whether the areas of board not lined by the turned-in cover material should be lined with paper before the endpapers are pasted down.

When the case is dry, impress with a folder the hinges between boards, stiffening and spine so that they flex easily.

4 *Sewing, or lacing, to case*

If the sewn book is placed within the dry case, it will be evident where holes need to be pierced through the zigzag and the related parts of the cover to allow the oversewing to be done. Choose an appropriate thickness of silk or cord to be strong enough to hold the weight of the book in place and to fit the colour and decorative quality desired in the cover. Sew as in the diagram (Illus. 13). Finish with a reef knot. Ends may be left long enough to fray into tassels.

5 *Endpapers and glueing*

The advantage of 'glueing' down endpapers inside the boards is in counteracting the effect of glueing on the

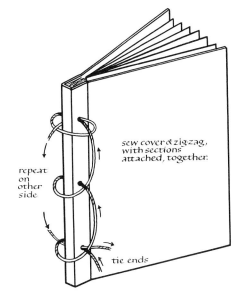

Illus. 13

covering material. It may be argued that it is a necessity though much depends on the material, card and adhesive used. 'Glue' is here used as a generic term indicating the use of an adhesive, animal glue, flour paste or PVA, etc. Because most adhesives contain varying amounts of moisture, when applied to the covering material of a book they will make it stretch at the stage when it is attached to the boards and then contract as it dries. This will draw the covered boards outwards in a degree of concavity depending on the materials used. If the concavity of the covered boards is exaggerated, 'glueing' the endpapers to the inside of the boards exerts a counterbalancing effect, and if the judgment of this effect is accurate, a very slight concavity of the boards *towards* the book results (to the advantage of its protection).

This is discussed at some length in these apparently simple instructions because the results can be dramatic and

the amateur bookbinder may not have the experience to predict the results. If in doubt, a test is advised before the finished work is embarked upon, especially if unusual materials are being used. Professional bookbinders may use a variety of adhesives for different purposes – for example, animal glue with a high degree of 'tack' and rapid drying may be used to cover the outside of the boards, giving little stretch, and a flour paste for sticking down endpapers inside the cover. Paste has a greater water content, provides more stretch and would ensure the edges of the boards curving towards the book.

Materials which become semi-transparent when glued, or whose texture allows glue to bleed through, may be used as covering materials if they are stretched tightly round the card and only the turn-over glued. A piece of paper the same size as the boards underneath the covering material might be used to guard against the card showing through.

Depending on the decision made earlier *(The 'case')*, the endpapers are now merely tucked under the turned-in flaps, laced to the cover or glued down to the inside of the cover to complete the book. Carefully place waste paper behind the endpapers if glueing. Put moisture-resistant material in between endpapers and book when this waste is removed, close the boards on to the glued endpapers (carefully positioning them square); press briefly; open carefully to examine for possible creases in the endpapers (which should be eased out with the folder); then press between boards and weight for a few minutes and stand open to dry.

The methods just described can be adapted to making a multi-section book consisting of a number of single sections sewn individually on to folds of a zigzag in the case of material which is too thick to form one successful single section. The zigzag must be equal in thickness to the book, as before.

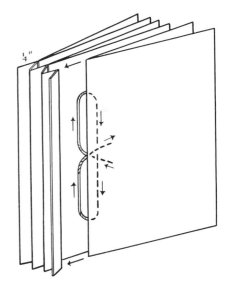

Illus. 14

Foregoing remarks on the choice of materials that will open well as a book should be taken into account. This method has the disadvantage, compared to a conventional binding, that slight gaps will be apparent at the spine between sections.

SCROLLS

This section on scrolls is based on a talk to the SSI by Tom Swindlehurst. The original notes made from the talk refer to parchment or vellum but obviously paper may be used if it is substantial enough. In this respect the choice is almost the

opposite of the choice for a book page – the paper will have to be rolled. If too thick it will crack, but if too thin it will crease rather than roll. Vellum or parchment may crease if very thin, but the problem with choice of vellum may well be to select a piece of reasonably even consistency, especially if the size of the scroll is large in relation to a skin. Stiff, horny patches will be reluctant to roll up.

There are three ways of presenting scrolls, of increasing complexity and formality. Methods 1 and 2 are appropriate for either 'portrait' or 'landscape' layouts. Method 3 is more appropriate for a portrait scheme because of the weight of the roller.

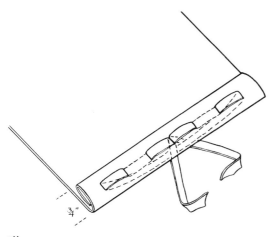

Illus. 15

1 The foot edge of the scroll is simply creased and folded over twice so that the edge is concealed. A ribbon, preferably silk, is laced through slits in the folded part, one slit in the centre, two more about 30–40 mm from each side and the others evenly distributed between. The slits should be fractionally *wider than the ribbon*, or be opened slightly by

means of a double cut to avoid the paper or vellum buckling from the thickness of ribbon inserted. This will need very accurate cutting with the folds held securely. The ribbon is laced as shown in Illus. 15. It may be knotted where the ends emerge, so that they are ready to secure the scroll when it is rolled up. A dressmaker's bodkin may ease the operation of lacing. It is easy to imagine more elaborate lacings giving a more decorative result. Remember to select your ribbon before finally deciding on any colour to be used in the writing: colours or ribbon available are much more restricted than pigments and so it is far easier to match mixed colours to the ribbon. The ends of the ribbon for tying should be cut at a diagonal to minimise fraying or, if a coarsely-woven ribbon is used, the ends may be frayed out purposely to avoid further fraying and to present a decorative result, or ends may even be embroidered – various possibilities will suggest themselves.

2 A sheet of paper, parchment or vellum placed within a pocket and rolled within a cover, tied with ribbons.

The cover may be made of a heavier weight of paper if the scroll itself is to be paper, or of leather or binding vellum if parchment or vellum is the writing material. If leather is to be used, test a small piece to make sure the colour will not rub off on to the scroll material when it is rolled up inside the leather cover. Cut slots as in diagram (Illus. 16b and c) (or in similar variations), turn over the foot of the pocket, insert the written scroll and lace up. The ends of the ribbon securing the pocket should be cut just short of the edges of the pocket and secured inside with a minimum of adhesive (Illus. 16d).

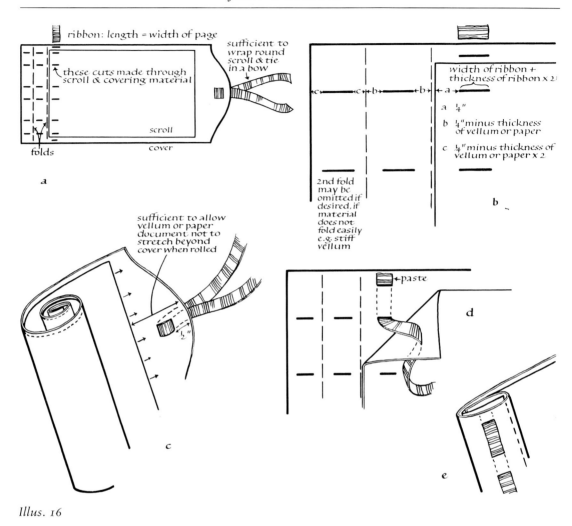

Illus. 16

3 Parchment or vellum scroll on a roller.

Paper could be used for this if it were strong enough in relation to its size to hold the weight of the wooden roller and to withstand the wedging operation, but the weight of the roller probably makes vellum more appropriate. The formality of this method almost demands a case to keep it in – this can be either a wooden case to suit the roller, or a leather-covered case made by a bookbinder. Either is outside the scope of this chapter.

White polished sycamore is suggested for the roller and bottom strip, the former being about 15–20 mm ($\frac{5}{8}$ – $\frac{3}{4}$ in.) diameter. Any smooth, close-grained hardwood can be used that matches or contrasts with the scroll material. It needs to be sufficiently longer than the width of the scroll to accommodate the end caps. Take out a

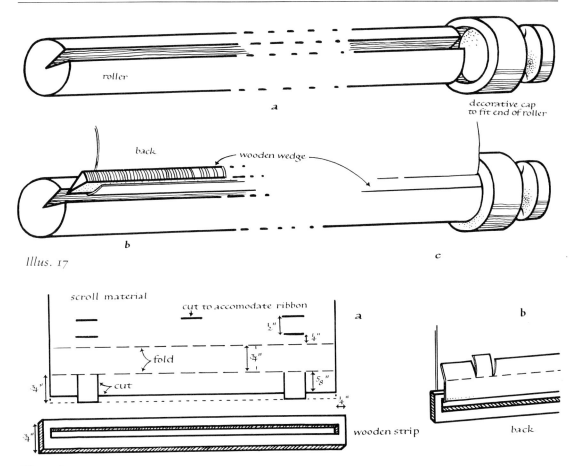

Illus. 17

Illus. 18

wedge about 3–4 mm ($\frac{1}{8}$ in.) in width along the length of the roller. (Illus. 17a). The top of the scroll is folded over and placed into this groove and with a little adhesive the wedge is secured behind the written surface of the scroll (Illus. 17b). Caps made from the same material as the roller may then be applied to cover the ends of the roller and further secure the wedge (Illus. 17c). The caps may be as simple or decorative as the design of the scroll's inscription suggests – they might carry a badge or emblem appropriate to the donor or recipient.

The foot of the scroll is folded and slots

cut as in the diagram (Illus. 18a) to accommodate the *tabs* securing the wooden strip. This must be measured and cut accurately. The strip gives rigidity to the foot of the scroll when it has been rolled round the roller, and acts as a base for the securing ribbon.

Ribbon long enough to allow each end to pass round the rolled-up scroll, plus an amount for lacing and tying a bow is laced through the centre slot (Illus. 19a). The ends are cut diagonally, frayed or otherwise finished, and are ready to tie up the finished scroll. (Illus. 19b).

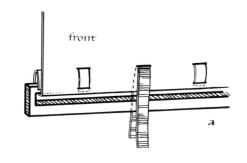

front

a

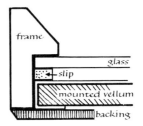

frame

glass

slip

mounted vellum

backing

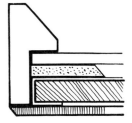

Illus. 20

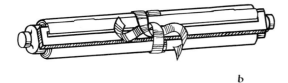

b

Illus. 19

MOUNTING AND FRAMING

The article on 'Parchment and Vellum' describes the stretching and mounting of parchment and vellum. If a piece of work so prepared is to be framed, prior thought needs to be given to the way in which it will be accommodated within the section of the frame. Two considerations apply: the thickness of the mounting base material, and the fact that skin will usually need to be kept away from the glazing of the frame. This latter need is because the skin could expand in unfavourable conditions, unless stretched over a heavy base, and ink, colour or, obviously, raised gold could be affected by touching the glass. It will look strange, anyway, if some parts are touching the glass and some not. So, a 'slip' is usually required between the glass and the front of the vellum to make sure of this separation. This can be elaborated as a sort of sub-frame, with a bevel or moulding to suit the 'main' frame.

It will be evident that the thickness of the mounting base material plus the slip may make necessary the provision of a deeper-than-normal frame section, and whether this will require a special moulding to be made or the addition of matching material needs preplanning.

There are now several varieties of 'instant' framing kit. These are quite adequate for some purposes but they do not usually allow much adjustment for the accommodation of a thickness greater than a sheet of paper or skin plus a single thickness of mounting card. Sometimes they do not even allow for mounting card. On the other hand they often make use of a system of spring clips and these can sometimes be replaced by neatly drilling and counter-sinking the sides of the frame to take an appropriate size and material of screw if wood has been used as a base material for stretching and mounting the work.

The perspex (plexiglass) box 'frames' can similarly have their card interiors replaced by wooden bases for stretched writing material screwed quite neatly and unobtrusively to the sides of the box.

Mounting in the alternative sense to that above, that is, providing a surround which acts as a foil to the work between it and its frame, is often done in a haphazard way. Many works recently seen when they were submitted for exhibition, showed a lack of care or understanding about this which was often disastrous to the presentation of

the work whether framed or not. They varied between small pieces of writing in the centre of a large piece of paper, without frame or mount, and with no clear indication of intention (although it was obvious that the work would have to be framed to be exhibited), and pieces completely dominated by the scale and colour of mounts, even though of the simplest. Mounts are usually neutral areas between work and frame, both in colour, area, and material. But not necessarily so – a work which is positive in colour and form may have a very positive mount and frame to match. The mount can occasionally play a definite part in the total composition even to the extent of creating different layers and shapes of interest which can also accommodate part of the writing – in effect becoming part of the work rather than a neutral foil to it.

Mount and frame for a broadsheet are an extension of the margins and need the same degree of consideration. They have functions and their own aesthetic, much as the binding of a book, and their quality must not be left to chance. In both senses of the word 'presentation', frame and/or mount need to be considered at the initial concept stage in relation to the character of the proposed work: is it informal/personal or formal/grand – or of what intermediate character? If informal/personal, for example, it might eventually be displayed on the simple sheet of handmade paper

with untrimmed deckles on which it is written, against a card or wood backing which is seen for what it is and simply spring-clipped to glass or perspex of the same size forming minimal protection whilst hung. If formal/grand the work might be on vellum which needs to be stretched on a heavy wooden backing which requires an adequate depth of frame moulding to accommodate its thickness *and* a slip. Both frame and slip could have a moulding or bevel to relieve their visual weightiness, related to the scale and detail of the calligraphy, maybe to the extent of using colour, gold or decoration. Or they might be covered in the material used as a base for the writing, or another in sympathy with it.

Many 'mounting cards' are formed by sticking coloured machine-made paper to cheap pulp board. Both are likely to deteriorate quite quickly and the acid/alkali qualities may affect the work beneath the mount. When careful consideration has been given to the choice of material and media for a piece of work, similar consideration should be given to the mount. 'Conservation board', with a neutral pH value, should be used or a composite board made from similarly neutral paper and card. A suitable colour/surface may not be easily available, but if it is seen as an essential part of the whole work, the virtue of overall planning is reinforced.

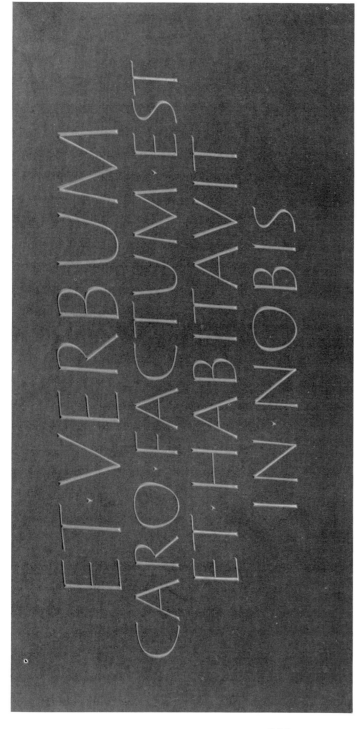

Tom Perkins: *And the Word was made flesh and dwelt among us,* Gospel of St. John, I, 14. Uncoloured inscription cut in Welsh black slate. $12\frac{7}{8} \times 26 \times \frac{7}{8}$ in. 1984. By courtesy of A. E. F. Davis.

Calligraphy as a Basis for Letter Design

TOM PERKINS

The purpose of this chapter is to provide a method of constructing letters which is rooted in calligraphic principles, and is suitable for a wide range of uses, e.g. signwriting, letter carving, other forms of letter engraving, type design, etc. By calligraphy or calligraphic I shall mean throughout the influence of the formal broad-nibbed pen. The problem with using calligraphic forms as a basis for letter design is the tendency for them sometimes to retain too strong a calligraphic image with the resulting associations 'of some pleasing archaeological reconstruction'[1], interesting in itself but with little relevance to contemporary needs. In contrast one need only instance the typography of Jan Tschichold or the type designs of Hermann Zapf to show that a thorough grounding in calligraphy, far from being an over-riding influence, can in fact make available a far wider range of options in the design and use of letterform.

Most contemporary lettering is a product of drawing and nearly all of the lettering around us will have originally been produced in this way. 'Today the pencil is the universal lettering tool'.[2]

Unfortunately, the pencil on its own provides us with no information as to how a letter is formed. Edward Johnston, writing in *Formal Penmanship* and commenting on 'the value and uses of the formal pen' states: 'The broad nib was the principal formative tool in the development of writing. From early stylus-made skeleton letters, it produced the conventional finished shapes and varieties which we now use (familiar to most of us mainly in print). The finished shape-and-structure of the common alphabet is, in fact, bound up with the shape and action of our pen'.[3] This suggests, and suggests strongly, that a thorough working knowledge of these calligraphic prototypes would greatly enhance our appraisal of modern adaptations and give our own adaptations a greater authority.

It is not possible to consider a wide range of letterforms here so I have used only Roman capitals. 'Nearly every type of letter with which we are familiar is derived from the Roman Capitals'[4] and these capitals form an excellent basis to demonstrate certain visual principles. These principles combined with a thorough understanding of freehand

[1] 'Tradition and the Individual Talent', – in *Selected Essays*, T. S. Eliot, second edition, revised, London, 1934.

[2] Page 10, *Lettering Design – Form and skill in the design and use of letters*, Michael Harvey, The Bodley Head Ltd, London, 1975.

[3] Page 121, *Formal Penmanship and other papers*, Edward Johnston, ed. H Child, Lund Humphries, London, 1971.

[4] Page 1, *Writing and Illuminating, and Lettering*, Edward Johnston, London, 1906.

drawing techniques can be applied to many sorts of letterform.

As carved classical Roman letters developed (almost certainly under the influence of the chisel-edged brush – see E. M. Catich, *The Origin of the Serif*[1] – which in turn was almost certainly influenced by the broad-nibbed pen), their design became more subtle and complex in construction to satisfy the visual and technical requirements appropriate to incised letterforms in stone. In their most highly-finished forms, though the letters appear direct and simple, their execution involved many manipulated changes of angle of the marking-out instrument to produce the familiar classic letterforms such as those in the Trajan Column and other inscriptions. In reconstructing or recreating letters of good design, we need to take these changes of 'marking' or 'writing angle' into account.

The following offers a simplified method of work (using double pencils) which may be helpful to the beginner who is unfamiliar with the use of an edged brush but has some experience with a broad-nibbed pen. It provides a starting point only, but one which is capable of great potential development. Double pencils (i.e. two pencils side by side, with the points level and fastened firmly together at each end) by their very nature create a natural link between calligraphy and drawn lettering. The double pencils show clearly how calligraphic character is made by overlapping monoline forms (assuming the 'pen angle' is constant), literally a kind of parallel motion. The idea of overlapping monoline forms at a given weight and angle may well prove a more logical and

intelligent starting point for the design of letterforms for computer usage than current methods. As stated recently in an article on this topic, 'Alphabets are no longer rigid constructions, but may now be manipulated endlessly as if they were printed on a sheet of rubber',[2] so we are perhaps now, more than ever, in need of some definable standard. Without some kind of objective reference point we have no means to enable us 'to distinguish between the genuinely good and the meretricious' and 'without some standard of fitness and beauty derived from tradition' we 'cannot be expected to produce, not necessarily masterpieces, but even intrinsically sound work'.[3]

As a starting point double pencils are a versatile tool for letter designing providing one has some knowledge of letterform and calligraphic principles. They provide a clearly stated foundation upon which visual and structural modifications can (and perhaps should) be made (see Illus. 1, 2, and 3). Ultimately, as drawing skills and appreciation of letterforms increase, the student may wish to use only one pencil to interpret calligraphic weighting in an intuitive way.

If we take our capital alphabet as being composed of a series of straight and curved lines arranged in various combinations, then the problem before us, simply stated, is the modification of straight and curved strokes as produced by the double pencils. This could equally apply to our lower case and italic alphabets.

For our present purpose it is useful to consider an O and an I (see Illus. 1) which

[1] *The Origin of the Serif*, E. M. Catich, the Catfish Press, Davenport, Iowa, 1968.

[2] Page 118, Penrose 1982 – International Review of the Graphic Arts – Volume 74, Supercomputers and the designer, Bruce Brown, Northwood Publications Ltd, London, 1981.

[3] Page 1, *A Potter's Book*, Bernard Leach, Faber and Faber, London, 1940.

may be thought of as the 'mother' and 'father' of any given alphabet. Generally speaking, if we have an O and an I from any particular alphabet we can make a reasonable conjecture as to the forms of the remaining letters. The O sets the relative weight-pattern of curve formation, roundness or degree of compression and the I tells us how the stems are shaped and how the terminations or serifs are formed.

Before letters are considered in more detail it is necessary here to say something about the changes of 'pen angle' needed to maintain an acceptable differentiation of thick and thin strokes. Double pencils with the points one-eighth of the letter height apart and at an angle of 30° will produce an agreeable weighting for E F H I J L and T, for all vertical strokes (except those in N) and all horizontal strokes, for the tail of Q (see Illus. 1f), as well as for the thin diagonals in A V W X and Y and for the third and fourth strokes in M. For the broad diagonals in A N V W X and Y and for the second stroke in M, the pencils are held at around 45°, and even more steeply (around 60°) for the verticals in N, the first stroke in M and the right-hand side of U. The angles for the diagonals of K are shown in Illus. 2. In Z the angle of 30° is maintained for the horizontals but flattened to a horizontal position to give a strong diagonal. For simple pen-written roman capitals a 30° 'pen angle' is usually acceptable for all curved strokes; however, for our present purposes, an angle of 15° will be found more satisfactory for O and therefore for C and Q (except the tail) and for the curved parts of D and G for reasons which will be dealt with later under curve modification. Finally, B P R S and U contain a manipulation or rotation of angle within some strokes (see Illus. 2 and 3 where changes of angle are indicated) which gives the bowls of B P

and R a similar treatment, whilst retaining a relationship with other curved strokes, but allows for junctures of acceptable weight in the case of B and R. This manipulation of 'pen angle' gives the tail of R a similar treatment to other broad diagonals, gives S a stronger diagonal stroke, and in U, which in this case has a thinner right-hand side, enables a smoother joining of the strokes.

Whilst the angle changes described here will give a reasonably even distribution of thick and thin strokes, certain minor adjustments in some cases, either of 'pen angle' (constant or manipulated) in the first instance, or later in the development of the final form, will be needed in order to give a similar treatment to related letter parts. The larger the scale one is working at, the more crucial these adjustments become. The following gives some basic rules helpful in roman letter design.

Curved strokes at their widest are made slightly wider than vertical stems which are the same width as the broad diagonals. Horizontals are usually about half the width of the vertical stems. This width is automatically determined in this method by the 30° 'pen angle' which produces horizontals slightly more than half the width of the verticals. Thin diagonals here are made to match the horizontals but can be nearer two-thirds the width of a vertical stem in which case the verticals in N are treated similarly. For the broad diagonal in N and the broad diagonals in X and Y, I have used entasis (which throughout this article means a subtle concavity) to narrow the strokes slightly by placing the curvature so that it cuts into the stroke. This makes the narrowest part of the stroke, viz. the mid-point or 'waist', slightly less than the width given by the double pencils. On all vertical stems (including, in this instance, those in N) I

have placed the entasis on the outside of a stroke so that the mid-point or 'waist', again the narrowest part, corresponds with the full width given by the double pencils (see Illus. 1b), thereby giving slightly weightier vertical stems necessary to balance correctly with the curved strokes.

Leaving aside, for the moment, the question of terminations, if we write the letter I with the double pencils one-eighth of the letter height apart and at a constant angle of 30°, we are left with a pair of parallel lines which we can imagine as being obliquely cut off at the fixed angle. By completing the sides of the letter which fall short of the lines top and bottom as in Illus. 1a, we are left with our letter I consisting of a pair of vertical parallel lines cut off by the horizontal height lines. Looking closely at this letter we observe that, because the sides are parallel, the letter appears to be wider across the middle and narrower at the two ends. In order to counteract this optical illusion, it is necessary to make the sides slightly concave (entasis) as in Illus. 1b. This has the added advantage of integrating the classical bracketed serif into the stem of the letter so there is no apparent join and the serifs appear to grow organically out of the stem. Similarly, the horizontal lines connecting the serifs, top and bottom, are slightly curved, up at the bottom and down at the top to prevent them appearing to swell out. Whilst a slight emphasis on these characteristics can lend a certain vitality, too much emphasis will completely distort the character of the letters.

Another consideration particularly affecting letters such as B D E and L, is that the lower serif is improved if raised slightly above the base line, as in Illus. 1d, thus producing an ogee-shaped line. This feature together with the rounded join

where the bottom horizontal, in E and L, or curve in B and D, meets the upright stem and the slight convexity in the serifs on the horizontal strokes on E (Illus. 1d), and similarly on other horizontal strokes, are most probably explained by the technique employed for setting out roman inscriptions, i.e. the use of a chisel-edged brush. For a full explanation of this brush method of making roman letters the reader is referred, once more, to E. M. Catich's book, *The Origin of the Serif*. It will be noticed in Catich's demonstrations that there are many subtle changes of brush angle within the strokes. The present article is giving only a very simplified version of changes of angle as a calligraphic starting point. I believe that ultimately the edged-brush method is the best way to acquire an understanding of these letters. The brush's soft edge allows for swelled strokes (entasis) and it is more easily swivelled between the fingers to produce manipulation than double pencils. However, the methods described here enable people with sufficient calligraphic or chisel-edged brush experience to incorporate calligraphic influence into their letter design and will, it is hoped, draw them into a deeper appreciation of the constructional powers and educational value of the broad-edged tool.

Illus. 1e shows a letter O composed of two ovals which have an upright axis and are overlapped at an angle of 15° and at a distance or weight of $\frac{1}{8}$ the overall height of the letter. The two ovals are overlapped so as to give an overall letter width which is circular (or very slightly less) in keeping with classical Roman proportions. The angle of overlap is reduced from the angle of 30° used for E F H I J L and T to 15°, as an overlap of 30° would give, in this particular instance, too marked a tilt with an awkward distribution of weight. A

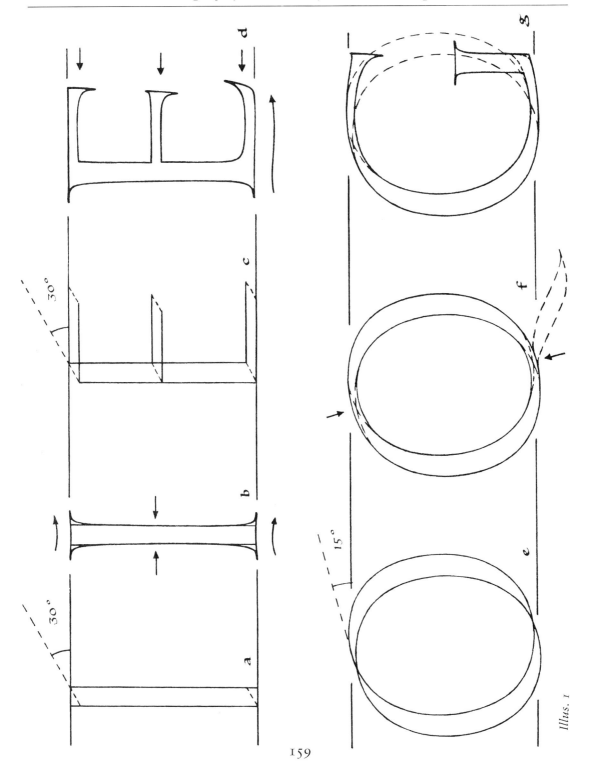

Illus. 1

Illus. 2 and 3: 'Double-pencil' letters with, beneath, the finished form developed directly from them. Broken lines indicate pen angle (either at the start of, or within, strokes). The letters shown here have been reduced from their original size and it is recommended, as a starting point, that the student should work with a letter height no less than 50 mm.

161

characteristic of calligraphic forms that is particularly evident in curved strokes is an abrupt change from thick to thin which contrasts with a more gradated change in 'built-up' or drawn forms. In Illus. 1f the final form is obtained by the thickening of the letter at the 'changeover' points (arrowed) – the now separated contours are carefully followed to produce smooth continuous curves.

Other curved forms or curved parts of a letter are treated in a similar way as the O, i.e. by the careful adapting of the 'changeover' points to give a gradual change from thick to thin. A 'pen angle' of 15° (or a 'pen angle' manipulated from 15° to 30° round the curves of B P and R) results in certain curved strokes or parts of curved strokes, which are almost horizontal, being too thin in comparison with other horizontals written at 30°. These are the flattened curves of C and G and most of the near horizontal parts connecting stem and curve in B D P and R which therefore need to be slightly thickened up on the inside of the stroke (see Illus. 1, 2 and 3). The bottom stroke of B and the middle stroke of R are already

thick enough as the pen manipulation enables these to be written nearer 30°.

The student would be well advised to study in conjunction with this article good examples of classical Roman letters (such as the Trajan inscription, but there are other good examples) and in particular the relative proportions of the letters to each other (see 'Formal Scripts' pages 111–13) and the disposition of the thicks and thins. A study of classical models is not necessarily recommended here as an end in itself but as a root form to demonstrate certain fundamental principles which, once thoroughly understood, are applicable to a wide range of letterforms. Much remains to be discovered about the relationship of calligraphy to drawn letterforms and this article can only indicate briefly one of the many possible ways to explore this method of letter design.

Acknowledgement
I would like to acknowledge with gratitude the valued assistance of Ann Camp, ARCA, for reading and commenting on this article.

POEM

FIND TIME HANGING, CUT IT DOWN
ALL THE UNIVERSE YOU OWN

MASTERLESS AND STILL UNTAMED
POET, LEAD THE RACE YOU'VE SHAMED

LOVER, CUT THE RATIONAL KNOT
THAT MADE YOUR THINKING RULE OF THUMB

AND BAREFOOT IN THE PLUM–DARK HILLS
GO WANDER IN ELYSIUM

LAWRENCE DURRELL

Brenda Berman: Poem by Lawrence Durrell. Brush-drawn letters in blue-grey gouache on Amalfi paper. $15\frac{1}{2} \times 24$ in. 1982.

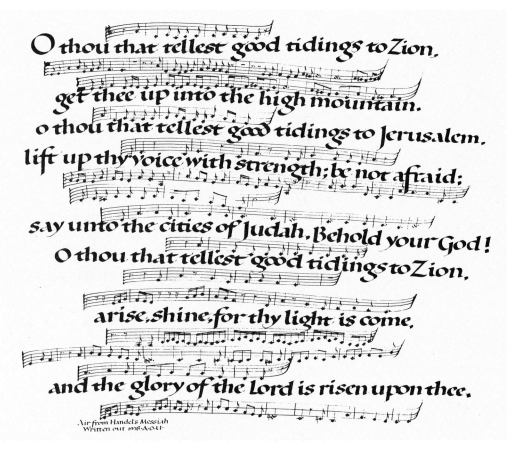

Alison Urwick: Air from Handel's *Messiah*. Panel written in black Chinese ink on white handmade paper. 39.5 × 48.5 cm. 1978.

David Williams: Book jacket for *Esthetics of Music*. Lettering for original written with steel pens and quills in black and red. $8\frac{3}{4} \times 5\frac{1}{2}$ in. 1981.

Donald Jackson: From *The Tree of Life*, framed panel on vellum. 760 × 710 cm. 1980. By courtesy of the Victoria and Albert Museum.

The detail shown, approx. $\frac{1}{3}$ original, illustrates three techniques for applying gold: *a* The winged figure is double-thick gold leaf burnished onto a plaster-based gesso which was applied freely with the barbed feather of a large turkey, the details applied with a flexible goose quill pen. *b* The geometric linear diagram is powder gold mixed to an ink-like consistency with water, gum arabic and fish glue, applied with a pen. *c* The flames on the menorah (candlestick) are white-gold leaf, burnished onto gesso and the natural gelatine adhesive on the surface of the vellum. The leaf was allowed to tarnish round the edges before being glazed over with glair (egg white and water).

Illumination and Decoration

DOROTHY HUTTON

This article is reprinted from the earlier *Calligrapher's Handbook*.

The aim of illumination and decoration is to tell the story and to enrich the page. Provided that certain conditions are observed there is no one technique which is right to the exclusion of others. The descriptive calligraphic outline drawings of the eleventh- and twelfth-century Winchester School of illuminators differ in treatment from the richly-coloured and gilded French manuscripts of the fourteenth and fifteenth centuries, yet both serve their purpose and remain marvels of beauty and workmanship. Behind each lie the same principles of approach: candid expression from which springs a sense of vitality and life, realization of a balanced design within the limits of a page, and, pervading all, an enjoyment in execution.

Within these principles which still persist today the scope is limitless both in treatment and subject matter. For some illuminators the pen is the chosen tool, for others the brush; some prefer the formal approach, others the naturalistic. But, however dexterous the work, if vitality is lacking, the result is a sad dull statement, and when it is present, however faulty the technique, the illumination may charm and delight.

Practice differs considerably; the approach is largely personal. Once the subject of the book has been decided it is of considerable assistance to look at a few fine manuscripts at the British Library or elsewhere. If this is not possible a close perusal of reproductions may help. The purpose of this step is to set a standard, to observe how the masters of illumination worked. Gradually the mind begins to visualize a scheme and becomes saturated with ideas. A book is conceived as a whole, with text and spaces for decoration left at appropriate intervals. The plan and colour of the decoration should be largely uniform throughout the book. A dummy book may be useful; by this means difficulties are avoided, otherwise it may be found too late that a full-page illumination appears on the 'flesh' or smooth side of the vellum or that the text terminates on the bottom line, leaving no space for a decorated finial. This preliminary planning may take many days but it is time well spent. The mood of the subject matter of the occasion or person for whom the manuscript is intended probably dictates the theme.

The text of the manuscript should be written to its conclusion before any illuminations are added. Blank spaces are left, however, in the text as arranged in the dummy book, and in these faint pencil indications of the subject matter can be drawn as a reminder of what is planned to fill them. Meanwhile material for working drawings can be collected. This collecting of material is frequently a considerable undertaking and may involve visits to museums, the making of studies from life and objects of many kinds, requiring more

Eleventh-century English School: From Aurelius Prudentius, *Psychomachia*. A free calligraphic pen line. British Library, Cotton MS, Cleopatra cviii, f.15.

drawings than may be finally used. Results will be worth the effort, for, unless intelligent studies are to hand there may be gaps in knowledge which will become distressingly apparent when making the final drawing. The idea that artists draw 'out of their heads' is largely a fallacy; the idea may come from their heads but studies are necessary to make the idea convincing when set down on paper or vellum. No details should be neglected, for instance, careful drawings of beaks and claws of birds, drapery, attachment of leaves, windows and cornices of buildings; these give the character. The decorative qualities of objects should be observed as,

for instance, how one leaf answers another on a stem in rhythmic balance. Such details give freedom of expression in the final work.

Having obtained sufficient studies for the subject the drawing can be composed referring to these studies as required. The act of drawing has to be 'lived'; this is an alert, not a gentle action. The essential 'movement' of the object is important with accent on structural details. The relative proportions of beasts and men and flowers and houses are immaterial, nor need the colours be rendered literally. In view of the fact that an illumination is within the convention of a book containing

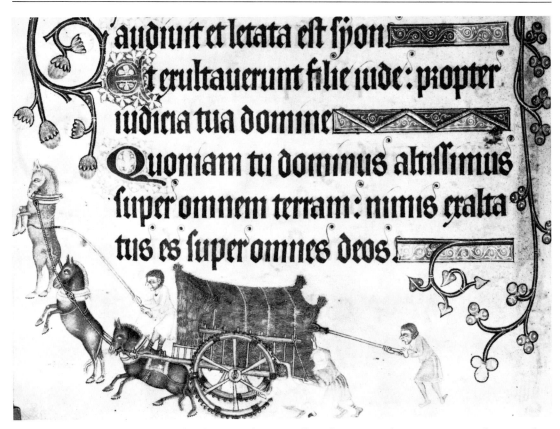

Fourteenth-century English School: From the *Luttrell Psalter*. A simple statement, emphasis on the decorative element of detail (e.g. collars and reins). Colour added as design. British Library, Add. MS 42130, f.173v.

calligraphic symbols and not that of a framed picture, a formal treatment appears to agree better with the text than a naturalistic one. Even in this there can be no fixed rule, though whichever manner of expression is adopted the statement should be clear and precise.

The amazing marginal decorations in the Luttrell Psalter[1] illustrate the points mentioned: the precision of 'movement', the structural details such as the attachment of the reins to the horses' collars and the nails on their shoes, the

lack of proportion between the driver's head and his feet, and the unexpected blue tint of one of the horses. Yet the subject of a 'Harvest cart going uphill' has been convincingly and graphically described in a lively candid statement (see photo above).

Unless the artist is very skilled it is as well to make a tracing of the finished drawing and to tranfer this on to the blank space left for it in the manuscript. Lead carbon paper should be used (never typewriting carbon paper which is indelible). The outline is traced with a fine point, the tracing on the vellum is then freely redrawn with a hard pencil using a light touch.

[1] British Library. Add. MS. 42130 written about 1340, English.

Fifteenth-century French School: From the *Book of Hours* of John, Duke of Bedford. Full-colour work, arranged within a formalised architectural setting, remote from naturalism. British Library, Add. MS 18850, f.257v.

Fifteenth-century Italian School: From Petrarch, *Trionfi*. An interesting example of unfinished decoration, showing preliminary lay-in of the main lines of the design in pen and pencil. Bodleian Library, MS Can. Ital. 83, f.44v.

By now the subject matter of the drawing should be clearly understood which is as well for the test is now to come. A duck quill pen is taken, one of its prongs is cut shorter than the other and this makes an excellent drawing pen. If a brush is preferred with which to draw, a sable size 'o' or 'oo' is useful. Chinese ink is rubbed down with distilled water as this produces a blacker shade than when tap water is used. The pen outline should in no way compete in strength or colour with the script or the illumination will overpower the text instead of making an harmonious balance. A fine pale ink line is freely

drawn, structural details being accentuated or even enlarged, never slurred. When the ink drawing is completed the pencil marks are removed with a soft india-rubber and the waste rubber wiped off with a silk cloth. Pumice powder is sometimes used instead of rubber to remove pencil marks but this is liable to pull up the vellum surface thus attracting dust and dirt in future handling. Should gold be included in the design this is the time to gild. It may be noted here that the introduction of raised burnished gold if used sparingly has the power to formalize a design and remove from it any naturalistic tendency.

The illumination is now ready to be coloured. A hurried impulse to paint has ruined many a promising beginning and it is now that restraint is necessary. Colour can be swiftly laid on but not so swiftly removed and with alteration the spontaneous brilliancy is impaired. The colour plan of the entire manuscript should be remembered for, when the first decoration is completed, the scheme is irrevocably set for the whole book. With this in mind it is sometimes a useful plan to begin with a small decoration within the text rather than a full scale first-page illumination before confidence of execution has been gained.

The manner of treating the colouring is a personal matter which may have been gained by trial and error. One illuminator may prefer merely an ink outline with the addition of a few touches of local colour introduced as a pattern, whilst another may favour a fully toned and lively colour scheme obliterating the ink outline. The choice of the medium for the colour may control the technique. Liquid paint used as a wash may cockle the skin, therefore paint is better applied in a dryish consistency, possibly stippling with a fine brush. One method of application is to lay

a foundation tone on the design; then the lighter and darker tones are modelled when this foundation is dry. Another method is to lay a coat of white; the colours are then applied on top of this coat, thus giving solidity and brilliance. This technique is, however, not possible if a gum medium is used, as the white underpainting will 'move' and make a muddy mixture with the super-imposed colour. Yet another method is to model the drawing with *terre verte* or other neutral shade; on top of this modelling when dry, a semi-opaque coat of colour is lightly washed. This method was frequently used in figure subjects by the mediaeval illuminators.

It is through constant and courageous attempts that some satisfactory results may be achieved. There is a vast field of enjoyment open to all. However simple the theme, if the decoration is descriptive, lively, fearless and sincere, it will be of interest and will enrich the text.

Editor's note: The author later became aware that much exquisite mediaeval illumination shows no sign of an outline drawn by either pen or brush.

Nothing is so beautiful as Spring —
When weeds, in wheels, shoot long and lovely and lush;
Thrush's eggs look little low heavens, and thrush
Through the echoing timber does so rinse and wring
The ear, it strikes like lightnings to hear him sing;
The glassy peartree leaves and blooms, they brush
The descending blue; that blue is all in a rush
With richness; the racing lambs too have fair their fling

Spring

GERARD MANLEY HOPKINS

What is all this juice and all this joy?
A strain of the earth's sweet being in the beginning
In Eden garden. Have, get, before it cloy,
Before it cloud, Christ, lord, and sour with sinning,
Innocent mind and Mayday in girl and boy,
Most O Maid's child, thy choice and worthy the winning.

Gaynor Goffe: Gerard Manley Hopkins, *Spring*. Written with an edged pen in green gouache on Fabriano Ingres paper. Illustration in pale green. 19 × 30½ in. Commissioned by Michael Taylor.

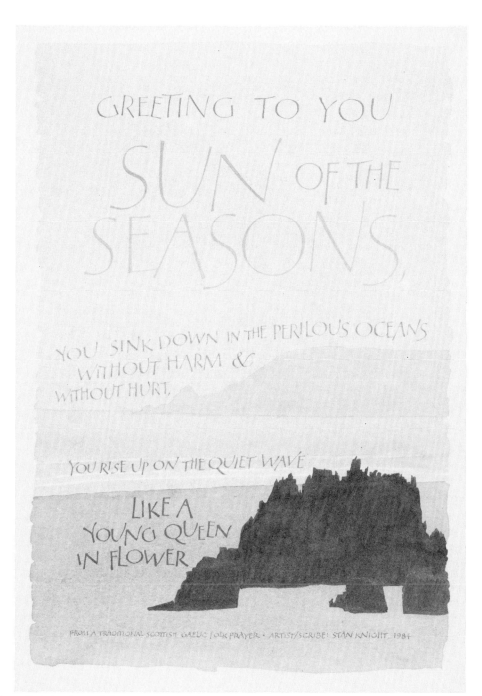

GREETING TO YOU SUN OF THE SEASONS,

YOU SINK DOWN IN THE PERILOUS OCEANS WITHOUT HARM & WITHOUT HURT,

YOU RISE UP ON THE QUIET WAVE

LIKE A YOUNG QUEEN IN FLOWER

FROM A TRADITIONAL SCOTTISH GAELIC FOLK PRAYER · ARTIST/SCRIBE: STAN KNIGHT 1984

Stan Knight: Sun of the Seasons, from a traditional Scottish Gaelic folk prayer. Watercolour in shades of yellow on Arches Aquarelle NOT paper. Lettering written with brush and pen. 40 × 27 cm. 1984. By courtesy of the Rijksmuseum, The Hague.

173

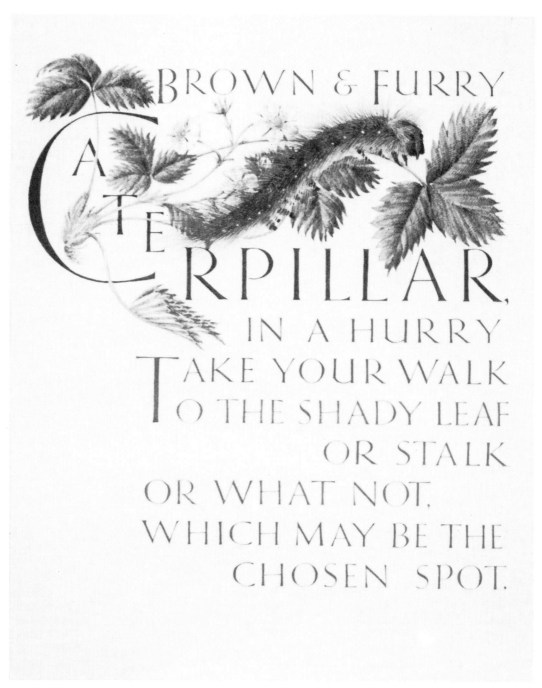

BROWN & FURRY
CATERPILLAR,
IN A HURRY
TAKE YOUR WALK
TO THE SHADY LEAF
OR STALK
OR WHAT NOT,
WHICH MAY BE THE
CHOSEN SPOT.

Marie Angel: Christina Rossetti, *The Caterpillar*. Watercolour on vellum. $8 \times 7\frac{1}{2}$ in. 1979. By courtesy of the Victoria and Albert Museum.

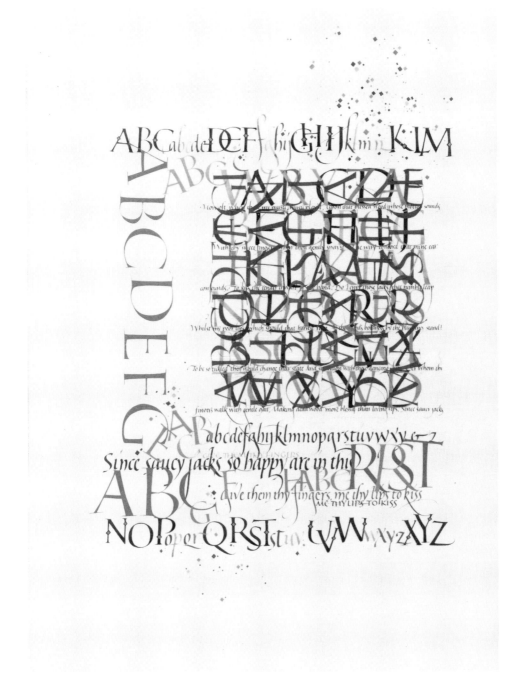

Thomas Ingmire: *Saucy Jacks*, Shakespeare sonnet. Written in Sumi ink and natural pigments on vellum. 17 × 24 in. 1983.

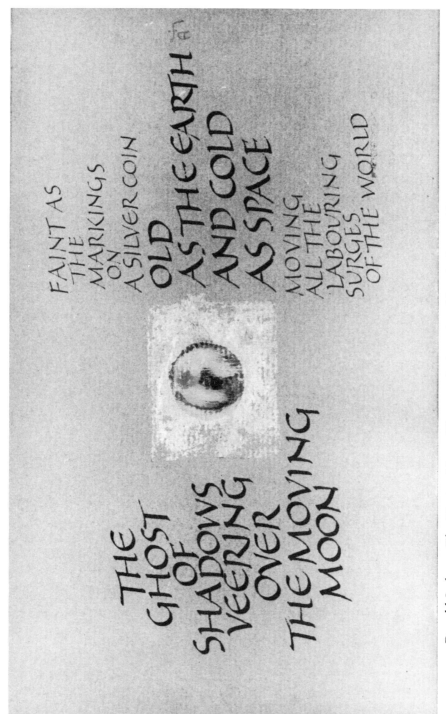

FAINT AS
THE
MARKINGS
ON
A SILVER COIN
OLD
AS THE EARTH
AND COLD
AS SPACE

MOVING
ALL THE
LABOURING,
SURGES
OF THE WORLD

THE
GHOST
OF
SHADOWS
VEERING
OVER
THE MOVING
MOON

Donald Jackson: *The Moving Moon.* The moon's shape is gold and white-gold leaf burnished onto a gesso base. The white gold burnishes well but, because it is an alloy of approx. 60% silver and 40% gold, it oxidises (tarnishes) when exposed to airborne acids. Oxidisation of the silver content can produce an attractive range of metallic colours but these gradually degenerate to a dull purple-grey after prolonged exposure to air. Tarnishing can be controlled at any stage, however, if selected areas are coated with a 'varnish' of glair (egg white and water), though there may be some loss of burnish, or if the piece is framed in a tight, well-sealed frame.

176

Gilding

DONALD JACKSON

with quotations from
IRENE BASE and VERA LAW

GENERAL INTRODUCTION

Many people's first reaction to a beautifully designed piece of calligraphy or illumination is to marvel at the painstaking care and effort spent on the 'perfect' finish and detail of it. This is only natural, for people generally are more easily impressed by the fact that a great pianist manages to remember all the notes in a piece of music, than by the artistry of his interpretation. But as our understanding grows we should learn that the main concern of the artist that lies within us all is not a 'perfect' finish, it is the expression of that creative energy and personality which is unique to every one of us. Of course it is skill that allows us to express ourselves *accurately*, and at first it is only proper that we should devote many hours to the acquisition of skill as an end in itself, but we should never forget that 'remembering all the notes' is not as important as the way that we play them.

The generally accepted priorities of Western educational systems with their emphasis on competition and literary information-gathering makes it hard for many of us to accept the premise that a mistake is anything other than a failure. As adults we are hard on ourselves; impatient with our technical shortcomings we compare ourselves unfavourably with others and are to some extent afraid of failure. Our first job, therefore, is to make a fundamental shift in our attitude towards our mistakes and to learn to see them as creative elements in problem solving rather than as retrograde disasters. If we aim to perfect the *spirit* of what we do as well as the surface of it, it will mean that even the worst technical mistakes can never be a complete failure.

Where then do we begin? In simple terms we must begin again like children copying others, and adding constructively thereby to that visual vocabulary we started to build so enthusiastically when we were very young, but neglected later in favour of more 'useful' subjects. What we should do is to aim to put into each piece of work something of the joyful spirit which a child brings to painting and drawing – improvements in skill and mastery of technique should follow on naturally from that.

Sources

History presents us with a glorious range of designs, colours and techniques. Do not be ashamed to copy as faithfully as you

can from good reproductions made to the same size as the original – reductions are more difficult. Even a pencil tracing will tell you a lot about a piece of decoration or illumination. Comparison of your own work with that of craftsmen of the past may be painful but it helps you to acquire a judgment of technical standards and a sense of scale.

Look closely at the symbols of heraldry and the various religions; at the letterforms of different cultures; at flowers, plants and even the exciting patterns created by modern electronic technology; the moving multi-lines of computer graphics and the minute cellular structures revealed by micro-photography. All these can be transformed by the art of illumination and decoration into visual extensions of the meaning and mood of the words we write. You need not fear that by copying you will forfeit your own individuality, you cannot fail to express that whatever you do.

Sharpness, freedom and unity, the trinity of virtues defined by Edward Johnston as the essentials of fine writing, can also be applied to the way we carry out our designs. The following basic instructions are intended to help you find your own way to achieve this.

GILDING

When we come to decorate our work, there are many eye-catching colours we can use. In a sense, gold is just another one of them, but our response to it, on many levels, denies it such a commonplace role. As a rare and precious metal, a living reflective mirror of light, it is a magnet for our eyes and emotions. Used judiciously it confers formality and richness on a document of state, used lavishly it can help create an awesome splendour appropriate

to spiritually significant words; but if it is used over-indulgently it may cheapen even the most profound literature. We must therefore use it with care, and save it like a trump card to play when the time and place seem right.

In general it is wise to avoid a large area of unbroken gilding unless it is relieved by decoration or texture. The large gilded panels of a Chinese or Japanese screen take visual advantage of the variation of texture obtained from the slight overlap of leaves of gold leaf. We see then not a single sheet of uniform brilliance but a series of rectangles within a rectangle.

Mediaeval illuminators punched and scored designs into the background of gilded gesso panels to catch and turn the light in different ways over large surfaces, so whilst the overall shapes were bold they were also enlivened with decoration and intriguing detail.

TYPES OF GILDING IN ILLUMINATED MANUSCRIPTS

Three different types of gilding: powder gilding, leaf gold on gum base and leaf gold burnished onto a raised gesso base are described here in turn, with instructions for their preparation and use. All three can produce a different range of effects and visual possibilities.

All these techniques require the use of pure, unalloyed gold. Powder gold is bought in small packets by weight or in tablets. Leaf gold comes in small books, with the leaves of gold paper-backed ('transferred gold') or as loose leaves each one separated by transparent paper from the next ('loose gold'). Powder gold is the most concentrated in use and therefore the most expensive – but it is unlikely to be used to cover large areas.

POWDER GOLD: PREPARATION AND USE

Powder gold dries flat and has no shine but can be easily polished into comparative brilliance. Dots, lines and patterns scored with a pointed burnisher bring it to life and these indented patterns catch the light in a way which subtly contrasts with the more brilliant gesso gilding. It can be applied with a pen or brush and because it is comparatively easy to control it is very suitable for tiny detailed designs, small lettering and for use on top of colour which has already been laid, so long as it is deftly painted without disturbing the undercoat; whereas leaf gold which pressed onto size, tends to stick to the background colour and is difficult to clean off afterwards.

This type of gold, sometimes called shell gold because it was traditionally supplied ready to use as a tablet in a half mussel shell, can still be bought in small tablets, similar to cakes of watercolour and used in much the same way. The tablets consist of gold particles bound together with a glue or gum. Loose gold powder is supplied by the gold-beater in packets that are still weighed against an old penny or halfpenny (dwt or $\frac{1}{2}$ dwt).

Two or three drops of water added to the edge of a gold tablet will soften the glue or gum. Using a clean small watercolour brush, dislodge enough of the particles to alter the viscosity of the mixture a little, tilt the palette slightly to one side; this will prevent your gold 'ink' from thickening further, and exposes less of its surface to evaporation. Only trial and error will help you decide the exact consistency for your needs.

The main problem in using any ink is to reconcile the flow or viscosity of it with even covering power. This usually involves a process of juggling quantities of pigment, in this case gold powder, with the medium (glue and water); too much water and, whilst it may flow easily, the result will be a patchy and semi-transparent covering. Too much pigment, and the ink will refuse to flow through the pen or brush, or at the very least, will produce a lumpy effect. Too little gum or glue, and the powder will brush off the surface when it is dry. Although the problem is simply stated, it is not so simply answered in practical terms. Unfortunately it lies at the root of most beginners' failure to apply or write with colour evenly.

Even when a satisfactory balance of the components has been achieved the mixture must be frequently agitated during use to ensure that an even distribution of pigment or gold particles is maintained. Care must also be taken to prevent undue evaporation which will alter this balance. Expose as little of the ink's surface to the air as possible when working with it, and cover the palette carefully after use. You can apply this 'liquid gold' with a pen or a brush, but since the gold particles tend to concentrate in the hair of the brush next to the ferrule, it is best to use as small a brush as is practicable as this can be filled and emptied 'like a spoon', otherwise you may find yourself painting with a very watery ink even though the consistency in the palette is correct.

Tiny writing can be done using a quill and powder gold but fine filigree work and highlights on delicate and elaborate illuminations are perhaps best applied with a fine brush. It must be emphasised that even after a pen has been charged with the 'gold ink', it should be frequently checked to ensure that the gold particles are well and evenly mixed within the medium.

Much of the powder gold in tablet form presently sold is manufactured in France. It is coarser in grain than was made in the past. For the finest results it may be improved by re-grinding it into finer particles which make a more smoothly flowing ink.

Thomas Ingmire has suggested the following method for doing this:

> Break up the tablet as supplied into small crumbs and place in a small glass mortar. Add one quarter tablespoon of salt, 3 or 4 drops of honey, and as much water as is necessary to lubricate the mixture. Grind this with a small (matching) glass pestle for 10–15 minutes. The salt and honey should prevent the particles from compounding. Fill the mortar with water and agitate the gold to mix it thoroughly. After the gold has settled drain off the liquid, leaving the gold undisturbed on the bottom. Repeat this 4 or 5 times to rinse away the salt and honey, and then let the gold powder dry in the mortar. Melt a small gelatine capsule, or $\frac{1}{2}$ of a medium sized one, in a teaspoon of warm water and add it to the gold, stir it thoroughly and then pour the whole mixture back into the original container where it will then be ready for use.

Mr Ingmire finds this technique also works well for reducing waste gold leaf to powder form.

Loose powder gold, also, can be ground finer if necessary and the particles bound together by the same method used for the reconstituted gold tablet.

A single drop of fish glue can be substituted for the gelatine; gum arabic may be used instead though it has a tendency to crack as it contracts over a period of years, and it does not burnish so brightly as the alternatives. The ultimate tests are: if the gold brushes off when dry – too little binding medium; if it cracks as the medium contracts – too much medium;

you will need to experiment for yourself. The best way to apply an even layer of powder gold is to think of the pen or brush as a ladle which pours out the ink, rather than to use the normal spreading action of a brush. Laying the gold ink in *two* thin coats – burnishing the first coat when it has dried, before applying the second – can help to prevent the gold from cracking off under pressure.

LEAF GOLD: ROLE OF THE MORDANT

Gold leaf cannot be applied direct to the surface of a manuscript. It requires a base or size, sometimes called a mordant, which can be applied spontaneously through a pen or brush. The application of the gold leaf has to be painstaking but the actual shapes have life.

As the writing surface is vellum or paper, which are not rigid surfaces, the mordant should be reasonably flexible when dry and, in addition, should be chemically inert (containing no acids or caustic substances which could attack the writing surface and affect other colours, nor be subject to mould).

It should be pointed out that the gold sizes used by signwriters for work on wooden panels and exteriors, are unsuitable for vellum or paper. They do not flow in a pen and more to the point, they are actually oil-based varnishes, the oil tends to creep beyond the shapes of the letters or the designs, staining the area surrounding them and coming through on the reverse of the parchment or paper.

All kinds of extraordinary substances, such as snail slime and garlic juice, have been recommended as mordants over the centuries, but gum and the plaster-based mixture called gesso now predominate.

LEAF GOLD ON A GUM BASE: PREPARATION AND USE

The gum described below is gum ammoniac (not to be confused with gum arabic) which derives from the milky secretions of an umbelliferous plant which grows in North Africa and Iran.

It is relatively simple to prepare. When mixed correctly it flows easily from a flexible pen or a brush and dries quickly with a transparent and glossy finish which is slightly raised from the writing surface. When gilded, the bright finish lies somewhere between the subtle effect of flat powder gold and the eye-catching brilliance of gesso gilding.

Gold leaf can be successfully laid on gum ammoniac immediately after it has dried or even after a time lapse of several years. It softens when heated or exposed to humidity – the illuminator's breath is sufficient. Because of this, however, it does not lend itself to direct burnishing which creates heat through friction.

GUM AMMONIAC SIZE

In dried form gum ammoniac varies in appearance between pieces resembling buttered popcorn and a large sticky block something like nougat. It usually contains a high proportion of impurities – seeds, husks, stones and dirt – and careful sieving is therefore important.

Requirements

A small jar with lid.
A separate larger jar with lid.
Fine knitted nylon (such as stockings or tights).
Small amount of non-acidic preservative – see Dorothy Hutton's article on Pigments and Media, page 56.

Method

1 *Remove impurities from the dried gum.*
Remove the obvious impurities such as seeds and stones and break the lumps of gum into small pieces about the size of a pea or less, this helps the dissolving process.

2 *Soak it.*
Place about a tablespoon of this in the larger jar. Pour in just sufficient water to cover the gum and leave to soak, stirring every now and again to help the gum dissolve. I have found it best to leave the gum soaking for at least 8 to 12 hours or overnight, by which time it should be sufficiently dissolved to be stirred and strained.

If the gum is needed urgently the process may be speeded up by dissolving the gum and water in the jar in a pan of hot water – it will melt within minutes and can then be strained and used as soon as it cools.

3 *Sieve it.*
Pour the mixture through one or two thicknesses of fine denier nylon stocking into the smaller jar. It should then be of the consistency and colour of single cream. If you force the undissolved sludge through the mesh, dust and dirt particles will mar the end result.

4 *Add colour and preservative.*
You may now add a little watercolour, ink or a drop of food colouring so that you can see more clearly what you write or draw with the size. *Armenian bole* (see page 184) tends to mix unevenly and cause grittiness.

A tiny drop of preservative may be added to keep the mixture free from mould and it is a precaution to keep the jar in the fridge. I once stored ammoniac in what seemed to be a clean pickle jar – it needed no preservative for months! Acetic acid is not recommended for the

illuminator however. If mould does grow on the top, it may be skimmed off and the mixture sieved again. If saffron is used to colour the gum it may also act as a preservative.

If a brush is used, take care to wash it thoroughly in warm water or ammonia and water, or it will set hard and be spoiled. As the gum dries the milkiness fades and it should set clear and glossy. The touch of colour added to the mixture should enable you to see your design.

LAYING THE GOLD LEAF

To apply gold you can use single-thickness transferred leaf (patent gold). A marginally brighter finish can be achieved by substituting double-thickness transferred gold or by using loose gold leaf which is placed on the size, covered by a thickness of crystal parchment (glassine) paper (see section on gesso gilding for methods of handling loose gold leaf) and pressed down firmly with a soft silk pad.

Because gum ammoniac softens and smears when burnished it is difficult to avoid damaging your designs when working close to it with a burnisher so remember to complete all burnishing, (whether gesso or powder gilding), and clean away all surplus gold before laying gum ammoniac close to it.

If the writing surface is smooth and does not absorb a lot of the size, you will have a better result than when working on a textured or absorbent surface which may rob the gum of its effectiveness, especially on thin lines and fine detail work.

Fine hair lines may not always hold sufficient gum to catch the gold, but a little trial and error will help you foresee the need to reinforce vulnerable fine lines with the corner of the pen when you are laying the size.

Breathe on the gum through a breathing tube made from a hollow reed, bamboo or rolled paper (plastic straws tend to dribble condensation onto the work after a time). The dampness of your breath will make the gum sticky, press the gold leaf through its paper backing firmly down onto the drawn shapes. Take care not to twist as you press or this will damage the soft shapes underneath. After you have breathed on it once or twice the gum is usually sticky enough to ensure instant success but if the gold does not stick perfectly all over at the first attempt then breathe on it again and repeat the process until you have covered all the ungilded places.

Finally brush away surplus gold with a soft pad or a piece of well-washed soft silk, or clean camel-hair brush.

Gum ammoniac with its slightly raised appearance looks well on a painted background. But because paint also contains a potentially sticky binding medium the leaf tends to stick to it as well as the size when it is breathed on. One way of inhibiting this tendency is to dust onto the undercoat, just enough fine talcum powder or French chalk to absorb any surface moisture before laying the size, but not so much to mix with the gum and cause it to dry lumpy. As with most techniques a great deal more will be learned from attempting them first rather than by reading and re-reading the instructions. It is better to read once, try once and then read again.

LEAF GOLD ON GESSO: PREPARATION AND USE

Gilding on gesso which has dried slightly raised from the writing surface, produces the most brilliantly reflective form of gold decoration for manuscripts.

When the principles of the technique of gesso gilding outlined below were rediscovered by Graily Hewitt and others in the early 1900s they relied heavily on sometimes imprecise translations from a treatise of the fourteenth-century Italian craftsman Cennino Cennini. Even though D. V. Thompson improved greatly on these translations in the 1930s, precise definitions of function and quantities of ingredients were often lacking, principally because Cennini did not specify them in the first place.

After many years of research, A. V. Hughes, a student and associate of Hewitt's, concluded that parchment size was an improvement on fish glue as a binding medium in the making of gesso. My own preliminary experiments confirm this but neither his findings nor my own are sufficiently specific to be of immediate value. With the exception of experiments with acrylic and polymer mediums, which are not dealt with here, little new ground seems to have been broken since the well-researched work of Irene Base was published in the 1956 *Handbook*. Since extremely successful results have been achieved with the same kind of recipe over the last sixty years, I will restate much of what Irene Base wrote, with some further suggestions on the techniques involved in making the gesso, applying it and gilding it.

My own researches suggest that most gilded letters and decorations on illuminated manuscripts of the past did not consist of high cushions of gesso built up, layer upon layer, with a brush. Unfinished manuscripts indicate the opposite. They show evidence of speed and dexterity in the laying down of gesso, with a flexible pen to form the letters and spread the size. The gesso seems to have been the consistency of a thick but free-flowing ink which dried with a comparatively low profile. We, however, often find this technique frustratingly difficult to master. Remember, though, these practitioners were specialists; we, in the main, are not. We should not expect gilding on gesso to be easy at first nor should we expect to find the answer in a simpler recipe; easiest is not always best. (We do not after all unscrew half the keys of a piano in the belief that it will then be easier to play.)

The problems of acquiring a working technique should be free from the anxiety of producing a finished piece of work. It is better to start by making a series of tests and to have several (constructive) failures at first – as only then will some of the instructions given here begin to make sense.

Whenever any experiments are made be sure to take notes at the time. However certain we are of our memories, it is unlikely that we will recollect ten years hence when coming across a beautiful piece of gilding exactly what recipe we used for it.

INGREDIENTS FOR GESSO

Parts

16	Plaster	Slaked dental grade.
6	*White lead	Fine powdered lead carbonate.
2	Sugar	Rock candy or raw brown coffee sugar finely powdered.
1	Glue	Fish glue as pure and unadulterated as can be found.
as little as necessary to see the forms clearly	Colour	Armenian bole or other highly concentrated non gritty pigment, red or yellow.
	Distilled water	

*CAUTION White lead is toxic, it can be easily inhaled or ingested, it is also cumulative, so great care must be taken when using it, especially when dry when its dust can be breathed in. George Yanagita and others have found that titanium dioxide is an acceptable alternative.

The quantities are not sacrosanct and once you have tried out the basic recipe, bearing in mind the different functions of the ingredients described below, you may modify them to suit local needs. However, these proportions have stood the test of time and deviations will have to await later judgment.

Plaster is used for its body and strength, slaked to render it inert. (See below)
Lead adds to the body or density of the gesso. It is malleable and its fine particles may also help as a filler between the relatively coarse grains of plaster.
Sugar is included because it is hygroscopic (attracts moisture) in theory at least, it thereby maintains a certain amount of

flexibility in the gesso, and when breathed on, helps to activate the glue to which the gold leaf adheres.
Fish glue also binds the rest of the essentially dry ingredients together.
Armenian bole is a refined form of iron oxide which occurs naturally in various parts of the Earth's geological strata. It is used to provide a rich background colour (deep red) to the gold. As the gold is very thin and slightly transparent its hue is to some extent affected by the colour of whatever it is laid on. When of the finest quality, the oxide seems to have the advantage of acting as a filler between the particles of the other ingredients in gesso and may assist in achieving a fine polish, though I have no proof of this.

Slaked plaster Although it can sometimes be bought ready made it is probably safer to make your own slaked plaster and I can do no better than paraphrase the description of this process written by Irene Base.

1 lb fine dental plaster
A gallon and a half of clean water in a rust-free pail, distilled water if possible (tap water can contain strange things!)
Sift the plaster gradually into the water, stirring it constantly with a wooden spoon. When all the plaster has been mixed in, continue to stir for about an hour until sufficient 'life' has gone out of the plaster to prevent it setting. Then leave it to settle for a day.
Gently pour off the water, which will be clear, without losing any of the plaster that has settled on the bottom. Refill the pail with fresh water, stir it for 10 minutes or so, and repeat this process every day for a week. After that, every other day for at least four more weeks [I would say three]. Then pour off all the water, put the wet plaster into a linen or muslin cloth, and

squeeze it dry. Turn this ball out of the cloth and allow it to dry gradually for a few days, kept clean and free from contact with ferrous metal. Cut it into several pieces while it is still soft and when these are completely dry store the separate cakes in a rust-proof container ready for use.

THE MIXING OF GESSO

Requirements

A sheet of ground glass 18 in. square minimum or 6 in. mortar and pestle and
A heavy glass muller 3 in. diameter rubber spatula
2 palette knives
A sheet of siliconised 'release' paper such as is used in baking, say 12 × 12 in.
1 small salt spoon or $\frac{1}{4}$ teaspoon (USA)

To make gesso for raised and burnished gilding we must:

1 *Pulverise sugar to a fine powder.*
 Crush and grind to a fine powder, on the glass, enough sugar to provide two measures. Scrape this to one side, and wash the glass and muller.
2 *Measure out quantities.*
 Take two spoonfuls, scraped level but not compressed, of this powdered sugar and tip them like separate sandcastles onto the clean glass. In the same way, also keeping them separate, measure out sixteen parts of plaster and six parts of white lead. By keeping them separate, you may easily check how many you have measured out should you be distracted while doing it.
 Place one measure of glue in the centre of the glass, scrape the other ingredients into a pile on top of it and sprinkle on a little Armenian bole or colour.
3 *Add water to blend the ingredients.*
 Add enough distilled water to help mix

the whole into a thick creamy paste with the palette knife, then scrape this to one side of the glass.
4 *Grind the mixture carefully and finely.*
 Take about half a teaspoonful from this coarse mixture with a palette knife and put it in the centre of the glass. Grind it thoroughly for a minute or so, then – with a clean palette knife – scrape it off the glass and where it has ridden up the muller and transfer it neatly to an empty area of the glass. Repeat this process adding just sufficient water from time to time to keep the mixture creamy enough to grind easily, until you have eventually ground all the coarse mix.
 To make doubly certain that the mixture is uniformly smooth and amalgamated, the process can then be repeated with the more refined mix.
5 *Decant onto a non-stick flexible sheet of material to dry.*
 Scrape off the finely ground paste and spread it onto the silicone paper in an even thickness using a circular movement as if you were icing a cake; you may need to wet the palette knife slightly in order to assist in spreading it evenly.
 Let the gesso cake dry gradually, in a dust-free container, but before it is completely dry, score the surface in radiating lines to produce indentations which will then help you to snap off sixteen or so cake-like segments cleanly when it has dried. An alternative method of storing it ready for use, is to deposit a number of small individual blobs of gesso onto the silicone paper and allow them to dry in the same way.
 The gesso is cut into cake-like sections because, in theory, each segment should contain the same distribution of ingredients as its neighbour. For the same reason, if the alternative method of

storage (small individual cakes) is used, it is important that each blob of gesso should be freshly amalgamated and well mixed. If it is allowed to settle for any time before depositing onto the paper, the liquid content tends to spread quickly causing an uneven distribution of ingedients especially of the more soluble elements such as glue and sugar. I have used fresh gesso straight from the slab on several occasions, but the gilding has never been quite as bright as when the mixture has been allowed to dry out thoroughly before tempering it for use.

An alternative method of mixing the gesso is to grind the ingredients in a mortar with a pestle, for 40 minutes to 1 hour, adding water when necessary. Care should be taken to ensure that the mixture which rides up the edge of the pestle should be returned from time to time to the bowl, and when the mixture has been thoroughly ground, it can all be removed using a rubber spatula and deposited on the paper in either of the ways described above. It is much easier to obtain a mortar and pestle than a sheet of ground plate glass and a heavy muller.

TEMPERING GESSO WITH GLAIR

Although the resulting dried out cake of gesso may be tempered (in this context, thinned out) with distilled water to a suitable consistency to flow in a pen or brush, I have found it better to take the extra trouble to make glair for this purpose. It seems to make the gesso more resilient under pressure from the burnisher and the gold seems to keep its brightness better over the years. (Glair does, however, seem to 'waterproof' the gesso and this may make it a little more difficult for the gold leaf to adhere.)

Glair is a mixture of egg white and water. To make it, first separate the white from the egg yolk, and beat it until it is stiff enough for the dish to be upturned without any fear of the mixture falling out. Put it in a clean jar with an equal quantity of water, say, 3 flat tablespoonfuls of beaten egg-white and 3 of water, stir it and leave it covered for 6 to 8 hours (say overnight), then strain off the froth and it is ready to use as a medium for tempering gesso.

Crush the segment or cake of dried gesso into tiny crumbs in a deep narrow palette (an egg-cup is excellent). If the gesso is powdered too fine, it will not absorb the glair so readily. Onto this, place 1 drop of glair, cover the palette and leave the gesso to soak for 10 minutes or so. During this time, you can prepare a quill or select a brush for applying the tempered size. Once the moisture has been absorbed by the gesso crumbs, compress the mixture firmly with your finger to exclude as much air as possible from between the particles; it should compress tightly if the dampness has spread, then add more glair depending on the volume of the cake. You will have to judge this for yourself, though it is better to start with too little glair, say 6 or 8 drops. Stir this with your finger, which should be protected by a rubber finger stall, or a 'finger' from an old rubber glove, to prevent lead entering any cuts or transferring to the mouth later.

Once the mixture has been thoroughly dissolved, it may appear quite obviously too thick and gooey to flow in a pen or brush. More glair must then be added drop by drop until the balance between density and fluidity is achieved.

Air-bubbles which will weaken the mixture when it is dry may develop in the palette of gesso at this stage or on the drawn shapes later if you work too

hurriedly. Larger bubbles can be pricked with a needle which has been slightly greased by running it through your hair for instance. If there are a lot of small bubbles a little ear wax stirred around in (but not mixed with) the mixture breaks down the surface tension and dispels them quickly.

The correct balance between density and fluidity is difficult to describe, but it is important to acquire a sense of it if you are going to achieve success in laying gesso. Too much glair will obviously make the mixture watery, and too little will make it too thick to behave well. A few trials will soon establish the optimum viscosity – it is surprising how thinly it can be used. When dry, it will still be raised enough for good results.

APPLYING GESSO

Before laying gesso or gilding or painting, remove all surplus gum sandarac which may have been used to prepare the writing surface. Burnish down any obvious nap on the vellum in areas intended for a gilded and painted design. The suede-like nap tends to resist the paint and gesso and sometimes creates air-bubbles which will leave small pin-holes in the surface of the painting and gilding. A clean bone folder, agate burnisher, or your thumb nail can be used for this purpose. (Do not use a haematite or psilomelanite burnisher as these may discolour the writing surface.)

Gesso should be laid and gilded and all surplus leaf cleaned off before the application of colour to your design or else the surplus gold may stick to the paint which is difficult to remove and burnishing may damage it, creating wearisome repair work to be done later.

When applying gesso, the board on which the work is mounted should be laid flat, as when writing with colour. This will stop the gesso from 'sagging' towards the bottom of the letters. The aim is to lay the gesso evenly and in such a way as to emulate the cross-section of a drop of water on a sheet of glass, starting from nothing, gently doming and shading off to nothing, because later, when the gold leaf is applied and the burnisher is pressed onto the edges of the form it should be able to cover the whole surface in smooth continuous strokes.

A quill used for applying the gesso will need to be more pliable than one used for writing with normal ink, and to have a longer slit. When gesso flows readily and cleanly through a pen cut in this way it is a good indication that the gesso is of the right consistency to produce the desired cross-section.

In order that the gesso may dry as evenly raised as possible, you will need to work quickly, first pressing the pen open to get the gesso to flow, working wet into wet (using the same technique as laying a watercolour wash) and teasing the gesso outwards to fill the required shapes and to create a continuous and evenly domed section in each part of a letter or other form. Leave repair of any mistakes until later, when the gesso is dry. The writing surface will then better withstand any necessary scraping.

If the mixture is the right consistency and the pen is working well laying gesso is a real joy. Because it has been so finely and carefully ground, it gives cleaner lines than many writing inks.

When gesso is applied with a brush and gradually built up, layer by layer, the process takes a good deal longer. A brush is suitable for laying down large areas of gesso, when it is best thought of as a spoon ladling out the frequently stirred gesso. This gesso must run freely at all times and be laid down wet into wet until the shape is filled. Because this method of application

is lengthy, the risks of creating undulations and rough edges are greatly increased and place more of a premium on the surgical than on the calligraphic ability of the scribe.

As with powder gold, the various ingredients in the gesso tend to settle onto the bottom once the glair has been added and will separate if the particles are not constantly agitated, so do not forget to stir the gesso from time to time as you use it. Again as with powder gold, the plaster and lead particles tend to collect in the hairs of a brush near the ferrule. Unless gesso is kept well mixed, you may end by painting or writing with watery glue rather than laying down an evenly balanced mixture.

When the gesso has thoroughly dried, you may repair any rough edges, excessive undulations, small bumps or hollows by carefully sculpting them with a curved sharp knife. Naturally the more evenly the gesso is laid to begin with the more satisfactory the gilding is likely to be, since even though it may be scraped with care, the knife tends to create slightly erratic facets here and there. When scraping it is better to smooth one undulation into another, accepting the irregularities such as they are, than to create cliff-faces through seeking to scrape the surface to a uniform flatness thus leaving the sides sheer and difficult to burnish later.

Another danger of scraping incautiously arises when the paper or vellum cockles. This creates a domed effect under the gesso, making it seem thicker than it really is and misleading you into scraping through to the writing surface beneath.

HANDLING GOLD LEAF

Loose gold, which is made in single or double thickness is supplied in books containing 25 leaves of gold about $3\frac{1}{2}$ in.

square. Larger sizes are almost certain to be *imitation gold* made from other metals which eventually tarnish. (They are used by the furnishing trade and picture-framers. This gilding is usually covered by a coat of varnish to prevent oxidisation.)

The best kind of gold leaf for illumination (apart from 24 carat which is 100% unalloyed gold) is $23\frac{1}{4}$ carat, called 'fine' – though it must be handled with care as it is more delicate than less pure grades. It will burnish layer on layer of itself and seems to take the shape more easily of the raised gesso.

A book of gold leaf should not be opened like a magazine but held spine uppermost between finger and thumb otherwise the fine leaves of gold tend to crumple into a heap in the joints between the pages.

Illus. 1: Avoid crumpling the loose leaf by opening the book with the leaves hanging downwards. Use thumb and first finger.

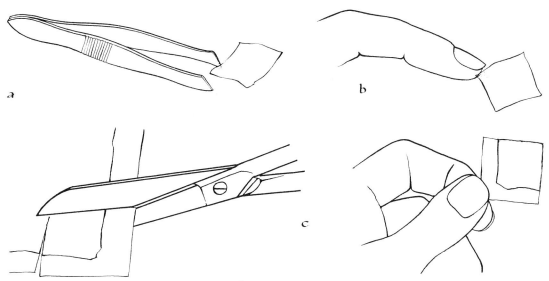

Illus. 2: Knives, scissors and tweezers must be kept absolutely free from grease because gold sticks to it so easily. When a piece has been cut with scissors, hold it without touching the gold.

A leaf can be laid on a pad of fine suede leather (a gilder's cushion) and cut into convenient pieces with a sharp straight-bladed knife, which is kept free from grease of any kind. Alternatively, it can be cut with an equally clean pair of scissors straight from the book (Illus. 2c), held against one of the tissue paper sheets which separate the gold leaves; it can then be conveniently handled with tweezers or between finger and thumb. (Illus. 2c). I pick up a pre-cut piece of gold from the cushion by touching the *extreme edge* of it with the forefinger of my left hand (Illus. 2b) – the gold sticks to even the slightest amount of grease. Provided that I do not actually press my finger on the gesso this usually works quickly and well. Avoid placing the finger on the gesso itself – grease and a bright burnish are incompatible. Tweezers (Illus. 2a) can be used instead of fingers and you can make your own from split pieces of sandpapered

bamboo and a rubber band. The professional gold beaters use wooden tweezers which they rub with French chalk or talcum to keep them grease-free.

TOOLS AND MATERIALS FOR LAYING GOLD LEAF

Loose gold (single or double thickness) $23\frac{1}{4}$ carat fine – or – 24 carat pure.
Gilder's knife and cushion.
Tweezers can be used for picking up gold leaf.
If using the alternative method of cutting gold between sheets of tissue paper, a pair of sharp scissors.
Breathing tube.
Silk scarf.
Crystal parchment (glassine).
Burnisher: haematite, psilomelanite or agate (see below). The usual tool of the mediaeval illuminator was dogstooth (bone).

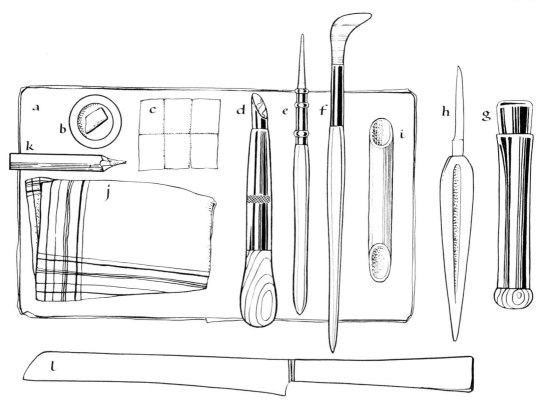

Illus 3: Gilding tools
a Pad of fine suede (gilder's cushion). *b* Tablet of gold powder. *c* Leaf cut into convenient sizes. *d* Psilomelanite burnisher. *e* Agate 'needle' burnisher. *f* Agate burnisher (a common shape). *g* Haematite burnisher for large areas of gesso. *h* Quill knife (traditional design). *i* Breathing tube. *j* Silk handkerchief. *k* Pencil (shaped) eraser. *l* Gilder's knife.

Finely sharpened scalpel with curved blade (for repairs).
A hygrometer which indicates an approximate relative humidity in a room is a helpful guide but before long the behaviour of the gesso and other materials will prove to be the best indicator of gilding conditions.

Burnishers

Haematite (a high grade iron ore) is perhaps the ideal burnisher for the illuminator. Though it appears to be black, it is in fact red, hence its common name 'bloodstone'. It does not readily absorb moisture from the atmosphere, it has a silk-like feel when in contact with gold and imparts a lustrous polish to it. Any static electricity created by burnishing is counteracted by its semi-conducting qualities, so gold does not readily stick to it. The disadvantage is that such burnishers are not easily obtained from commerical sources.

Psilomelanite burnishers are manufactured for gilding in a shape especially designed for our work. The material is used commercially because it has comparatively

few flaws and it is less wasteful in manufacture than haematite. When rubbed on a fine polishing grade emery, its colour is revealed to be essentially black. I recommend polishing off the rather excessive glossy finish of the factory-produced psilomelanite (use the finest grade 'crocus' cloth or polishing grade emery, say 0/4) because the mirror-like finish of a new burnisher seems to attract gold leaf to it. Otherwise, burnishers of this material are excellent provided that they are kept scrupulously clear of grease – no touching with your fingers!

Agate (a semi-precious stone) is cheaply and widely available as a polishing stone, but it has the disadvantage of absorbing moisture from the atmosphere and may badly smear the surface of gesso when conditions of humidity are approaching the upper levels of tolerance. A pencil burnisher made of agate, because of its comparatively small area in contact with the gold, is perfectly adequate for burnishing dots and fine lines.

THE HUMIDITY FACTOR

A key factor in gilding is humidity. Here I quote from a paper by George Yanagita on this subject:

> The air around us has the capability of containing moisture in the form of water vapour. . . . Our writing surfaces and sizes also assume the humidity level of their surroundings; relative humidity is a measure of the amount of water vapour in the air as related to the maximum amount it is capable of holding at a certain temperature.
> The significance of this to the gilder is that when relative humidity is low, the condensed moisture from our breath on the (gesso) evaporates quickly and we are disappointed because the gold leaf did not stick well. When the humidity is higher,

the condensed moisture evaporates more slowly and better results are experienced. If the humidity is too high, the (gesso) could soften from the moisture and cause burnishing difficulties. . . . When we breathe on the (gesso) our saturated breath at 98.6 degrees impinges on the cooler (gesso) and moisture condenses on it. . . . How long the moisture lasts however, depends on the relative humidity of the room and its effect on the rate of evaporation.

Humidity also affects the comfortable handling of skins, papers, inks and paints. We have to bear this in mind while we are working. East wind, west wind, bright sun or cloud, are all different ways of saying the same thing; humidity is variable and must be accounted for by the craftsman.

LAYING DOWN GOLD ON GESSO

The main methods are:
1 Applying directly with a burnisher with or without breathing on the gesso.
 This is the quickest and perhaps the best method especially in dry conditions when speed between breathing and burnishing is of the essence. It does require sensitive control of the burnisher because whilst it is often necessary to exert firm downwards pressure, sometimes when the gesso is soft only the most delicate stroke may be required. All tools are extensions of our hands and practice will ensure that we master the technique.
2 Burnishing first through a thin, transparent, non-stick paper like crystal parchment (glassine), with or without breathing on the gesso, and burnishing, again later, without the paper, when the gold has stuck.
 This second method has the advantage, especially when working with relatively soft gesso in humid

conditions, that you can see the shape under the paper soon after beginning to burnish, and so you can trap the gold leaf around the edges of the design with confidence and accuracy, thus minimising the effects of any insensitivity or lack of skill with the burnishing. The gold can be polished afterwards, without the paper, as soon as the gesso feels firm enough.

3 Pressing the gold leaf on with a soft pad of silk cloth and burnishing later when the gesso is less soft – often without breathing on the gesso.

The third technique is used for similar reasons to the second, especially when humidity dictates that plenty of time should be allowed to elapse between the application of the gold and the final burnishing of it. The texture of the silk, which sometimes leaves its impression on the surface of the design, will burnish out under pressure.

I have found that the recipe for gesso (given on page 184) can work successfully between about 63% of relative humidity up to around 73%, at which latter point even breathing on the size may be unnecessary. Below 63% or above 73%, however, timing becomes more critical and adjustments may have to be made to (a) the techniques used, or (b) the gesso recipe, or (c) control of the humidity itself. Below 63% the gold has to be burnished very quickly after breathing on it; to catch the elusive humidity above 73% slower steps are needed.

Whatever methods you use, have all the tools ready close to hand. It is easy to forget that seconds are lost whilst rummaging for a burnisher under a piece of cloth or fumbling with the gold leaf after you have breathed on the gesso.

It is best to place the paper or vellum onto a smooth hard surface when gilding.

A cool material like marble, glass or formica will help to prolong the presence of humidity in the area if that is desirable. If the burnishing is done on a board which is soft the surface will give under pressure from the burnisher and the gesso is more likely to break away from the writing surface or craze because of this flexing. When the vellum or paper is cockled under the gesso, the balloon effect mentioned earlier in relation to scraping down gesso should be borne in mind. It is advisable to gild large areas only in conditions of reasonably high humidity because the vellum will then have the extra pliability to absorb the inevitable flexing.

Constantly check the *feel* of the burnisher in relation to the gold's surface, pinning down the leaf to the edges of the design and trapping it neatly in the corners of awkward shapes, pressing down quite hard when the gesso is not too soft and, skating around the curves, mould the leaf onto the gesso form. Breathe on the burnisher from time to time and polish it on the silk; if a spot of gesso sticks to it wipe it off with a damp cloth or tissue, never with a finger nail. Sometimes an area of the design obstinately refuses to accept the gold even after breathing heavily on it. Carefully scrape this area with a very sharp curved scalpel, trying to avoid making an obvious dip in the surface by shading off the edges over a wider area, then breathe on it again and gild. The scraping will probably provide a key for the leaf.

Pure gold will stick to gold and the gesso will accept several layers of it; after which, however, it seems that the available stickiness in the gesso is absorbed by the succeeding layers and there is a tendency for the surplus gold to flake off.

It follows that we should exercise a flexible approach to the gilding processes;

we can either modify the gesso ingredients, by increasing the sugar to attract more moisture for instance, or alter the environment in which the work is done. Using the recipe for gesso as it stands I have found that in certain dry conditions it is imperative to use a humidifier/vaporiser to create sufficient dampness, (This is most effective in a small room.) If a room is too damp, air-conditioning will have a drying effect on the air, as will direct sunlight even in a humid climate, or an electric heater even though it makes the room uncomfortably hot for the craftsman.

Therefore, if conditions are otherwise stable and satisfactory we should avoid placing an electric lamp close to our work, as the heat will cause the work to dry out. I gild in a bathroom below ground level, usually after leaving the manuscript there for an hour or so to absorb the atmosphere. I work under a cool strip-light placed some distance above the table.

Although it is tempting in dry conditions to gild on freshly-laid gesso as a means of getting on with the work it is best to wait until you are sure that it has dried completely first, because whilst it may seem dry on the surface it is not always dry underneath, nor is the vellum or paper.

A GUIDE TO PLANNING YOUR WORK

These are not hard and fast rules, but a sequence of operations for writing, gilding and decorating a manuscript:

1 Rule up and trace out design from prepared roughs.
2 Write out the main text body and subsidiary writing.
3 Clean off all surplus sandarac or pounce.

4 Lightly burnish down the nap of the vellum in the area for painting or gilding and lay the board flat.
5 Gild (if powder gold only is being used, ignore this stage; if ammoniac gilding only, omit a, c, d, e).
 a Soak gesso crumbs.
 b Prepare pens (longer slits if necessary) or brush.
 c Temper gesso for use.
 d Apply the gesso.
 e Scrape smooth when dry.
 f Breathe and apply gold.
 g Clean off surplus.
6 Complete broad areas of colour.
7 Add further details in the painted or drawn decoration.
8 Add outlines.
9 Add highlights such as gold or white.

If you wish to draw with a pen over gold or colour, pounce the area when it is dry with sandarac before starting. If the sandarac is carefully and thoroughly dusted off afterwards and before further details are painted with a brush, it does not seem to affect the gold or other areas adversely. Because it does not need to be burnished firmly, ammoniac gilding can be laid on colour (stage 9), as can powder gold.

Painting on, or up to, burnished gold or ammoniac gilding presents special difficulties because paint easily rolls off the shiny surface of gold leaf, and if the paint does adhere at first, it often flakes off later when it is dry. Old manuscripts reveal that this has always been a problem. A stronger medium such as parchment size (described in the chapter on pigments) can help, and I find that the scraping action of a pen makes a better key for the ink and that a pen works more effectively in this respect than a brush.

Finally here is a quotation taken from Irene Base's article on gilding:

The gilder should make as many experiments as possible. If they lead to nothing at the time, they add to his knowledge of the way materials act in different circumstances; and they provide him with a number of tricks which, held in reserve, may be valuable on a difficult day. Steady success in gilding can never be attained by a fixed rule, for the work does not behave in the same way twice, even on consecutive days under apparently exactly the same conditions. Success is most likely to come by flexibility in method, by resourcefulness in getting out of difficulties, and by a willingness to go back on special occasions to methods long discarded. . . .

Try to develop an 'inner rule' – a *feeling* for what each of the ingredients is providing and act accordingly. And finally don't be afraid to make mistakes – he who hesitates will not gild.

TO REPRESENT SILVER

Silver leaf, or white gold, will turn black within a few years unless it is varnished. Aluminium or platinum leaf should be used instead in illuminating. Powdered aluminium can be obtained in cakes, but it tends to be rather coarse in texture and takes very little burnish.

Vera Law wrote the following note on the use of platinum for the earlier *Calligrapher's Handbook*:

The application of platinum leaf is similar to that of gold leaf, but, owing to the fact that platinum leaf is both thicker and stiffer than gold leaf, the laying of it is more difficult.

In order to make the platinum leaf adhere to the raising preparation it would seem that a slightly stickier asiso (gesso) than that used for gold leaf is necessary. The following preparation has been found to give sufficient stickiness, and has also resulted in a laid ground remaining uncracked when bent in a curve: 8 parts plaster of Paris, 3 white lead, $1-1\frac{1}{2}$ ground centrifugal sugar, 1 fish glue (Le Page's), 4–5 distilled water, pinch of Armenian bole (for colour). The above measurements are by capacity. It is advisable to buy fish glue in a bottle as the strength of that sold in tubes is apparently reduced in order to keep it moist and squeezeable.

It may be found that some platinum leaf is unevenly beaten. For easier attachment it is best to choose the thinnest parts.

If, after burnishing, a sort of tarnish, with a blueish tinge appears, the affected part should be carefully wiped over with a very soft piece of wash leather. It is the opinion of certain manufacturers that exposure to coal gas would cause such a blemish.

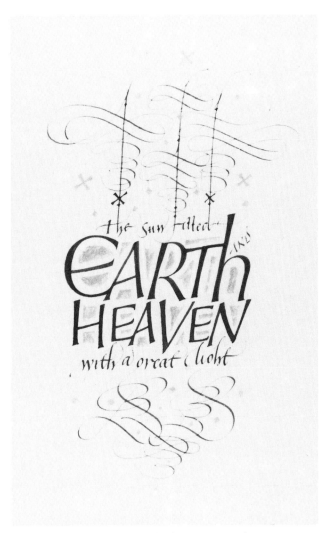

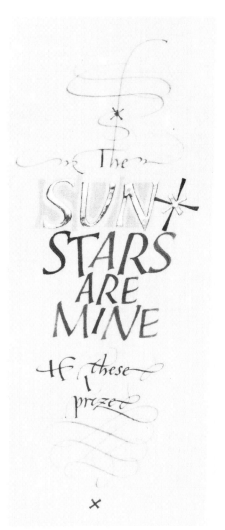

Ann Hechle: From Edward Thomas, *March*. Brown and blue watercolour and matt gold. c. 9 × 5 in. 1984.

Ann Hechle: From Thomas Traherne, *Salutation*. Written on vellum in stick ink, with raised and burnished gold leaf, matt gold and watercolour. $5\frac{1}{2} \times 2\frac{1}{4}$ in. 1984.

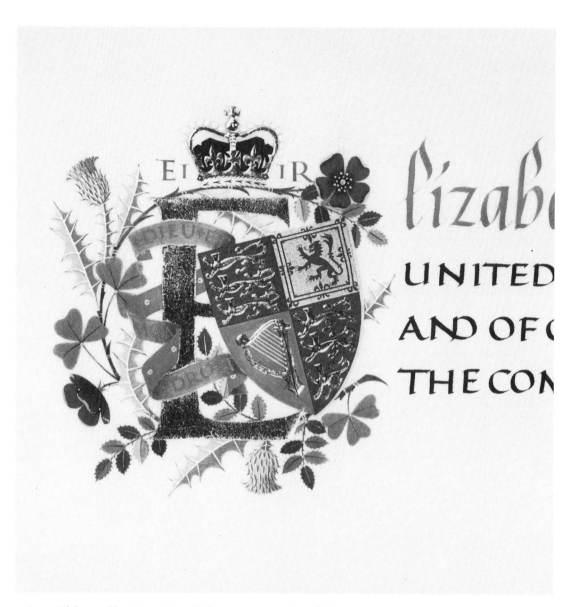

Joan Pilsbury: Illuminated initial from a Patent of Nobility. The E in raised and burnished gold. $3\frac{3}{4} \times 3\frac{1}{2}$ in. 1985.

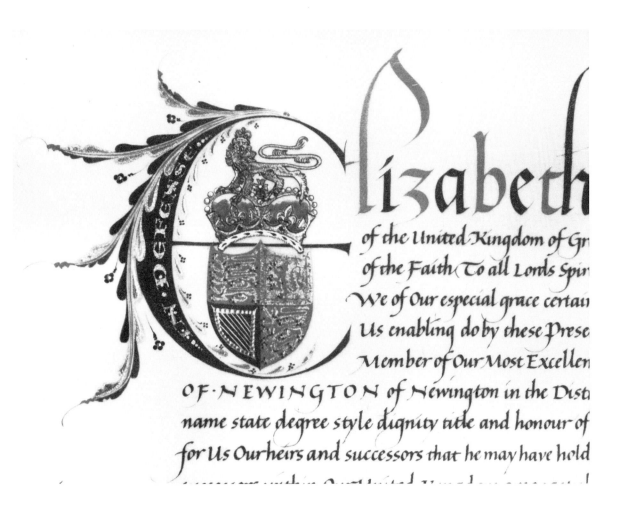

Donald Jackson: Illuminated initial from a Patent of Nobility for a Life Peerage. Powder gold used directly from a ready-prepared tablet tempered with water on the lion, shield, decoration and motto, partly burnished for emphasis. The crown is double-thickness gold leaf laid on gum ammoniac size. The slightly raised but unburnished effect of gilded gum ammoniac is used for writing elsewhere on the same panel. Size of E: 70 mm high. 1984.

'WATERSHIP DOWN'

Presented to
H.M. Ambassador to the
Federal Republic of
Germany
Sir Oliver Wright, KCMG DSC
on the occasion of his visit to the
Frankfurt Book Fair
on 20th September
1976

John Woodcock: Inscription for tipping-in to a presentation copy of *Watership Down*, published by Penguin Books. Black ink and vermilion watercolour on handmade cream paper. Approx. $6 \times 3\frac{1}{2}$ in./15×9 cm. 1976.

Cursive Handwriting

ALFRED FAIRBANK

This article is reprinted from the earlier Calligrapher's Handbook.

This book is primarily concerned to help those who desire to make works of artistic craftsmanship by means of formal penmanship. Information is given concerning the best tools, materials, and methods, and the principles of design. It is not out of place, however, to offer advice as to the writing of a cursive hand, since the only significant factors that divide the formal from the cursive hand are speed of performance and purpose.

The letters and words written by the calligrapher, giving pattern, form, and grace to inscriptions, are made with slow pace to allow precision of construction, for the appearance of the writing is more important than the speed of execution. A calligrapher, when writing his formal script, will naturally be intent on making satisfactory progress but yet will proceed with no faster movements than are appropriate to the careful formation of the strokes which, when fitted together, will make good letters. It is inconceivable that a contemporary calligrapher who has spent much time preparing a precious vellum sheet will hurry his quill with undue urgency along the writing lines. But a calligrapher's alphabetical interest may not be wholly confined to formal usages and he may wish, when writing his correspondence with proper speed, to maintain quality belonging to a penman's script. Being a calligrapher he will not mind if the hand he writes shows some

writing-consciousness and control, so long as it is legible and speedy enough for his purpose; indeed it might be expected of a calligrapher (though it would not apply necessarily) that his everyday handwriting would give some indication of his calligraphical skill and that whilst writing quickly he would have half-an-eye on appearance. The need, therefore, of the student of formal calligraphy who wishes his cursive handwriting to be related to his formal penmanship, although without close propinquity, is to know what examples, past and present, he should look at, what sort of pen to use, how to hold the pen, and what to do about joining letters. When he has arrived at his principles he will find that his hand and arm, being different things from his head, will not be entirely compliant; and that handwriting implies a compromise between head, hand, and pen, as well as reconciliation of freedom and control; and so an expression of individuality emerges.

Undoubtedly the most promising hands for the calligrapher to study in order to gain an appreciation of good cursive handwriting are the humanistic cursive hands of the fifteenth and sixteenth centuries, developed as a result of the revived use of the Caroline minuscule. Scholars of the Italian Renaissance in their study of the classic authors came upon and were attracted by the Caroline scripts of the ninth to twelfth centuries. Through the

adoption of these antique hands by the 'humanists' for their own use, we may see in fifteenth-century manuscript books two sorts of humanistic hands, namely those we should recognize as related in form either to the roman or to the italic types of today. The italic is the freer letter, cursive in character, and having an oval *o*. Models of italic are often to be seen in the books of the writing masters of the sixteenth century. Sometimes these models are of a 'set' cursive tending to return in the direction of the formal, i.e. they may incorporate certain formal characteristics, such as letterforms that require too many penlifts or too much attention to be truly cursive in character.

The sixteenth-century writing books which may offer the greatest help are those of Ludovico Arrighi (Vicentino), G. A. Tagliente, Gerard Mercator, and Francisco Lucas, but there are examples of writing of the period not intended as models which can serve for study and are reproduced in various contemporary publications. The masters of the copperplate tradition of the seventeenth and eighteenth centuries (Lucas Materot, Jan Van den Velde, Louis Barbedor, Ambrosius Perlingh, Edward Cocker, Colonel John Ayres, Charles Snell, *et al.*) have given place with the associated copperplate tradition in the estimation of amateurs of calligraphy to the masters of the preceding era, some of whom are named above.

William Morris in 1876 was practising an italic hand derived from the sixteenth century and possibly from a copy of Arrighi's manual in his possession. In 1898 Mrs M. M. Bridges, wife of the late Poet Laureate, showed in *A New Handwriting for Teachers* models related to 'Italianized Gothic of the sixteenth century'. In 1906 the late Edward Johnston published his classic book *Writing and Illuminating, and*

Lettering and on pages 281–287 (of the current paperback edition) he illustrated and described a sixteenth-century Italian hand (also to be seen in Illus. 1) which he considered might conveniently be termed *semi-formal*. He noted the good shapes of the letters and their great uniformity and that the hand combined great rapidity and freedom with beauty and legibility and he concluded that it 'suggests possibilities for an improvement in the ordinary present-day handwriting – a thing much to be desired, and one of the most practical benefits of the study of calligraphy'. Perhaps in describing it as *semi-formal* Johnston diverted some attention from its cursive characteristics. Be that as it may, it did not excite as much interest amongst Johnston's early pupils as his models of formal hands. It is not quite a pure hand: indeed it might well be called a cursive hand with some formal characteristics. A word such as *nunc* may be written without lifting the pen and yet the smaller letter *d* is made with three separate strokes fitted together will great skill. The mixture of opposed factors is well hidden, however, by the general easy uniformity and patterned rhythm of the script and in spite of its slight impurities it constitutes a remarkable and valuable example for study.

At one time Edward Johnston was of the opinion that the *ideal* method of teaching children handwriting was to go through the evolutionary phases. In giving a tribute to Edward Johnston at a Memorial Meeting of the Society of Scribes and Illuminators held on 10th November 1945 the author read the following extract:

The Board of Education pamphlet *Print-script* states that: 'At the annual Conference of Teachers held under the auspices of the London County Council in January 1913, Mr. Edward Johnston of

the Royal College of Art, gave an address on Penmanship, in which he suggested that, in the early stages of teaching children to write, the Roman alphabet, as used in the manuscripts of the ninth and tenth centuries, with its italic development of later date, might with advantage be used as a model. Before the end of the year two London Schools were experimenting on these lines.'

On 13th November 1932, when I was preparing to read a paper to the Royal Society of Arts on the teaching of handwriting, Edward Johnston sent me the following comment:

'To quote from my address of 2nd January 1913 (page 19 of Report): "It is the broad nib that gives the pen its constructive and educational value. It is essentially the letter-making tool. ... It may therefore be relied on largely to determine questions of form in letters. ... In fact a broad-nibbed pen actually controls the hand of the writer and will create alphabets out of their skeletons, giving harmony and proportion and character to the different letters."

'I went on to suggest an ideal course in which children might begin with:

Roman capitals and their origins;

let them trace with stylus and wax tablets the passage of the Capital into the skeleton small letter;

followed by the practice of a half-uncial book hand;

followed by the practice of a *Caroline* book hand (such as the tenth-century 'Foundational hand');

followed by the development of the Foundational hand into the italic.

'I believe that this (F.H.)[1] would make a good model and that in practice it would develop into a fluent hand.

'I should not wish to be thought that I was *directly* responsible for the *form of print-script characters*. I was not consulted in the experiments and have not even

[1] By F.H., Johnston meant 'foundational hand'.

become "familiar" with the P.–S. characters. My impression is that they are *rather formless skeletons of roman l.c.?* It is difficult to *give* or *preserve* form in letter *skeletons* except by skill and knowledge. I advocated the broad nib and the study of the book hands for the giving and preserving of Form. Recently, however, I have been given evidence that very young elementary school children (at 5–7, I *think*) found the broad nib a difficult tool to manipulate, which seems quite to justify the use by such children of (carefully planned) skeleton forms and 'pointed' or stylus-like tools. But, of course, as soon as they were able, they should be given the broad-nib and a broad-pen. Book-hand (or a modification of B.H.) as foundation for their future handwriting.'

In reading this comment I have wanted to make it clear to what extent Johnston was responsible for the reform of printscript.

A modification of Johnston's views is to be noted in 'An Appreciation of the Dudley Writing Cards' (included in Sets A and 1 of the *Dudley Writing Cards* by Marion Richardson), for in April 1928 Johnston states:

'I still believe that some of the formal "bookhands" (to be found in MS. Books, etc., from the third to the sixteenth century) offer the best models and the best training for the various purposes of penmanship – where time is not of first importance. But I fear that their use as models for speed writing is impracticable; for though they are capable of being written with considerable speed, and even of being modified into Approximate Running Hands, they cannot – without radical changes – produce the great speed required in the modern penman, because they consist of essentially static forms, while that great speed is compatible only with essentially Running Forms.'

In 1916 the publishing of Mr Graily Hewitt's model in a booklet *Handwriting: Everyman's Handicraft* coincided with the

P · Victoris de Notis Antiquis ·

E st etiam Cura circa praescribendas · uel paucio
ribus lris annotandas uocef studium necessa
rium · Quod partim pro uoluntate cuiusq · fit
partim usu proprio · et obseruatione communis
nanq · apud ueteres · cum usus notarum nullus
esset pp scribendi facultatem maxime in Senatu
qui aderant in scribendo · ut celenter dicta com
prehenderent quaedam uerba · atque nomina
ex commum consensu primis lris notabantur
& singule littere quid significabant ut i prom
ptu erant quod in nomimbus pronominibus
legibus publicis · pontificumq · monumentis ·
iurisq · Ciuilis libris etiam nunc manet · Ad
quas notationes publicas accedit studiorum uo
luntas · et unusquisque familiares notas pro
uoluntate signaret quas comprehendere infinitu
est · publice sane tenende sunt · quae in monume
tis plurimis et historiarum libris · sacrisque pu
blicis reperiuntur · ut Sequitur ·

From a catalogue of classical inscriptions, an Italian manuscript book of the sixteenth century. Written in Latin on paper. This manuscript once belonged to Edward Johnston and was reproduced by him in *Writing and Illuminating, and Lettering*. Later acquired by James Wardrop. Now Victoria and Albert Museum, L5161–1977.

reading of papers at a meeting of the Child Study Society on experiments with print-script in the two London schools. Neither Mr Hewitt's early model nor print-script have running forms, for at that time it was thought by the reformers that joins offered no advantage. Mr Hewitt's fine italic script involves the use of an edged pen but its beauty depends also on the good formation and spacing of letters: there are no joins in his model and therefore there is no rhythmic flow. Print-script is a letter related to roman, made up simply of straight strokes, circles and parts of circles, and it is said to help children to learn to read, but its circular motions, its static quality, its lack of any hint as to how letters may be joined, and its independence of penmanship, make it seem but a poor expedient. Doubtless it has contributed (with other factors) to the decay in the nation's handwriting. The late Dr P. B. Ballard remarked that there was 'one matter in connection with the print-writing movement developing into a cursive hand which violated a pedagogical maxim, namely, that one should begin with what one meant to go on with'.

Two tracts of the Society of Pure English on *English Handwriting*, edited by Robert Bridges, appeared in 1926 and 1927, and contained numerous illustrations of the hands of contemporary scholars, calligraphers, and artists, and these could be contrasted with sixteenth-century Italian scripts. Other collections have since been reproduced in *Lettering of To-day, Written by Hand, Sweet Roman Hand* and *Italic Handwriting*, but the examples are principally in the italic tradition. The two tracts were soon followed by the first model offered by the late Marion Richardson, an alphabet with joins written with edged steel pens and owing much to italic sources, namely *The Dudley Writing Cards*. Miss Richardson's *Writing and Writing Patterns* shows a development of the art of teaching handwriting by the making of patterns related to the letters of the alphabet and simple writing rhythms but her later models are lacking in distinction or promise.

Following the publication of the author's book *A Handwriting Manual* and *Woodside Writing Cards* in 1932 and through the interest of the then Director of Education of Barking, Mr Joseph Compton, a further set of cards was produced in 1935 for use in Barking schools, later titled the *Dryad Writing Cards*.

In recent years so much interest has been shown in italic handwriting that, in November 1952, the Society of Scribes and Illuminators inaugurated successfully a new Society: the Society for Italic Handwriting.

At this stage it is convenient to consider, in greater detail, what we should regard as a cursive hand. Cursive is the writing for ordinary usage, and it is so related to an individual that it has a special value to him, and his friends, and in business transactions, as an expression of personality, and this quite apart from its function as a means of communicating, recording, and remembering. A person may write a cursive hand with different standards of care and speed so that his writing ranges from something that all can read to a scribble which he himself finds illegible; yet his varying handwriting could always be identified as his own. When the writing master executes a model for the teaching of cursive penmanship, that model may be regarded as a *set* cursive. The *free* cursive is what the pupil develops in time. The set cursive of a writing master's model, of, say, the eighteenth century, engraved on copper, may be

executed with an astonishing skill but having little about it to suggest that a fallible human has used a pen. He may conceivably have written his script with much greater control than a contemporary calligrapher employs when executing a book hand. The slow and exact writing of a model is not only to show a high standard but to make intentions clear. The writing master says in effect: 'This model represents an ideal of legibility and pattern, but I admit that when I write quickly the writing is different. Even when making a copy slowly your writing will be different because it is yours and not mine. Regard the model, therefore, not as an impossible standard but as a guide to economical method and to form. The faster you write the more easily will your handwriting be seen as belonging exclusively to you. But bear in mind that legibility should come before speed and that no two persons can write alike.'

Fast writing necessitates economy – labour-saving devices and time-saving expedients. In a formal hand the pen is often lifted from the vellum: for example, there may be eight or more pen-lifts in writing the word 'and'. Pen-lifting when too frequent expends time and energy and must therefore be reduced in cursive writing. One must not assume, however, that this argues that all letters should be joined. There must be some joins, both oblique and horizontal, brought into use as the hand quickly decides. Some fast writers may naturally connect up most if not all letters of a word, even joining, say, *g* to an *h*, but the author holds that a moderate use of pen-lifts aids the moving of the hand and reduces fatigue and is advantageous both to legibility and appearance. The principle then is not to join every letter nor, on the other hand, to separate every letter, but to do what is expedient.

From Ludovico degli Arrighi of Vicenza, *La Operina*, the first writing book, produced in Rome, 1522.

204

From a page of Mercator's Manual.

The diagonal join, so frequently a significant feature of the humanistic cursives of the Renaissance, is not suitable for the pointed pen of the copperplate tradition, and so was forgotten. The stiffish edged pen is held and used differently from the pointed pen in making up-strokes. The author learned the character and importance of the diagonal join in studying a model in Tagliente's manual and he recommends calligraphers to consider its function as an aid to speed and good spacing and its dominating influence on the rhythm of writing and therefore on the form of letters. In designing a set cursive hand one might begin with the letters *u* and *n* (opposed counter-clockwise and clockwise movements) and the join that connects them. The rising interior stroke of both letters should be but slightly different from the diagonal join. The appropriate but slight deviation from the join will ensure *n* and *u* being recognizable particularly if they are curved and not pointed sharply. Once the shape of the two letters has been decided on little difficulty should be experienced in devising more than half the alphabet (conforming to the principle of family relationship of letters of the alphabet and the contrasting principle of individual distinctiveness of letters) and when that is accomplished, calligraphers will find that, with the Renaissance examples as guides, the whole alphabet will occur to them, and unity is achieved. Then to the alphabet the other common join can be added, namely the horizontal join, which would, say, join *f* to a succeeding letter and which is demonstrated by Arrighi (opposite).

The classic Roman capitals at their finest are letters cut in stone. Through the use of pen, uncials, half uncials, and minuscules were developed. But if the minuscule *o* is to be oval, as in italic, whereas it was circular in the earlier scripts, there is an argument that the capital O should be oval too. The calligrapher has, therefore, to decide whether capitals and lower case letters are to conform generally in this respect or whether capitals may still be considered as something quite different from minuscules, as they were regarded at the time of the Renaissance, and be in the classic tradition. A third factor is that many writers, including children only ten years of age, like to flourish some of their capitals, and the swash capitals of the Italian writing masters are indicated for study.

The pens used by the Renaissance writers were quills, sometimes sharply cut, sometimes quite blunt. We, today, do not write to our friends with a quill: we use a dip-pen or fountain pen.

A reference has been made to Lucas and

a page from his book is reproduced in my *Handwriting Manual*. The exquisite forms of his letters are an inspiration. The words move forward with elegant dignity; and legibility and beauty are served splendidly. We cannot hope, however, to write quickly with the precision of this set cursive. Discipline will give way to freedom (but freedom does not mean one is to be completely free of discipline). Fine letter shapes will always delight the eye, but the fashioning of each letter must yield something to the inherent rhythm of the words and motions as well as to the urgencies of the scurrying hours. The calligrapher, however, has two opportunities in the writing of italic: he can write a set italic with quill on vellum and employ all the means by which a manuscript is made a work of art, and he can dash down by rhythmical movements the thoughts he wishes to communicate pleasingly by visible words.

The State of Handwriting

TOM BARNARD

THE LEGACY OF EDUCATION

To write an article on handwriting is a daunting task because one enters into an area of personal choice, which in turn is reinforced by long-established habits. This creates a kind of sacrosanct territory which makes any discussion on this theme an uncertain affair and causes more heated arguments than any other aspect of calligraphy, especially when dealing with its application in schools. Alfred Fairbank once told me that Edward Johnston saw very little virtue in perpetuating any interest in handwriting because of its strong links with personality, and that if he received an intelligent but illegible letter from a friend he looked upon it as a source of amusement rather than censure. It was all a part of the rich mosaic of life. I think most people would agree with this enlightened attitude when dealing with the mature person. However, in writing specifications, prescriptions, memoranda, lecture notes and the like, accuracy and speed are desirable and legibility is essential. There is a period in our lives when handwriting plays an important role in our development and that is during the formative years of our education. The school is the cradle of the nation's handwriting habits and for just over hundred years, and with varying degrees of attention and teaching ability, pupils have been alternately dragooned by dogmatic

teaching or allowed to discover for themselves how to write their native tongue.

The most revealing way to understand the nation's handwriting habits is to survey the sequence of events since the Education Act of 1870. To those professionally involved with the craft of calligraphy, much of this information is common knowledge, but for people coming to the subject for the first time it will be new.

1870 This is the historical moment when compulsory school attendance became law. The curriculum consisted of the three main subjects known as the 'three Rs'. The style of writing in everyday use was the looped copperplate variety and it was therefore a natural choice for the first State schools. The tradition still continues, although it is no longer taught to the degree of refinement once seen. All that remains are the loops and a few attempts to incorporate the odd flourish as a last gesture of its former glory.

1890s The amount of handwriting used began to decrease, and standards of legibility required for handwritten documents declined as mechanical systems for receiving, recording and relaying information became more efficient. As the nation's teachers began to learn more about child development, methods of teaching gradually changed and new ideas

about handwriting began to spread, long before they were adopted in the classroom. Towards the end of the last century Mrs Bridges, the wife of the Poet Laureate, started the process. She had been influenced by William Morris and the Arts and Crafts movement and became particularly interested in handwriting which led to a published treatise called *A New Handwriting for Teachers*. The plea put forward in this document was that schools should return to the historical Roman tradition as a starting point for introducing children to their first experiences of letter structure; however a whole generation was to pass before anything was attempted along these lines.

1913 These early ideas were continued and propounded by Edward Johnston when he addressed an audience of London teachers in 1913. The precise details of this event are described by Alfred Fairbank in his article on *Cursive Handwriting* (page 201) where he states that although Edward Johnston did not eventually agree with the teachers' interpretation of his ideas, nevertheless there was set in motion a system of writing which has become known as Print Script. This style is now almost universally taught when introducing five-year-olds to their first steps in writing. Although it has tended to become an ossified method of writing letters, the importance of this movement was the realisation of the value of blending the visual skills of reading with the physical skills of writing. Conversely it also introduced an element of conflict because as pupils advanced to the next stage in their educational life they had to learn, or some would say re-learn, how to write in the former copperplate style, where many of the letters were formed with completely different movements.

Illus. 1

These inconsistencies are still common practice.

1930s Educational pioneers began stressing their belief in the inner creative potential of young pupils. Instead of imposing standards which adults thought they should attain, methods of teaching were encouraged which gave pupils the opportunity to express their true abilities and their own standards. From this 'school' came Marion Richardson, whose name is indelibly ingrained in the minds and classroom practice of nearly two generations of teachers, and the pupils who came under their influence. The scheme of writing she published is still one of the most popular choices for the 7–11 year age group in Britain today. Its chief virtue is that it attempted to obtain a continuity of teaching practice between the developing phases of educational growth. An interesting feature of this style is the carry-over of a few letters from the copperplate tradition. Because of her untimely death Marion Richardson never revised certain details of form in her writing system in the light of her later experience.

Illus. 2

1950s After the disruption of the Second World War, a fresh opportunity was given to reassess the education system, including methods of teaching, and the door was opened to introduce another approach to handwriting known as the Italic style. Alfred Fairbank had been attempting since the 1920s to persuade educators of the advantages of adopting his principles of handwriting but, like Mrs Bridges before him, he had to wait for another generation to pass before Italic became common practice in schools, chiefly in the 1950s and 1960s, when there was a considerable boom in italic handwriting.

THE CONTEMPORARY SCENE

During the twenty-five years that I have been travelling around the country visiting schools, I have seen excellent examples of all the mentioned styles (Illus. 3).

It is this variety which creates the undercurrents which flow through the nation's handwriting habits. We are each the product of our own educational system and I daresay that most people retain elements in their writing which can be traced back to their schooldays, unless of course an exceptionally strong influence has led to a radical change of style. As a rough guide it can be said that those who graced the classrooms until the 'thirties would have been taught the copperplate style. Pupils entering school after the 'thirties would have stood a good chance of having their hand directed towards the Marion Richardson system, and a great number of the 'fifties' and 'sixties' generation of children came under the influence of the Italic style of writing.

Not only have there been changes in style of writing but the post-war generations have also become used to a variety of writing implements. Until the latter half of the 1940s the main writing tools in use in the classroom were pencils and the dip-nib pen, which required an inkwell to keep it functioning. It was the Italic movement in the 'fifties which popularised the use of fountain pens in schools. These were the boom years for fountain pen manufacturers and it went some way towards easing the problem of using inkwells which had been an educational nightmare since 1870. The ink cartridge models assisted further in making writing a cleaner and safer task. This situation was disturbed when inventive progress eventually caught up with schools in the latter part of the 'sixties and in the 'seventies by permitting the use of viscous ink ballpoint pens. These pens completely eliminated the risks associated with traditional ink. This fact seemed to be the chief attraction for their acceptance, rather than the effect of ballpoint pens upon handwriting standards. Copy books were published claiming to teach a ballpoint-pen style of writing.

In the 1980s yet another invention was to break upon the educational scene in the form of fibre-tip pens, which not only do not need filling with ink, but are more controllable than a ballpoint and for just these two reasons are now widely used in the earlier years of school life (5–12 years). They are not yet as durable in use as metal nibs and are less precise.

Running parallel with fibre tips is the Rollerball pen which has a similar action to that of the ballpoint. These particular writing instruments are more prevalent in the senior school and college student sectors of academic life.

This was lucky; he was about to begin to groan, as a "starter" as he called it, when it occured to him that if he came into court with that argument his aunt would pull it out, and that would hurt. So he thought he would hold the tooth in reserve for the present, and seek further. Nothing offered

The looped 'Copper Plate' style 9 years of age

Sunday in Scotland is the Sabbath, a day

you might easily mistake for Doomsday

if you were not used to it, a day that barely

struggles into wakefulness. Shops, pubs,

cinemas, cafés, bandstands, anywhere, in fact,

The 'Italic' style 12 years of age

The masterful wind was up and out, shouting and chasing, the lord of the morning. Poplars swayed and tossed with a roaring swish; dead leaves sprang aloft, and whirled into space; and all the clear-swept heaven seemed to thrill with sound like a great harp. It was one of the first awakenings of the year. The earth stretched herself, smiling in her sleep; and everything leapt and pulsed to

The 'Marion Richardson' style 10 years of age

Illus. 3

WRITING INSTRUMENTS USED IN SCHOOLS IN ORDER OF ADOPTION

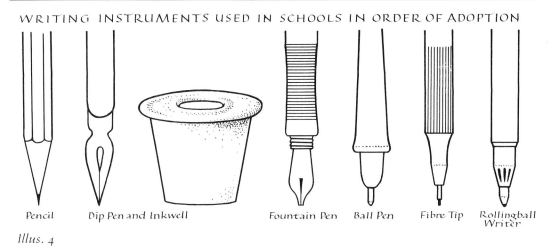

Pencil Dip Pen and Inkwell Fountain Pen Ball Pen Fibre Tip Rollingball Writer

Illus. 4

Most of these writing tools have in turn been initially resisted by schools, and although this natural instinct towards caution is wise, it can become too restrictive if judgment is suspended. Popular choice and improved performance have gradually worn down early objections and all these different writing tools are now in general use alongside each other, even in schools. However there is a genuine dilemma posed by the choice of writing implements today for they do not all have the same characteristics; guidance on handwriting practice should include advice on this matter.

An indication of how invention can change and diminish certain skills is evident in the fact that the present generation often finds it extremely difficult to use a fountain pen, just as most people would find it strange to use a quill.

If the system of handwriting we were taught (using whatever writing instrument we find most suitable to our hand) has over the years matured into a legible and practical hand, then it fulfils its function as a system of communication. It also means that our preferences are going to lean in that direction when it comes to discussing

a method of teaching and it would be foolish for us to change for the sake of change, because the way we write is an integral part of our personality. Given the opportunity to observe the nation's educational standards, even the most opinionated person would have to admit that where there is a consistent method of teaching letter shapes, based upon knowlege of the subject, it is possible to develop a pleasing style of writing and there are many schools who can claim such an achievement. The pity of it is that the schools often work in isolation as very little liaison exists between them on the subject of handwriting; consequently each develops its own variations of style, seemingly overlooking the eventual transfer of pupils to other schools. So far-ranging are the differences within the selected writing styles that educationally we flounder in a quagmire of our own making. There are instances of infant pupils ($4\frac{1}{2}$–7 years) transferring to six separate schools (8–12 years), which all teach their own variations of style. The problem increases as pupils advance to the senior stages of school life where the schools concerned can receive an annual

intake of pupils with their own particular brands of handwriting. In this general context, even the Italic style is seen as adding another complication to a confused situation. The situation would be acceptable if the outcome were a mature and serviceable style of handwriting. Unfortunately the lack of consistent teaching methods produces a communication handicap – many pupils find it extremely difficult to express themselves in the physical terms of handwriting.

Needless arguments go on about the virtues of the different styles of writing because of strong personal preferences, but if it could be understood that there is a fundamental historical link between all handwriting styles which are derived from the Roman-based norm, it helps break through immovable and set opinions.

If one looks at the copy books which represent classroom teaching practice in the past hundred years, it is not too difficult to observe how similar the basic letter shapes are. Apart from the ornate copperplate capitals, which are in any case rarely taught today, and a few bizarre minuscule forms, the similarity is very evident in terms of hand movements.

The first task of anyone involved in shaping educational standards is first to have an appreciation of the historical roots of the alphabet, secondly to accept the changes of style and writing instruments which have left their mark on teaching practice, and finally to try to reduce and level down as many differences as possible. When teachers see the historical reason for the similarity between styles of writing it clears the way for reaching an agreement upon teaching a consistent method of handwriting. The ingredients to achieve this ideal already exist. A number of respected studies of Primary Education ($4\frac{1}{2}$–12 years), such as the Plowden and Bullock Reports have seen fit to mention the supportive role that a good style of handwriting can make during the formative years of school training. Commercial enterprise has not been slow to take note of these observations by

a b c d e f g h i j k l m n o p q r s t u v w x y z
The 'Copper Plate' style

a b c d e f g h i j k l m n o p q r s t u v w x y ʒ
The 'Marion Richardson' style

a b c d e f g h i j k l m n o p q r s t u v w x y z
Print Script

a b c d e f g h i j k l m n o p q r s t u v w x y z
The 'Italic' style

Illus. 5

producing handwriting schemes and other relevant aids. Some are good and others are not so good, but an instant glance at the current titles shows that they do not have the 'pure' italic flavour of the early 'fifties and 'sixties copy books where the recommendation and use of the square-cut nib was a dominant factor, and whether intended or not, overshadowed other considerations. Many schools caught up in the enthusiasms of the Italic movement began using such nibs without really understanding that handwriting is (to use a Fairbankian phrase) 'a system of movements', and that there needs to be a consistent build-up of the physical language of writing from the first years of school life until it becomes an automatic and accomplished process. Only then will a special nib bring its own mature contribution to a personal style. The present copy books reflect this view in their content and manner of presentation.

The noticeable increase in schemes of handwriting and supporting aids reflects to some degree the renewed awareness, among those within the educational system, of the need to reappraise this skill. Such a sharpened attitude has led to the promotion of retraining programmes for teaching (through in-service projects) so that they can renew their acquaintance with the historical foundation of the alphabet and gain some practical knowledge of how to teach handwriting. Suitable writing tools are readily available both from educational suppliers and in the commercial market. There is also a sufficient number of sensitive advisory staff and good teachers around to set in motion a national movement to establish an accepted pattern of good handwriting practice. Another important factor which is often overlooked is that today's parents are more involved in their children's

education and can give valuable support in the home if they receive informed advice from the school. The difficulty lies in harnessing and channelling all these interests in a unified direction.

THE IMMEDIATE FUTURE

In a world of electronic communication systems it is possible to imagine a world without paper, printing or writing. It is now possible to do away with written instructions and drawings for certain manufacturing processes. Every detail, even when a specification is changed at short notice, can be immediately processed on to a computer screen. Business conferences can be conducted entirely through audio-visual methods. To many craftsmen these developments spell death to human creativity, but to those involved in the struggle to survive economically, it is essential and necessary to use these new techniques. At school young people are being prepared for these new skills and they are becoming as dexterous with a computer keyboard as they were once expected to be at manipulating a pen. Are we then over-stating the importance of handwriting in such an environment?

Ever since the invention of the typewriter right down to the present-day word-processor and hand-sized electronic typewriter, imaginative and impulsive prophecies have been made about the eventual eclipse of handwriting, and yet the subject still dominates discussions on the school curriculum. The skills of reading and writing are fundamental in creating a literate society and will remain so until the alphabet can be replaced by an alternative or better system. Since we therefore cannot ignore the contribution of handwriting, even for those who are going

ai aj am an ap

ai _____

ar as at au av

ar _____

aw ax ay Alternative join: as

A Riddle.
My first is in house
But not in mouse.
My second's in open
And round as can be.
My third's in run

Yak Y Y Y Y
Zebra Z Z
Elephants
A tail behind, a trunk in front
complete the usual elephant;
The tail in front, a trunk behind

THE DIAGONAL JOIN Linking to a forward and backward
movement. Write over the strokes and then try writing them
yourself.

v v v v v v
v _____

Write over the letters and then try writing them yourself.

a c d g q o v aa
ac ad ag aq ao

Writing Carefully and Well

Write each of these words carefully but not too slowly.

robin sparrow starling blackbird
wren thrush jackdaw swallow

Examples of contemporary handwriting schemes.

Look for faults in what you have written. There is a list of faults
you should look for on page 15. Write the words again but a little
faster this time. When you can write the words very well, write this
poem.

In the bleak midwinter
Frosty winds made moan,

Illus. 6

to inherit a computer-ordered world, why not combine the two disciplines to help generate a base for a common teaching practice?

Professional 'know-how' can easily be transferred on to video recordings. A handwriting computer programme with built-in instructions is possible and is already in use. Self help lessons can be produced on slides together with a synchronised soundtrack, and Schools T.V. can be encouraged to give a consistent presentation of letter shapes. Such aids would help to channel the enthusiastic, but so often unnoticed and parochial efforts of individuals and schools towards a unified goal.

In the final analysis the main priority is not to produce a nation of calligraphers but to assist young people to communicate to the best of their ability in a legible and fluent manner and in the most practical way possible. If they wish to give their handwriting that extra polished appearance which makes it a delight to the eye, then that is a bonus that comes from good teaching methods and personal endeavour, and the opportunity should be there to promote creative satisfaction. This attitude towards the skill of writing is a quality which no teaching aid can convey, however ingenious it may be, and this is where the sensitive teacher will always be essential to make handwriting a true educational experience; something that remains with us for life.

Tom Barnard: Invitation to a calligraphy demonstration. Originally reproduced 7.8 × 15.8 cm.

Quinquereme of Nineveh
from distant Ophir
Rowing home to haven
in sunny Palestine,
With a cargo of ivory,
And apes and peacocks,
Sandalwood, cedarwood,
and sweet white wine

Stately spanish galleon
coming from the Isthmus,
Dipping through the Tropics
by the palm green shores,
With a cargo of diamonds,
Emeralds, amethysts,
Topazes, and cinnamon,
and gold moidores

Dirty British coaster
with a salt-caked smoke stack
Butting through the Channel
in the mad March days,
With a cargo of Tyne coal,
Road rails, pig-lead,
Firewood, iron ware,
and cheap tin trays

Cargoes Poem by John Masefield calligraphy & illustration by sidney day

Sidney Day: John Masefield, *Cargoes*. Calligraphy and illustration reproduced by a two-colour lithograph and printed in blue and green on white paper. 30 × 42 cm. 1981.

Printmaking, Printing and the Calligrapher

SIDNEY DAY

'Print' can be variously defined as a mark left on a surface, an impression left on paper by inked type, engraved plate or natural object, photography, textile pattern, reading matter, a full-colour photo-mechanical copy of a painting or an original work by an artist. The calligrapher may well be concerned with two quite different kinds of printing and it is important to emphasise the difference between them.

The first, broadly named fine art printmaking, is that where the artist initiates the complete concept/idea and chooses to multiply or widen its distribution by working directly onto the printing surface in one of the four main autographic processes. The resulting prints (usually in a limited edition) retain the intrinsic qualities of an original work of art, and control is exercised by the artist over size, format, number of copies, etc. They can be exhibited and sold at a price which is modest enough to be within the means of a wider range of potential art collectors.

The second kind of printing concerns the photo-mechanically printed commission where the project originates from a client, sponsor or publisher who defines the size, content, number of copies, etc., all of which are constraints upon the freedom of the artist/designer. The calligrapher who is adept at meeting the demands of others will thrive in this situation, indeed it is an indication of

calibre as performer that some creativity is achieved within the constraints imposed. The printed result, reproduced in great quantity, has a well-defined function, e.g. poster, wallchart, book jacket, package, stationery range, although in some instances it may well become a collector's item with the passing of time.

A practical understanding of the four major print processes to be described here will be helped by a brief look back into history, where it will be seen that the dichotomy between original printmaking and the frankly imitative function of the process has always existed. With any printing activity it is initially convenient to think in terms of the surface from which the print will be directly, or sometimes indirectly, taken and to consider whether that surface, when inked, prints image, background, or both.

DIRECT PRINTMAKING

RELIEF PRINTING

The principle of this process is that ink is applied to the raised (or relief) surface of the printing block, created by the cutting away of unwanted or background parts. The image required is drawn onto the block reversed left to right, like a mirror image, and the background then cut away. The method applies to the rubber stamp, potato-cut and lino-cut but historically the

original surface of wood

Illus. 1

oldest example of relief print is to be seen in the woodcuts of Japan and other Eastern countries in the eighth and ninth centuries AD (about the time that the Book of Kells was written). The greatest period of Japanese woodcut came some ten centuries later in the eighteenth and nineteenth centuries.

In Europe, the early fifteenth century marked the beginning of the use of wood blocks for books, religious images and playing cards. It is believed that for the most part printing was allographic, meaning that one person drew the picture and another or others cut the blocks. Initially, the prints were somewhat crude in drawing and mainly in black line with few, if any, areas of solid black. Even so, many are aesthetically most pleasing to the eye. Holbein and Dürer were artists of the period who were among the greatest to

make relief prints and it is thought that Dürer may have cut some of his own blocks. The writing books of the great Italian writing masters of the sixteenth century were produced in woodcut form where scribe and cutter combined to produce prints of each page.

Woodcutting techniques depend upon wood that has been cut from the trunk so that the grain runs along the surface ('plank' grain) of apple, pear, sycamore or cherry. The main tool is a knife of European or Japanese origin supplemented by the gouge, chisel and V tool. Similar tools (now available inexpensively in the form of a handle and a range of removable blades and gouges) are used for linocutting – a technique first used extensively in the 1920s and later by such artists as Picasso.

Wood engraving on 'end' grain usually of boxwood as opposed to the 'plank'

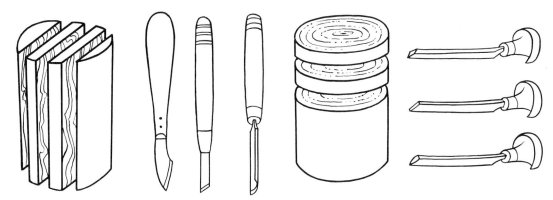

Illus. 2: Woodcutting – plank grain and tools. *Illus.* 3: Wood engraving – end grain and tools.

grain probably existed before its great period of development during the late eighteenth century. It was then that Thomas Bewick, following apprenticeship to a metal engraver (see Intaglio), used engraving tools on end-grain boxwood to produce the creative prints (mainly of natural history subjects) which have made him such a landmark in the history of print. The nineteenth century saw the skill of the commercial reproduction engraver used to the full in the interpretation of artists' drawings in the same way as in the fifteenth century this division of labour applied to the woodcut. The engraved work of Eric Gill during the 1920s and 1930s would seem to be of particular interest to the calligrapher. There are three basic kinds of engraving tool, the graver or burin, the spitstick and the scorper, used for engraving lines of variable width, even width and for clearing spaces.

Embossing is a technique related to relief printing. It was used with skill by Japanese artists of the eighteenth century in blind and coloured form. The methods are employed today to produce inkless prints or in combination with coloured inks to heighten certain areas of a print.

INTAGLIO PRINTING

The reverse of relief printing, this is a method whereby the image itself is incised, usually into metal, rather than raised. The incision is made (again as a mirror image) either directly with a tool which cuts the metal (engraving, drypoint, mezzotint) or indirectly, when parts of the metal surface are protected and exposed areas eroded by acid (etching, aquatint). Ink is applied over the whole surface which is then wiped clean. This leaves ink only in the recessed image areas. Dampened paper under considerable pressure lifts out the incised image and also leaves a 'plate mark' impressed into the sheet of paper – the hallmark of this process.

Long before printing, engraving on metal was used for decoration by the Etruscans. In the early fifteenth century AD, similar decoration was carried out by European goldsmiths and metalworkers. It was from the incised designs on plates and armour by these craftsmen that proofs were taken and that intaglio engraving as a print process first developed. At that time engravers worked with a burin to produce a firm hard line or with a drypoint needle to create a scratched ragged softer line.

original surface of metal

Illus. 4

Illus. 5: Burin and drypoint needle.

The sixteenth century saw the introduction of etching on a wide scale following experiments with wax resist techniques on armour. Artists of the period who used this kind of engraving or etching as an expressive print medium were Mantegna, Dürer, Raphael and Rembrandt – much later, about 1800, Goya. Most of them engraved their own plates but, as with relief printing, some relied upon engravers to interpret the original drawings for them.

Copper and zinc are the most popular metals used for plates which have to be prepared so that they are clean and smooth. Tools used in engraving must be sharp and accurately prepared to give the best possible results. The 'copperplate' letterform illustrated has qualities which characterise the process and the eighteenth-century period.

PLANOGRAPHIC PRINTING

Printing from a flat, plane surface, one that is neither raised (relief) nor incised (intaglio) is called lithography. The image simply rests on the surface of the printing plate or stone as an ink-attracting area. The method was discovered in 1798 by Aloys Senefelder, almost by chance, when he was attempting to find a more

background & image
on the same surface

Illus. 6

economical way of duplicating the scripts which he produced as a playwright. His early experiments were made using local Bavarian limestone slabs, which provided a grained printing surface which became rarer in the late nineteenth century, to be replaced by grained zinc plates which are still used today.

Sticks of transparent grease or special transparent inks are used to draw directly onto the plate or stone – the image is reversed mirror fashion (as in relief or intaglio printing) if the printing method is 'direct'. (For 'offset' printing, see page 225). After the drawing and subsequent processing, the plate or stone is dampened with clean water from a sponge and printing ink applied firmly with a hand roller to reveal the image. Image areas reject the water and retain the ink, whilst background areas retain the water and reject the ink. With the 'direct' method, prints are then taken from the plate or

stone under pressure, whereas with the 'offset' method they are taken from the intermediate rubber blanket cylinder. After initial commercial use, the process was exploited more fully by major artists such as Goya, Blake, Delacroix and Odilon Redon.

The medium proved important to the Impressionist movement in France where a wide range of techniques were used by Degas, Toulouse-Lautrec and Bonnard – and important later to Picasso and Chagall. The overprinting quality created by two colours overlapping to produce a third is probably best seen to advantage in prints by the lithographic process. This, together with the freer painterly approach that the process allows make it arguably the most popular printmaking method of them all.

squeegee forces ink through the
mesh in open areas of the stencil

Illus. 7

SCREEN PRINTING

In this process a stencil or mask is attached to, or painted on, a fine mesh material (silk, nylon, copper, etc.) which is itself stretched on a wood or metal frame. The image is printed when ink or paint is drawn across the screen with a rubber squeegee and forced through the open apertures of the mesh onto paper or fabric. Related stencilling techniques date back to prehistoric times when hands were used to mask out earth pigments blown against cave walls. Cut stencils subsequently developed in the Far East to the point where fine hair was used to tie the open or floating element (such as the centre of the letter O). The final step of replacing this mesh of fine hair by a woven silk fabric was taken during the first decade of this century and developed by signwriters. William Morris had already taken advantage of the stencilling process quite

extensively when it involved the use of a bristle brush to force colour through the open mesh of material – the rubber-bladed squeegee was a later innovation.

There are two basic types of stencil: 'direct' which is made on the mesh and 'indirect' which is made or processed separately and later attached to the mesh. Where *oil*-based printing inks are to be used, the direct method simply entails the painting or blocking-out of background areas with a *water*-based glue filler which leaves the image as open mesh. The alternative direct tusche method allows the image to be drawn on the mesh with crayon or paint of a greasy nature, the remainder of the mesh (background) being then filled with a water-based glue. When the glue has dried, the drawn image is washed out with a solvent, and the mesh is open again for printing. Indirect stencils can be made of paper, of stencil film or of

photographically produced film, and attached to the mesh by heat, dampness or the printing ink itself.

Screen printing has become widely popular since the Second World War and has been used by artists such as Ben Shahn, Eduardo Paolozzi and Victor Vasarely. Wide acceptance of the combination of hand-produced and photo-mechanical methods of stencil-making during the 1960s led to its use by Pop artists such as Andy Warhol, Robert Rauschenberg, R. B. Kitaj and Joe Tilson – with certain reservations on the part of the printmaking purist. Screen-printed transfers can be widely used in ceramic and glass decoration techniques, an area of possible exploitation by the calligrapher perhaps.

PHOTO-MECHANICAL PRINTING

The invention of photography in the 1820s was, in time, to have a considerable influence upon the commercial adaptation of the four basic printing methods described above. The artist's or calligrapher's work is photographed and the printing blocks, plates or stencil are then made following exposure to light through the photographic negatives or positives which can be produced to any scale. The purist may argue that calligraphic work, for example, should be printed at the size it is written, but photography will allow its reproduction smaller or larger than executed. An illustrator often works at a scale which is 50% or more larger than it will be printed in order to ensure that a sharpening-up occurs on reduction.

PRINTING COPY FOR BLOCK/PLATE/STENCIL MAKING

To the calligrapher, the word 'copy' usually means typewritten text for writing out but to the process engraver or printer it means anything to be printed (type, lettering, photographs, drawings, patterns, etc.). 'Copy' is divided into two important categories, Line copy and continuous-tone copy. Line copy is any black image with no gradation of tone which may include solid masses, lines, dots, lettering or type. It is photographed on a process camera usually with high contrast film that can also produce line conversions from continuous-tone photographic originals.

Line Half-tone

Illus. 8

Continuous-tone copy on the other hand consists of images which have a full range of tones from black to white, such as photographs, shaded pencil, charcoal, crayon drawings, paintings, airbrush work, etc. As a printing process can print only solid colour or black, this continuous-tone copy must be converted to a form of line copy by the use of the half-tone process. The half-tone screen which is placed between the lens of the process camera and the unexposed film is made of glass upon which a finely ruled grid has been etched. This screen reduces the continuous-tone original to a series of dots of varying size which, when printed, give the illusion of the original tone values. Half-tone screen grids are measured by the number of dots to the linear inch (55, 65, 85, 100, 133, 150,

Tinted line

Illus. 9

etc.), the higher the number the finer the quality and the more accurately reproduced the fine detail involved.

Flat-tone or tinted copy can be reproduced photo-mechanically from line copy by the use in the process camera of screens with a regular pattern of lines or dots. Different screens will produce flat tone to represent any specified percentage of solid black (10% being a very light grey and 80% a dark grey) or of any single colour.

The four-colour half-tone process reproduces *full*-colour continuous-tone copy such as paintings, photographic colour prints and transparencies. Printing plates are made by the photographic or electronic separation of the image into three primary colours and black, with each of the four plates a complete half-tone. The primary colours used in this process are yellow, magenta (process red) and cyan (process blue), to which black adds definition. When printed, the four colours appear as dots of solid colour, so placed that they do not fall immediately on top of each other. These dots combine to reproduce as nearly as possible the full range of colours to be found in the original. The colours are finally created by the optical mixing of the four original process colours by the viewer's eye.

RELIEF PRINTING: LETTERPRESS

The photo-mechanical adaptation of relief printmaking methods was first introduced in line block form, often to accompany metal type. Metal type has, of course, relief characteristics obtained through the casting or moulding process and it is print-compatible with line and half-tone blocks. The line block was perfected in the 1880s and later used to great effect by the illustrator Aubrey Beardsley. The half-tone screen was first used in 1890 to reproduce continuous-tone lettering, drawing and photography. Letterpress blocks are made of zinc for coarse line and half-tone work and of magnesium and copper for fine line and tone. Their making involves the light-sensitised surface of the block being in contact with a photographic negative of the original and then being exposed to light. Areas that receive light through the negative are hardened by it and resist acid when etched, whereas the unexposed or background areas are etched away to a predetermined depth. The raised image area left will then be the printing surface for inking.

Letterpress printing machines are of three basic types: platen (flatbed or jobbing) where both printing surface and paper are flat, flatbed cylinder where the printing surface is flat but the paper is on a cylinder, and finally rotary where the specially-made printing plate is curved and the paper on a cylinder.

Embossing and stamping processes related to letterpress can produce raised or recessed images in blind form or in register with printed colours or metallic foils. Embossing necessitates a female brass die and a male counter between which paper is pressed, with added heat where the relief is heavy and complicated. Stamping or imprinting as on case-bound books originally used brasses (which had to be

Illus. 10: a Embossing. *b* Stamping.

cut by hand) but nowadays different varieties of copper die (which are chemically etched) leave an impression which may be blind or with colour or metallic foil.

INTAGLIO: GRAVURE

A commercial form of intaglio printing, gravure involves the taking of impressions from curved plates or cylinders which carry, etched on the surface, a grid of cells, each of the same surface area but each varying in depth according to the tonal value of the original. The printing cylinder revolves in a bath of ink and a flexible steel scraper or 'doctor blade' wipes ink clean from its surface. Ink left in the etched cells (the image) is drawn out onto paper by the pressure between the plate cylinder and the impression cylinder (which carries the paper).

The unique aspect of gravure is that all copy, line and continuous-tone, must be screened and etched as cells. This means that lettering when viewed through a magnifying glass will have a serrated edge caused by the cell struture. Although expensive to set up, gravure is most efficient for long runs (the colour magazine supplements issued by some newspapers, postage stamps, etc.) and, at its best, for accurate facsimile reproduction. Fine detail in postage stamps, for example, is obtained by using a grid of some 400 cells to the linear inch or 160 to the linear centimetre. Gravure rotary presses can be either sheet-fed or web-fed from a continuous roll of paper.

PLANOGRAPHIC: OFFSET LITHOGRAPHY

In this highly reformed version of Senefelder's invention, the aluminium or zinc plates are prepared photo-mechanically. The plate, coated with light-sensitive chemical, is exposed to high-intensity light and processed. Chemical treatment after exposure allows the image area to reject water and accept ink, whilst the non-image or background area accepts water and rejects ink. Offset presses work on a three-cylinder rotary principle, the plate cylinder which has the printing plate wrapped round it, a blanket cylinder (with a rubber or plastic surface) onto which the image is 'offset' and an impression cylinder which presses paper against the blanket cylinder. Because of the 'offsetting', the image on the printing plate is in this case not reversed left to right but matches the final printed image.

Mention should be made of the less used but related Collotype process which involves the production of a reticulated gelatine coating on a sheet of thick glass by baking in a moderate temperature. This flat surface gives excellent quality facsimile reproduction of continuous-tone without using a half-tone screen and is ideal for making fine colour prints or reproductions of works of art – but in relatively limited quantity.

SCREEN PRINTING

The commercial form of this process has been mechanised but its speed still does

not match that of the other printing methods. It is however extremely inexpensive to set up and very versatile in its breadth of application. The 'indirect' photographic stencils used consist of a two-layer film, one layer comprises a light sensitive emulsion as used in 'direct' stencils and the other is a transparent backing or holding sheet. A *positive* transparency of the image is used in exposure to ultra-violet light when the background non-image areas harden and become impervious to water. Following further development in a solution of hydrogen peroxide the image areas which have been masked from light remain soft and will fall away when washed with water. At this stage the stencil is attached to the screen mesh.

The commercial advantages of screen printing are numerous: economical costings on short runs, the capacity to print large sizes (four-sheet posters, etc.) and on a wide range of materials and variety of surfaces. Materials include paper, card, wood, glass, metal, textiles, plastics, etc. Surfaces do not have to be flat, they can be cylindrical, conical or otherwise unusual in shape. Finally, and most importantly, because the inks used are heavier and more opaque than in the other processes, white, metallic or bright colours can be printed over black or dark backgrounds.

PRESENTING ARTWORK TO THE PRINTER

The following illustration describes how a complete page of lettering should be made up as artwork and marked up for printing. The two reproductions demonstrate how it is possible to obtain printed versions with the lettering reversed white out of black or colour and at a reduced scale.

226

Presenting artwork to the printer

Camera ready artwork for line reproduction must be in opaque black ink & may be written on any suitable paper (even layout paper) · It is then pasted on to mounting or ivory board using cow rubber adhesive or spraymount · Layout paper sellotaped to ivory board is adequate as the copy camera has a vacuum frame board which keeps all surface paper flat by suction · This method of paste up is convenient when mistakes may be cut out & replaced by a rewritten portion attached with tape ·

Second or third colour printings not overlapping may be marked as above for separation at the negative stage · Where overprinting does occur it is necessary to use an overlaid transparent film with separated second colour pasted, written or painted on it · A protective paper overlay should be used to keep artwork clean · trim marks must be included for print registration purposes and to indicate precisely where the oversize printed sheet is guillotined · Descriptive marking up for the printer should be accurate about scaling, paper quality & weight, colour specification, quantity etc · Artwork may even be presented in positive form as here but with the instruction to print Reverse white on black or a colour · It is advisable to have written artwork proofread for mistakes prior to its presentation to the printer ·

Presenting artwork to the printer

Camera ready artwork for line reproduction must be in opaque black ink & may be written on any suitable paper (even layout paper) · It is then pasted on to mounting or ivory board using cow rubber adhesive or spraymount · Layout paper sellotaped to ivory board is adequate as the copy camera has a vacuum frame board which keeps all surface paper flat by suction · This method of paste up is convenient when mistakes may be cut out & replaced by a rewritten portion attached with tape ·

Second or third colour printings not overlapping may be marked as above for separation at the negative stage · Where overprinting does occur it is necessary to use an overlaid transparent film with separated second colour pasted, written or painted on it · A protective paper overlay should be used to keep artwork clean · trim marks must be included for print registration purposes and to indicate precisely where the oversize printed sheet is guillotined · Descriptive marking up for the printer should be accurate about scaling, paper quality & weight, colour specification, quantity etc · Artwork may even be presented in positive form as here but with the instruction to print Reverse white on black or a colour · It is advisable to have written artwork proofread for mistakes prior to its presentation to the printer ·

Presenting artwork to the printer ⟩ ———————— Red printing

camera ready artwork for <u>line</u> reproduction must be in
opaque black ink & may be written on any suitable paper
(even layout paper) · It is then pasted on to mounting
or ivory board using cow rubber adhesive or spraymount ·
Layout paper sellotaped to ivory board is adequate as the
copy camera has a vacuum frame board which keeps all
surface paper flat by suction · This method of paste up is
convenient when mistakes may be cut out & replaced by
a rewritten portion attached with tape ·

Second or third colour printings not overlapping
may be marked as above for separation at the negative
stage · Where overprinting does occur it is necessary to use
an overlaid transparent film with separated second colour
pasted, written or painted on it · A protective paper overlay
should be used to keep artwork clean · trim marks must
be included for print registration purposes and to indicate
precisely where the oversize printed sheet is guillotined ·
Descriptive marking up for the printer should be accurate
about scaling, paper quality & weight, colour specification,
quantity etc · Artwork may even be presented in positive
form as here but with the instruction to print Reverse
white on black or a colour · It is advisable to have
written artwork proof read for mistakes prior to its
presentation to the printer ·

Remainder
prints Black

Print on Keays Packwood
Antique White 175 g. m²

Quantity 1000

Trim marks

Reduce 18" to 12" (or 66·7 %)

Illus. 11: A marked-up piece of artwork (above)
with (left) examples of the artwork
reproduced at a reduced scale and
reproduced with the lettering reversed
black to white.

Bibliography

Understanding prints: a contemporary guide, Pat
Gilmour, Waddington Galleries
Woodcuts, John R. Biggs, Blandford, 1958
The Complete Guide to Prints and Printmaking,
John Dawson, Phaidon, 1981
About Prints, S. W. Hayter, Oxford University Press
Homage to Senefelder, Felix H. Man Collection,
Victoria and Albert Museum, 1971
Production for the Graphic Designer, James Craig,
Pitman, 1974

John Woodcock: Bookplate for the Taylor
Institution, Oxford. Lettering written with a
metal pen, adapted with a brush, then varied in
some of its detail on the enlarged photographic
print that formed the artwork for reproduction.
Printed in brown on white paper.
10 × 7.5 cm. c. 1975.

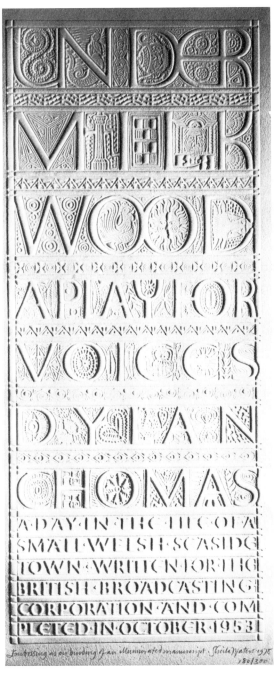

Sheila Waters: Title panel for the binding of Dylan Thomas, *Under Milk Wood*, an illuminated manuscript of the play, made for Edward Hornby. Panel embossed on buff handmade paper and set into the front board of the binding. Panel size: 32.5 × 13.5 cm. 1978.

ALPHABET

John Prestianni: Logo for *ALPHABET*, journal of the Friends of Calligraphy. Pen calligraphy on rough paper. 1983.

FINE
PRINT

A REVIEW
for the ARTS
of the BOOK

John Prestianni: Lettering and calligraphy for a promotional brochure. 1984.

Gaynor Goffe: Invitation to an exhibition. Emerald lettering on cream card. $6 \times 4\frac{1}{2}$ in. 1984. By courtesy of the Craftsmen Potters Association.

JAMES
PATERSON
· ROSS ·

Baronet, Knight Commander
of the Royal Victorian Order,
BORN 26TH MAY 1895
DIED 5TH JULY 1980
M·S; F·R·C·S; F·A·C·S·(Hon.);
F·R·A·C·S·(Hon.); LL·D·(Hon.)Glasgow; F·R·C·S·Ed·(Hon.);
F·R·C·S·Glas.(Hon.); F·F·R·(Hon.); F·D·S·(Hon.)

✦

He was Surgeon to King George VI 1949-1952,
& to Queen Elizabeth II 1952-1964; Professor of Surgery,
St. Bartholomew's Hospital 1935-1960; President of the
Royal College of Surgeons of England 1957-1960; Director,
The British Postgraduate Medical Federation 1960-1966.
For many years he served as Churchwarden of
the Queen's Chapel of the Savoy, where, by his constant
attendance at public worship he bore faithful witness
to his steadfast Christian convictions.

Joan Pilsbury: Memorial Book of the Royal Chapel of the Savoy. Written in black stick ink on vellum. Name and degrees on verso page in vermilion. (Name on recto page in blue.) Heraldry in full colour with burnished gold and platinum leaf. Double-page opening: $19\frac{1}{2} \times 14$ in.

The Binding of Manuscripts

SYDNEY M. COCKERELL

with drawings and a note on the finishing of vellum bindings
by Joan Rix Tebbutt

The purpose of binding a book is to hold the leaves together so that the book can be opened for reading and closed for protection. The book should open easily with the leaves lying in a gentle curve. When closed the manuscript should be well protected with the leaves held flat between the boards of the binding. Basically, binding is a matter of mechanics and strength of materials, as is the case with the building of a house or of a boat.

Binding is only a part of book production. If the final whole is to be a satisfactory unit there must be co-operation between the craftsmen concerned: the vellum maker, the scribe and the binder. When the scribe has finished writing and illustrating a manuscript, it is not sufficient to send it to the binder with a note that it is to be bound and must open flat.

The now usual codex form of book (Illus. 1) is made of one or more sections of folded leaves of vellum, parchment or paper. This form of book, made up of folded leaves of papyrus, came in about AD 200. (Codex comes from the word caudex – tree trunk – as books were bound between wooden boards.) By AD 400 vellum was being used for codices, the vellum withstanding the folding better than papyrus.

The section of a book (Illus. 2) is the binder's unit. In the case of manuscripts, a

Illus. 1

Illus. 2

section may consist of a single leaf folded in the middle (bifolio), which makes two leaves (four pages), or of several bifolios placed one inside the other. Two bifolios together (quarto) make four leaves (eight pages); four bifolios (octavo) make eight leaves (sixteen pages). Leaves are folded because it is convenient to sew through the folds in order to fasten the leaves together and to hold them to the binding.

SINGLE-SECTION BOOK

If the book is of a few leaves, it may be bound as a single section, the leaves being sewn together with thread or silk (Illus. 3). This is something that the scribes may very well do for themselves, adding a folded vellum or paper cover and lettering it. This will keep the leaves in order but they will need some further protection if they are not to become dirty and dog-eared.

For better protection, stiff cards (boards) are usually attached to the outside. These boards are cut slightly larger than the book so that they will project beyond the edges of the leaves; these projections are called squares. In order that the boards may be firmly attached, two or three bifolios of strong paper, with a strip of thin linen for additional strength, are folded round the section and sewn into position. The outside papers are pasted and boards stuck in place, a space being left between the back edge of the boards and the spine of the book. This space enables the boards to open freely. The cover can be lettered by the scribe.

The covering materials may be leather, cloth, or a combination of these, such as a leather-covered spine with paper sides. The paper sides may be plain or patterned. The four outside corners of the boards can have

vellum tips – these are very hard and durable and do not interfere with the rectangular shape of the book as leather corners can do. The title of the book can be lettered in gold on leather up the side of the spine; or the book may be covered wholly in leather, then lettered and tooled with a pattern.

The number of leaves that can be bound as a single section depends on their thickness and size; as an approximate guide I would say that not more than six thin vellum or ten thin paper leaves should be bound as a single section.

MULTI-SECTION BOOK

With a larger number of leaves the book is not likely to open well or handle nicely as a single section and should be arranged and bound as a multi-section book. For this the individual sections must be held together and also attached to each other (Illus. 4). This is achieved by sewing down the centre of each section over tapes or vellum strips or round cords stretched at right-angles to the spine of the sections. The thread is taken in near the end of the first section, along inside the central bifolio, out and over the first tape or round the first cord and back into the section, out for the next tape or cord and finally out near the end of the section and up into the second section and so on until the book is sewn.

The thread is looped together at the head and tail of the sections so joining them together at these points (kettle stitch). A section of endpapers is sewn on at each end of the book; these endpapers may be of paper for a paper book or vellum for a vellum one, with linen or leather hinges (joints).

The end of the cords or tapes to which the book is sewn are left projecting on each side of the spine; these projections are called slips and are very important as they form the main attachment for the boards.

A sewn book has a strand of thread at the centre of each section and the sum of these strands of thread can cause the spine to be thicker than the fore-edge when the book is closed. This swelling of the spine, as it is called, enables the closed book to be rounded which results in a convex spine and a concave fore-edge (Illus. 5). The amount of swelling depends on the thickness of the thread in relation to the book. The choice of the right thickness of thread needs careful judgment as too much or too little swelling can spoil the shape of the book.

After the book is sewn, it is usual to apply adhesive to the spine, and to round and back the book so as to form a convex spine with a concave fore-edge. The backing is the forming of ridges (joints as they are called) by fanning out the backs of the gatherings on each side of the spine. This forms a position for the boards to hinge in (Illus. 6). Whilst these processes can be satisfactory for a book of paper leaves it is not satisfactory for a book of vellum leaves as adhesive direct on to the spine is liable to make the spine very stiff and also cause the vellum to contract at the spine thus making horizontal cockling across the leaves which can become worse with changes in humidity as the spine can be held very rigidly by the adhesive. A manuscript with a stiff spine and horizontal cockling of the leaves will open very badly.

Twelfth-century manuscripts were not glued up or rounded and backed and they open very well; there are quite a number of bindings of this date still in existence. These books are sewn on alum tawed

Illus. 3

Illus. 4

Illus. 5

Illus. 6

thongs laced into wooden boards, the boards flush with the edges of the leaves. In the early Ethiopian bindings and the present-day ones, the sections are sewn together with a kind of chainstitch without any thongs using a thread made from gut which is very strong, the wooden boards being held on by the gut thread. No adhesive is used and the books open very well (Illus. 7). On a visit to Ethiopia in 1977 I saw a number of early manuscripts bound in this way still in good condition.

Illus. 7

When sewing a manuscript it is a good plan to put a free paper guard round the back of each section, so that no adhesive can come into contact with the vellum (Illus. 8), also with all books to use a free paper guard round the first and last section as this enables the endpapers to open freely when tipped to the guard, without pulling up the first and last leaf.

The boards are cut to size, allowing for suitable squares, and attached to the book by means of the slips. When the book is sewn on tapes, the boards can be made up of a thick and thin board stuck together (split boards) (Illus. 9), the ends of the tapes being inserted between the thick and thin boards and stuck in position. If the book has been sewn on cords these are laced into the boards (Illus. 10); two holes are punched in the boards for each cord, the slips are threaded through the holes and the burrs round the holes hammered flat. If the boards are of wood, the holes are drilled and the slips held in place with wooden pegs. The wood for the boards should be quarter cut, oak or similar, not beech as beech is very susceptible to furniture beetle. Quarter-cut is less likely to warp than plank cut because the growth rings are at right-angles to the surface of the wood.

As the board projects beyond the edges of the leaves there is a space at the head

Illus. 8

Illus. 9

Illus. 10

and tail of the spine equal to the height of the squares. This space is filled in by working a head band over a strip of vellum; it may be made with coloured silks or threads and gives the appearance of buttonhole stitching. It should be flexible and firmly attached by frequent tie downs below the kettlestitches and forms a firm foundation for the head and tail caps of the covered book.

The book may be covered wholly with leather, or with a leather spine and cloth or paper sides. The leather is cut to size and carefully pared along the joints for flexibility and where it will be turned in at the head and tail and over the boards. The leather is pasted with flour paste brushed well into the leather; the moisture in the paste softens the leather which enables it to be moulded to the shape of the book. A well-covered book should look as if the cover has grown on it.

Leather joints are then pasted down, the turn-in of the leather trimmed out on the inside of the boards, the space being filled in with thin card. The binding is lettered and may be tooled and the board papers are pasted down.

This, briefly, is an outline of binding practice. There are, of course, numerous variations.

Among the points to consider are the following:

1 The leaves of the book must bend if the book is to open (Illus. 11)[1]. The binder cannot make a book of playing cards open except by drastic methods.

2 The sections must be of a suitable size for if they are too large, with too many leaves to the section, the book will tend to open in chunks. If, on the other hand, the book is of too many bifolio sections it will tend to have too much swelling in the spine, and will be floppy and wedge-shaped. Therefore it is important to plan the size of the sections before beginning to write the book and it will be a wise precaution to send particulars to the binder before starting on the writing with a sample of the vellum or paper that is going to be used, a rough of the layout, size and number of leaves so that the binder may suggest the size of the sections and comment if necessary on the inside margins and the position of raised gold. If the manuscript is to be on vellum the sections may be quarto; if on paper they must be at least quarto sections as the thread is apt to cut through a single thickness of paper.

[1] See Edward Johnston's *Writing and Illuminating, and Lettering*, page 99.

Illus. 11

3 If the scribe should have the misfortune to spoil a page that is part of a bifolio the whole bifolio need not be scrapped, the faulty leaf may be cut from the bifolio making sure to leave a fold of vellum along the back margin, so that the binder may have a fold to sew through. The same applies should it be necessary to insert a single leaf in the manuscript. The leaf must have a fold along the back margin and not be cut to the dead width of the page; otherwise the leaf will have to be guarded in and the guard will show.

4 The back spine margin must not be too small and flourishes should be kept within limits on the inside margins as a book does not open flat like a bifolio on a drawing board but in a curve from the spine to the fore-edge. The illustration of the Wilton Psalter (Illus.

12) (Royal College of Physicians) shows that the tails of the initials on the recto page tend to be obscured in the spine in spite of the book opening well (Illus. 13).

This is an instance of the repair and binding of an early illuminated manuscript. It was because of the flourishes going so far back into the back margins that the book was thrown out on guards. The meeting guards as they are called are sewn on through the centre of each section so that the sections still have their original makeup. It is the method that was used for the rebinding of the Codex Sinaiticus by Douglas Cockerell, the Book of Kells by Roger Powell and the Codex Bezae by myself. It is particularly suitable for some early manuscripts as it enables the book to

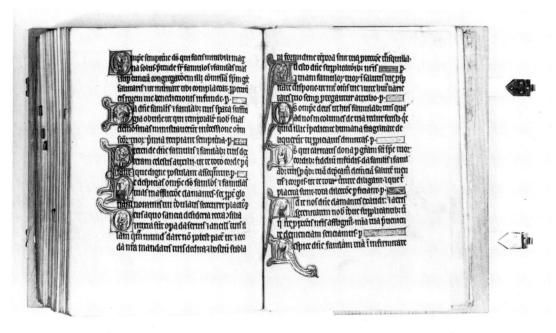

Illus. 12: The Wilton Psalter showing flourishes on recto pages.

Illus. 13: The Wilton Psalter showing opening and guards.

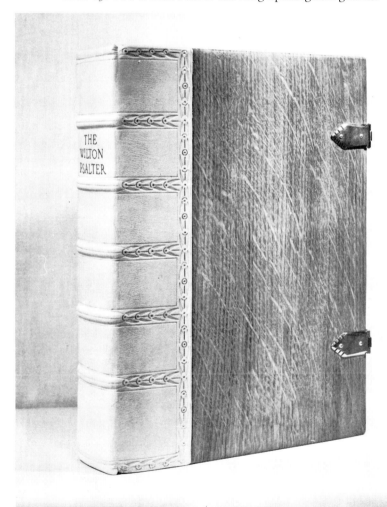

Illus. 14: **Sydney M. Cockerell**: Binding of the *Wilton Psalter*, thirteenth-century MS. White alumed morocco; gold and blind tooling; English oak boards; silver clasps. $12 \times 8\frac{1}{2}$ in. By courtesy of the Royal College of Physicians.

be examined right to the back of the sections. It is not the same as the guarding of single leaves where the vellum is too thick for folding. The Wilton Psalter was resewn on double cords to an old marking-up, laced into quarter cut English oak boards; the spine covered with alum tawed morocco; tooled in blind and gold with a simple pattern similar to the patterns in the manuscript, and fitted with silver clasps with leather crossovers. (Illus. 14).

5 If the book can be written on folded leaves it generally makes a better book than one of single leaves that have to be guarded before the book can be sewn. If it should be decided to write the book on single leaves it can be a good plan to have the leaves guarded before writing as this will save some handling of the finished manuscript. The Metropolitan Police Roll of Honour in Westminster Abbey written by Dorothy Hutton with gilding by Vera Law is on single leaves, also the three volumes of the Arms of the Prime Wardens of the Worshipful Company of Fishmongers written and illuminated by Heather Child, Joan Pilsbury and Wendy Westover are on single leaves. The ten volumes of the Book of the RAF are written on folded leaves; the Coastal Command Roll written by Dorothy Hutton and bound by Roger Powell is on single leaves.

Illus. 15 is of the binding of the London Transport Roll of Honour. The manuscript of folded leaves was written by William M. Gardner, the binding is red morocco with gold tooling.

6 *Parchment*. I think of parchment as split sheepskin and vellum as a whole skin, generally of calf or goat.

Sometimes it can be difficult to tell parchment from vellum, though parchment tends to be much more slippery than vellum, thin and tinny. (See page 62.)

7 *Raised Gold*. This causes a local thickening of the leaf; and a book can assume ungainly proportions where for example an illuminated shield is in the same position on each page because the aggregate of all the shields can make a serious lump in one area of the book. This unevenness will prevent the book closing properly and will tend to make the leaves cockle. It will mean that the pressure of the closed book will be on the gold; for instance, if a book of sixty-four leaves had an initial of raised gold one sixty-fourth of an inch high at the head of each recto page, the additional thickness caused by the raised gold through the whole book would be an inch – an impossible lump to deal with. It is, of course, an exaggerated instance, but it illustrates the point and can very easily happen in a modified form. Therefore if there are to be a number of initials or arms with raised gold they should be staggered so as to even up the thickness as far as possible. Incidentally, this can make for interesting variations in layout. Gold on facing pages should be arranged not to touch when the book is closed.

8 *Title pages from a binding point of view*. The title page should be arranged so that there is at least one leaf between the title page and the endpapers so as to avoid having a guard showing at the title page opening.

9 *Trimming square*. The edges of the leaves of a manuscript must at least be square at the head and square with the spine margin, before the book is bound.

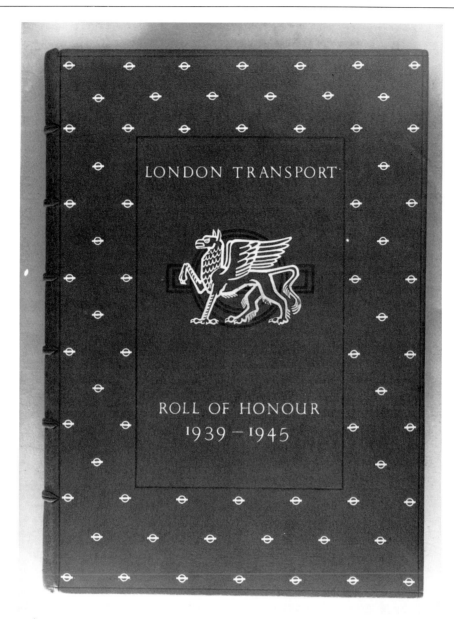

Illus. 15: **Sydney M. Cockerell**: Binding of the *London Transport Roll of Honour*, manuscript by
W. M. Gardner. Red levant morocco; gold tooling; griffin from a design by Eric Ravilious.
15 × 10 in.

Binders will cut vellum leaves square and to size before they are written and this is a better plan than trimming the leaves after they are written. If the binder is required to trim the finished manuscript it is a help if the guide lines can be left as it provides something to work from. Otherwise a fine gold title page without marginal lines can be a frightening thing to square up.

10 *Endpapers*. For manuscripts on vellum a bifolio of toned vellum slightly darker than the book helps the transition from the dark exterior of the binding to the relatively light interior of the book. On the inside of the boards there will be the turn-in of the cover with maybe leather joints which will form a leather margin round the inside of the boards (the remaining area can be filled in with paper, leather or some woven material). Vellum pastedowns are liable to become detached from the boards in time particularly at the corners.

11 *The spine* of a bound book must be flexible and bend when the book is opened (Illus. 11 and 16). Therefore it is most important that any lining of the spine be kept to the minimum. The spine of the bound volume will be concave when it is open and convex when it is closed. If the book is sewn on raised cord these will show as bands on the spine of the binding. If the book is sewn on tapes it will normally have a smooth spine. Whether the book should be sewn on tapes or cords depends on a number of factors: the size of the book, the material it is made of, the make up of the sections and the use the book is to be put to. When the book is sewn on tapes and bound with split boards it is usual to have a French joint, a groove between the spine and the back edges of the boards and less paring of leather is needed than with a tight joint (Illus. 6).

12 *Leather for binding*. Morocco (goatskin) is mainly used for binding because the goat has a hard close skin that is not too thick. One of these leathers is the red native niger morocco. It is strong, works well, a good colour and has a good durability record. Quantities of partly tanned niger goatskins are imported in the crust as it is called, and retanned for binding leather. Sheepskin is not as a rule satisfactory for binding as it is apt to be soft and tends to split in its thickness. Calf has been used a great deal for binding, the skins being sometimes pared down to a paper thinness for neatness and this excessive paring makes the leather very weak. The calf is a large animal compared with a goat and so has a thick skin which needs to be pared down for binding; excessive paring makes a weak binding material.

Illus. 16

Alum-tawed skins are skins that are pickled in salt and alum. Alum-tawed pigskins and goatskins are more usual but various other animals' skins have been prepared in this way. It is the most durable binding material that we know of and there are still numbers of twelfth-century bindings in good condition. Because of this, alum-tawed morocco was used for the rebinding of the Codex Sinaiticus, the Book of Kells and the Codex Bezae. These three books (eight volumes) were all bound with quarter-cut oak boards, the wood showing on the sides with the spine covered with the tawed skins. Of recent manuscripts the ten volumes of the Book of the RAF were bound in alum-tawed skin, the three volumes of the Arms of the Prime Wardens of the Worshipful Company of Fishmongers, with quarter-cut oak, the wood showing on the side.

13 *Vellum for binding*. Vellum can be a strong and durable binding material provided that the construction of the book is suitable. For a vellum binding the book needs to have a hollow back (Illus. 16) and French joints, the inside of the boards should be lined with vellum so that the pull on each side of the boards may be similar. Like the alum-tawed skins, vellum is not destroyed by the sulphur dioxide of our city atmospheres, though it is sensitive to changes in humidity which can cause the boards of a closed book to warp. This is because the outside only of the boards is subjected to the change in humidity. Under normal conditions the boards will usually straighten out again when the inside of the boards have become conditioned to the atmosphere. The shape of a book board is a matter of balance between the covering

material and the lining. Most materials that can absorb moisture will swell in a moist atmosphere and shrink in a dry one. Therefore if one side only is exposed to a change in humidity the boards will tend to warp until the other side of the board is equally conditioned.

Limp vellum bindings. These showed up very well in the 1966 Florence flooding. There are no boards to warp in a limp vellum binding and the vellum is free to move with changes in the humidity which can cause the vellum to cockle. Limp vellum bindings are more suitable for the binding of paper leaves than vellum leaves, where a binding with wooden boards helps to keep the leaves flat.

14 *Paper*. Paper is made from vegetable fibres such as those from wood, cotton, linen and manilla hemp. These fibres are longer than they are wide and, when damp, swell more in their width than in their length.

Handmade paper has the important characteristic of swelling evenly in every direction when damp, and correspondingly shrinking on drying. This is of importance to the scribe and the binder as it means that endpapers and paper for blank books can be cut from either way of the sheet.

In machine-made paper the fibres tend to get drawn into a side-by-side pattern owing to the motion of the machine, with the result that on becoming damp a sheet of machine-made paper will become larger across the way of the grain than down the grain and correspondingly shrink more across the grain. Also a sheet of machine-made paper will bend more freely with the grain than across it. Therefore a book will open more freely

with the grain of the paper running from head to tail rather than across the leaf. To find out which way the grain is running, cut a 3 in. square of paper and sponge one side only with water; the paper square will tend to roll up into a cylinder, the grain or machine way is down the length of the cylinder. The same applies to machine-made card used for book boards.

15 *Lettering and tooling.* As the finished book will be a co-operative production the scribe should let the binder know what is proposed for the lettering and tooling of the binding and the final pattern should be arrived at by the binder in consultation with the scribe. The tooling of a binding is done with hot brass finishing tools making impressions on the leather. These can be left blind, of a darker colour than the surrounding leather or in gold. For gold tooling, blind impressions are painted with white of egg. When the egg is dry a little Vaseline is rubbed on the leather, the gold leaf is laid in position and the hot tool struck again, which fries the egg and holds the gold in the impressions.

Lettering. This is usually done with brass handle letters, each letter being put down separately. Unfortunately the typefaces that are available in binder's letters are apt to be very limited. Printer's type can be used, using a type holder or onto a leather lettering piece using a blocking press.

When designing for the *tooling* of a binding there are a number of things one should take into account: the book itself, its size and how it is going to be used, whether it will be held in the hand or placed on a lectern, or start its life in a glass-sided case (like a Roll of Honour). If these things have been considered from the beginning of the making of the book it is likely that the book will turn out well, for the design of the binding is related to the first stitch of the sewing.

Tooling on leather has a quality of its own and designing for it is not the same as designing for a flat surface in black and white because besides the shapes and spaces of the tooled areas, the quality and texture of the tooling have to be taken into account. A binding is a three-dimensional object with a function, and number one rule is that the decoration must not interfere with the working parts. The three usual textures of a binding are the leather, blind tooling and gold tooling. The binding may be entirely blind tooled or tooled entirely in gold or a combination of the two. If the book is to be held in the hand there is the feel of the tooling to be considered besides the look of it.

Colours can be applied to a binding by means of inlays. They are called inlays though it is usually leather that has been pared very thin and stuck on top of the leather of the binding.

16 *Coat of Arms.* These are sometimes required on a binding. This generally means having a block made and striking this in a blocking press. For the making of a block a drawing must be made in black and white, as simply and boldly as possible without fine lines or small spaces, as leather is a soft material that does not take the impressions of fine lines readily and small spaces tend to fill in. The Griffin by Eric Ravilious in Illus. 15 is blocked.

17 *Metalwork.* If the book is a heavy one it may be advisable to fit metal corners and possibly nails with raised heads or bosses for the book to ride on. If silver

is used it may be gold plated or oxidised; the grey oxidised silver will develop highlights where the metalwork becomes rubbed with use. If silver colour is needed then the metalwork can be rhodinum plated. Whatever is used in the way of metalwork must be smooth, and free from sharp corners. It must be securely attached to the book by riveting through wooden boards.

Clasps are to keep the boards of the binding closed and the vellum leaves flat. It is usual to have two clasps at the fore-edge with crossovers made of strips of thick vellum covered with leather or sometimes metal crossovers. It needs careful adjustment to make a clasp close with a firm snap and yet not be too hard to open. This depends on the spring of the book which is caused by the undulations in the leaves.

18 *Finishing vellum bindings*: Blind tooling on vellum is not as durable as on leather as the impressions tend to pull out and also the blind tooling hardly shows as the warm tool does not change the colour of vellum as it does on leather. Gold tooling can look very bright on white vellum and a white vellum binding can look very pure. Natural toned vellum has more character and is more practical for a binding.

For many years now I have been making toned vellum bindings with the scribe Joan Rix Tebbutt and she has written the following note:

There is a vellum-covered dictionary in the bindery with ink drawing and gold tooling. We hoped this work would be durable and are pleased and surprised that twenty years later it is in reasonable condition having survived a considerable amount of handling. It was Sandy Cockerell's idea that we try a combination of our work and it has been interesting to see how things have developed since, particularly now that we have been using a variety of brass tools which he makes in the workshop as patterns demand them. It was refreshing to me to see new basic shapes appearing so promptly in response to my needs – I like to use them in multiples, on the vellum books, or to combine them with black and gold lines that form areas of tone and texture. It is a luxury to work where a change of mind can mean the almost instantaneous adjustment of the shape of the tool.

The vellum itself can often provide inspiration by its strange, dark or muted markings, on which gold, and black, and sometimes coloured foil can look very rich. (Pouncing with Fuller's Earth seems to cope with the sometimes unpredictable surfaces of skins.) The problem of working on the curved surface of the spine when it comes to lettering it, is not too acute if a finishing press is used to hold the book at a suitable angle to the table. Pens, especially chisel edges, are to me less sympathetic than brushes for lettering on such a surface.

A dense and non-clogging ink of American origin works well with the very small brushes used for building up simple capitals, (and this ink can be on occasion disconcertingly permanent within a few minutes). Sometimes standard printer's type is used as part of a design, choosing one of the many faces available, and striking in a blocking press. And occasionally blocks are used which reproduce an entire area of letters for a cover.

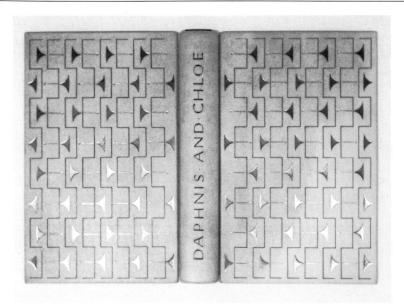

Illus. 17: **Joan Rix Tebbutt and Sydney M. Cockerell**: Binding of *Daphnis and Chloë*, book of Maillol woodcuts from the Philip Gonin Press, Paris. Toned vellum binding with gold and black tooling and brush ink lettering. 8 × 5 in.

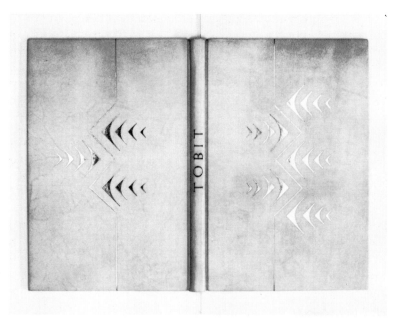

Illus. 18: **Joan Rix Tebbutt and Sydney M. Cockerell**: Binding of *The Book of Tobit*, published by the Raven Press. Toned vellum binding with gold tooling and brush ink lettering. 9 × 5 in.

Another luxury to me is a device of Sandy's construction which enables these sometimes quite large brass tools to be positioned by eye over the book and impressed through gold and coloured foil with freedom and accuracy, the pattern being built up and adjusted as the tooling proceeds. (The implications of this tool are extremely encouraging and stimulating to any designer, as larger units can be used than would be possible by hand.)

The design for the tooling is drawn on paper. The key points from this drawing are marked in pencil on the vellum of the binding. Working from these points, I can carry out the tooling by eye. The brush lettering is drawn directly onto the vellum spine of the binding.

<p style="text-align:center">✻ ✻ ✻</p>

19 *Scrolls.* I have had little to do with scrolls apart from the repairing of a few old ones and the making of scroll cases for new ones. A tubular case with a pull-off lid may be covered with leather and tooled or covered in paper. Scrolls are awkward things to house as although they were suitable for the Alexandrian Library in 200 BC they do not fit easily into our present-day book cases.

20 *Rolls of Honour.* These books often start their life in a glass case with a leaf turned every day. The binding should be closed from time to time, otherwise it may fail to close altogether.

21 *Show Cases.* The cases can be of wood or metal with glass sides and a glass top. The base board that the book rests on should be slightly sloping, not more than 10° and have a narrow ridge to keep the book straight. The glass top should also slope and be parallel to the base. The case should not be deeper

than necessary and should be buffered by packing cotton wool under the base board of the case at the rate of 1 lb of cotton wool per cubic yard (or 500 g of cotton wool per cubic metre) of the area of the case. Such packing will even up the changes in humidity.

22 *Repair and flattening of vellum.* When vellum is made it is dried under considerable tension in a frame. Should it get damp at a later date it will tend to curl and cockle and go back to the shape of the animal. In order to flatten it out again it must be relaxed in a humid atmosphere and then allowed to dry under tension and even the cockled leaves of early manuscripts can be flattened in this way. It can be held in tension by means of bulldog clips which should be lined with paper. The clips can be put in place all round the leaf and pinned down on a softwood board with thick needles in wooden handles.

23 *Tears.* If they are small ones they may be mended by sticking on small vellum patches with parchment size. The area around the tear and the edge of the patch should be roughened with fine glass paper. Larger tears may be sewn up with fine linen thread, provided the vellum is strong and not too thin. A cross-stitch is used taking the thread through the tear at each stitch to check the edges of the tear overlapping when the thread is tightened.

24 *Bindings of old manuscripts.* There is not much change in the methods used for binding of the early illuminated manuscripts and those in use today. The books were then sewn on leather thongs whereas now hemp cords are usually used. The old books had wooden boards and were unbacked as we know it, though a form of backing

was achieved by lacing the boards on tightly, thus pulling the backs of the sections round when the boards were closed. Headbands were very strongly made with thread over thongs which were laced into the boards forming an important part of the construction. Thin metalwork was often nailed on in a rather haphazard manner and liable to become loose and a bit scratchy. Some book boards were covered entirely with metal and mounted with semi-precious stones. Elaborately carved ivory was also used and there have been some sumptuous embroidered bindings.

From a binder's point of view it is difficult to make a nice book out of a few magnificent leaves of large area, one reason being that the thickness of the boards needs to be increased as the area is increased in order to be stiff enough to protect the manuscript. With a few leaves of a large area the manuscript will be thin but the boards clumsy and out of proportion.

With a manuscript of a number of thin vellum leaves of small area it is possible to make a well-proportioned book that will open and close sweetly, be pleasant to handle, easy to read and look at, a book that can be loved.

SELECTED LIST OF BOOKS

The following books are recommended by the writers of the articles which make up this new *Calligrapher's Handbook*. Some more general handbooks and historical manuals have also been included, the bibliographies of which should lead to further reading. The books have been divided into several sections for easy reference. The date of the latest edition is given, except in the case of titles which have been in print for many years when the date of first publication may also be given.

The articles on *Calligraphy* written by Stanley Morison in the 1945 edition of the Encyclopaedia Britannica and by James Wardrop in the 1950 edition of Chamber's Encyclopaedia are recommended reading. Articles of special interest to scribes have also appeared in periodicals, some of which are now available only from libraries. These include: The Studio, Fleuron, Imprint, Signature, Alphabet & Image, Motif, The Journal of the Royal Society of Arts, Scriptorium, Graphis, Visible Language and Typos. Makers of art materials and writing materials produce interesting booklets about their own products and it can be worthwhile to make enquiries of manufacturers.

The Society of Scribes and Illuminators and the Society for Italic Handwriting publish valuable journals in Britain. Some calligraphic societies in America do likewise.

PRACTICAL GUIDES

Calligraphy and Lettering

Angel Marie *The Art of Calligraphy* Robert Hale 1978

Benson J H & Carey A G *The Elements of Lettering* McGraw-Hill Book Company 1950

Benson J H *The First Writing Book: Arrighi's Operina* Oxford University Press 1955

Camp Ann *Pen Lettering* Dryad 1958 A & C Black 1984 (USA: Taplinger)

Evetts L C *Roman Lettering* Pitman 1938 Now published by A & C Black

Fairbank Alfred *A Handwriting Manual* Dryad 1932 Faber & Faber 1978

Gardner William *Alphabet at Work* A & C Black 1982 (USA: St. Martin's Press)

Gourdie Tom *The Puffin Book of Lettering* Penguin 1961

Graham David *Colour Calligraphy* Search Press 1991

Haines Susanne *The Calligrapher's Project Book* Collins 1987

Halliday Peter (editor) *Calligraphy Masterclass* Collins 1990

Harvard Stephen *The Cataneo Manuscript* Taplinger/Pentalic 1981

Harvey Michael *Lettering Design* Bodley Head 1975

Hewitt William Graily *Lettering for Students and Craftsmen* Seeley Service 1930 Taplinger 1981

Johnston Edward *Writing and Illuminating, and Lettering* John Hogg 1906 Pitman 1948 Now published by A & C Black (USA: Taplinger)

Johnston Edward Heather Child (editor) *Formal Penmanship and Other Papers* Lund Humphries 1971 paperback reprint 1977 (USA: Taplinger)

Johnston Edward Heather Child & Justin Howes (editors) *Lessons in Formal Writing* Lund Humphries 1986

Kaech Walter *Rhythm and Proportion in Lettering* Walter-Verlag 1956

Lindegren Eric *ABC – an ABC Book* Pentalic 1976 (Now available from Taplinger)

Mahoney Dorothy *The Craft of Calligraphy* Pelham Books 1981 (USA: Taplinger)

Mitchell C Ainsworth *Inks, their Composition and Manufacture* Griffin & Co 1937

Pearce Charles *The Little Manual of Calligraphy* Taplinger 1981

Smith Percy J Delf *Civic and Memorial Lettering* A & C Black 1946

Wellington Irene *The Irene Wellington Copy Book* Omnibus Edition Pitman 1977 Now published by A & C Black (USA: Taplinger)

Paper Making

Hunter Dard *Paper Making – the history and technique of an Ancient Craft* Pleiades Books 1947

Mason John *Paper Making as an Artistic Craft* Faber & Faber 1959

Turner S & Skiold B *Hand Made Paper Today* Lund Humphries 1983

Bookbinding

Clarkson Christopher *Limp Vellum Binding* The Red Gull Press Hitchin 1982

Cockerell Douglas *Bookbinding and the Care of Books* Pitman 1901. Fifth edition 1953 Now published by A & C Black (USA: Taplinger)

Johnson Arthur *The Thames & Hudson Manual of Bookbinding* Thames & Hudson 1978

Middleton Bernard *A History of English Craft Bookbinding Technique* Hafner Publishing Co 1963

Heraldry

Boutell Charles *A Manual of Heraldry* Warne 1863; revised by C W Scott-Giles 1950 under the title *Boutell's Heraldry*; revised by J R Brooke-Little 1983

Child Heather *Heraldic Design* Bell & Hyman Ltd 1979

Child Heather and Bromley John *Armorial Bearings of the Guilds of London* Frederick Warne & Co 1960

Neubecker O *Heraldry. Sources Symbols and Meanings* Macdonald & Janes 1977

St John Hope W H *Heraldry for Craftsmen and Designers* Pitman 1913

St John Hope W H *Grammar of English Heraldry* Cambridge University Press 1913

HISTORY OF WRITING AND ILLUMINATING

Alexander J J G *The Decorated Letter* Thames & Hudson 1978

Alexander J J G (editor) *A Survey of Manuscripts in the British Isles* 1) *Insular Manuscripts 6th to 9th Century* J J G Alexander 1975 2) *Anglo Saxon Manuscripts 900–1066* Elzbieta Temple 1976 3) *Romanesque Manuscripts 1066–1190* C M Kauffmann 1975 Harvey Miller London

Alexander J J G (introduction & commentaries) *Italian Renaissance Illuminations* Chatto & Windus 1978

Anderson D M *The Art of Written Forms* Holt Rinehart & Winston 1969

Backhouse Janet *The Illuminated Manuscript* Phaidon 1979

Backhouse Janet *The Lindisfarne Gospels* Phaidon 1981

Backhouse Janet, D H Turner & Leslie Webster (editors) *The Golden Age of Anglo Saxon Art 966–1066* British Museum Publications 1984

Bishop T A M *English Caroline Minuscule* Oxford University Press 1971

Catich Edward M *The Trajan Inscription in Rome* Catfish Press 1961

Catich Edward M *The Origin of the Serif* Catfish Press 1968

Cennini d'Andrea Cennino translated by Daniel V Thompson Jr. 'Il Libro dell' Arte' in *The Craftsman's Handbook* Dover 1954

Degering Herman *Lettering* Ernest Benn 1929 Pentalic 1965 (Now available from Taplinger)

de la Mare Albinia *The Handwriting of the Italian Humanists* Printed at the University Press, Oxford, for L'Association Internationale de Bibliophilie, Paris vol 1 1973 vol 2 in preparation

Diringer David *The Illuminated Book: its history and production* Faber & Faber 1967

Diringer David *The Hand Produced Book* Hutchinson 1953

Fairbank Alfred *A Book of Scripts* Penguin 1949 Faber & Faber 1979 Pelican 1979

Fairbank A & Hunt R W *Humanistic Script of 15th and 16th centuries* Bodleian Library 1960

Fairbank A & Wolpe B *Renaissance Handwriting* Faber & Faber 1960

Gray Nicolete *Lettering as Drawing* Oxford University Press 1971 (USA: Taplinger)

Gullick Michael (introduction) *The Art of Limming* SSI Publication 1976

Guttmann Joseph (introduction & commentaries) *Hebrew Manuscript Painting* Chatto & Windus 1978

Hayes James *The Roman Letter* Lakeside Press, R R Donnelley, Chicago 1951–1952 1983 reprint

Henry Françoise *The Book of Kells* Thames & Hudson 1974

Herbert J S *Illuminated Manuscripts* Methuen & Co 1911

Herringham Lady Christina J *The Book of the Art of Cennino Cennini* George Allen & Unwin 1899

Jackson Donald *The Story of Writing* Studio Vista 1981 Then published by Trefoil Books (USA: Taplinger)

Kaech Walter *Rhythm and Proportion in Lettering* Walter-Verlag 1956

Kauffmann C M see Alexander J J G (editor)

Kendrick T D *Anglo Saxon Art to AD 900* Methuen 1938

Kendrick T D *Late Saxon and Viking Art* Methuen 1949

Ker N R *English Manuscripts in the Century after the Norman Conquest* Oxford University Press 1960

Knight Stan *Historical Scripts: a handbook for calligraphers* A & C Black 1984

Lowe E A *Codices Latini Antiquiores.* 11 vols and supplement Oxford University Press 1934–1972

Lowe E A *English Uncial* Oxford University Press 1960

Lowe E A (ed. Ludwig Bieler) *Palaeographical Papers (1907–1965)* Oxford University Press 1972 (two vols)

Marks Richard & Morgan Neil (introduction and commentaries) *The Golden Age of English Manuscript Painting* Chatto & Windus 1981

Meyer Hans E *Development of Writing* Stampfli Zurich 1977

Moé Emil-A van *Illuminated Initials in Mediaeval Manuscripts* Thames & Hudson 1950

Morison Stanley *Politics and Script* Oxford University Press 1972

Nordenfalk Carl (introduction and commentaries) *Celtic and Anglo Saxon Painting* Chatto & Windus 1977

Oakeshott Walter *The Artists of the Winchester Bible* Faber & Faber 1945

Ogg Oscar *Three Classics of Italian Calligraphy: Arrighi, Tagliente and Palatino* Dover 1953

Osley A S (editor) *Calligraphy and Palaeography: essays presented to Alfred Fairbank* Faber & Faber 1965

Osley A S *Mercator* Faber & Faber 1969

Oxford History of Art T S R Boase (editor)
 English Art 871–1100 D Talbot Rice (1952)
 1100–1216 T S R Boase (1953)
 1216–1307 Peter Brieger (1957)
 Oxford University Press

Rickert Margaret *Painting in Britain in the Middle Ages* Pelican History of Art Series 1954

Temple Elzbieta see Alexander J J G (editor)

Thomas Marcel (introduction and commentaries) *The Golden Age. Manuscript Painting at the time of Jean Duc du Berry* Chatto & Windus 1950

Thompson D V Jr *Materials of Mediaeval Painting* George Allen and Unwin 1936

Thompson E Maunde *Handbook of Greek and Roman Palaeography* Ares Publishers, Chicago 1966

Tschichold Jan *Illustrated History of Writing and Lettering* Zwemmer 1946

Tschichold Jan *Treasury of Alphabets and Lettering* Reinhold Publishing Corporation 1966

Ullman B L *The Origin & Development of Humanistic Script* Edizioni di Storia e Letteratura Rome 1960

Ullman B L *Ancient Writing and Its Influence* Cooper Square Publishers 1963

Wardrop James *The Script of Humanism* Oxford University Press 1963

Weitzman Kurt (introduction and commentaries) *Late Antique and Early Christian Book Illumination* Chatto & Windus 1977

Welch Stuart Cary *Royal Persian Manuscripts* Thames & Hudson 1976

Whalley Joyce Irene *The Pen's Excellencie: Calligraphy of Western Europe and America* Midas books 1980 Now published by Baton Press

Whalley Joyce Irene *English Handwriting 1540–1853* HMSO 1969

Whalley Joyce Irene *Writing Instruments and Accessories* David & Charles 1975

Williams John (introduction and commentaries) *Early Spanish Manuscript Illumination* Chatto & Windus 1977

Wilson David M *Anglo Saxon Art* Thames & Hudson 1984

BOOKS OF INTEREST TO SCRIBES

Angel Marie *Painting for Calligraphers* Pelham Books 1984

Angel Marie *Fables de la Fontaine* Neugebauer 1981

Child H, Collins H, Hechle A & Jackson D *More than Fine Writing: Irene Wellington* Pelham Books 1986

Dreyfus John *The Work of J van Krimpen. An Illustrated Record* Sylvan Press 1952

Gray Nicolete *The Painted Inscriptions of David Jones* Gordon Fraser 1981

Gullick Michael *Words of Risk: the Art of Thomas Ingmire* Calligraphic Review Editions 1989

Johnston Edward *A Book of Sample Scripts* HMSO 1966

Johnston Priscilla *Edward Johnston* Faber & Faber 1959 Barrie & Jenkins 1976

Kindersley David & Cardozo Lida Lopes *Letters Slate Cut* Lund Humphries 1981 (USA: Taplinger)

Neugebauer Friedrich *The Mystic Art of Written Forms* Neugebauer Press 1980

Osley A S *Scribes and Sources* Faber & Faber 1980

Stone Reynolds *Engravings* John Murray 1977

Wormald Francis *English Drawings of the Tenth and Eleventh Centuries* Faber & Faber 1952

ILLUSTRATED SURVEYS

Brinkley John (editor) *Lettering Today* Studio Vista 1964

Child Heather *Calligraphy Today: Twentieth-century Tradition and Practice* A & C Black 1988 (USA: Taplinger)

Halliday Peter (editor) *Contemporary Calligraphy – Modern Scribes and Lettering Artists II* Trefoil Books 1986

Holme R & Frost K M (editors) *Lettering of Today* Studio 1941

Holme R & Frost K M (editors) *Modern Lettering & Calligraphy* Studio Publications 1954

Miner D E, Caslon V & Philby P W (editors) *2000 Years of Calligraphy* Walters Art Gallery Baltimore 1965 Pentalic 1980 (Now available from Taplinger)

Rees Ieuan & Gullick Michael *Modern Scribes and Lettering Artists* Studio Vista 1981 Trefoil Books 1983

Victoria and Albert Museum Whalley J I & Kaden V (editors) *The Universal Penman* HMSO 1980

Zapf Hermann (foreword by) *International Calligraphy Today* Thames & Hudson 1982

Index